DRAWING FILE

for architects, illustrators and designers

Drawing File

SZABO 10-17-81

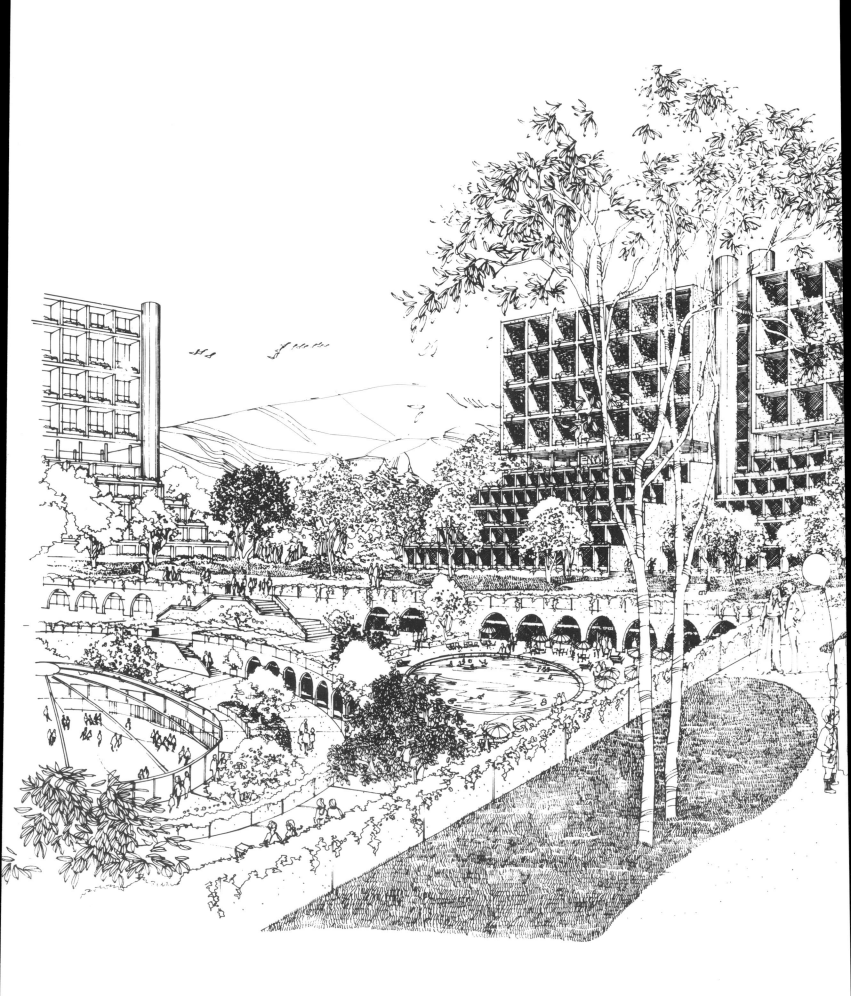

DRAWING FILE

for architects, illustrators and designers

MARC SZABO

MARC SZABO

VNR VAN NOSTRAND REINHOLD COMPANY
New York Cincinnati London Toronto Melbourne

Special thanks and acknowledgment to my wife, Tanya, without whose months of help this work could not have been completed. I would also like to recognize the assistance of Wayne Blickenstaff in completing the final art work. I sincerely hope these pages will be as great an aid to others as they are for me.

Published in 1976 by Van Nostrand Reinhold Company
A Division of Litton Educational Publishing, Inc.
135 West 50th Street, New York, N.Y. 10020

Van Nostrand Reinhold Limited
1410 Birchmount Road
Scarborough, Ontario M1P 2E7, Canada

Van Nostrand Reinhold Australia Pty. Ltd.
17 Queen Street
Mitcham, Victoria 3132, Australia

Van Nostrand Reinhold Company Ltd.
Molly Millars Lane
Wokingham, Berkshire, England

16 15 14 13 12 11 10 9 8 7 6

Library of Congress Cataloging in Publication Data

Szabo, Marc.
 Drawing file for architects, illustra-
tors, and designers.

 1. Drawings. I. Title.
NC52.S9 702'.8 75-29209
ISBN 0-442-27878-0

These sketches were compiled for the purpose of upgrading in-house presentation for the architect, interior designer, advertising agency, commercial artist, and art student. The figures were selected for naturalness of pose and are divided into the following categories, which the author has found most useful in his practice:

 people standing · walking · sitting · lounging · in restaurants
 people dancing
 people with horses
 people on bicycles
 people skating
 people in ski wear
 people in swim wear
 people in tennis wear
 people golfing
 children
 domestic cars
 foreign cars
 luxury cars
 classic cars
 sports cars
 motorboats
 sailboats

A rendering begins each section and shows how the figures, all taken from these pages, might be used to strengthen the composition and mood of your illustrations.

The figures are drawn as large as possible and can be reduced by photocopying machine to many sizes to provide an unlimited range and variety of combinations. The book itself is designed so that the pages will tear out cleanly, so that you can make your own fingertip scrap file.

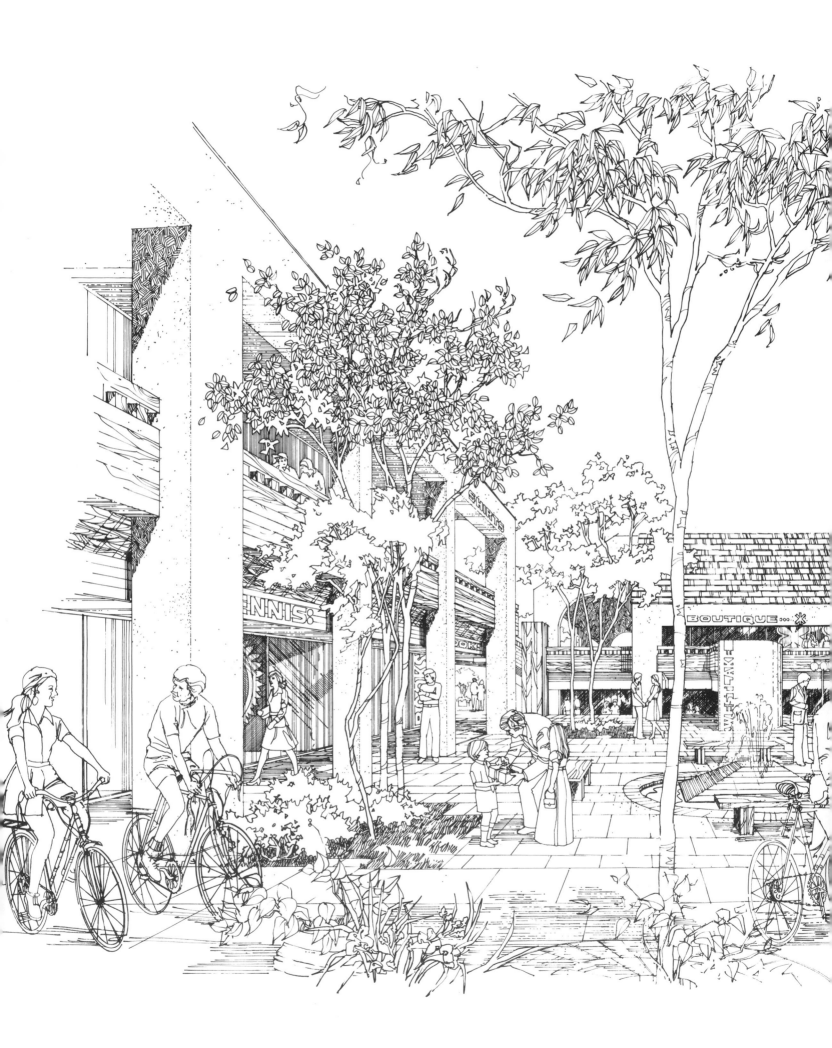

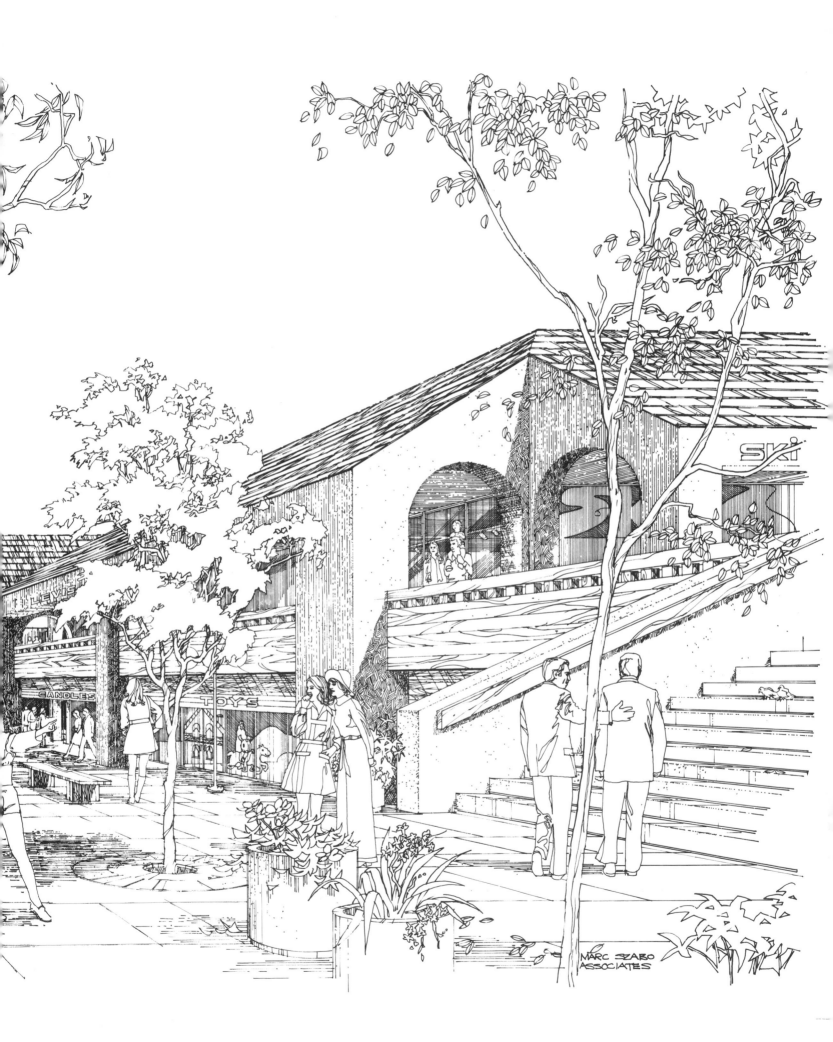

LEVI'S

CANDLES

TOYS

SKI

MARC SZABO
ASSOCIATES

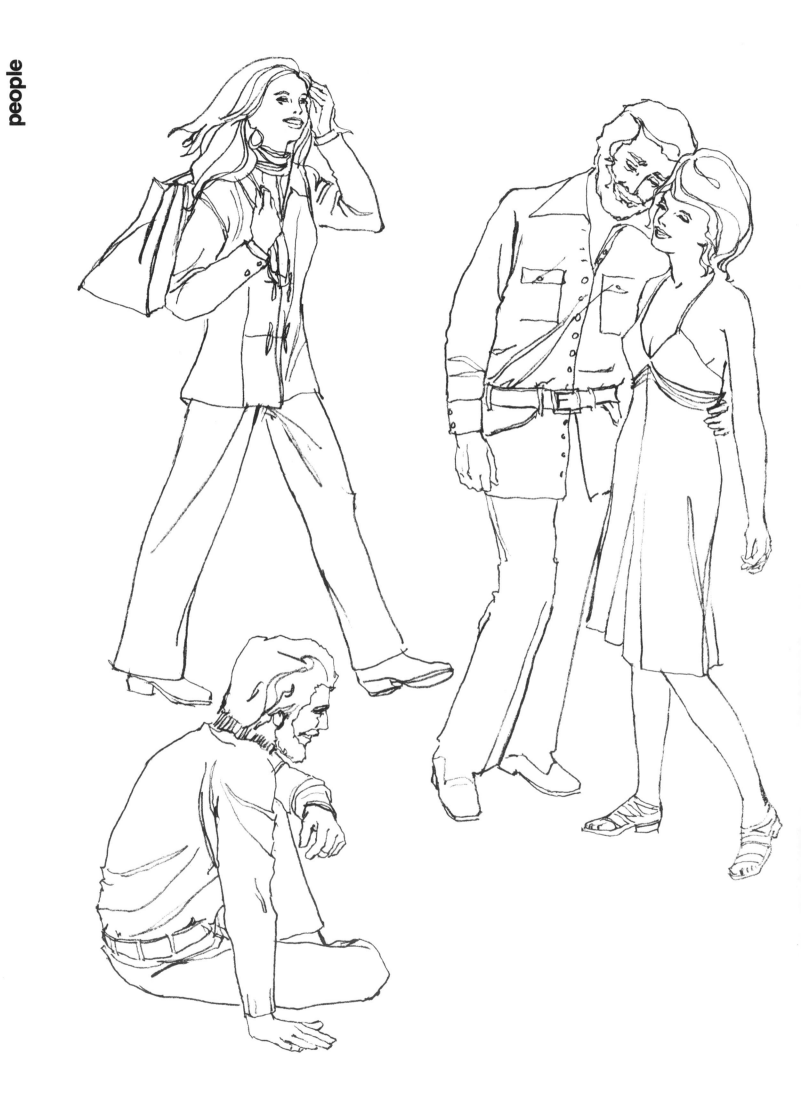

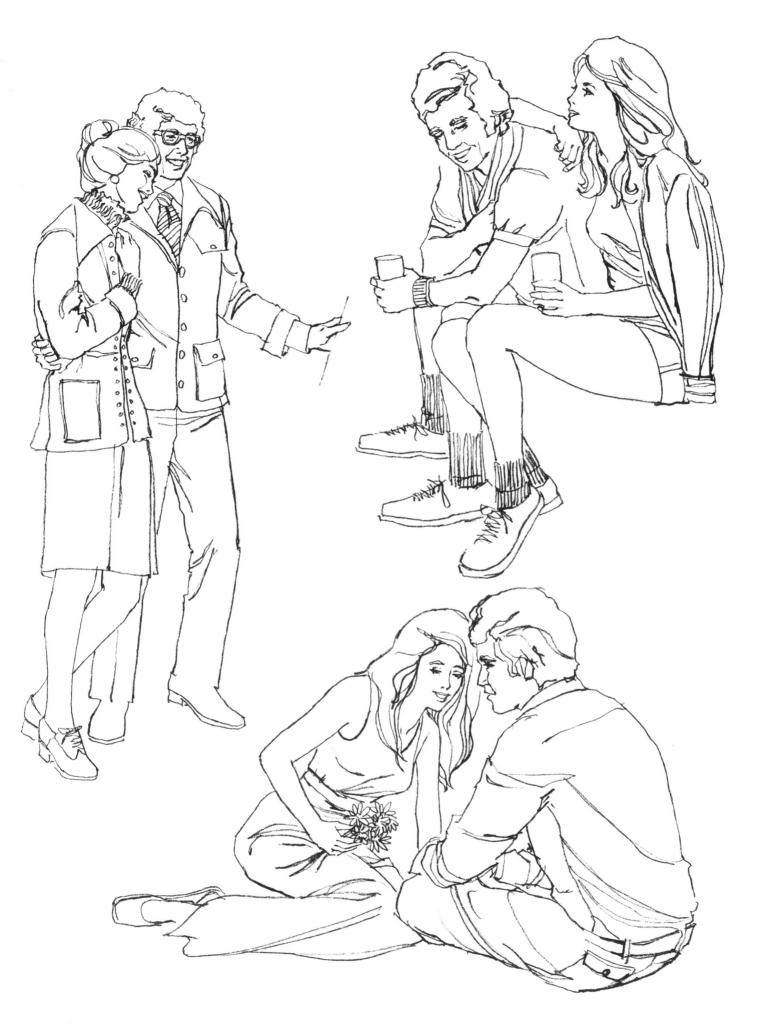

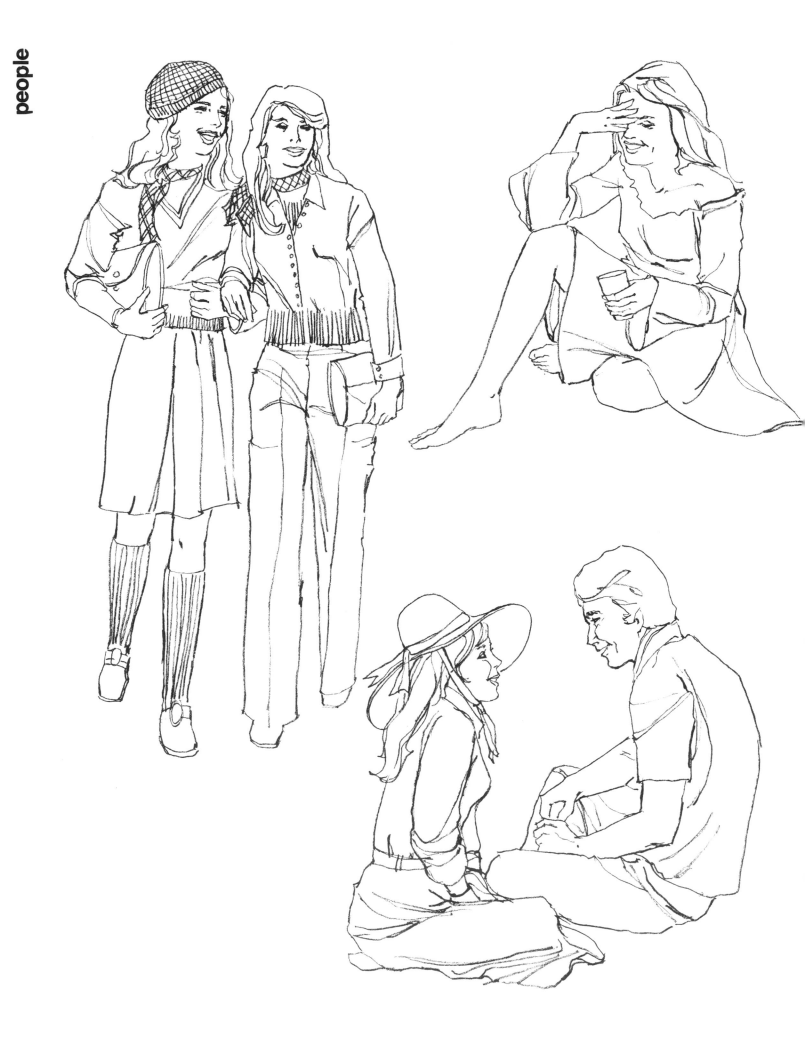

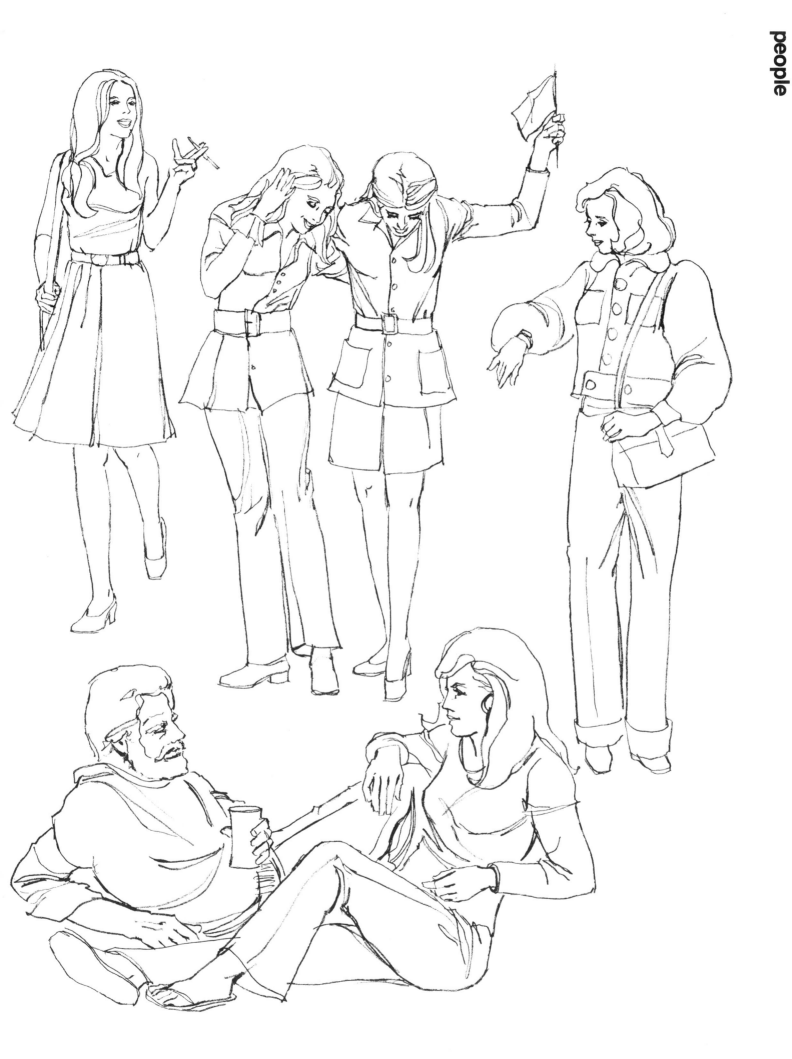

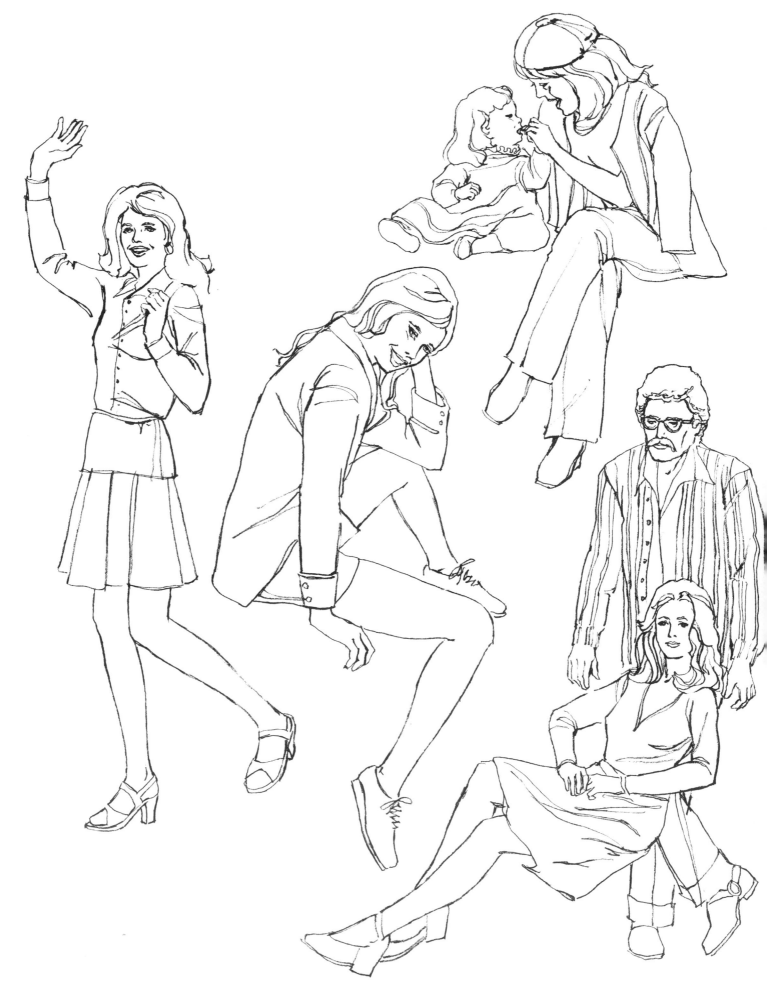

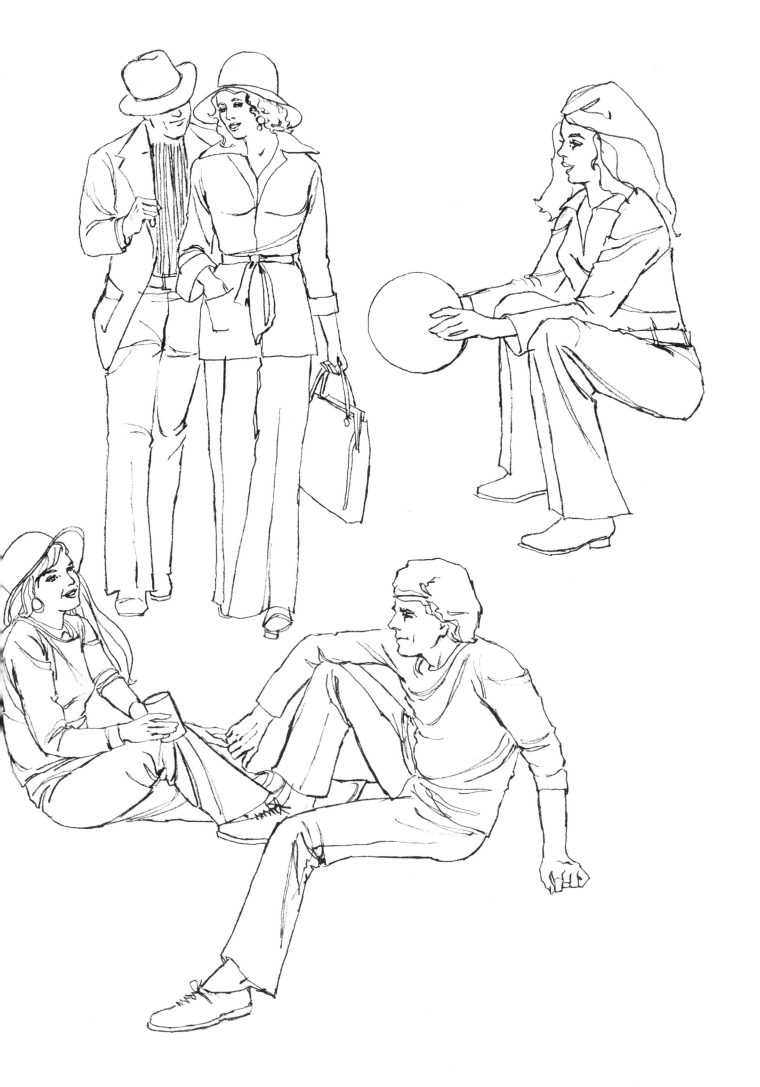

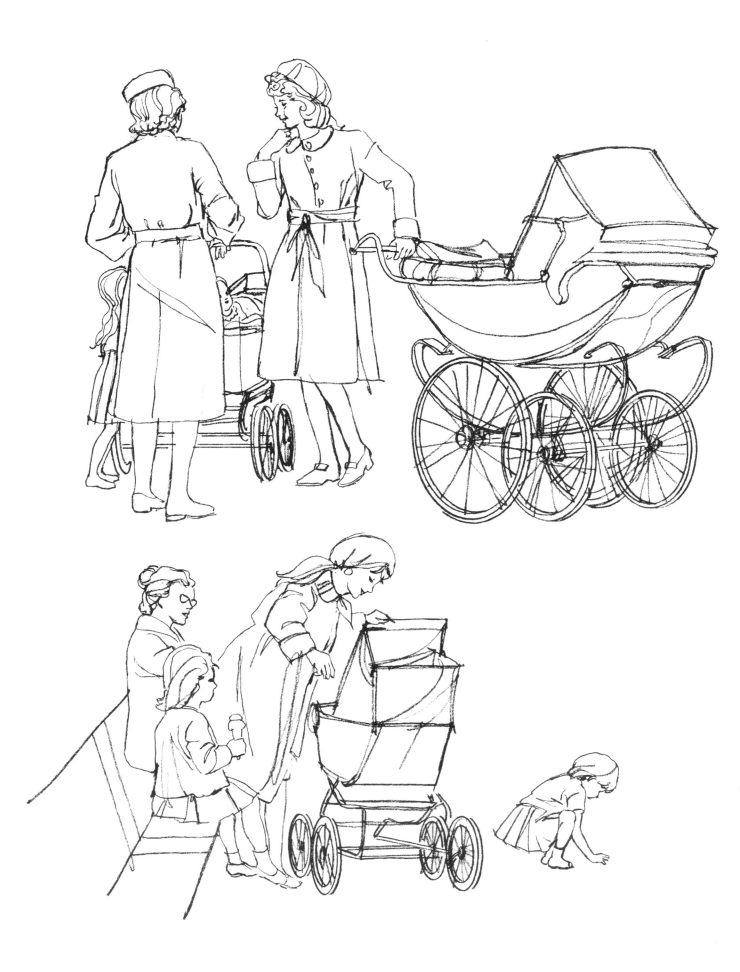

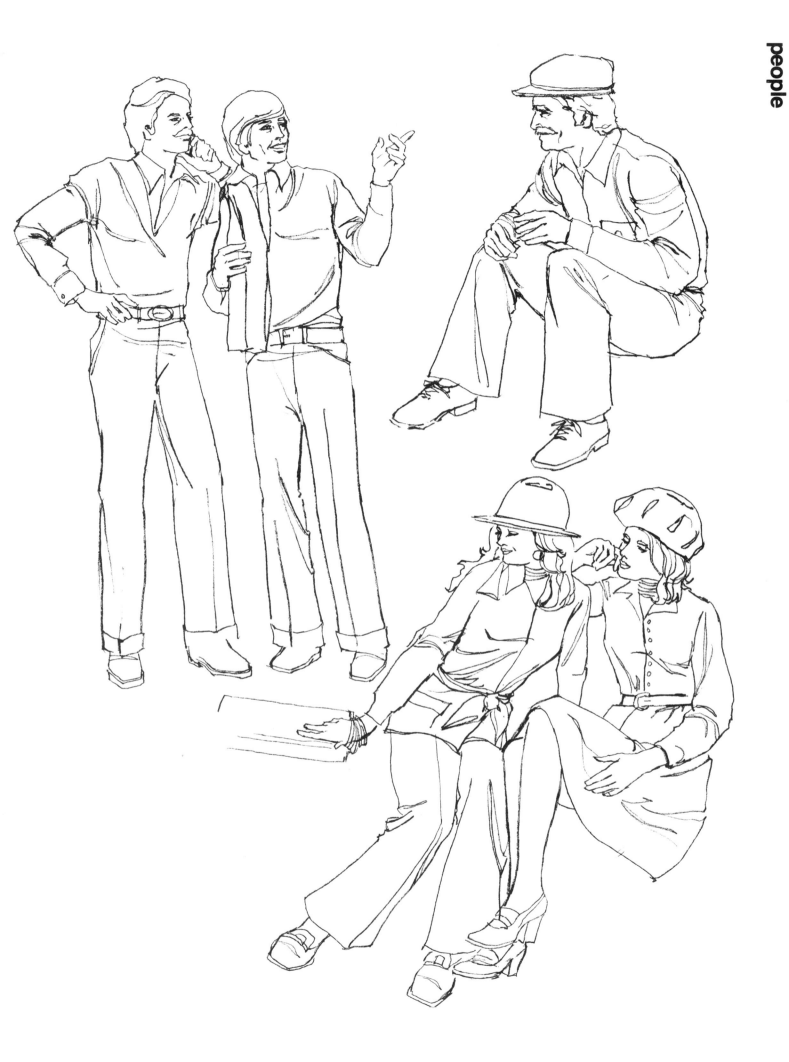

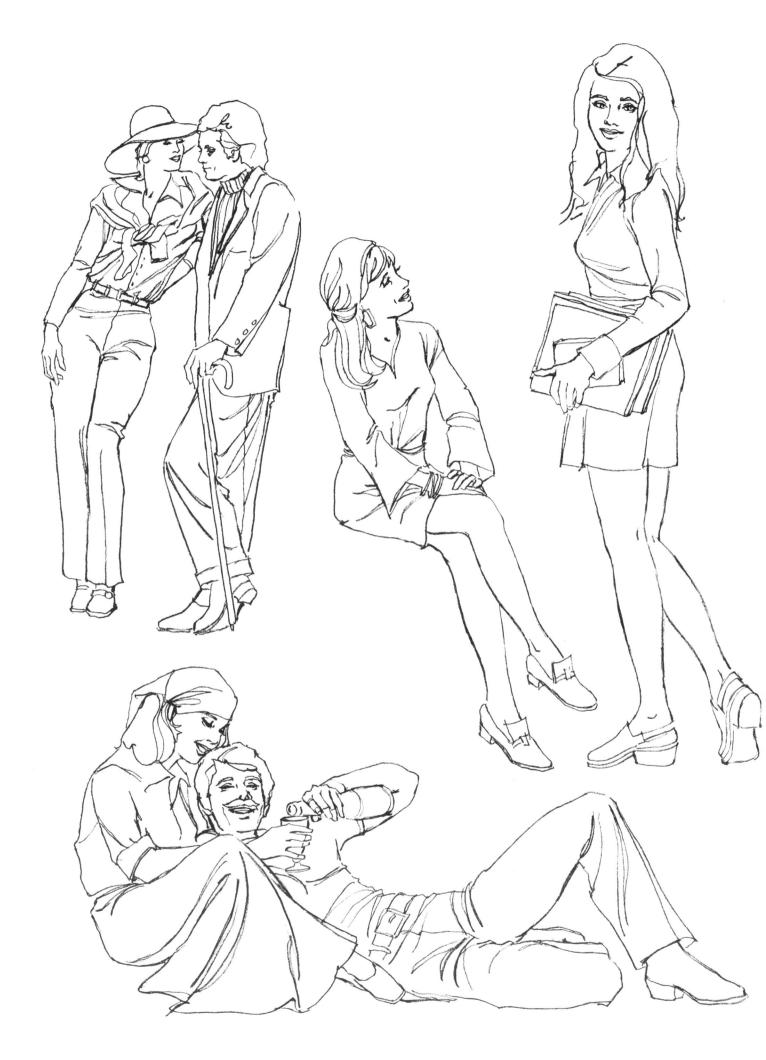

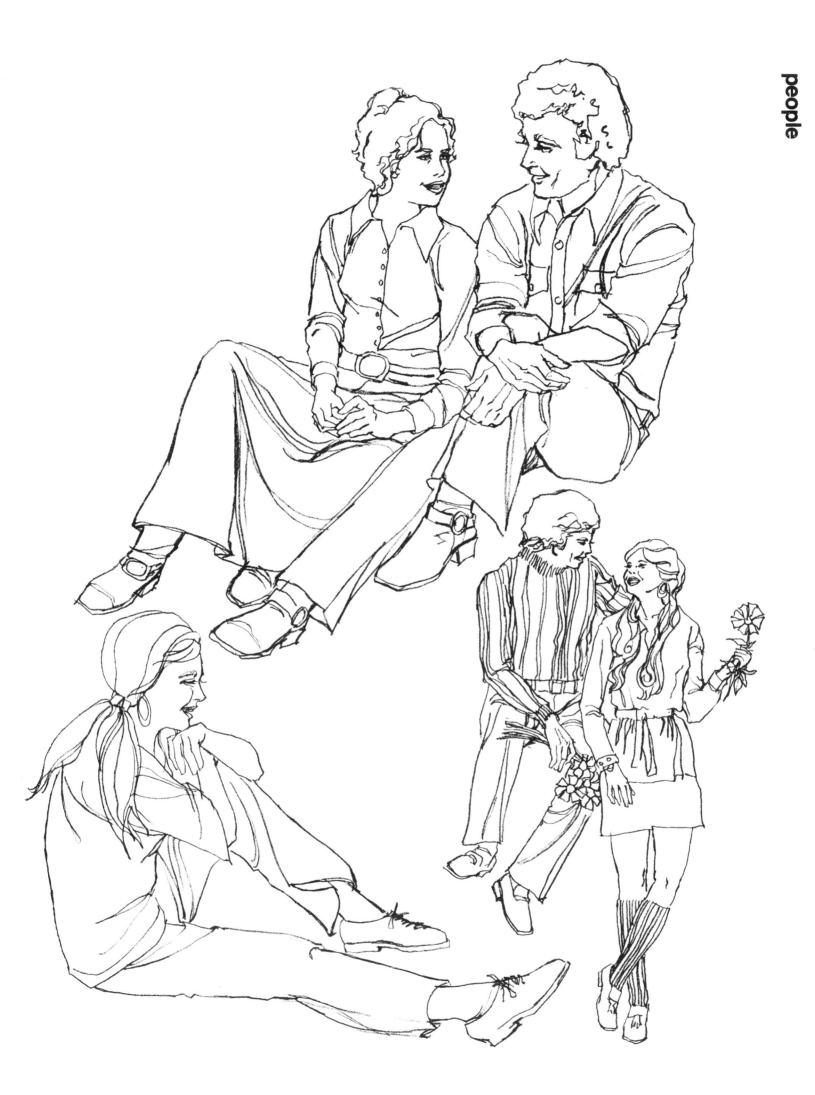

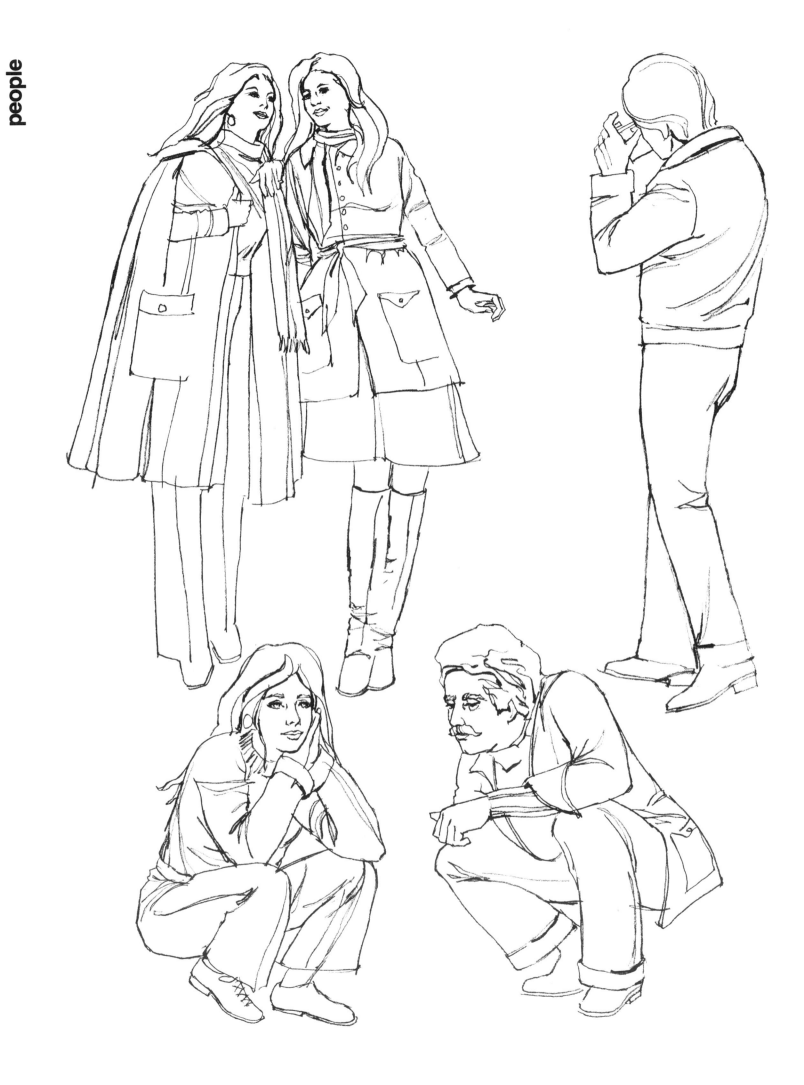

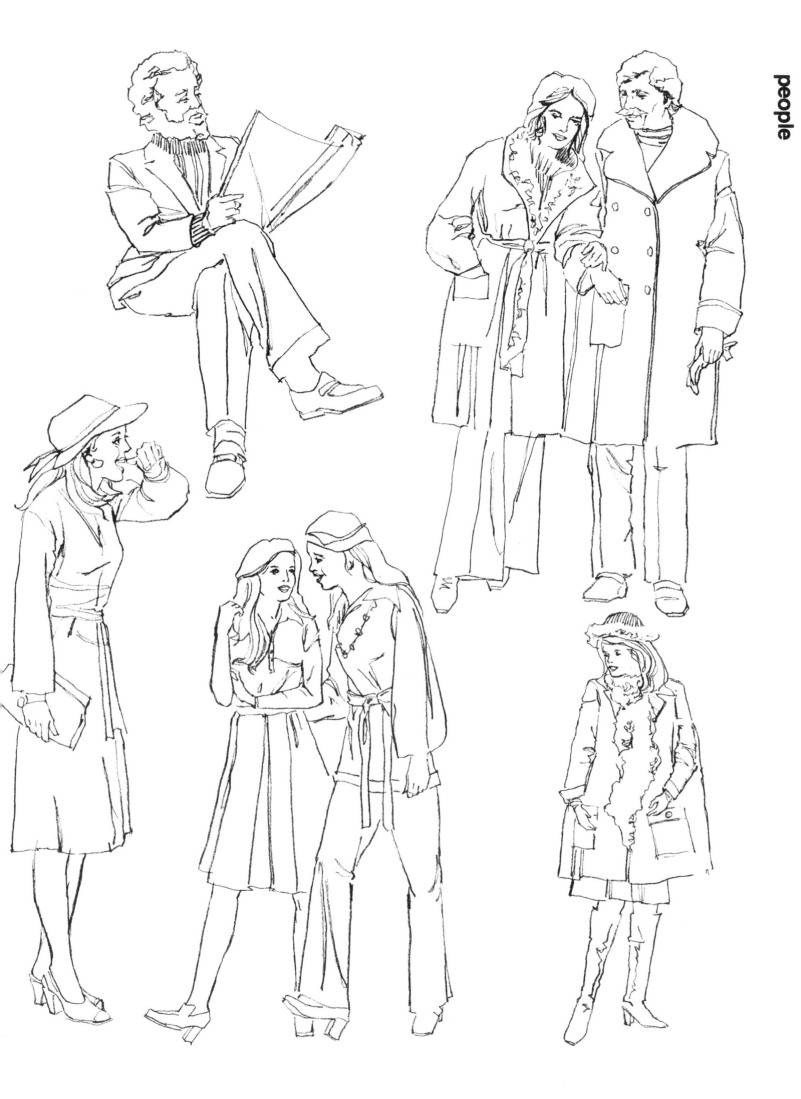

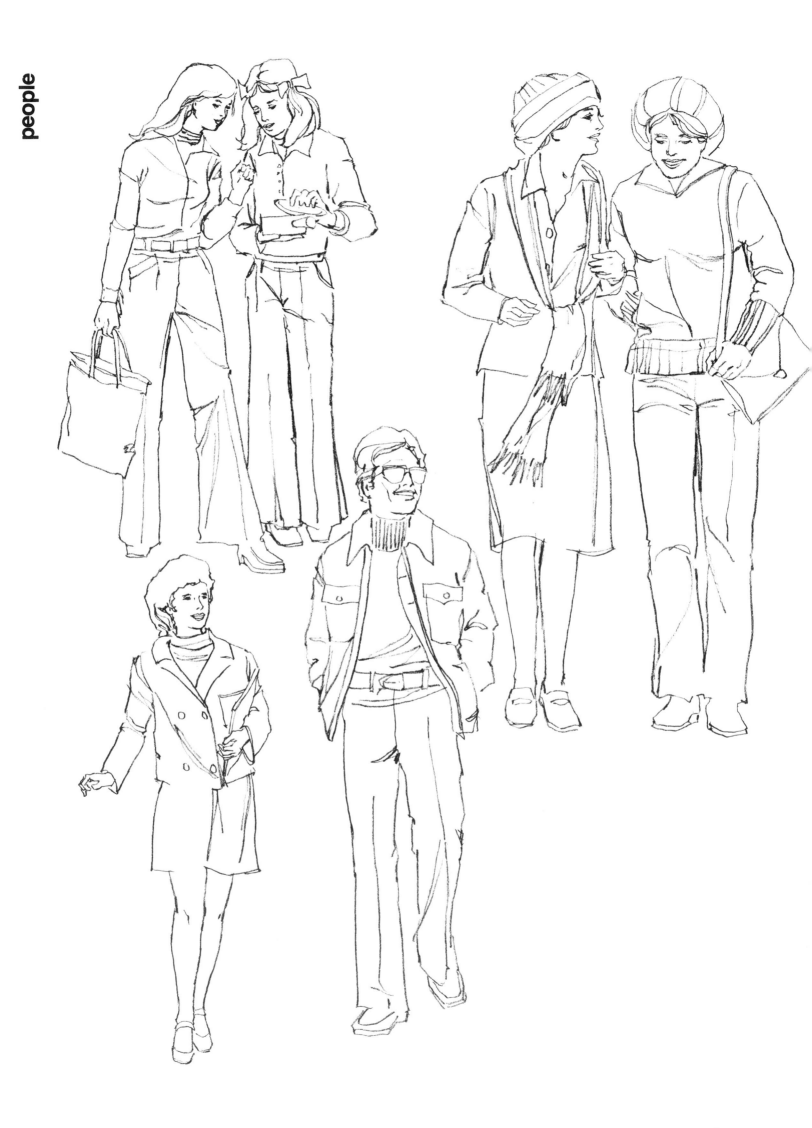

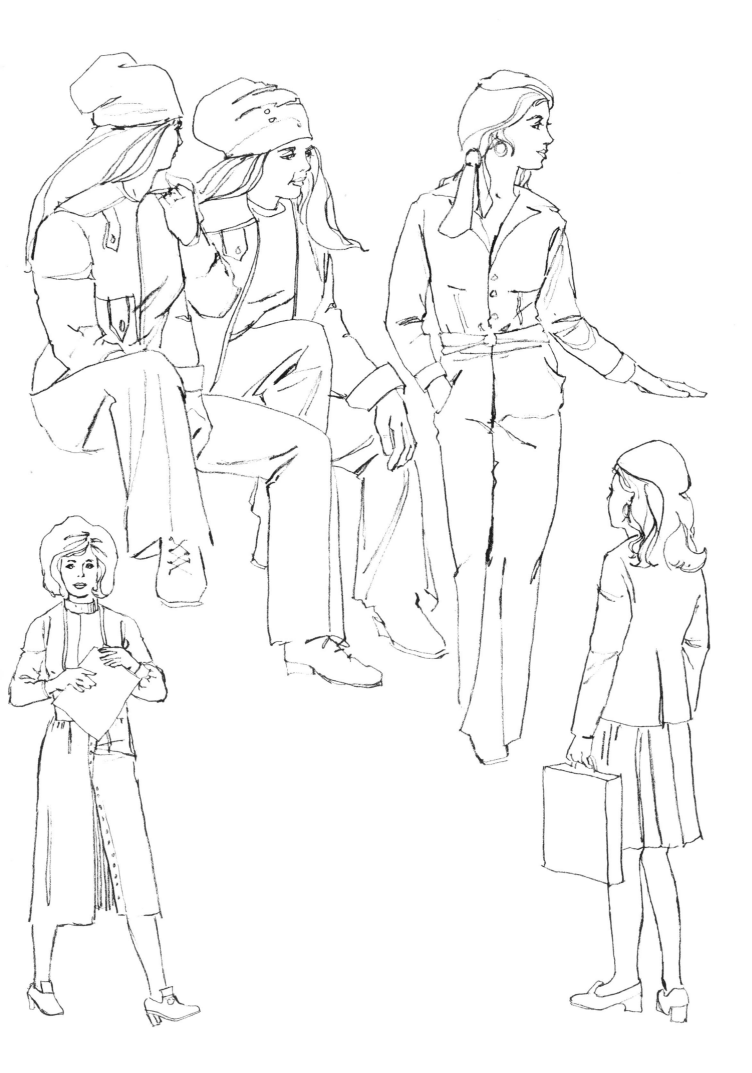

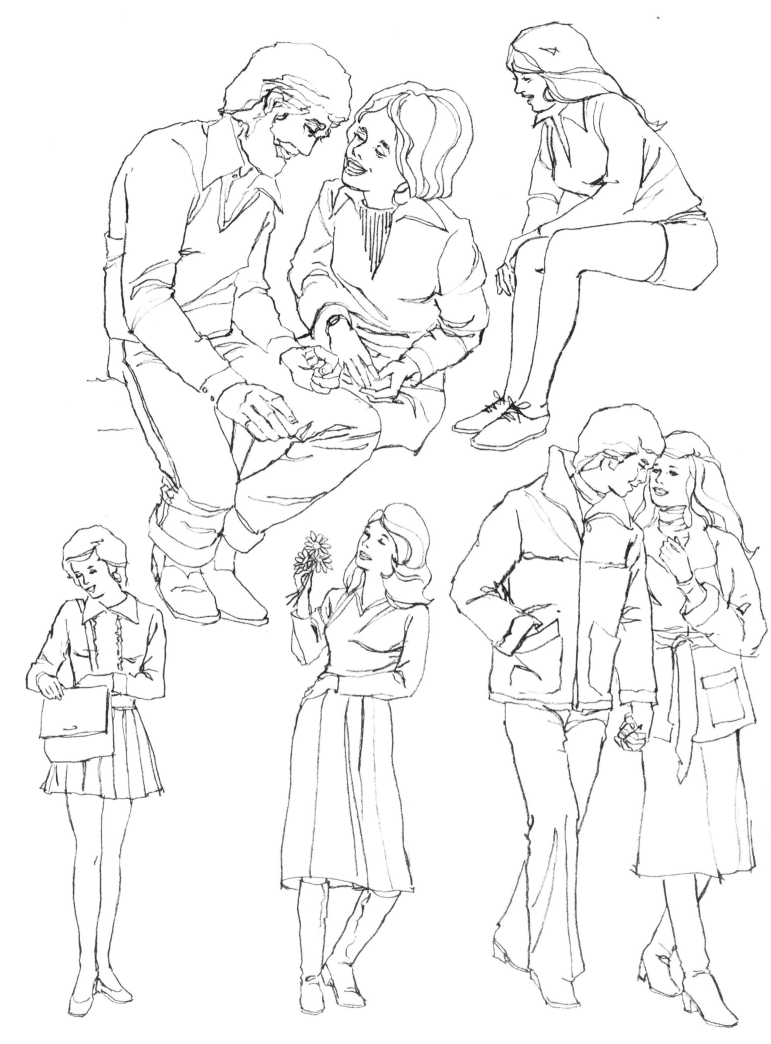

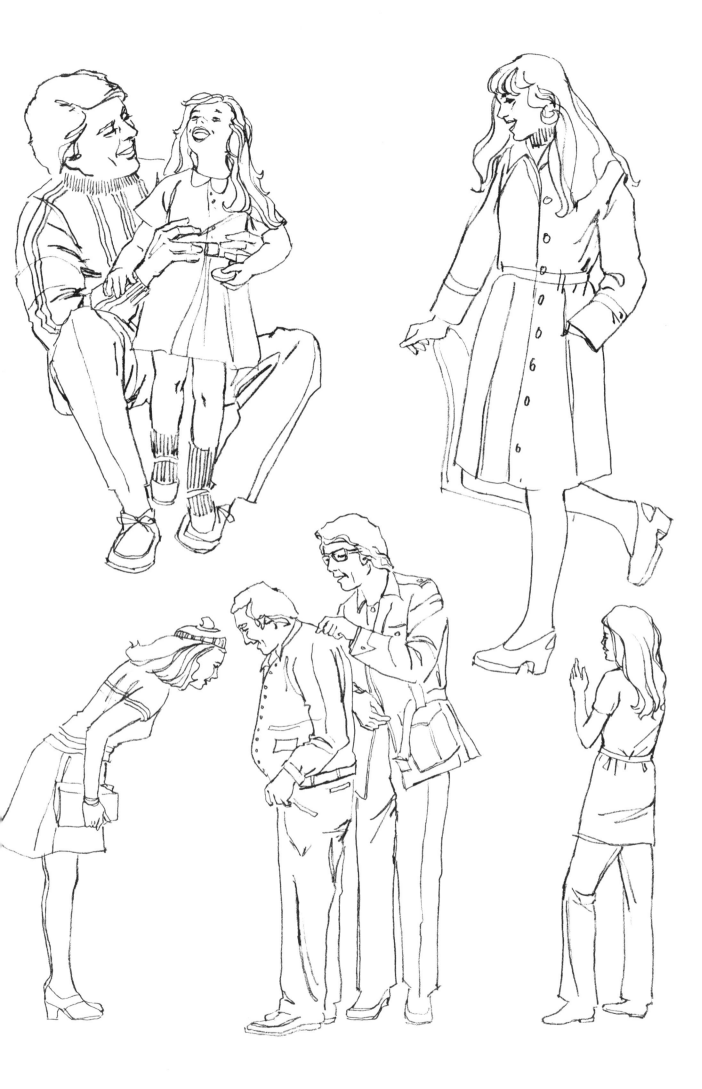

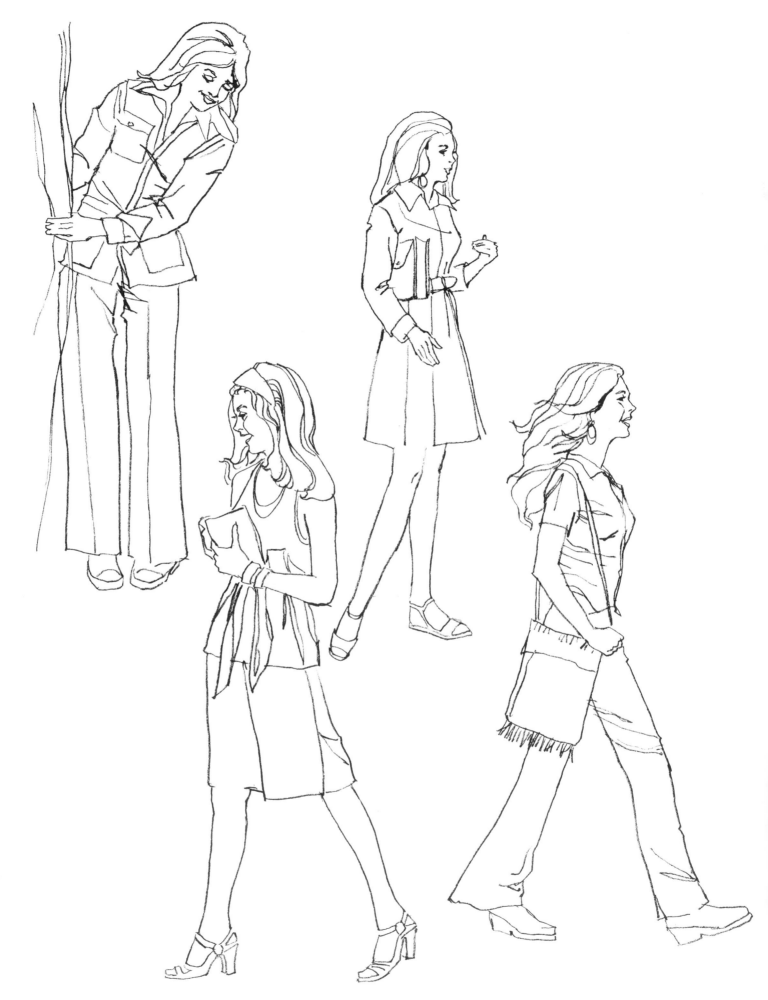

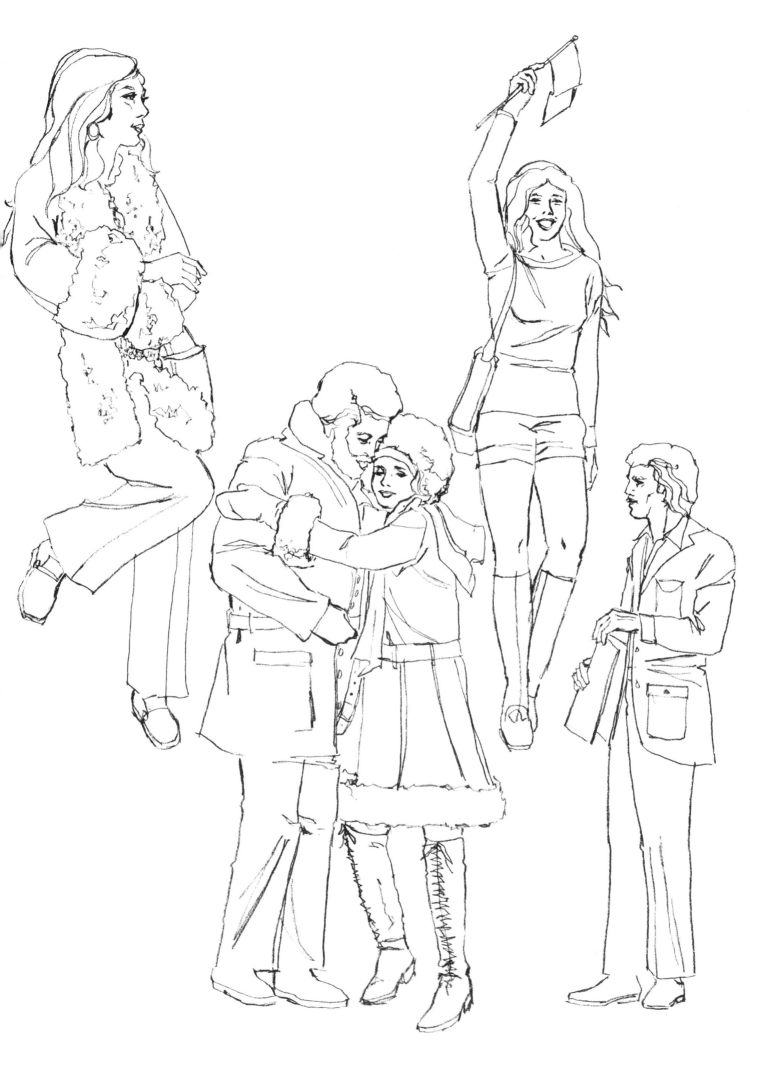

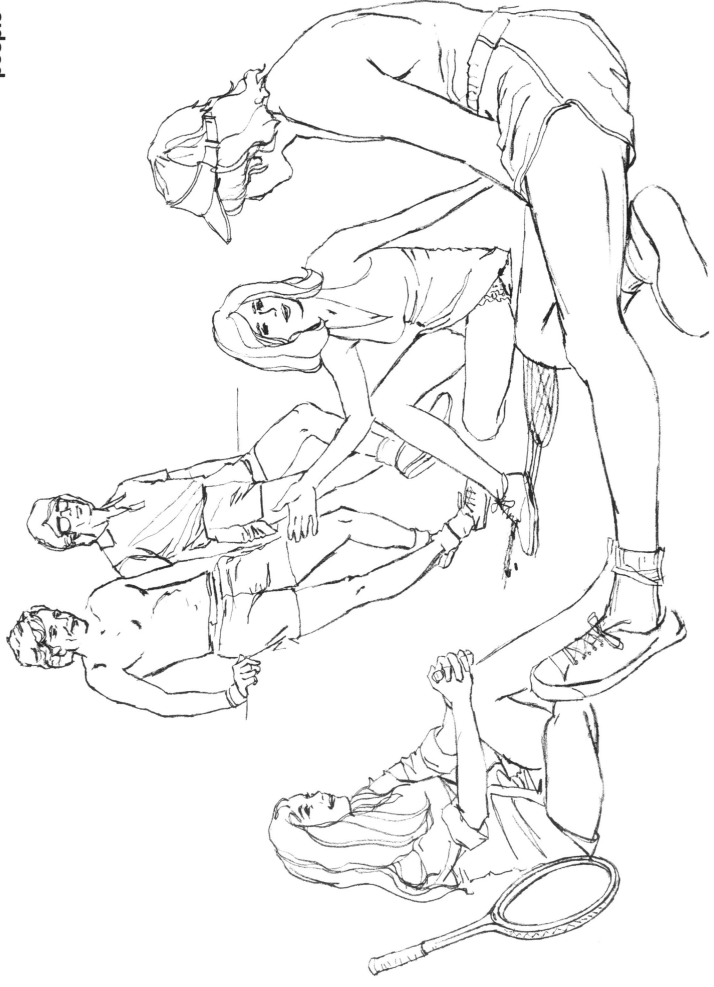

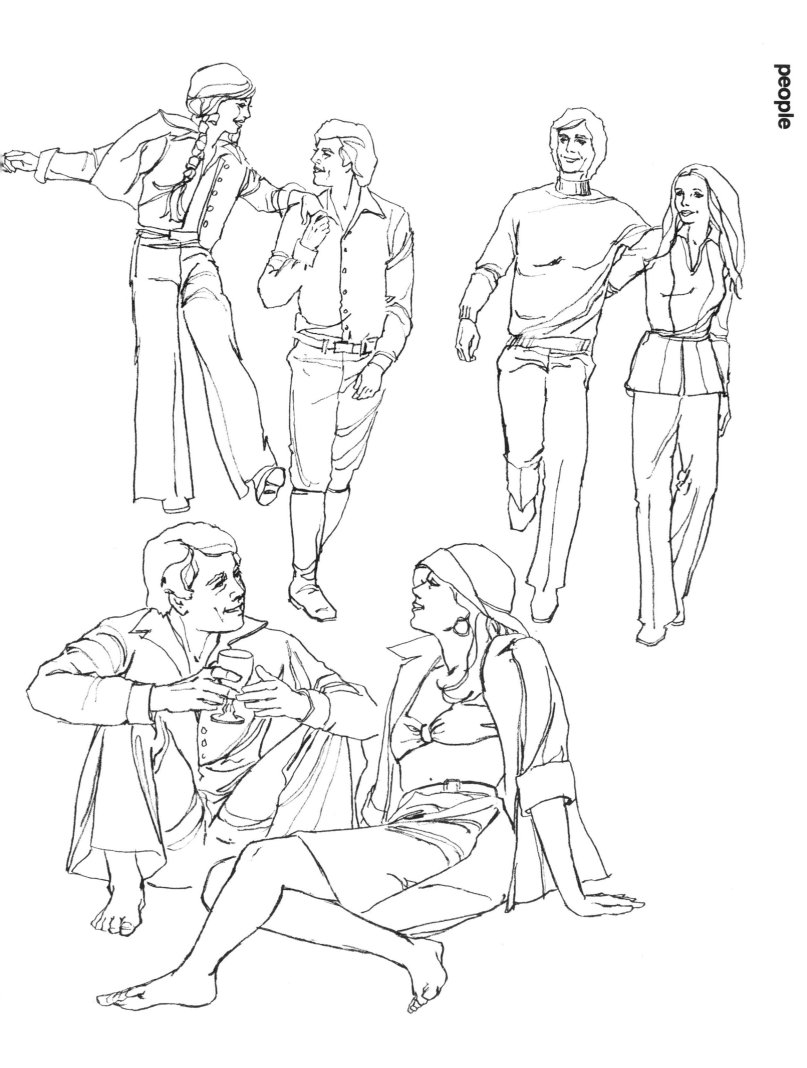

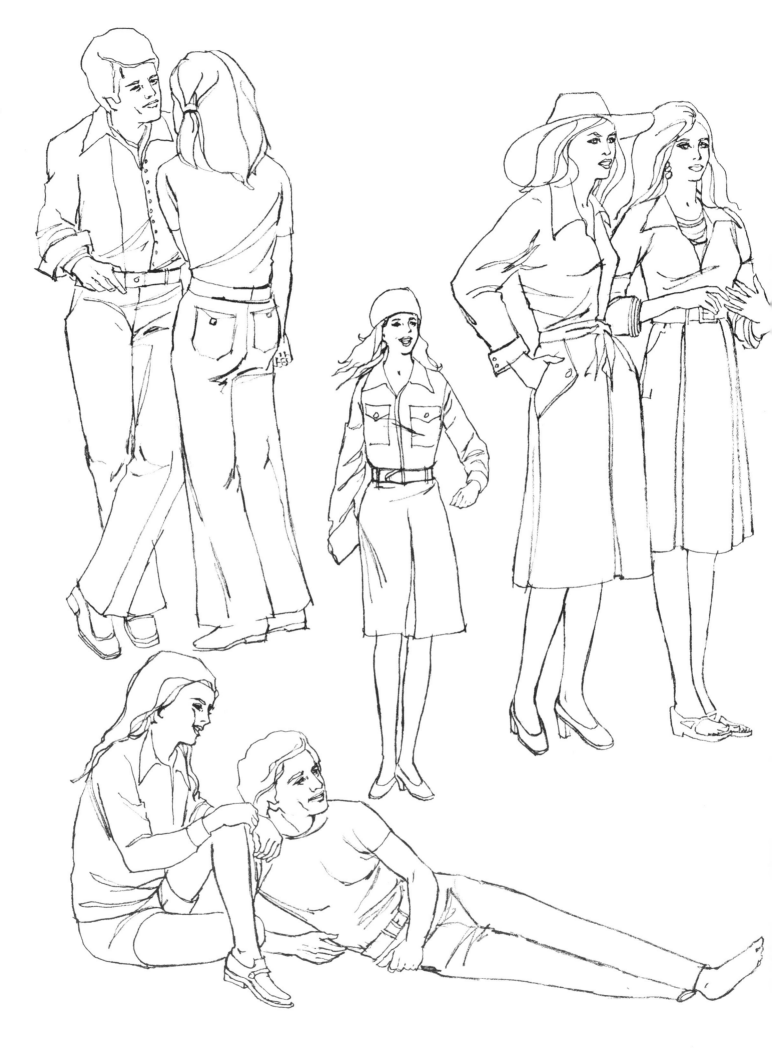

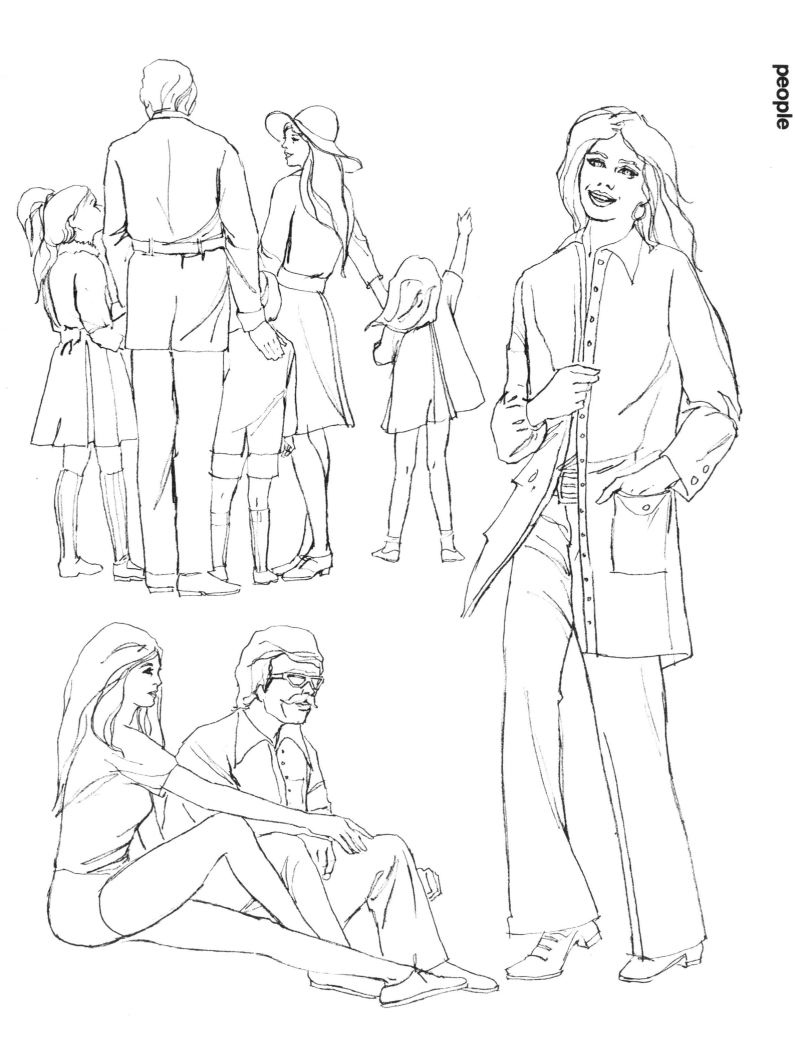

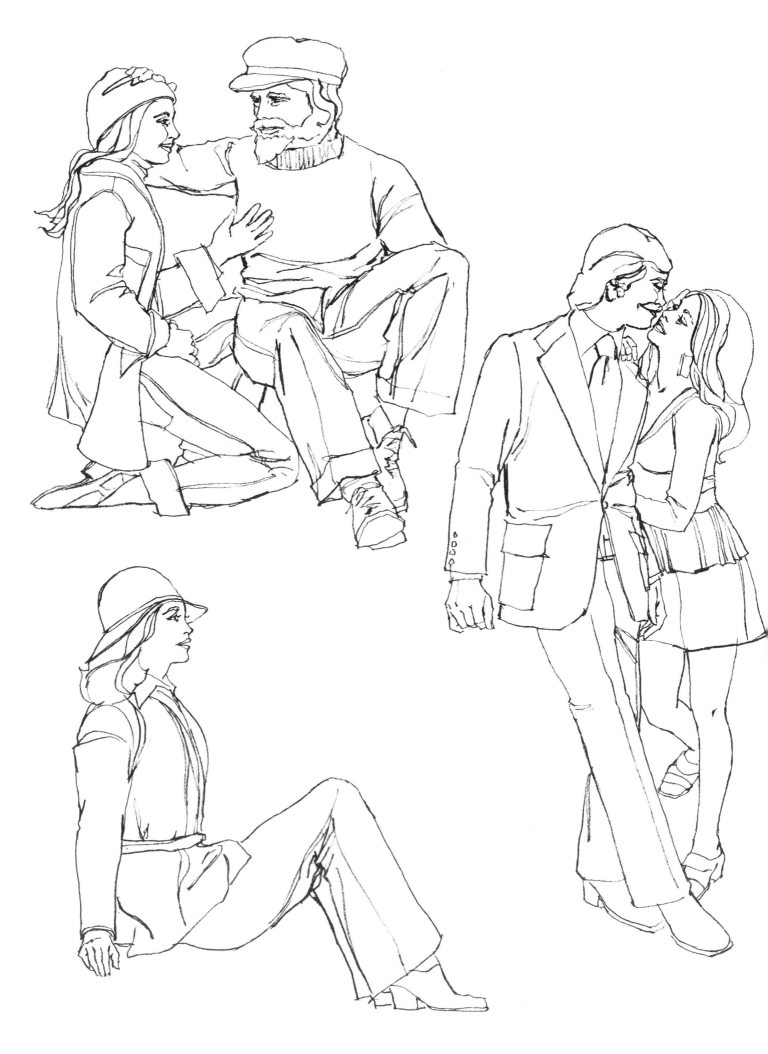

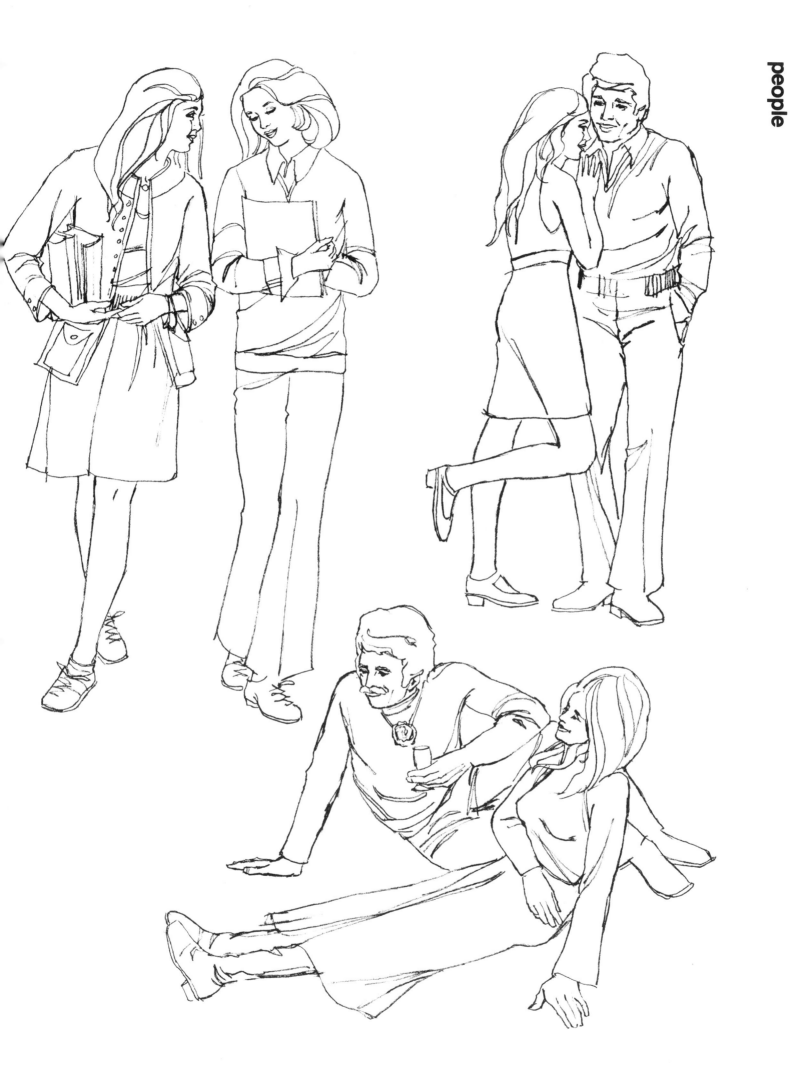

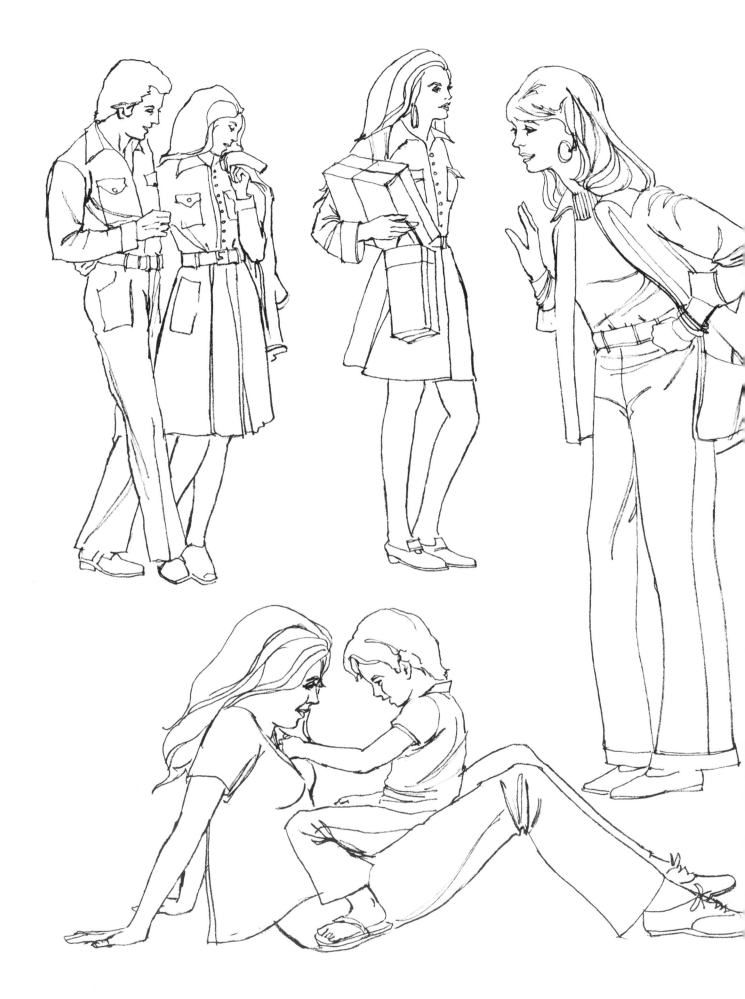

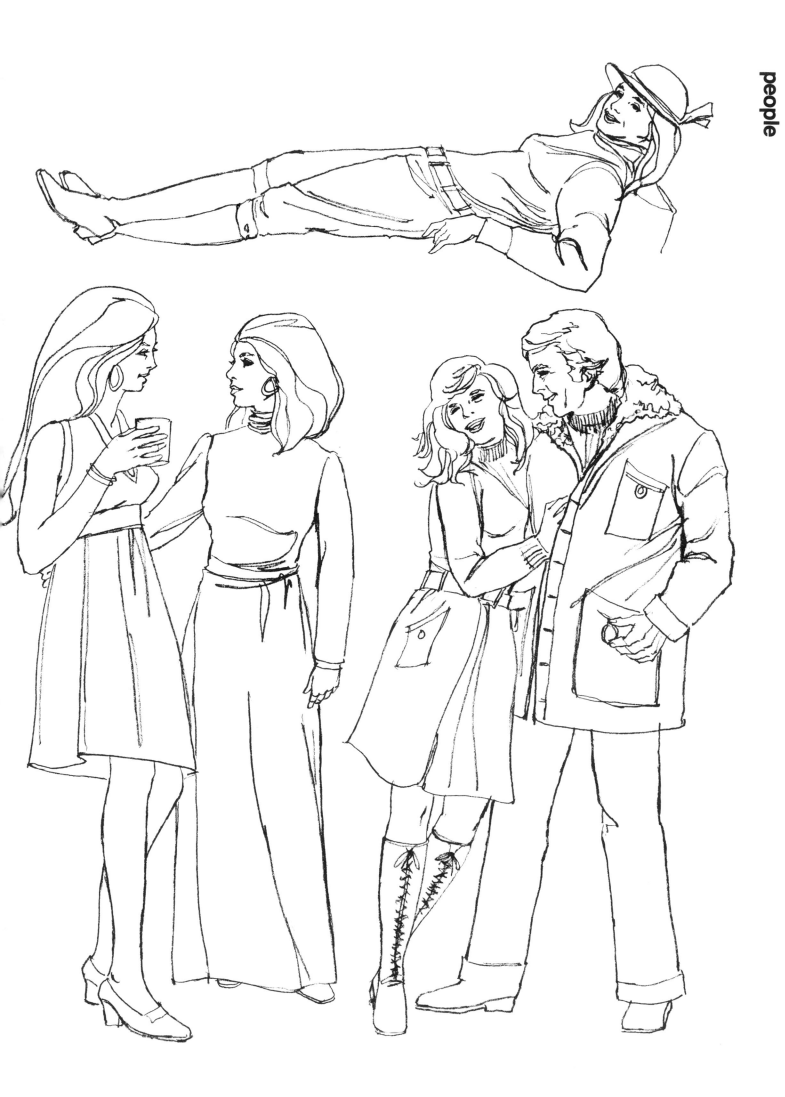

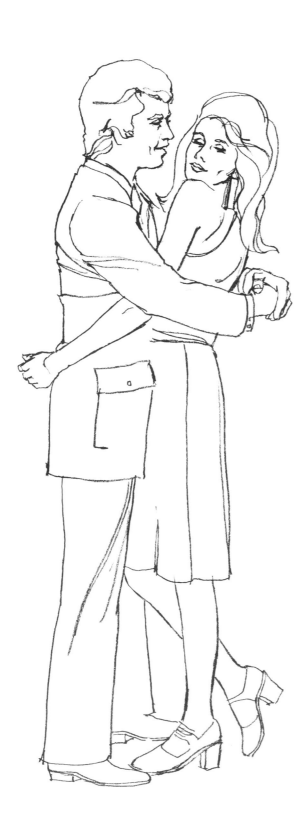
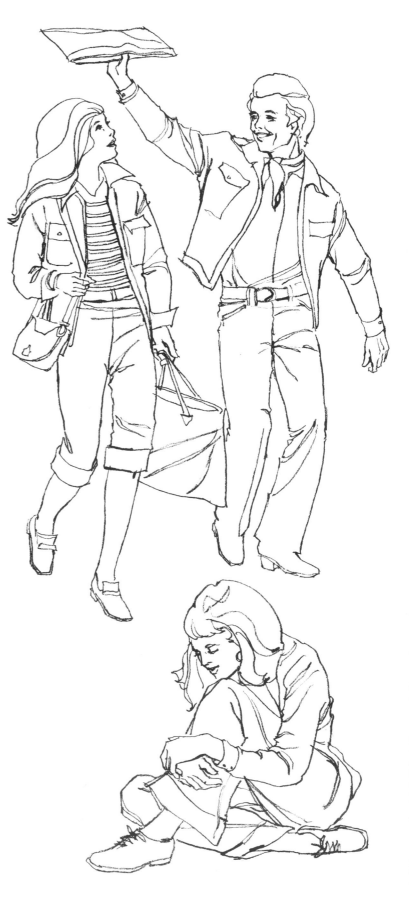

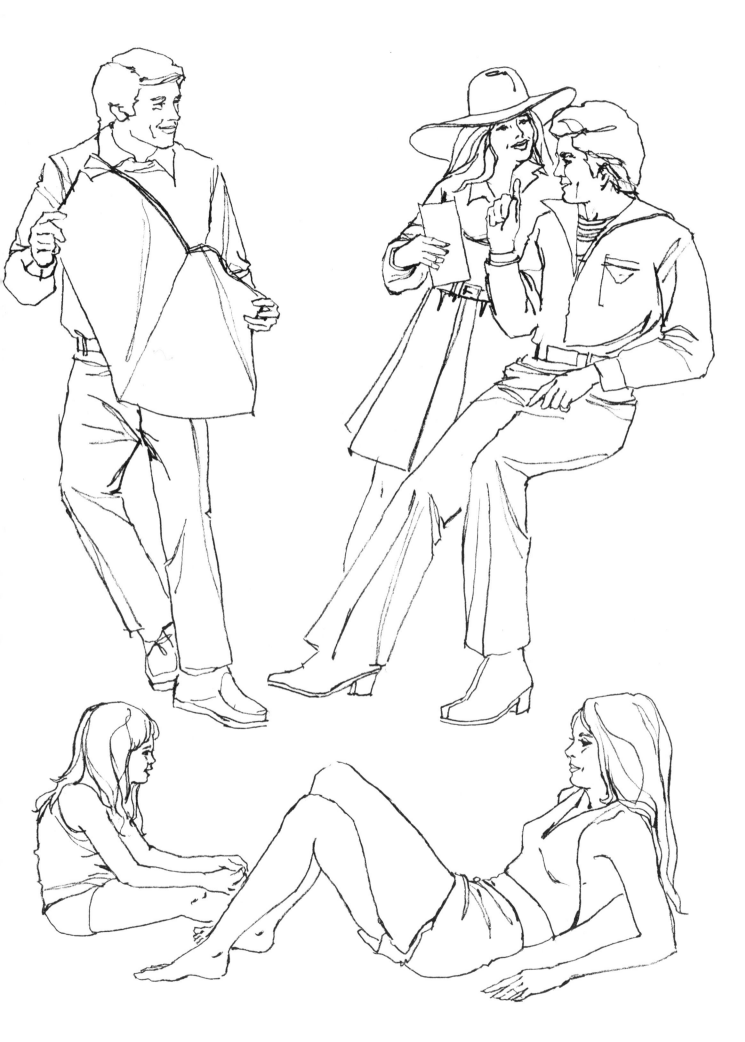

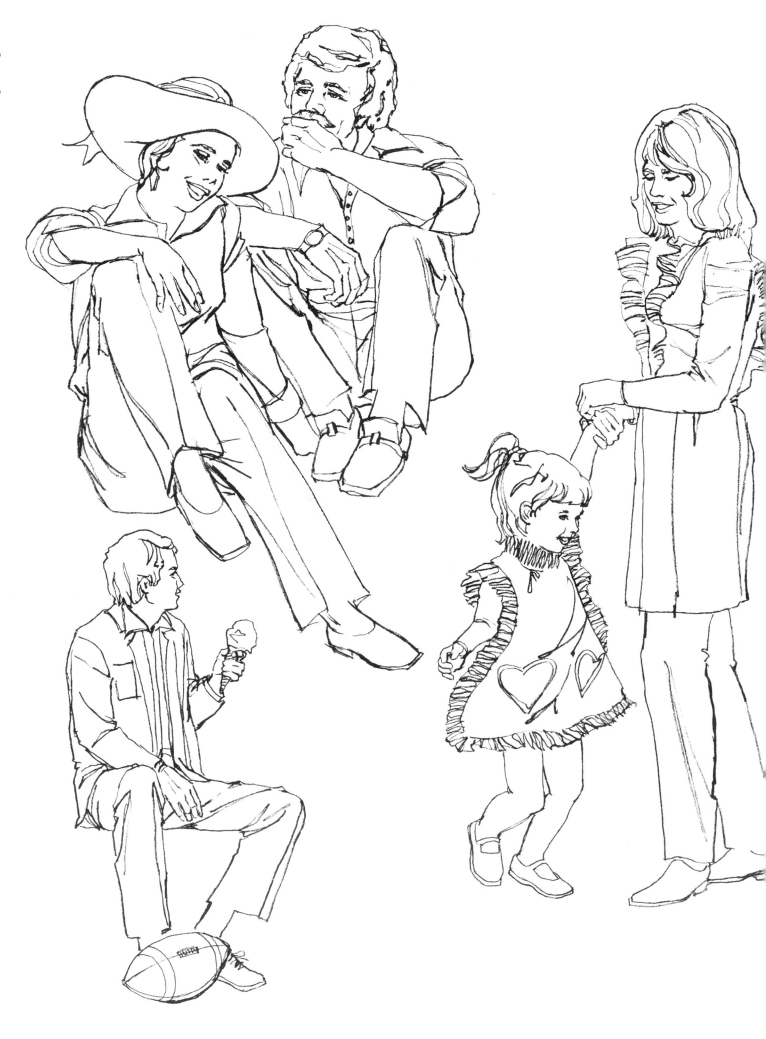

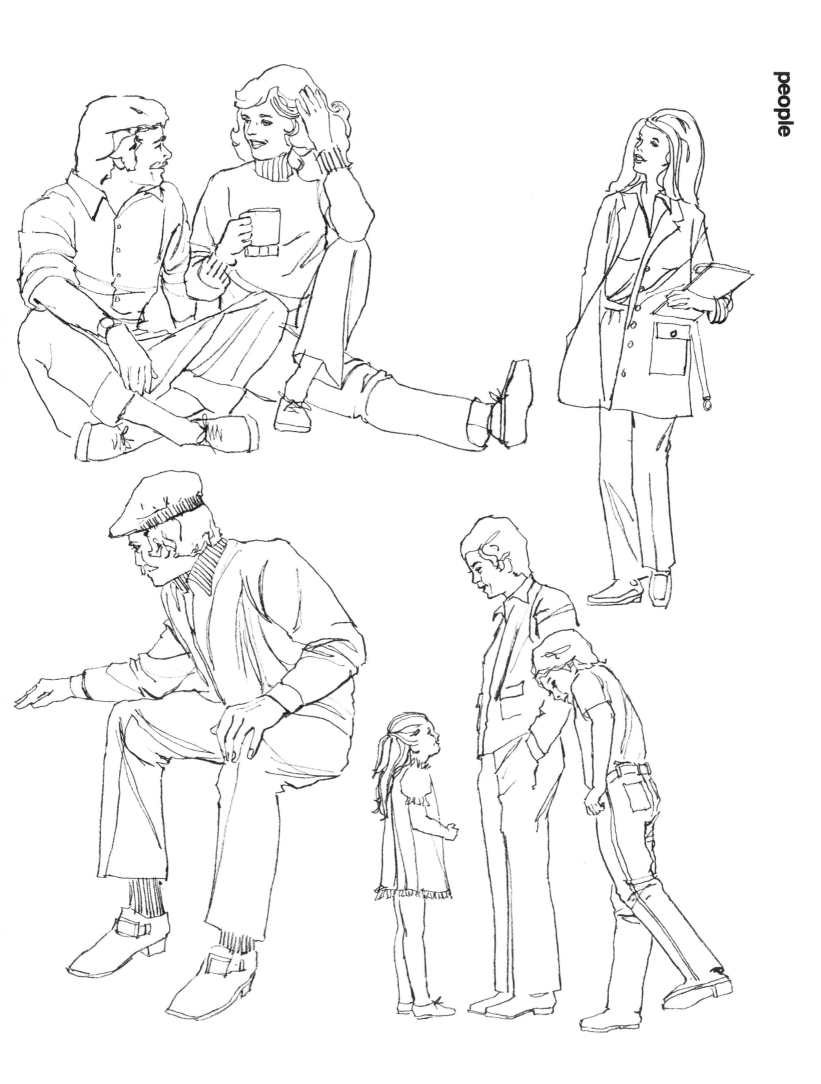

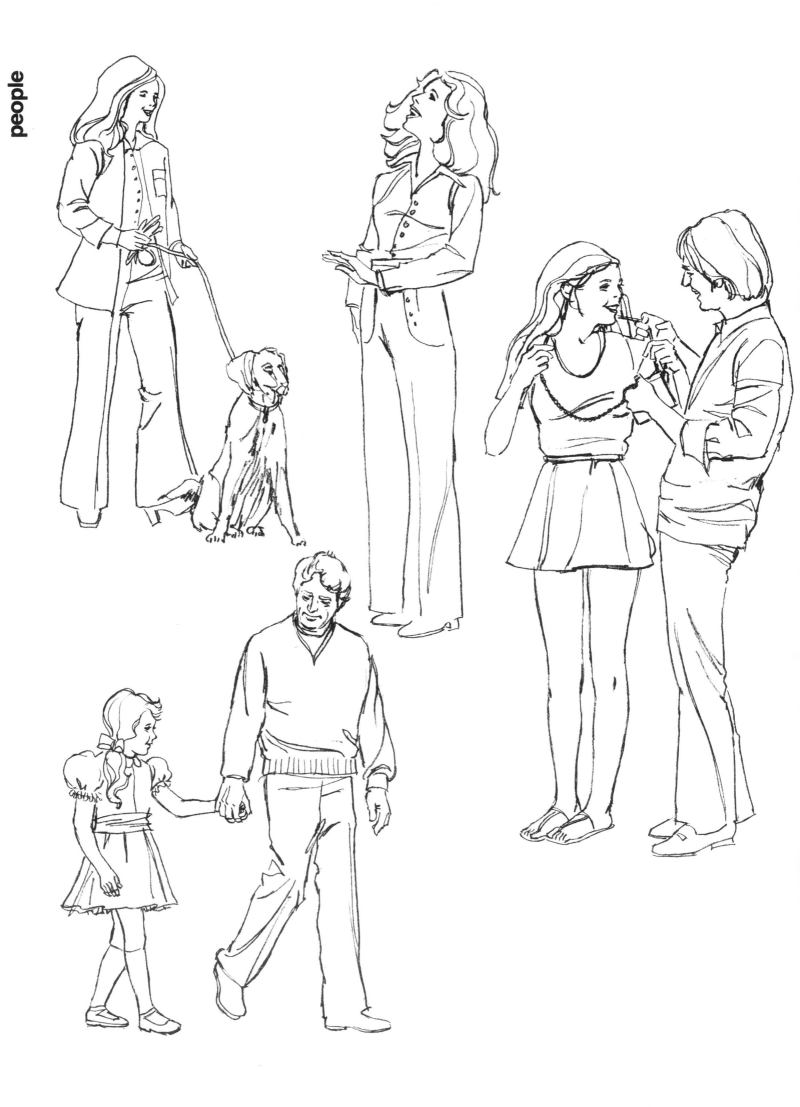

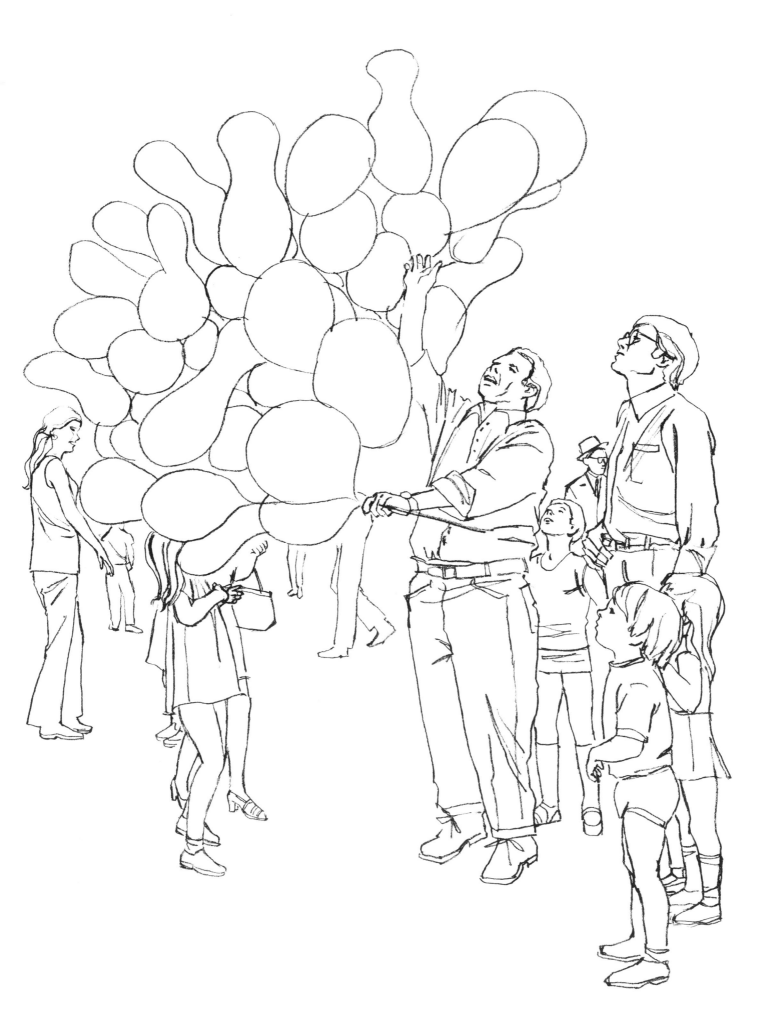

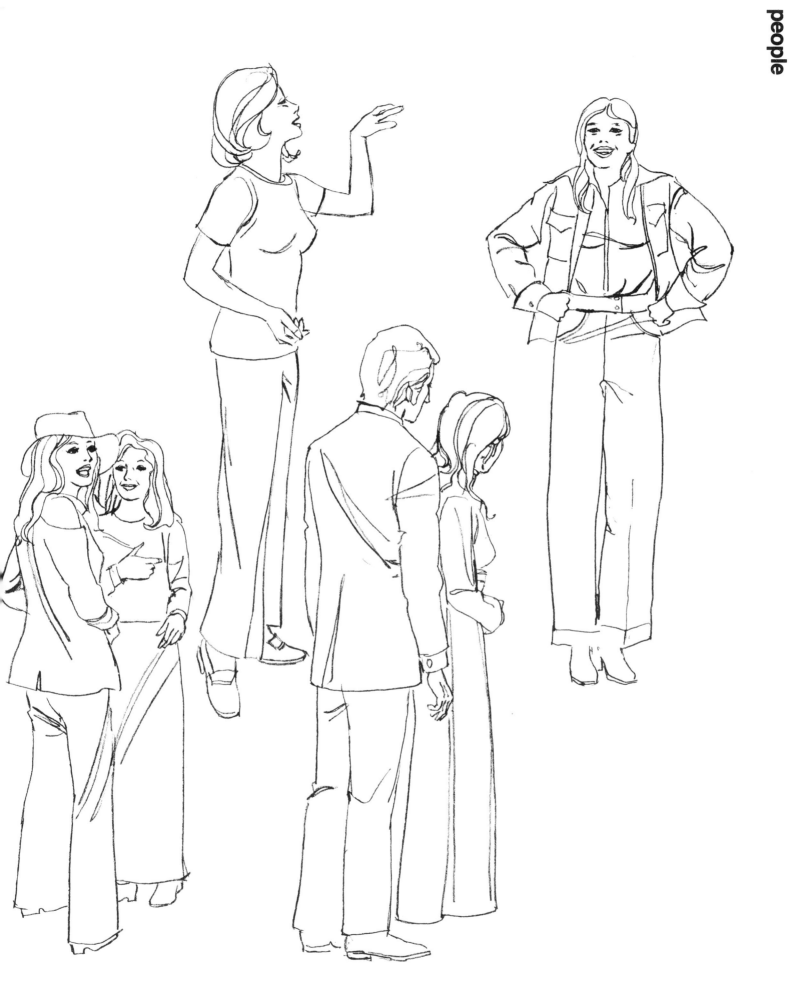

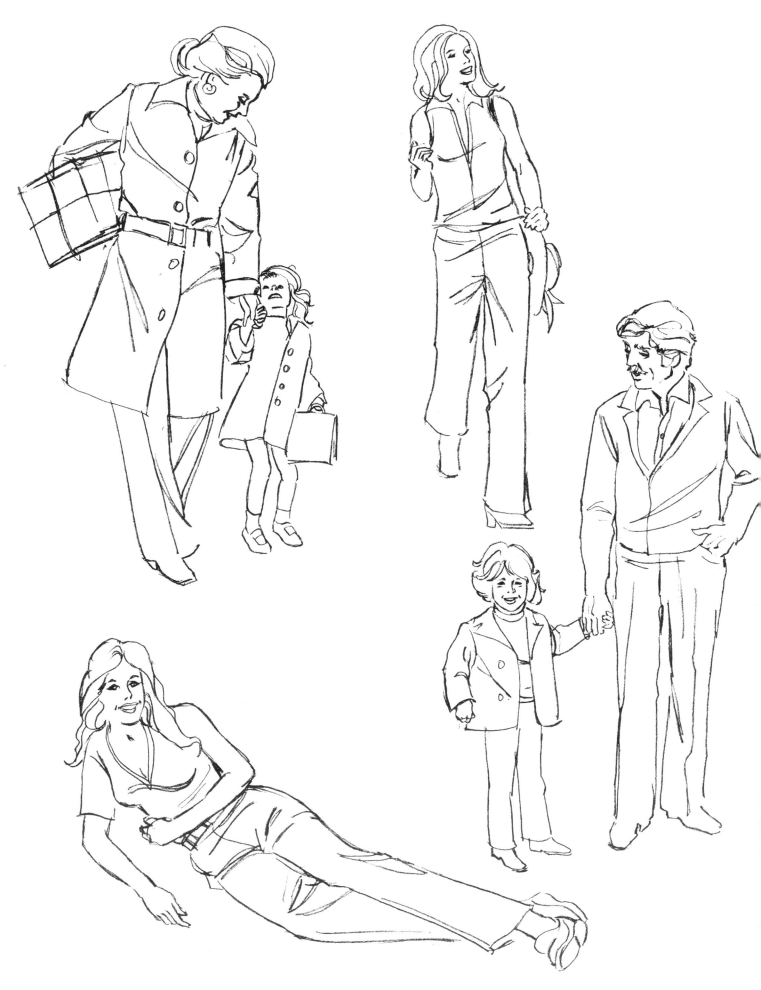

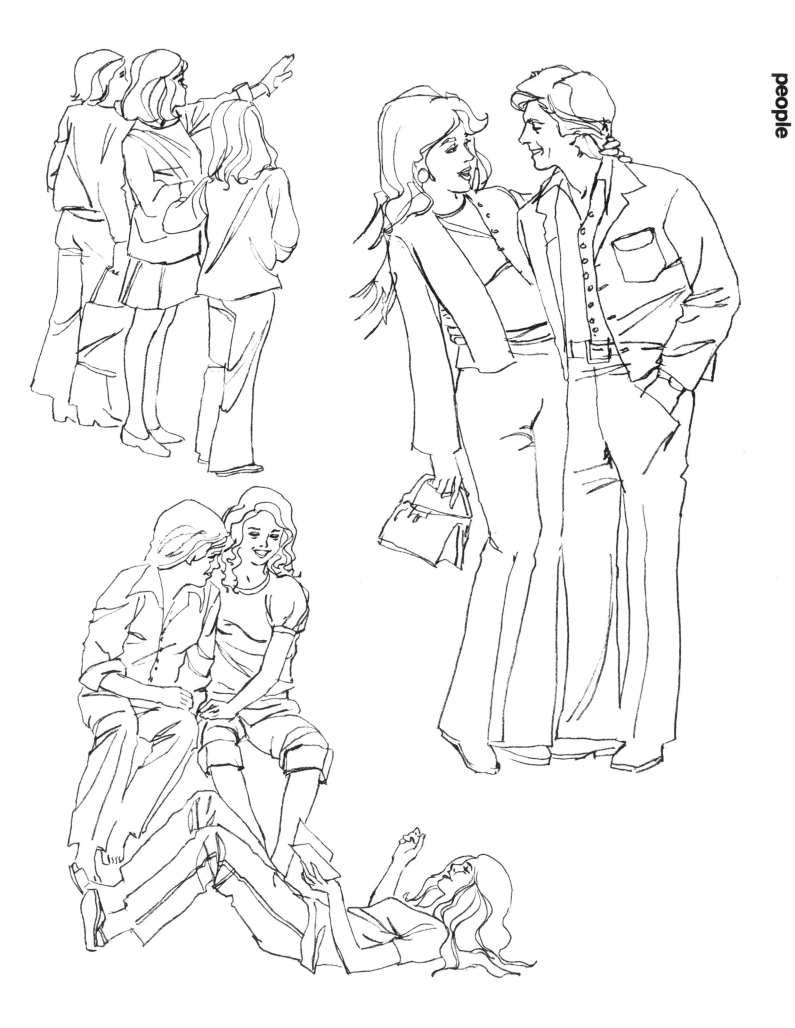

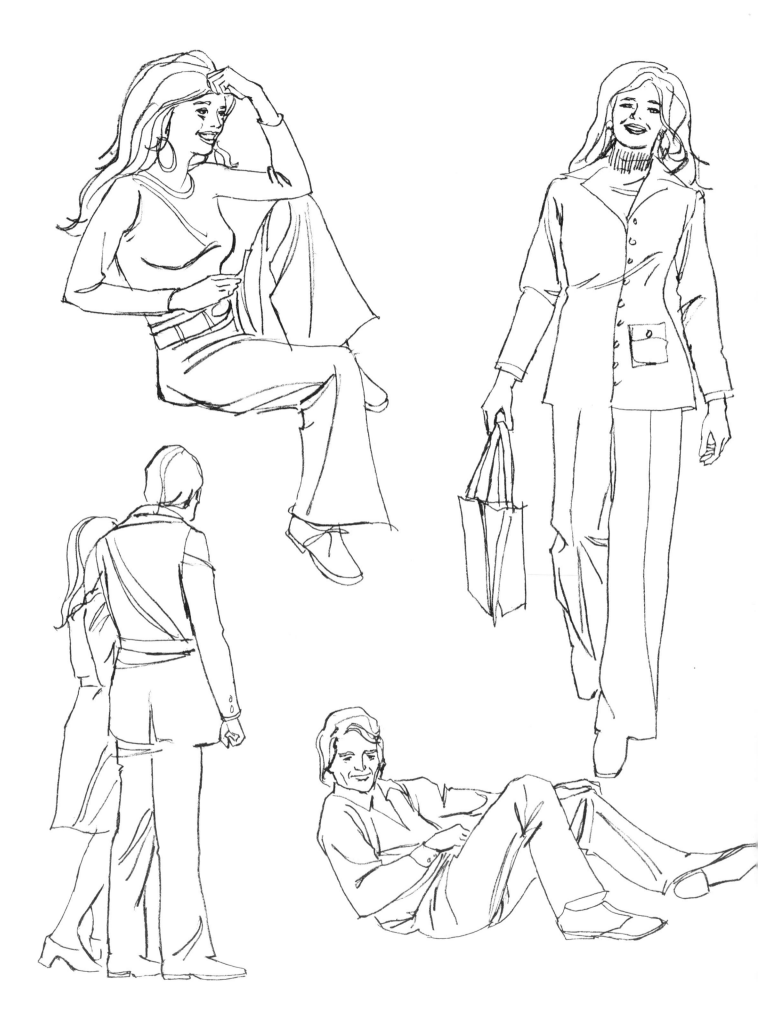

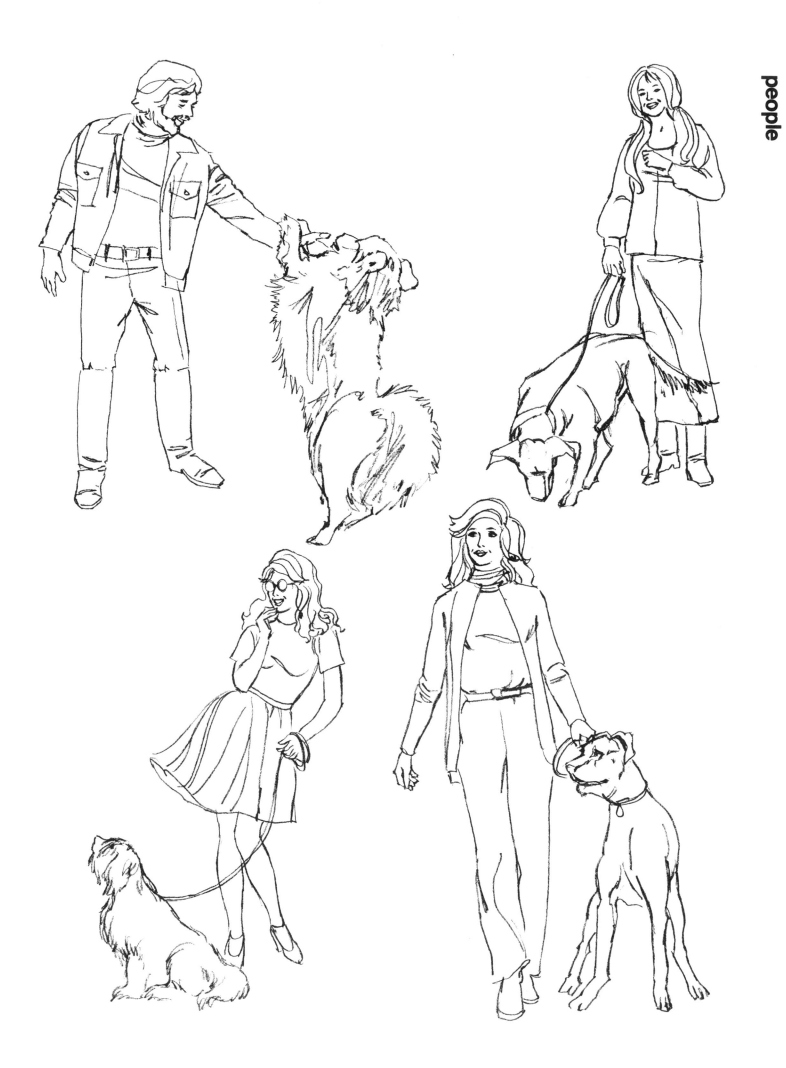

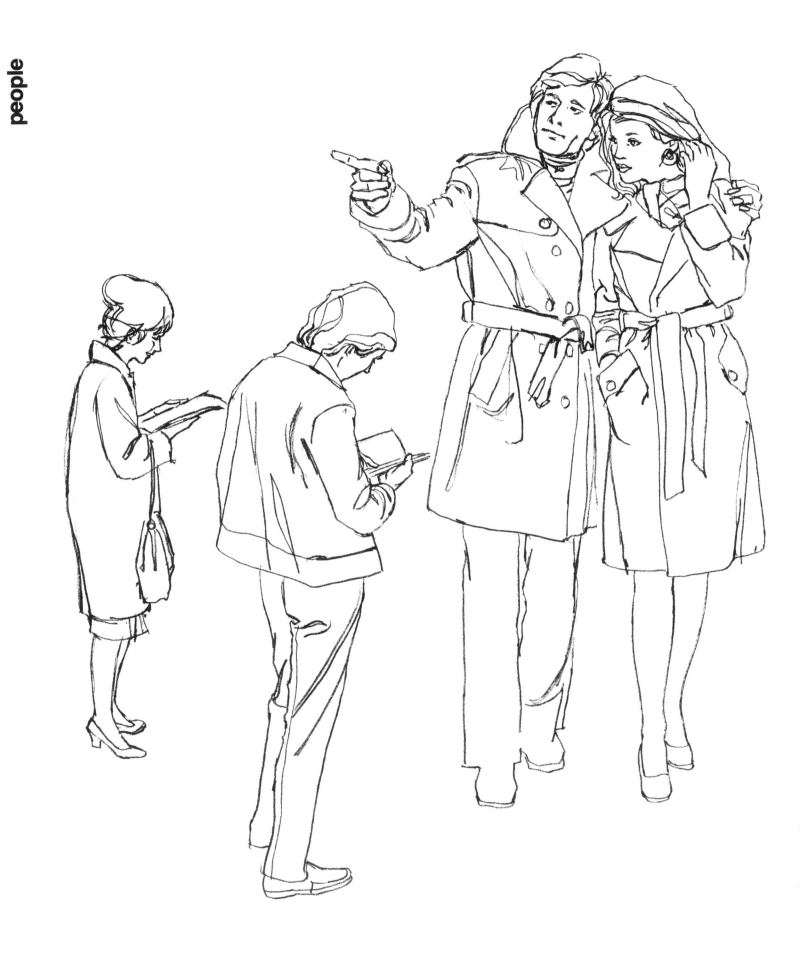

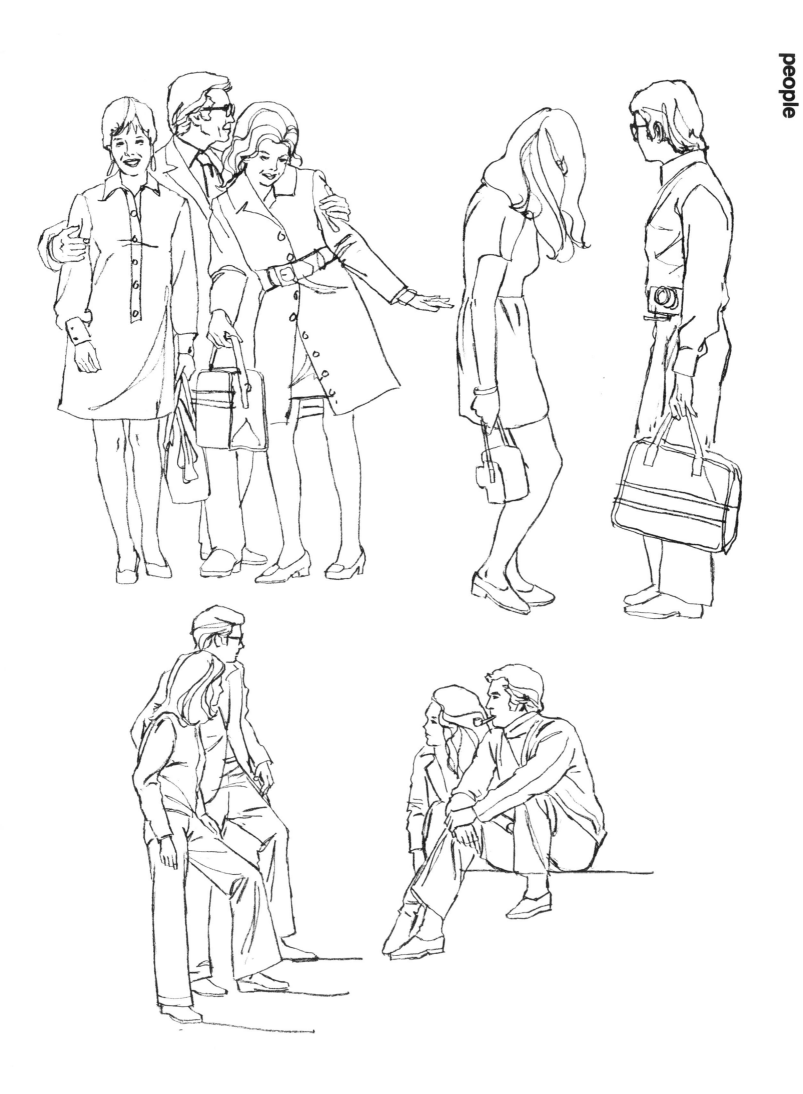

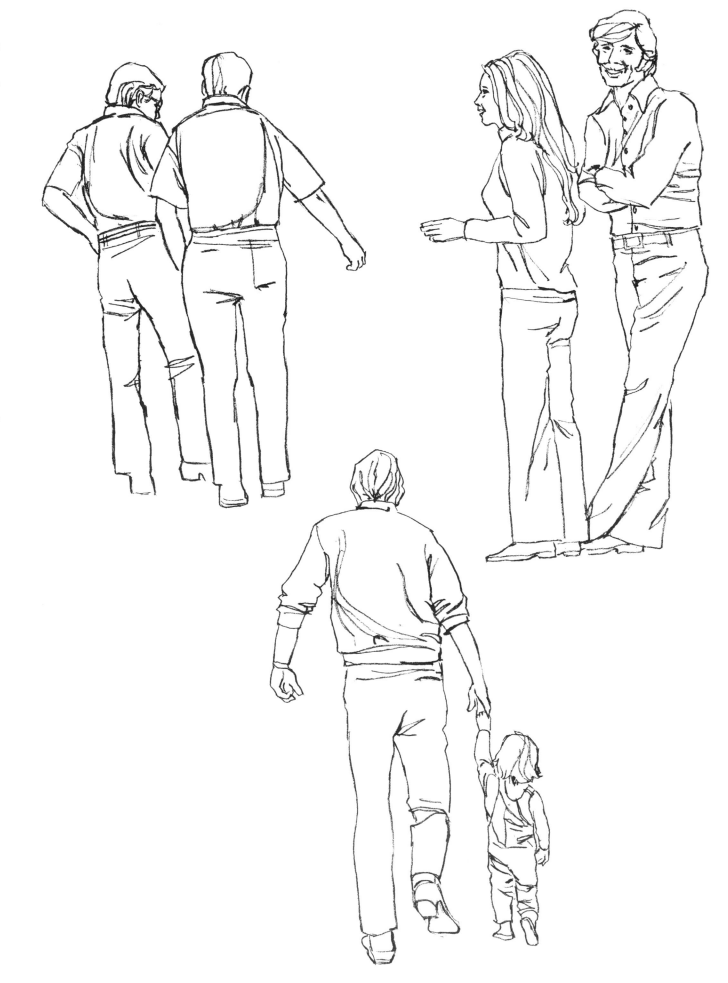

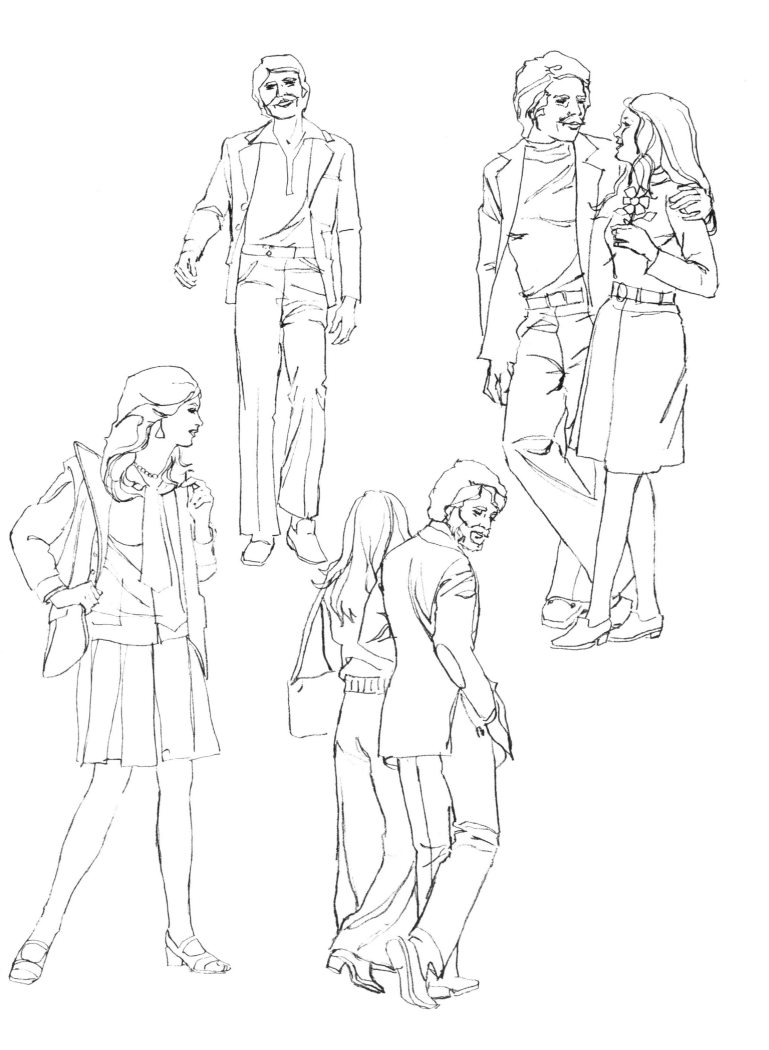

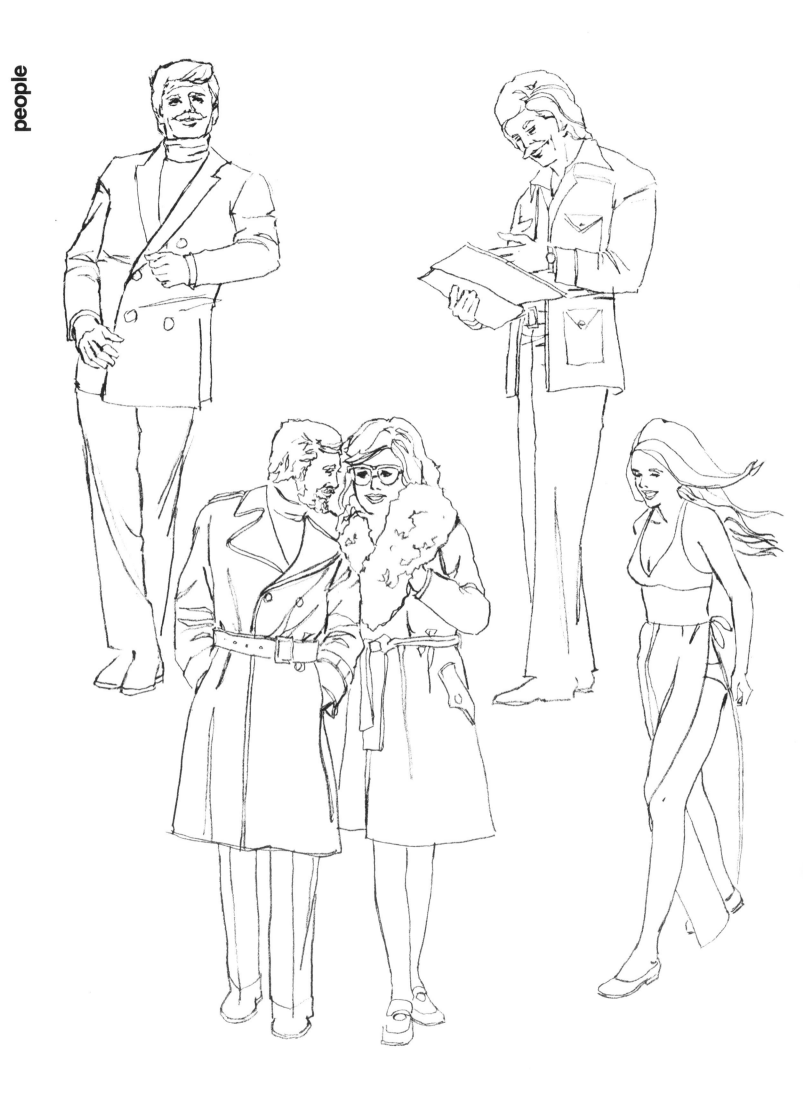

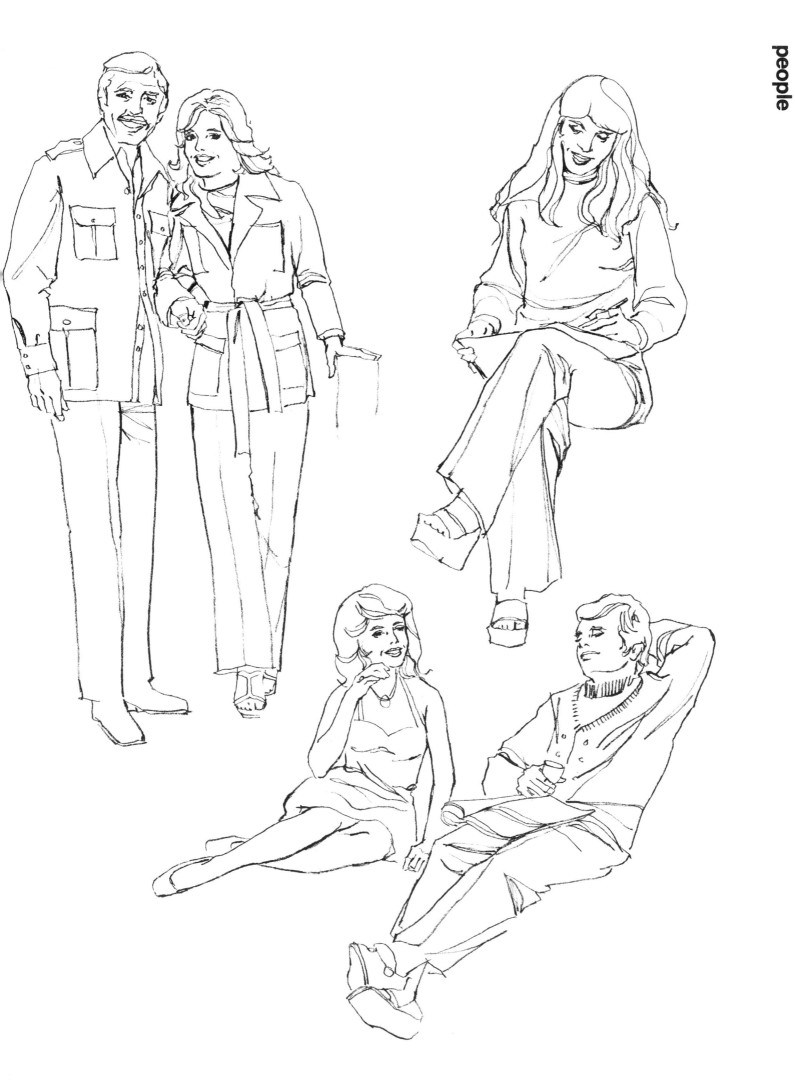

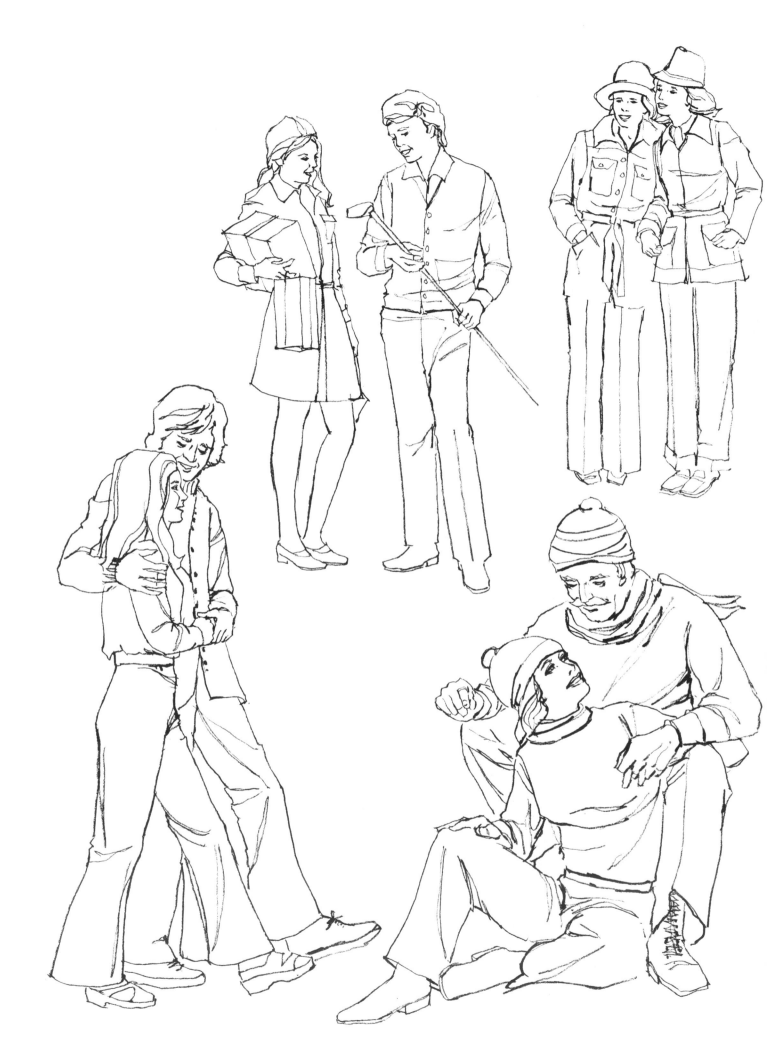

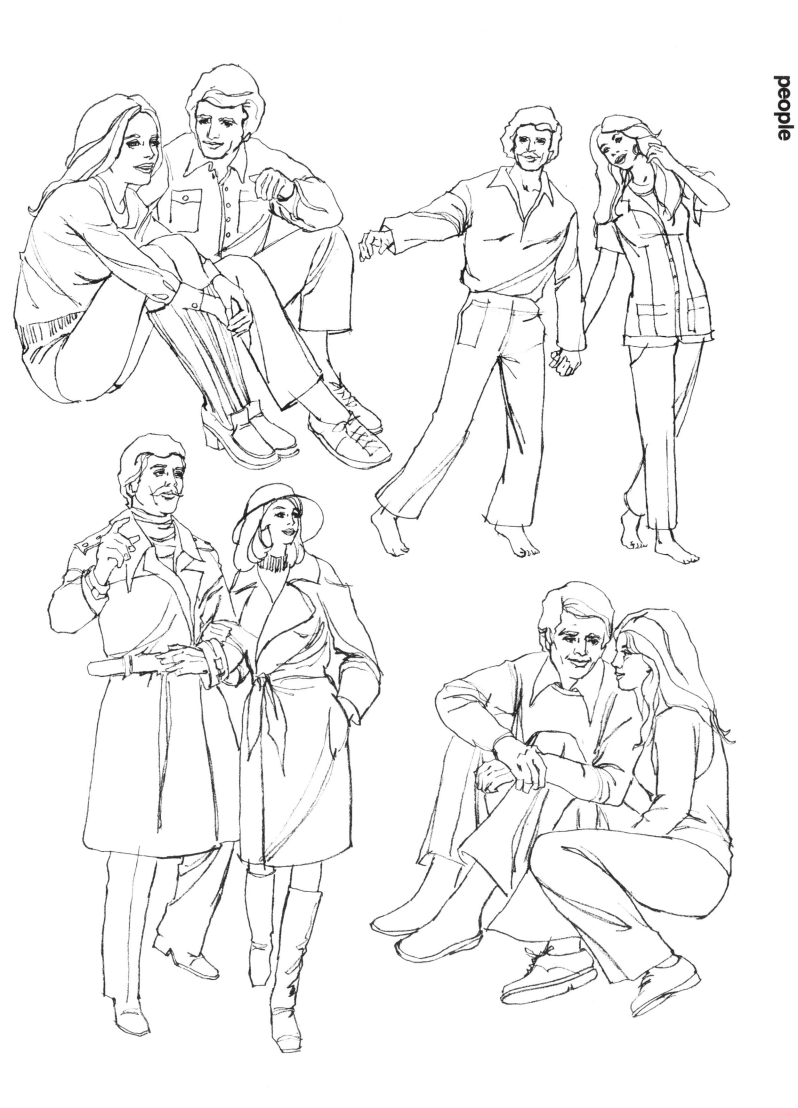

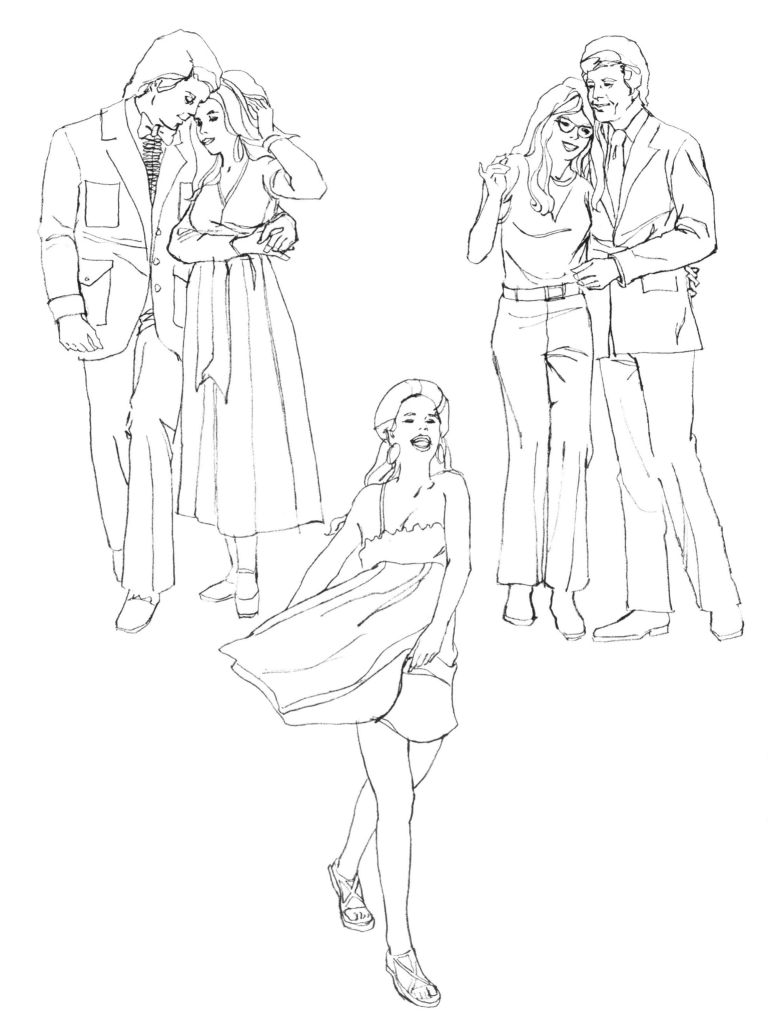

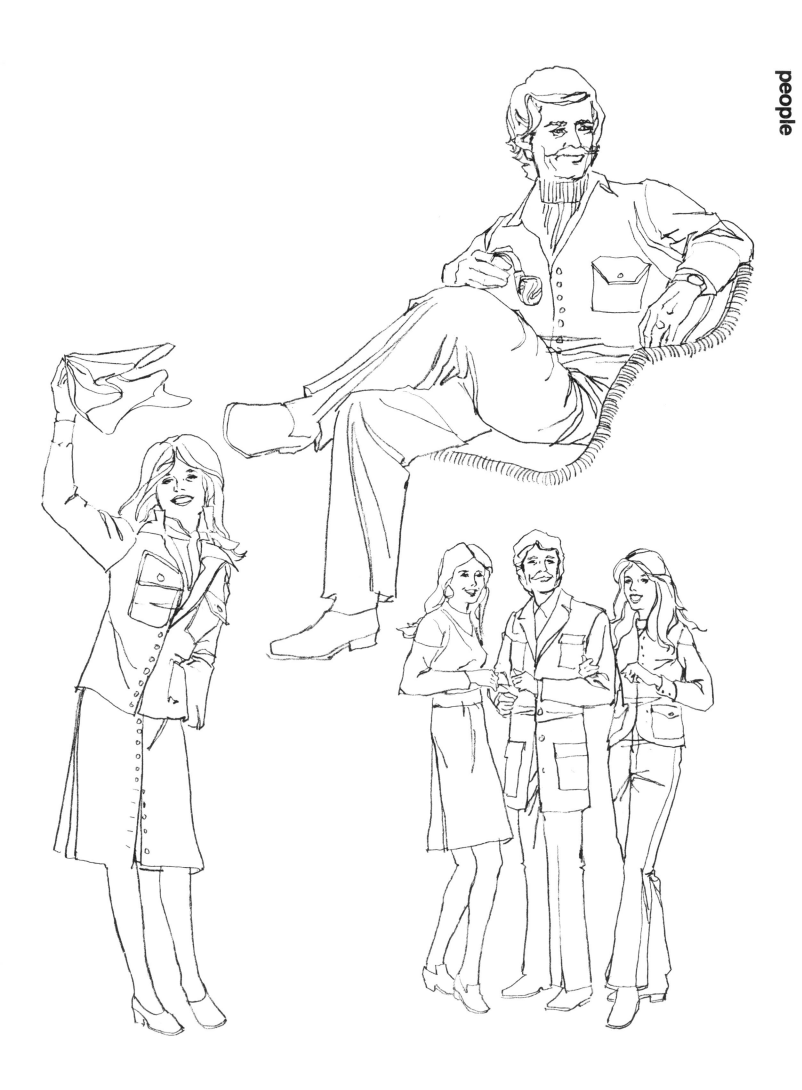

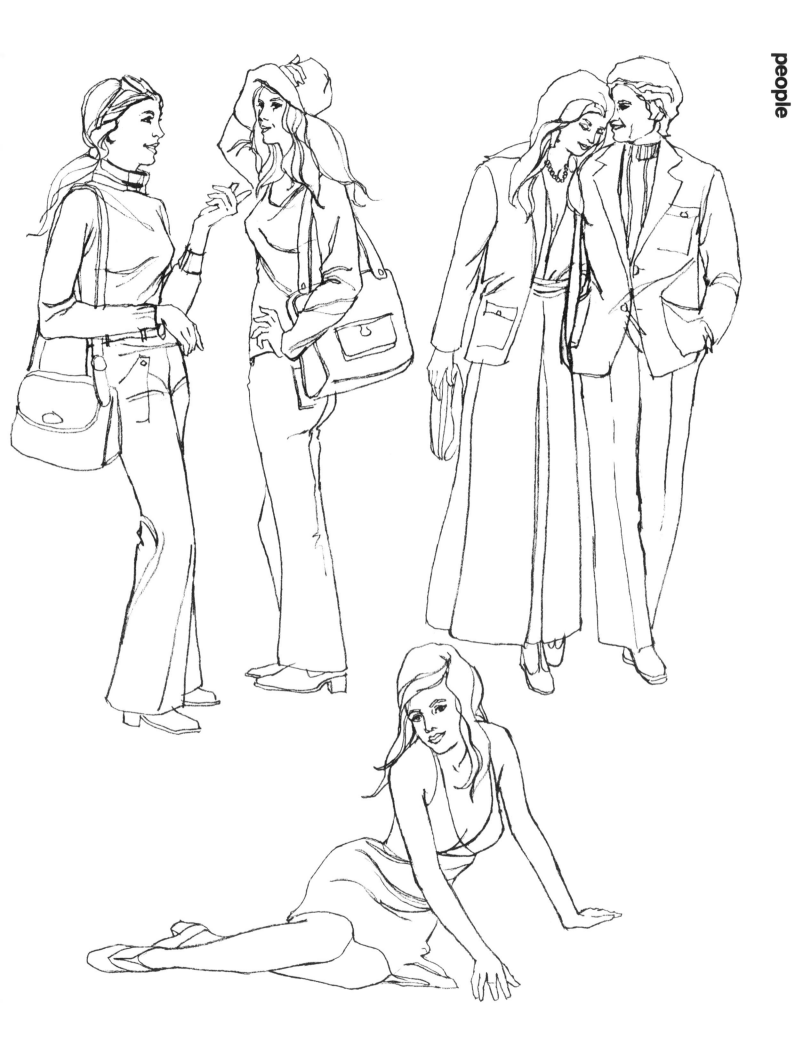

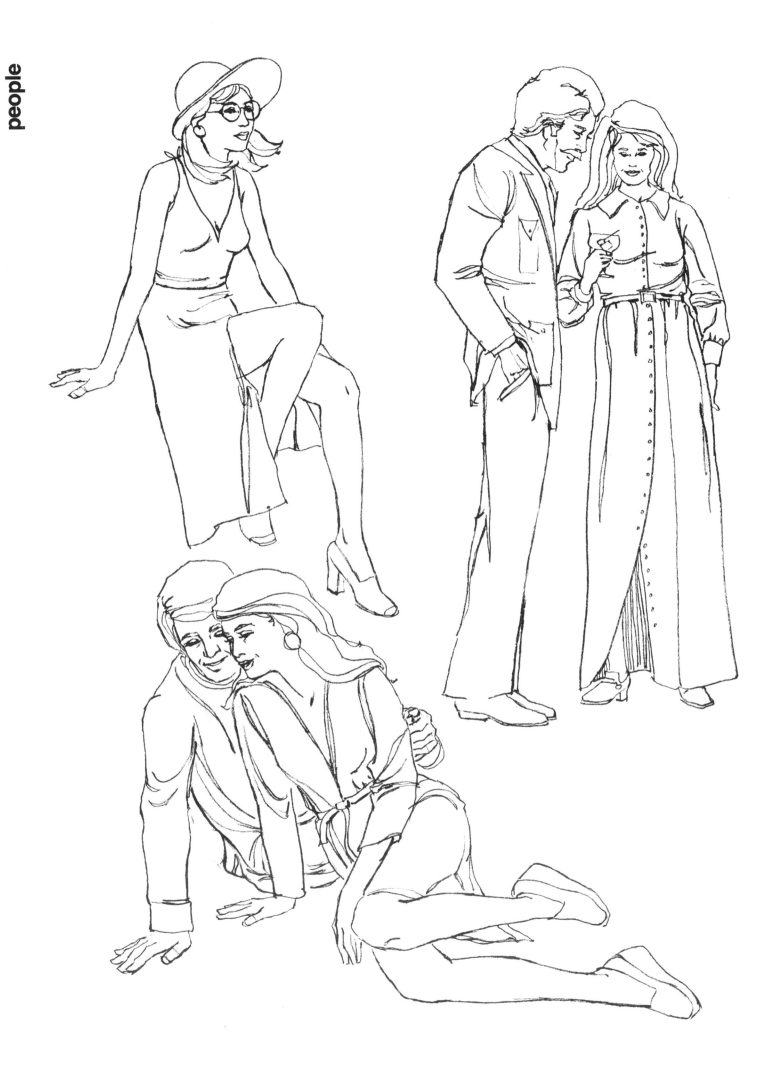

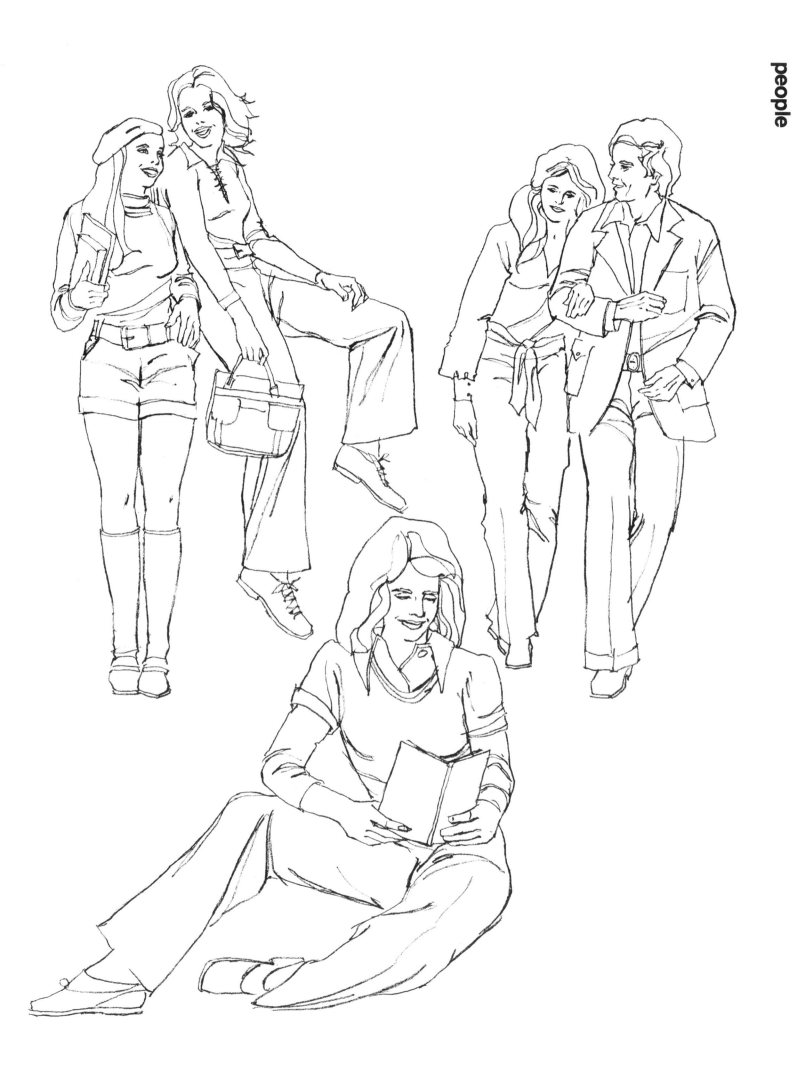

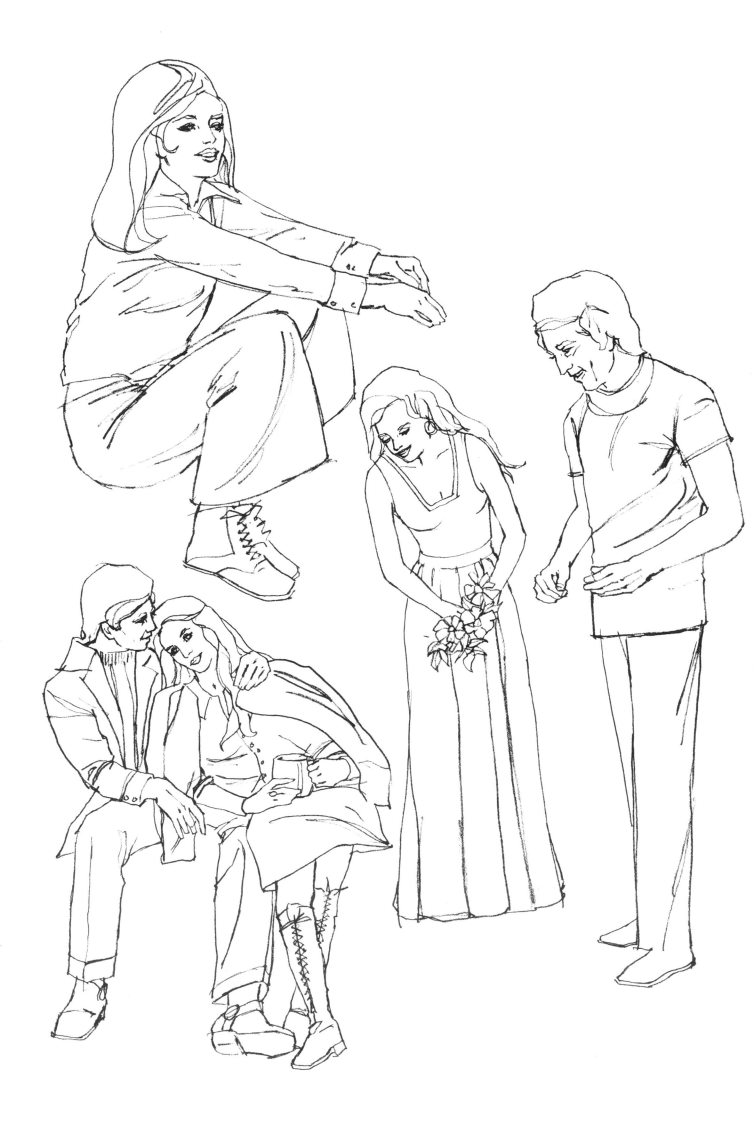

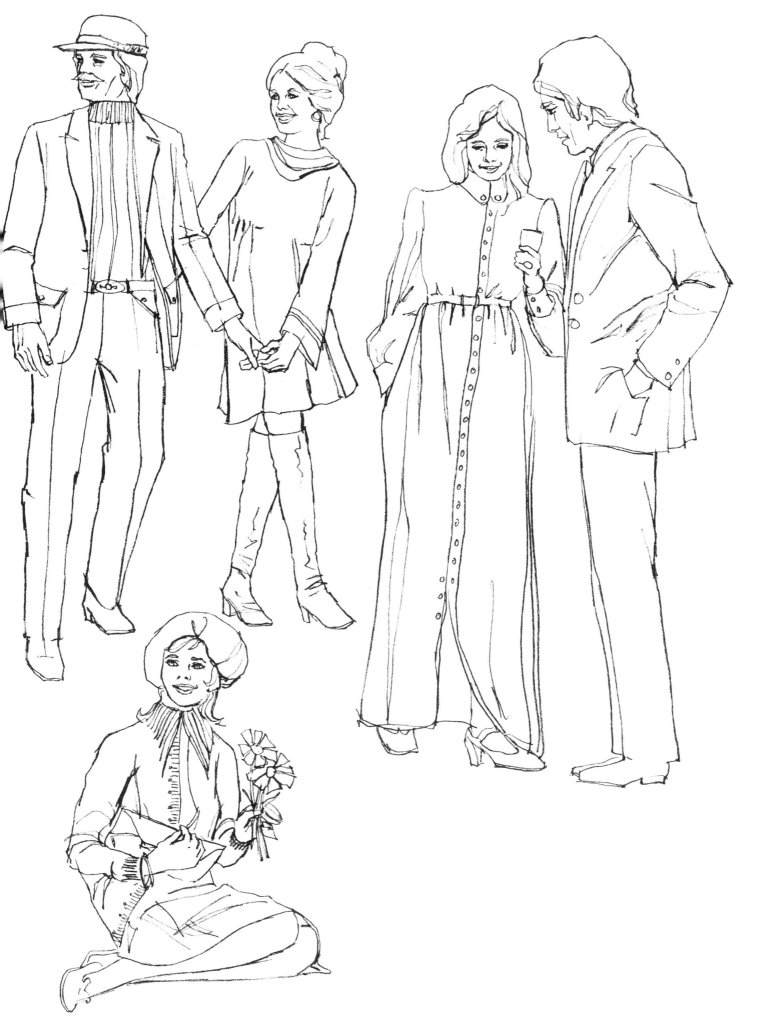

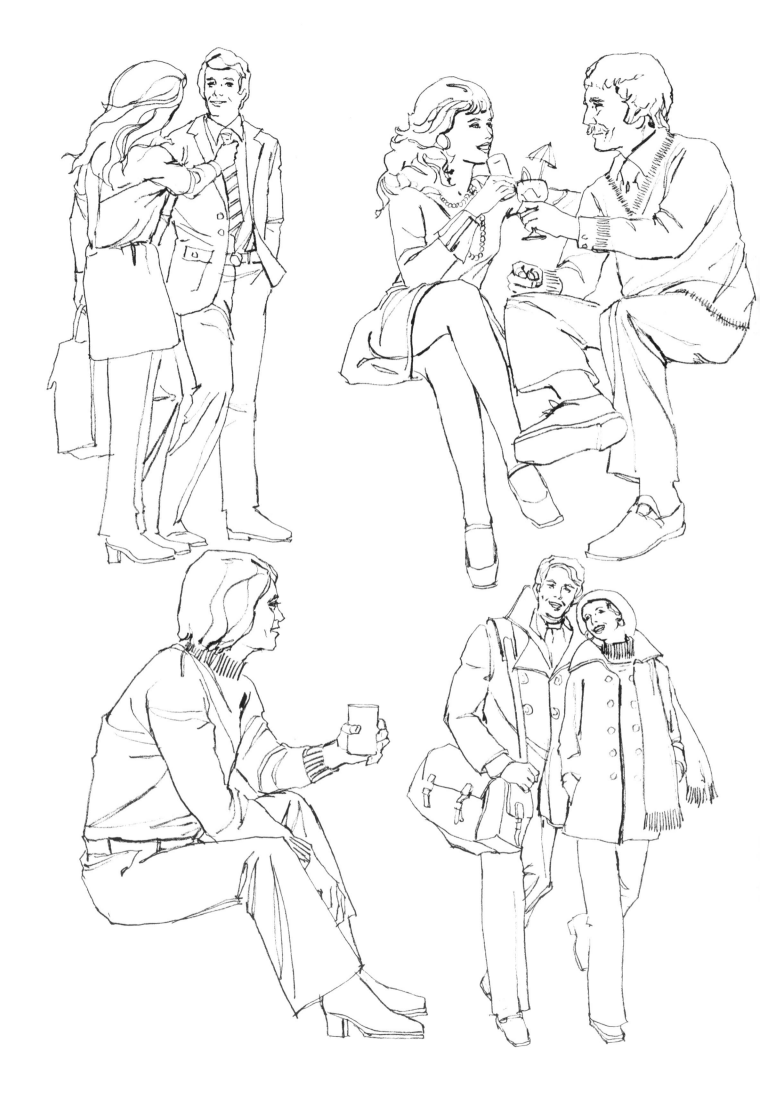

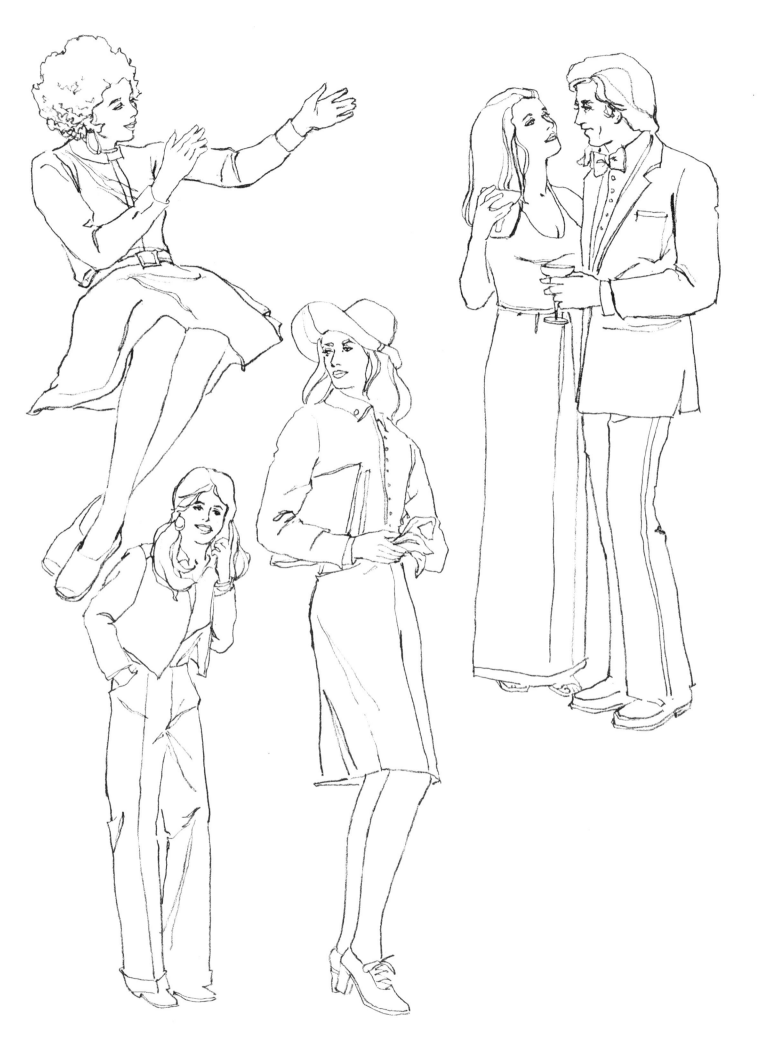

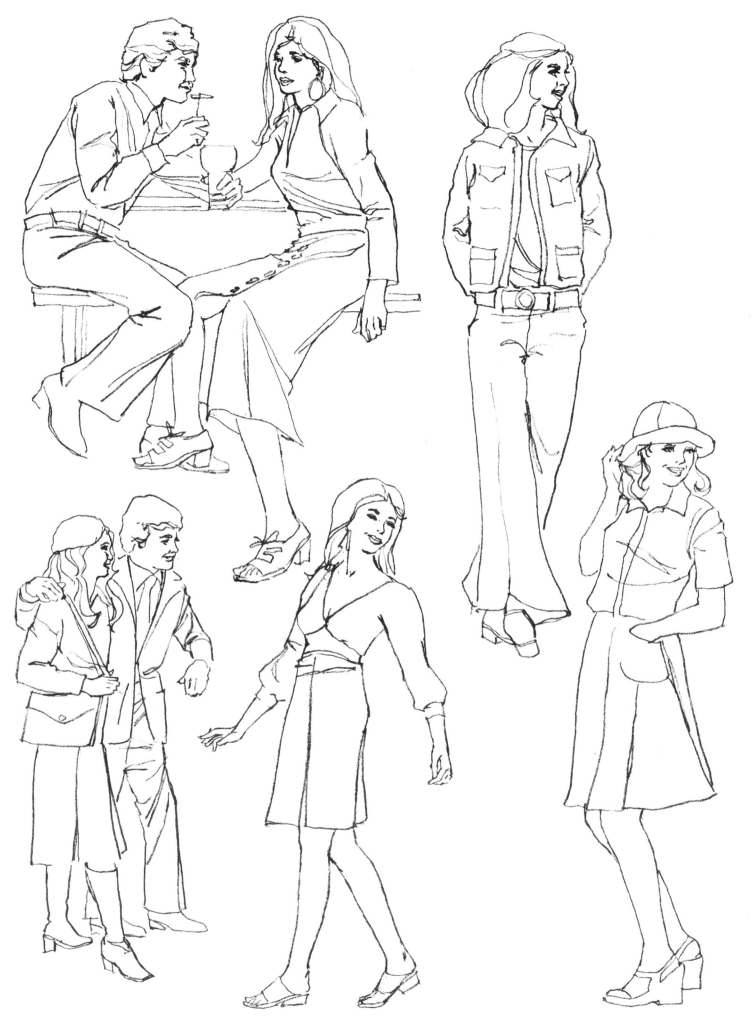

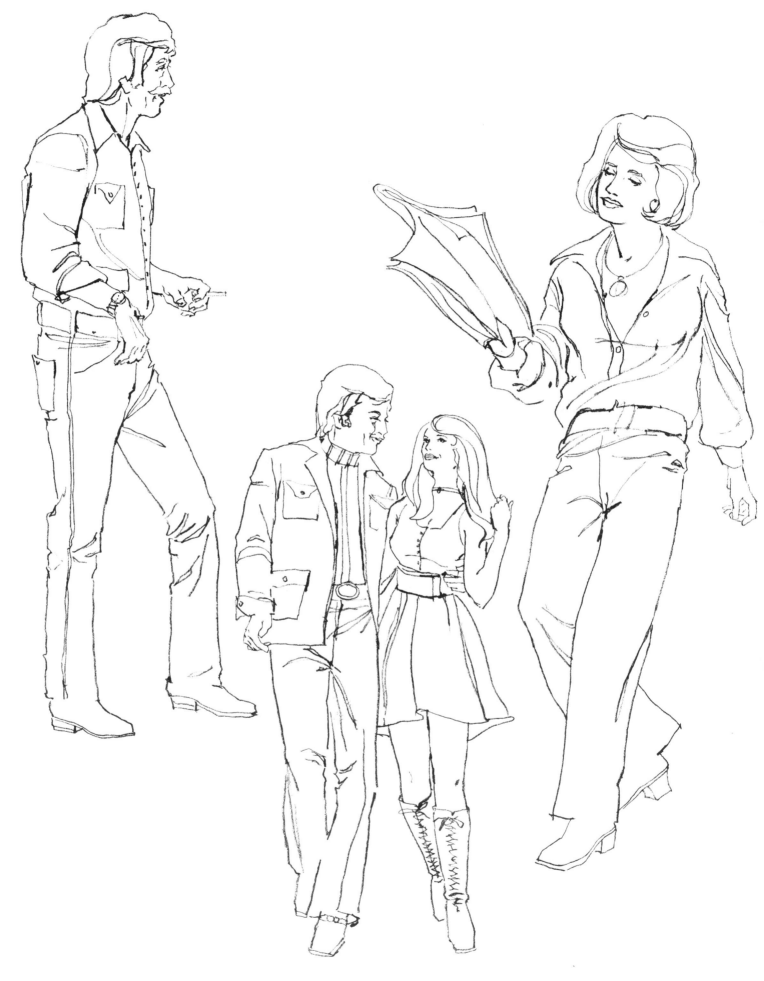

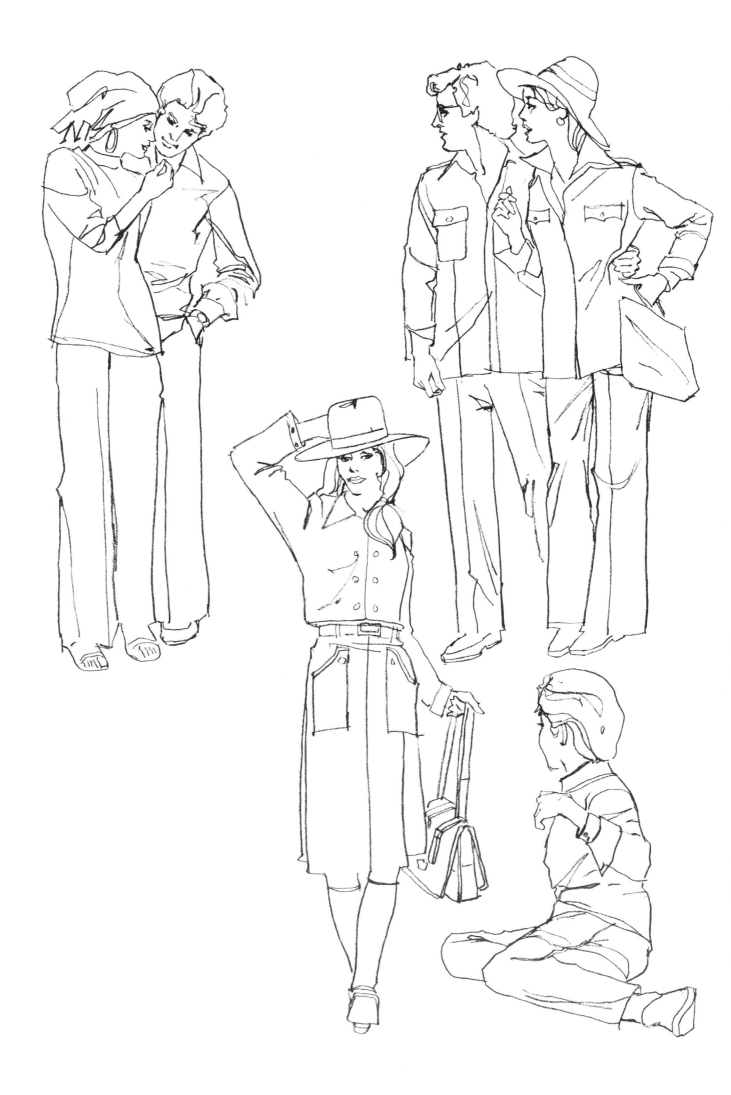

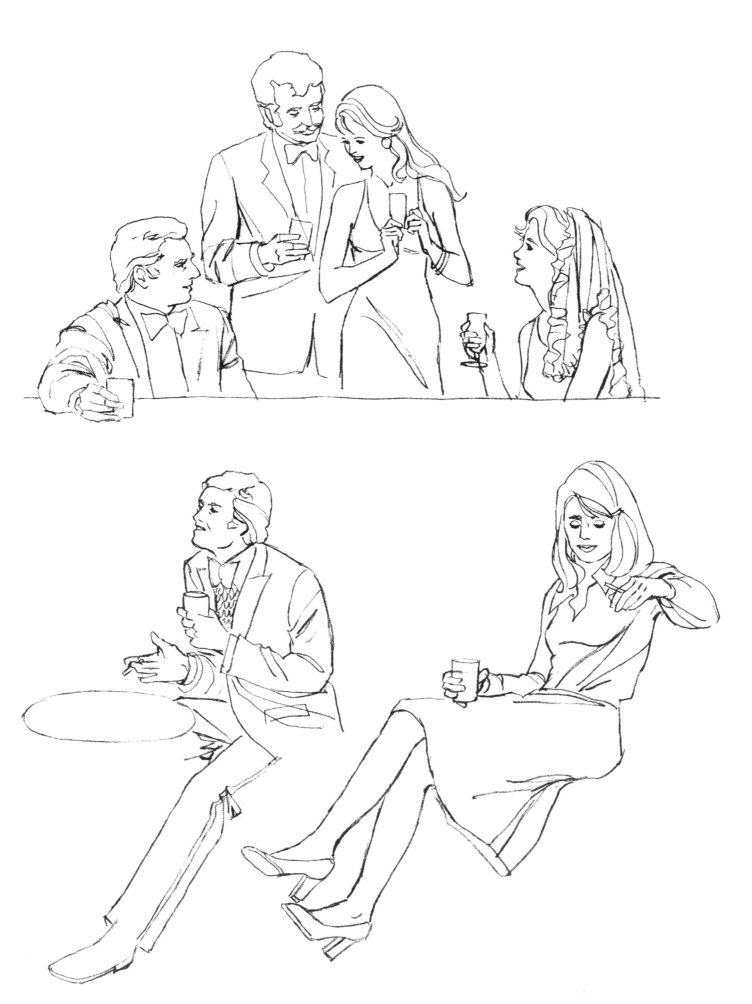

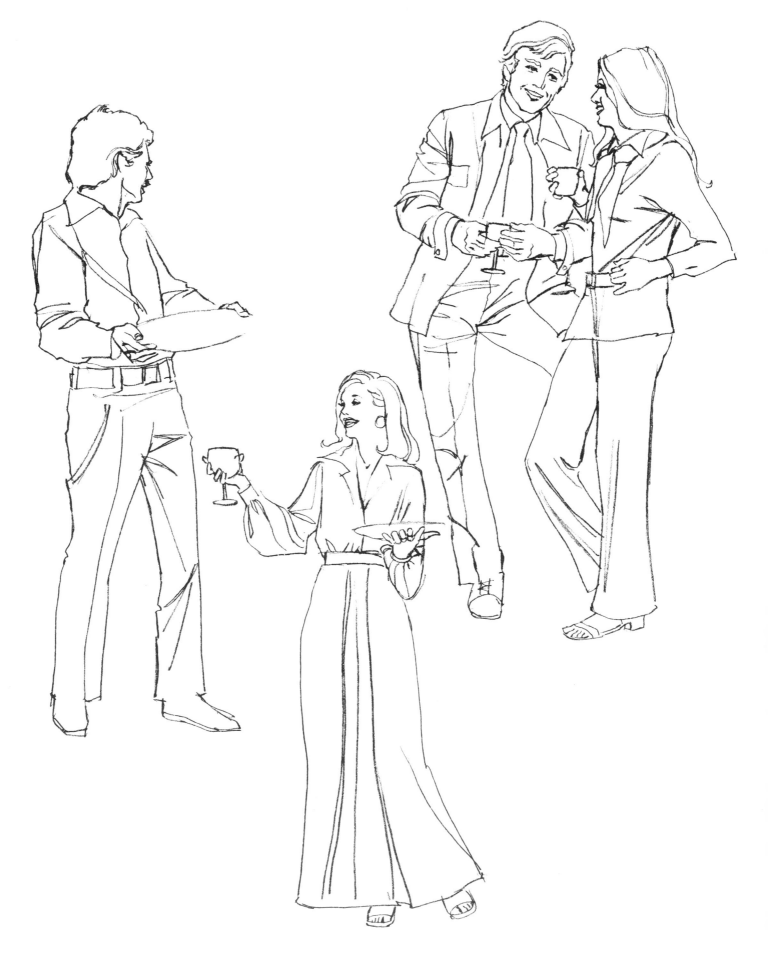

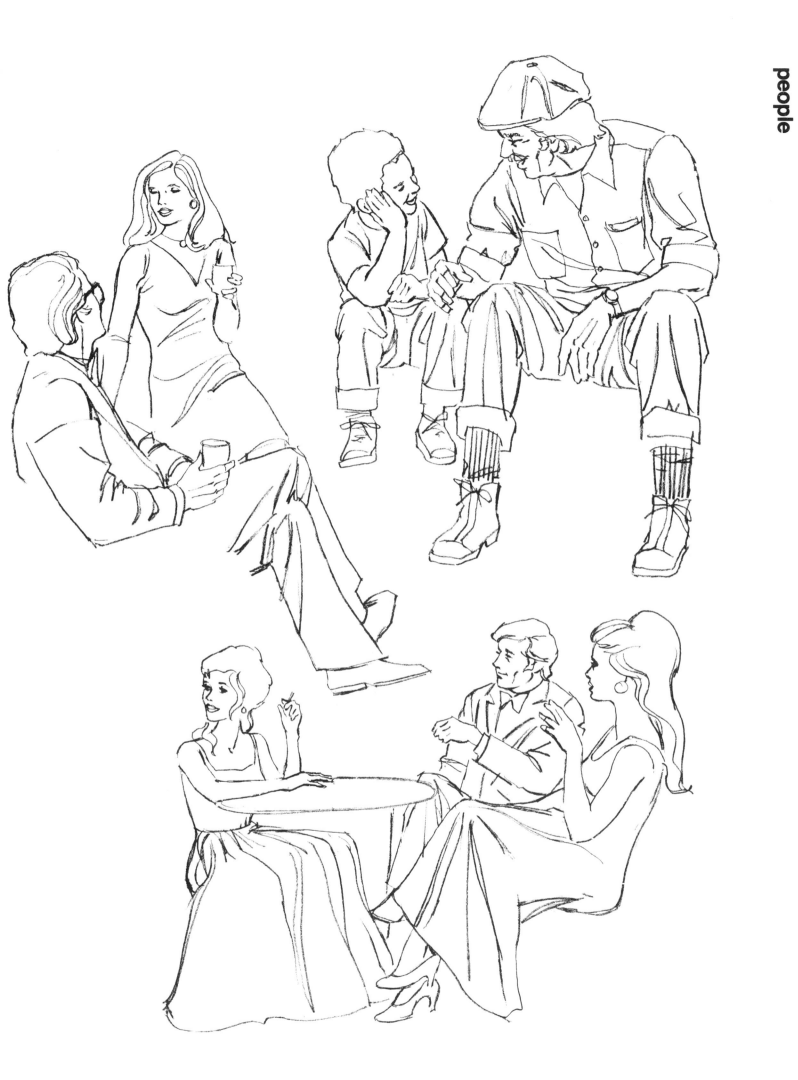

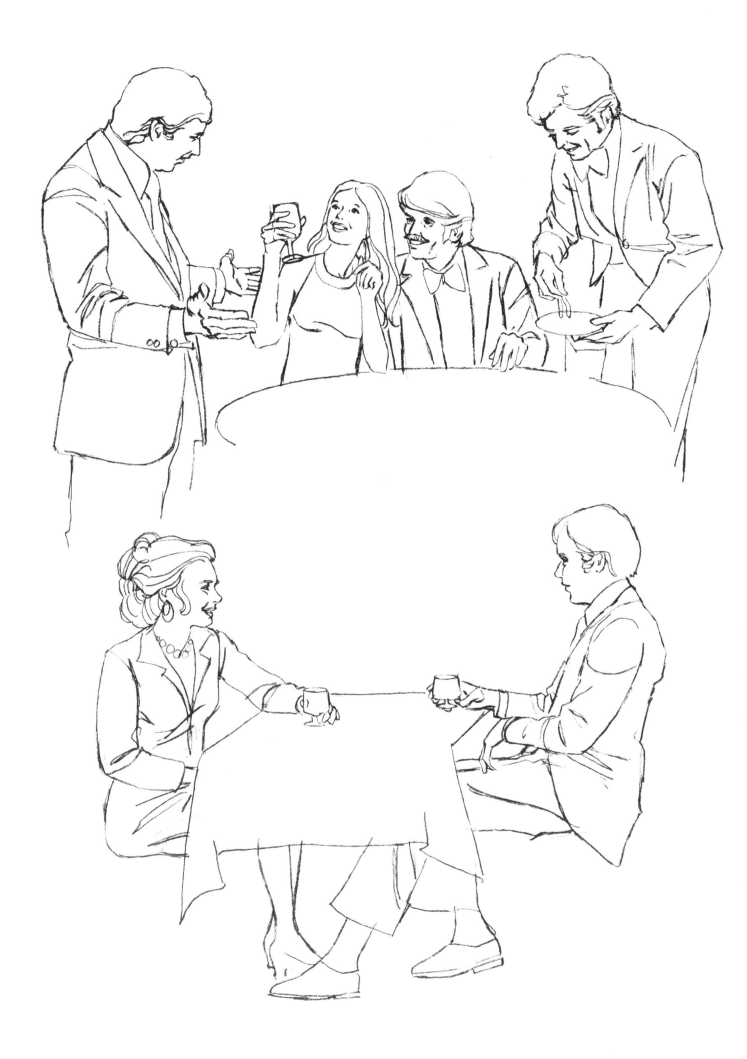

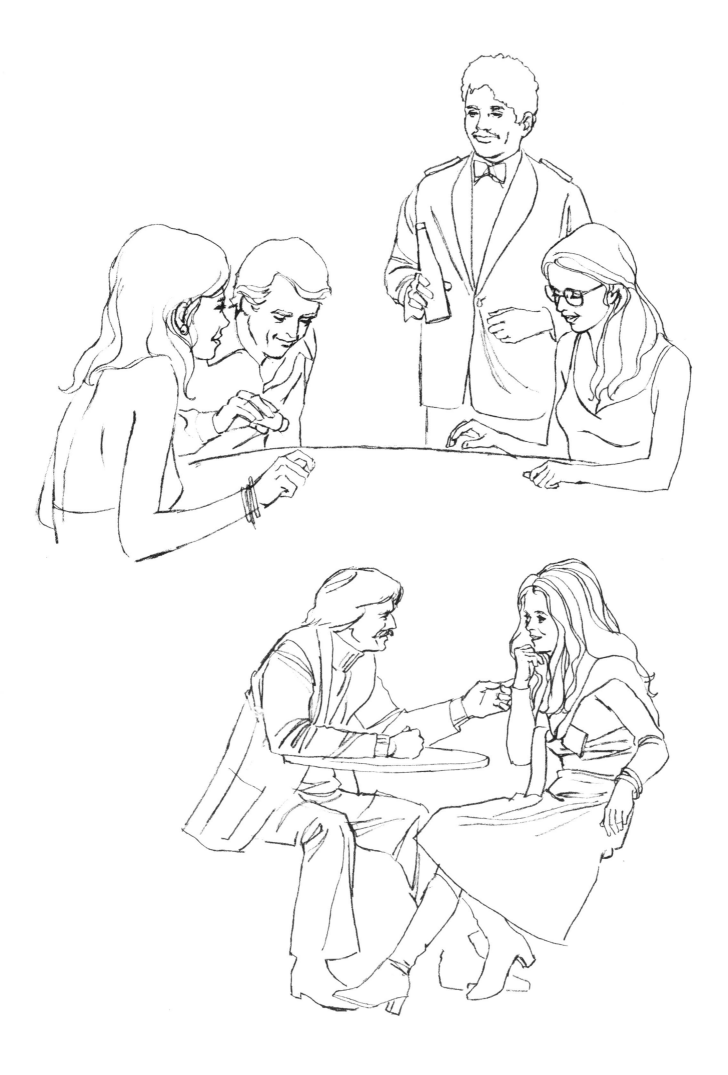

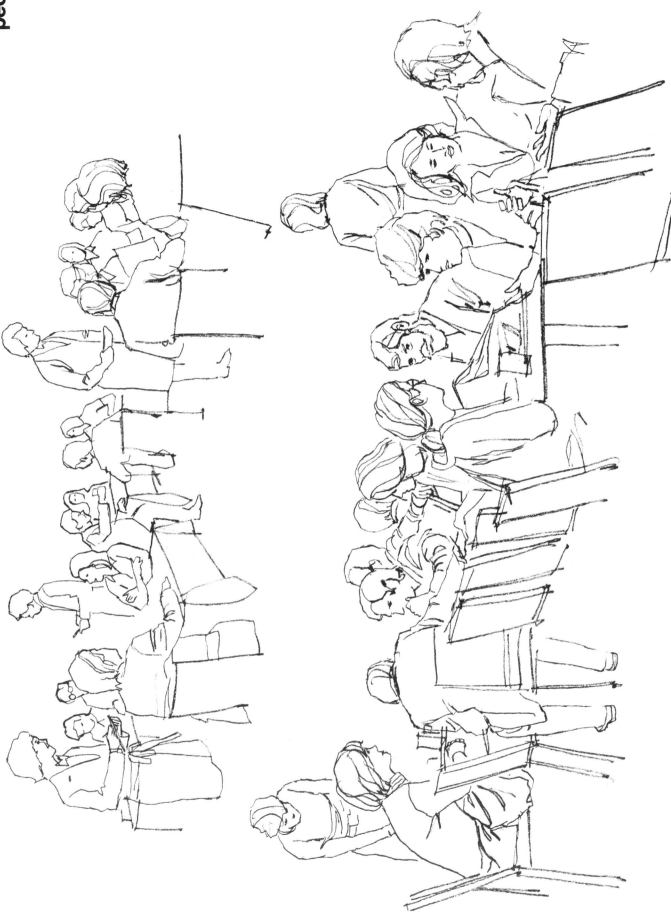

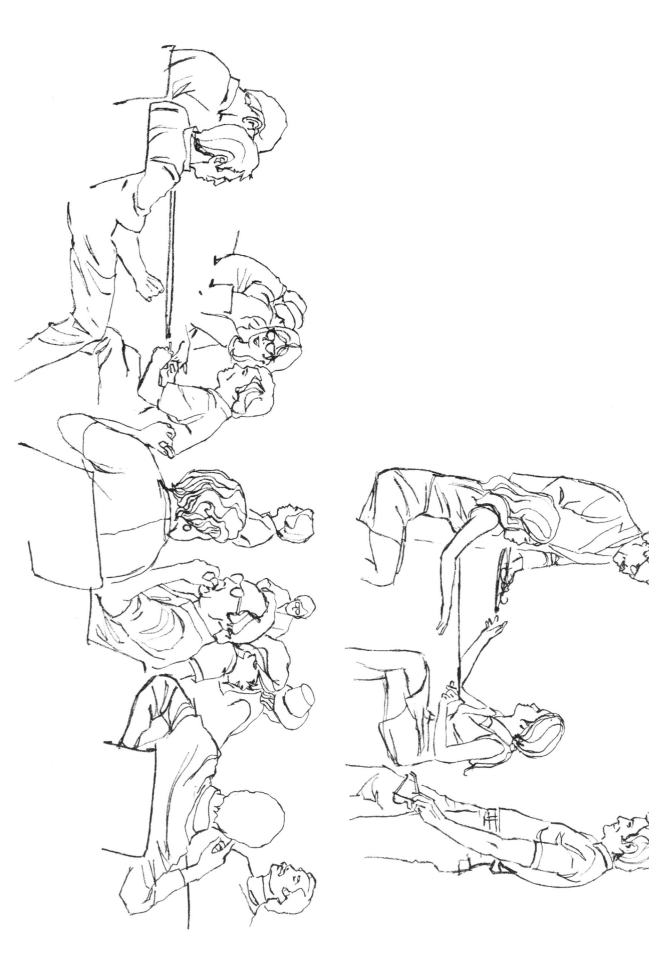

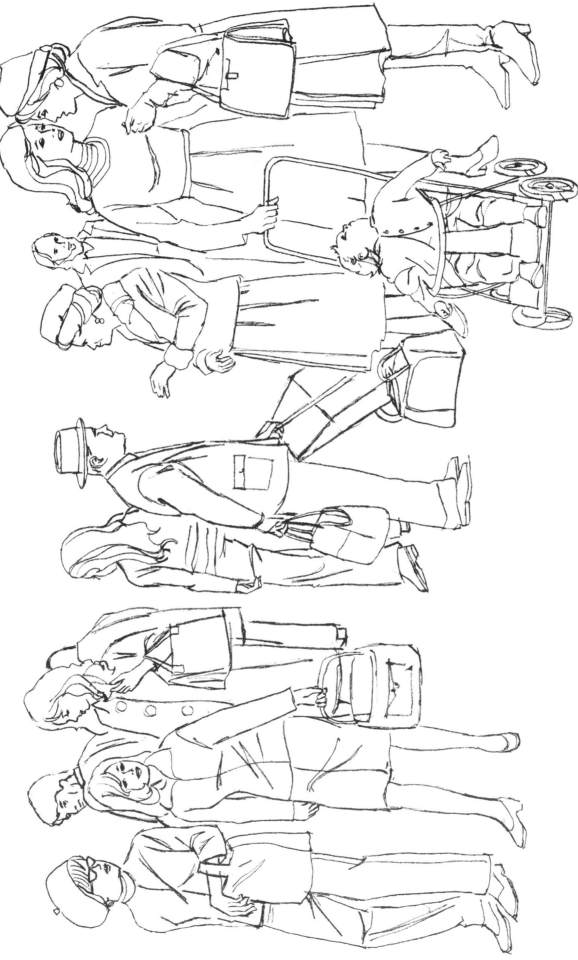

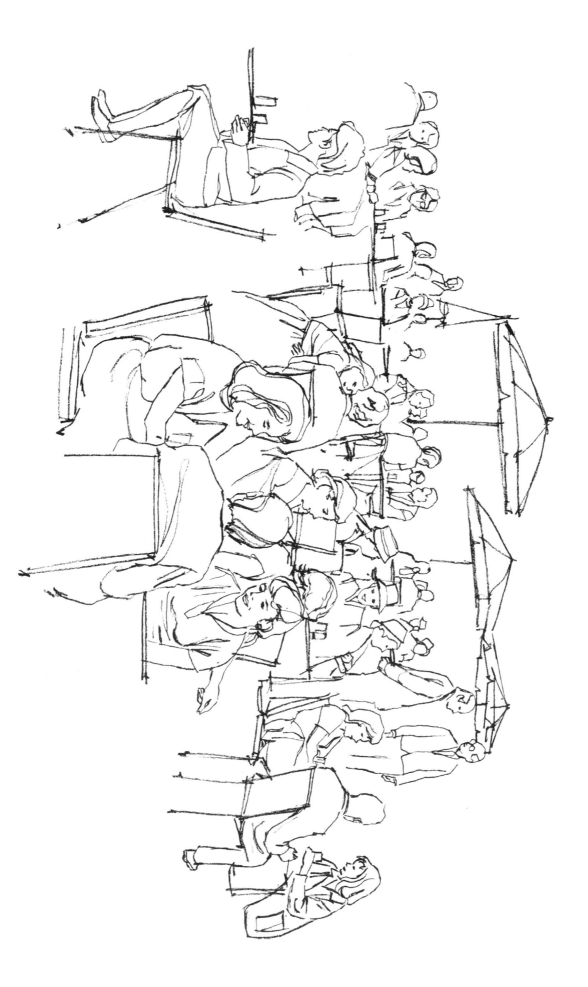

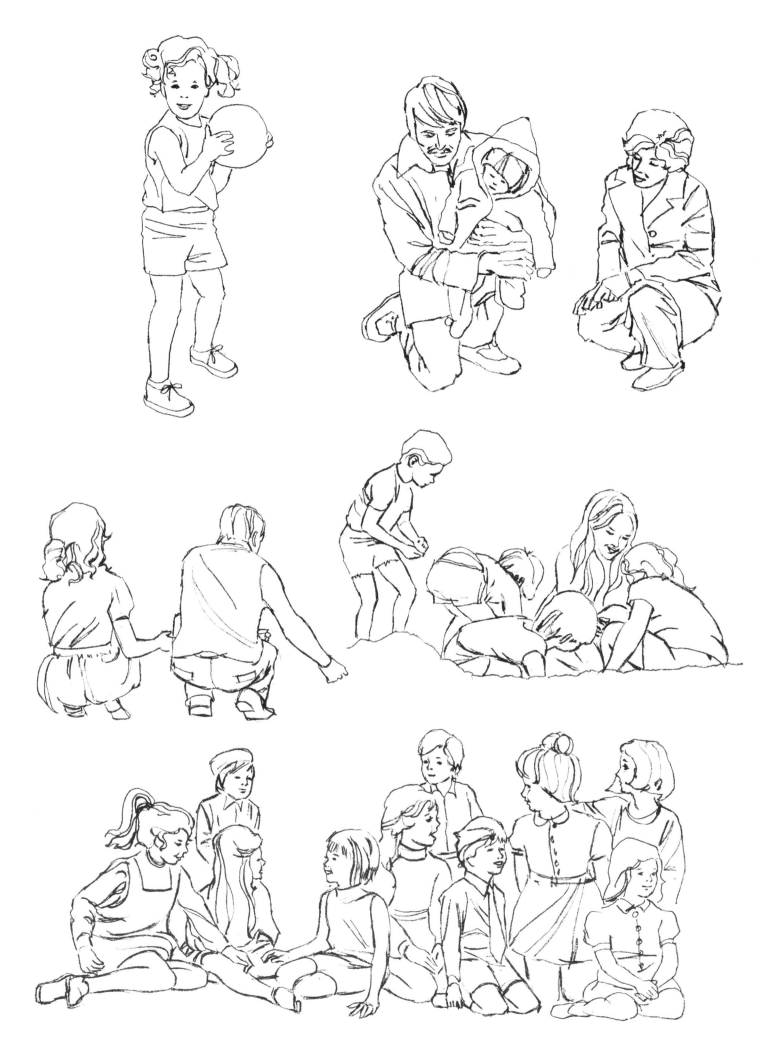

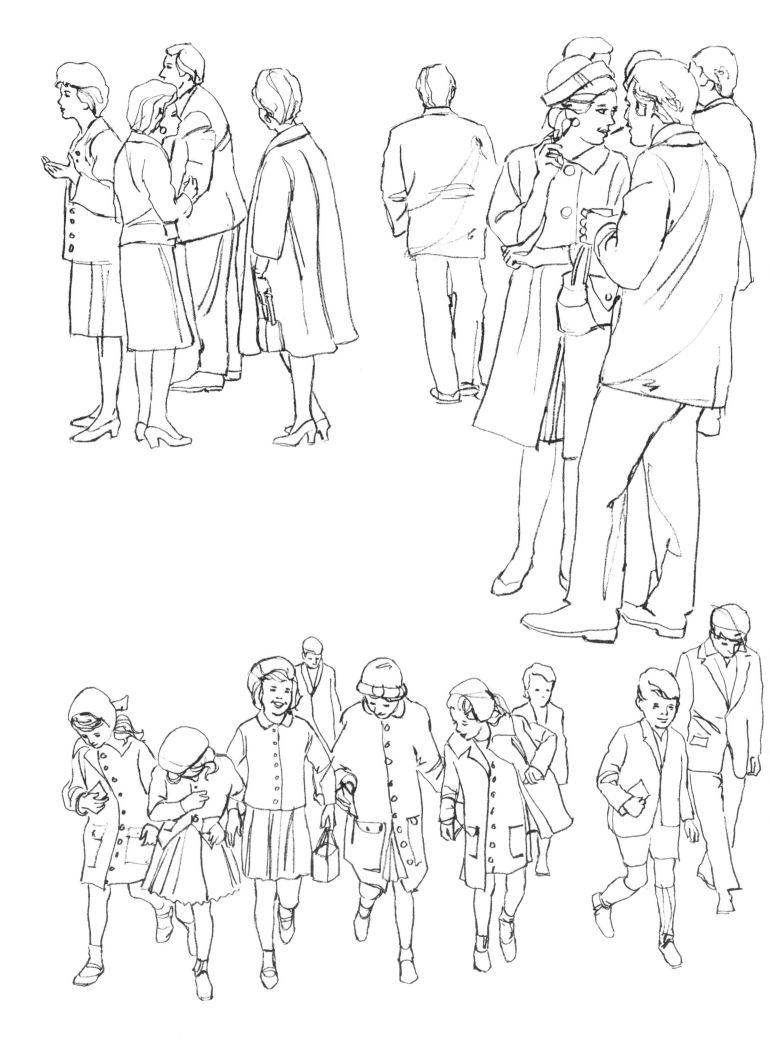

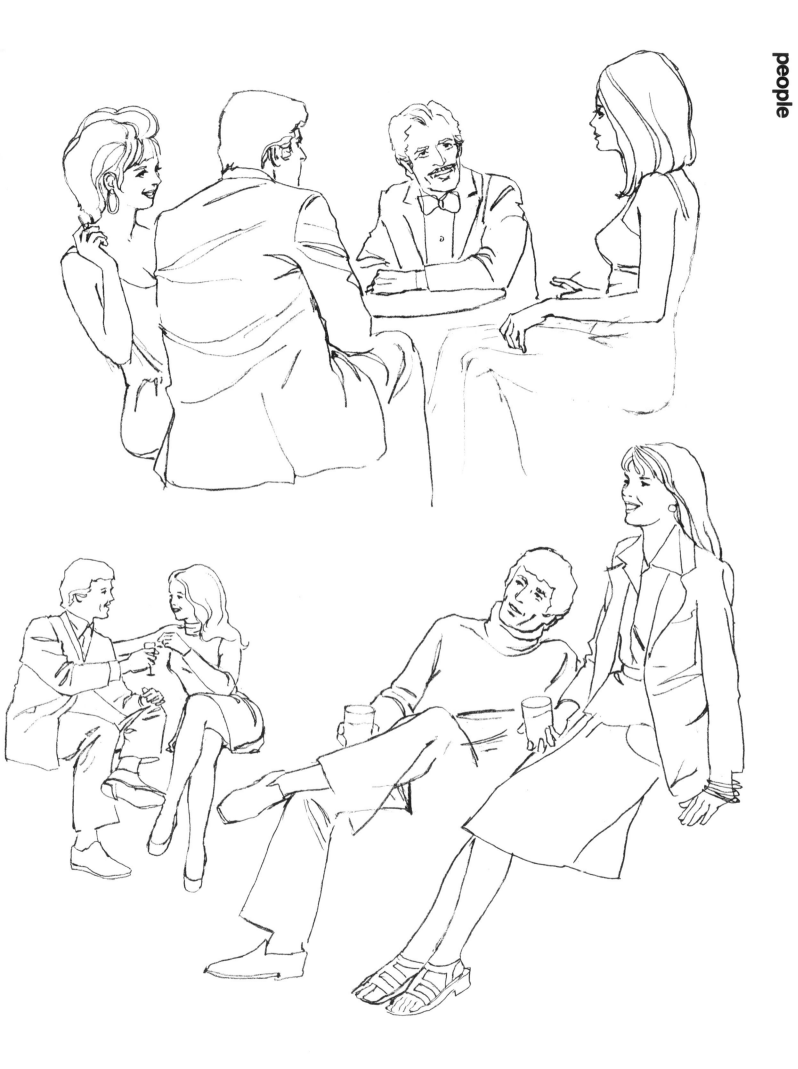

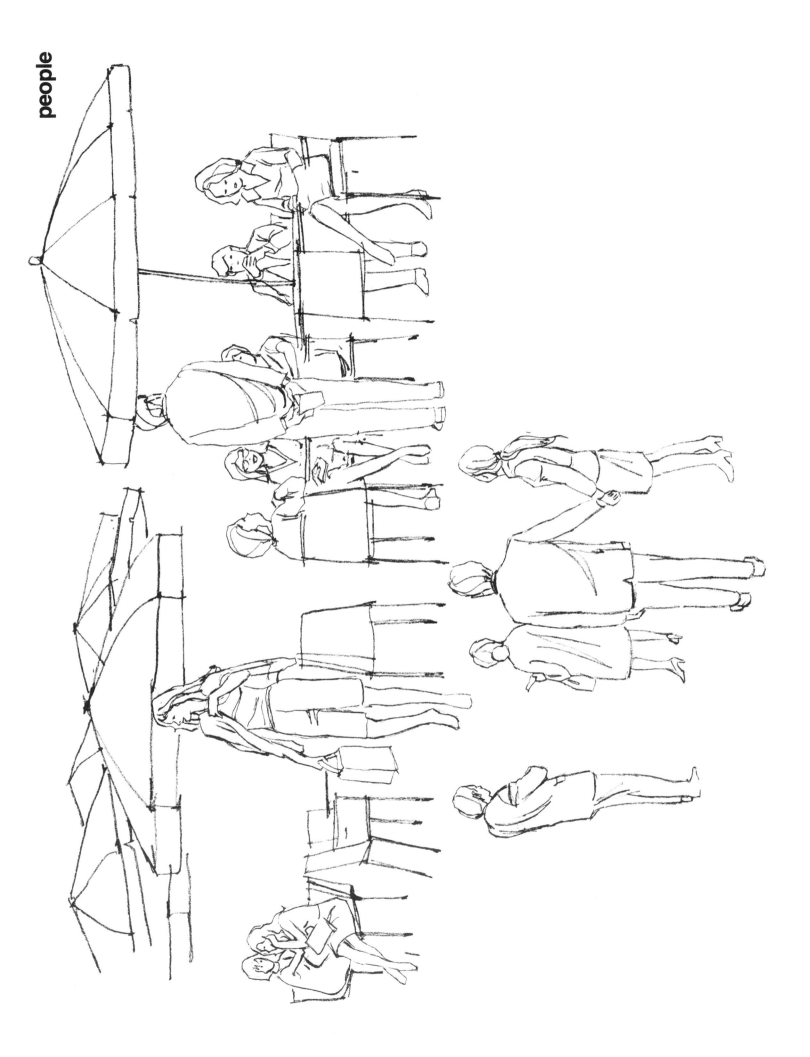

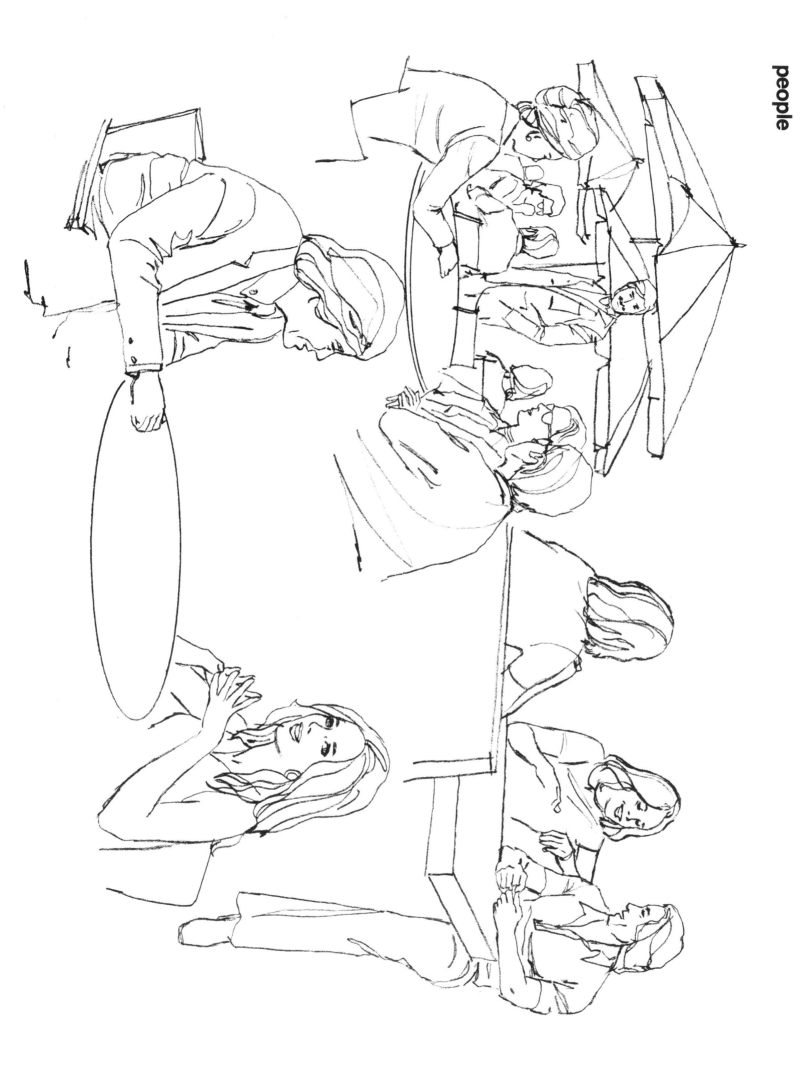

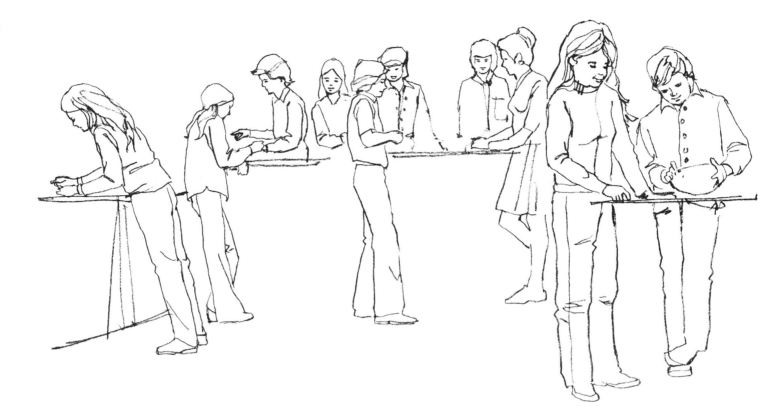

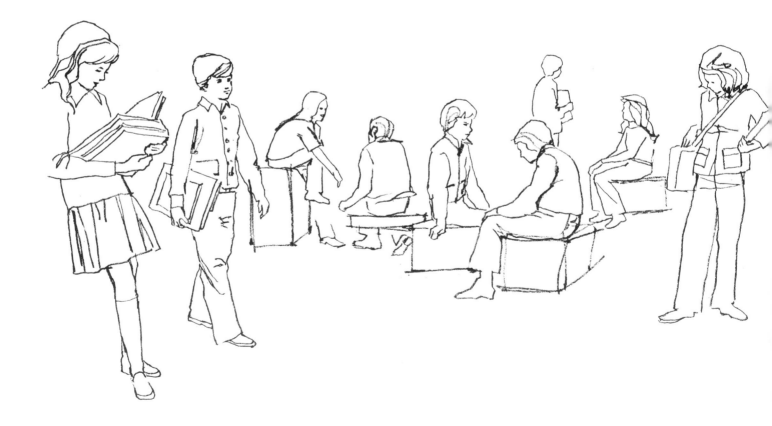

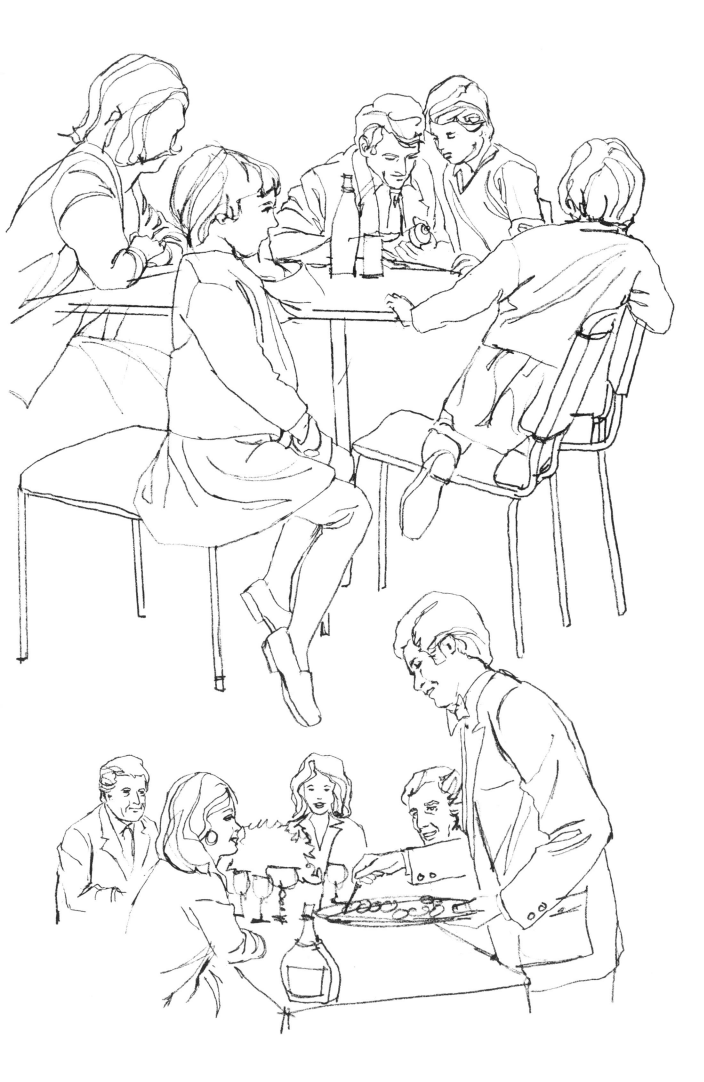

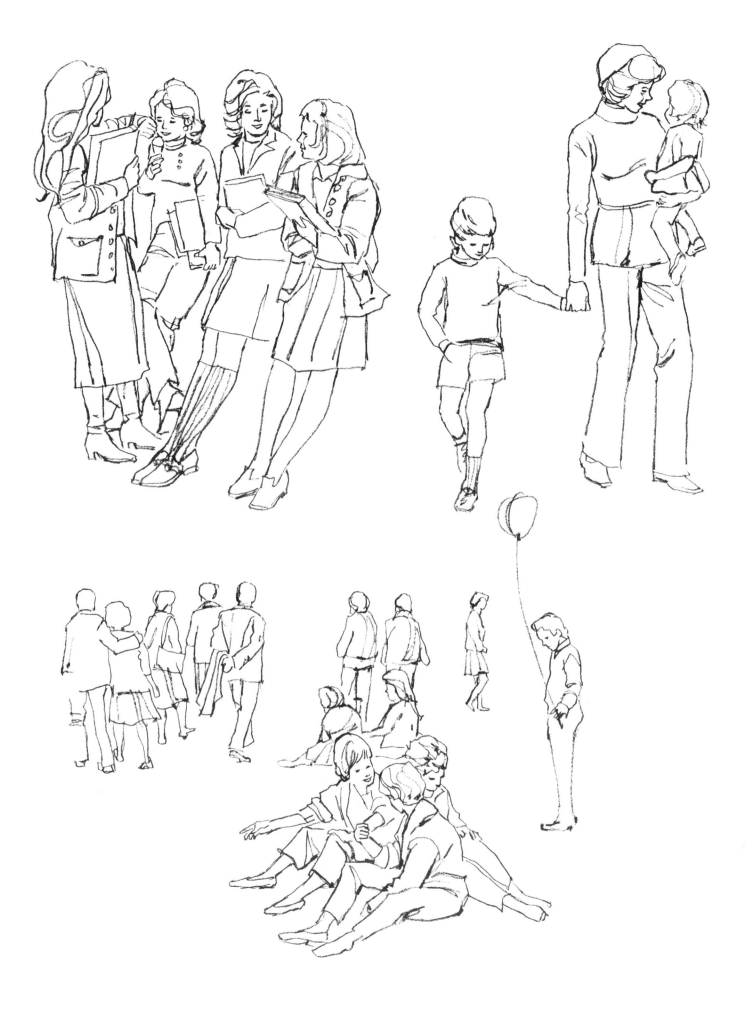

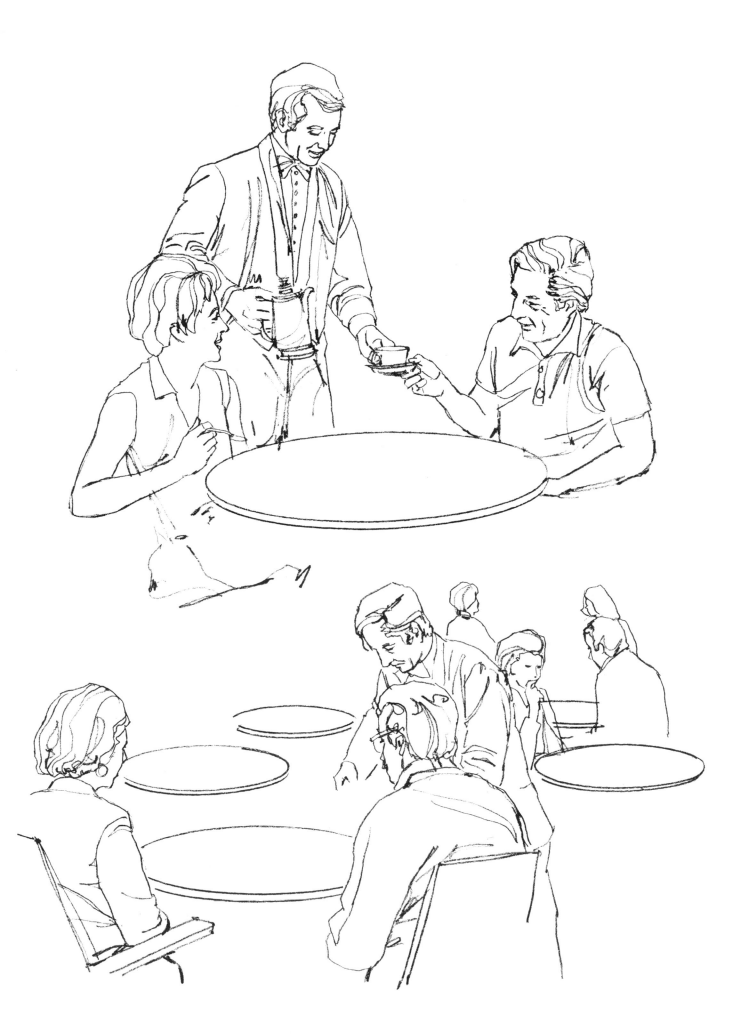

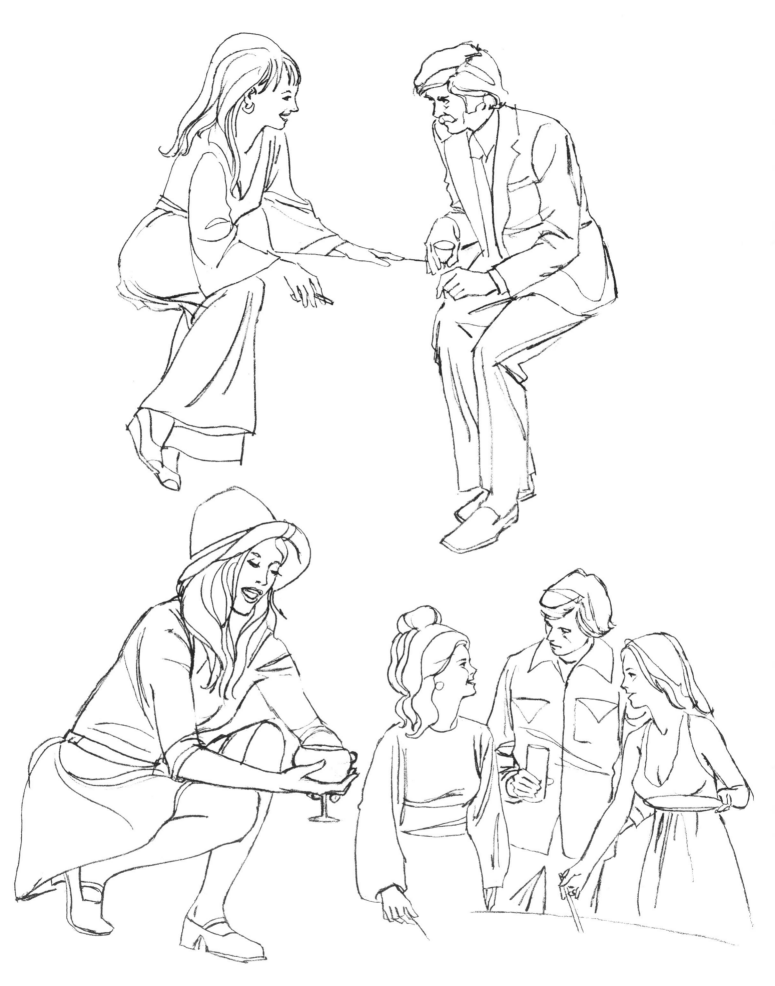

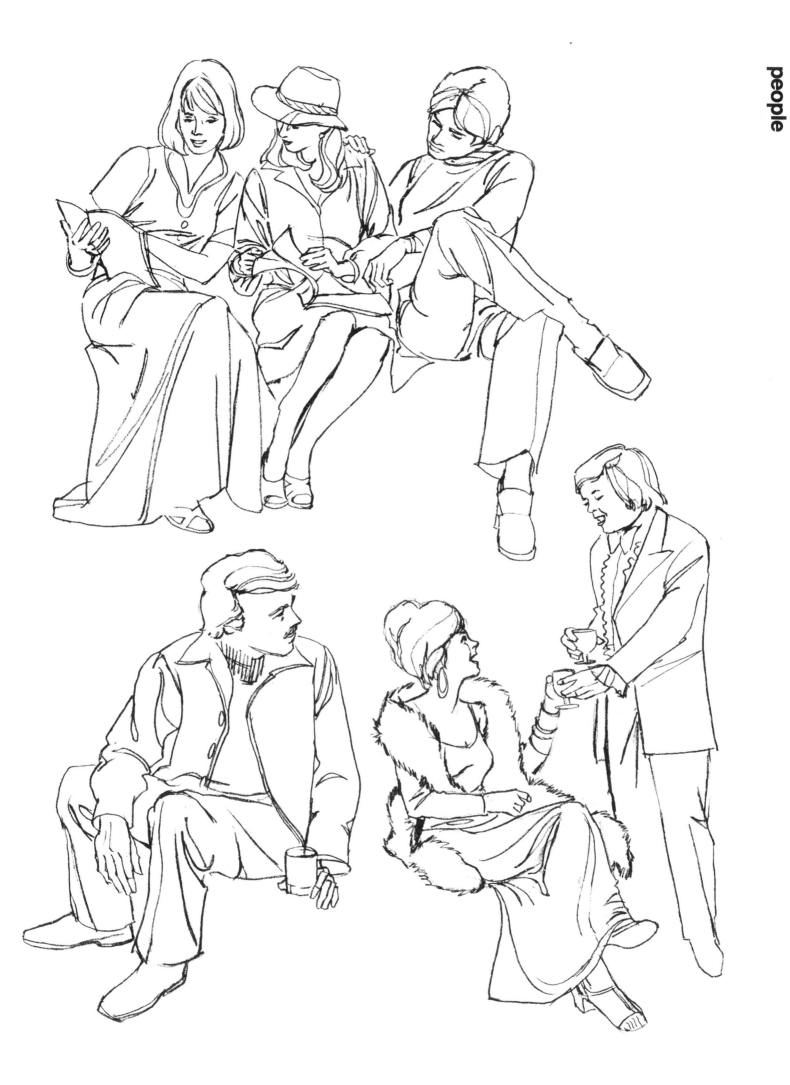

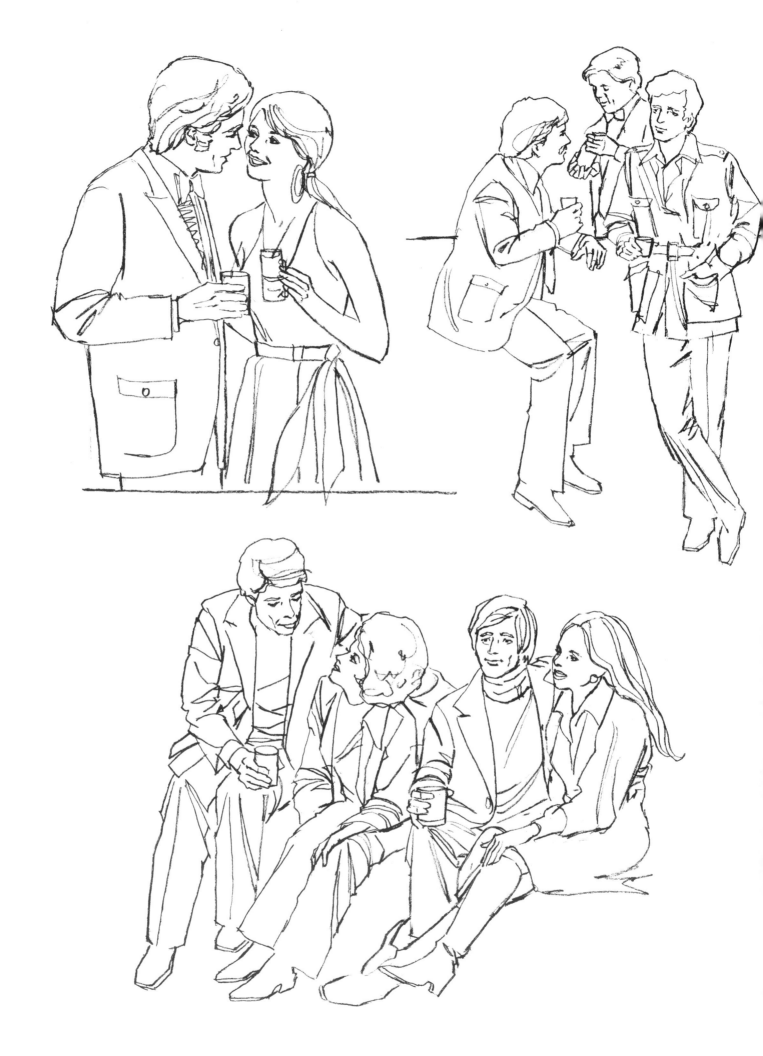

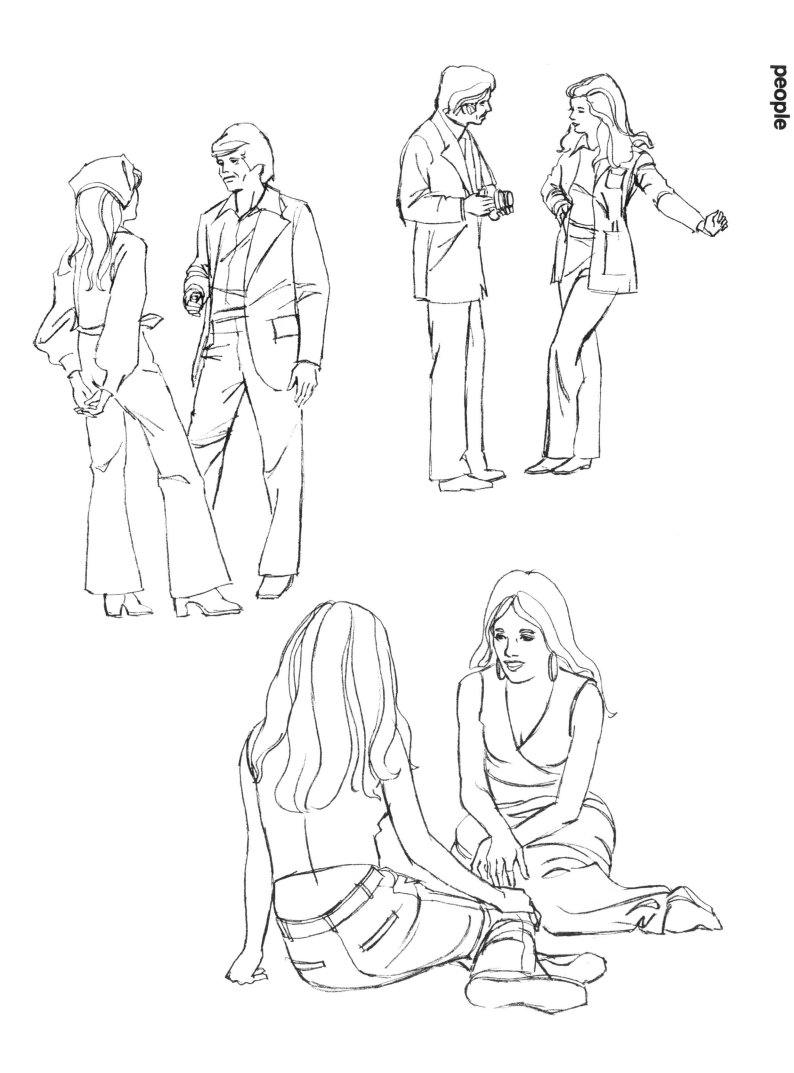

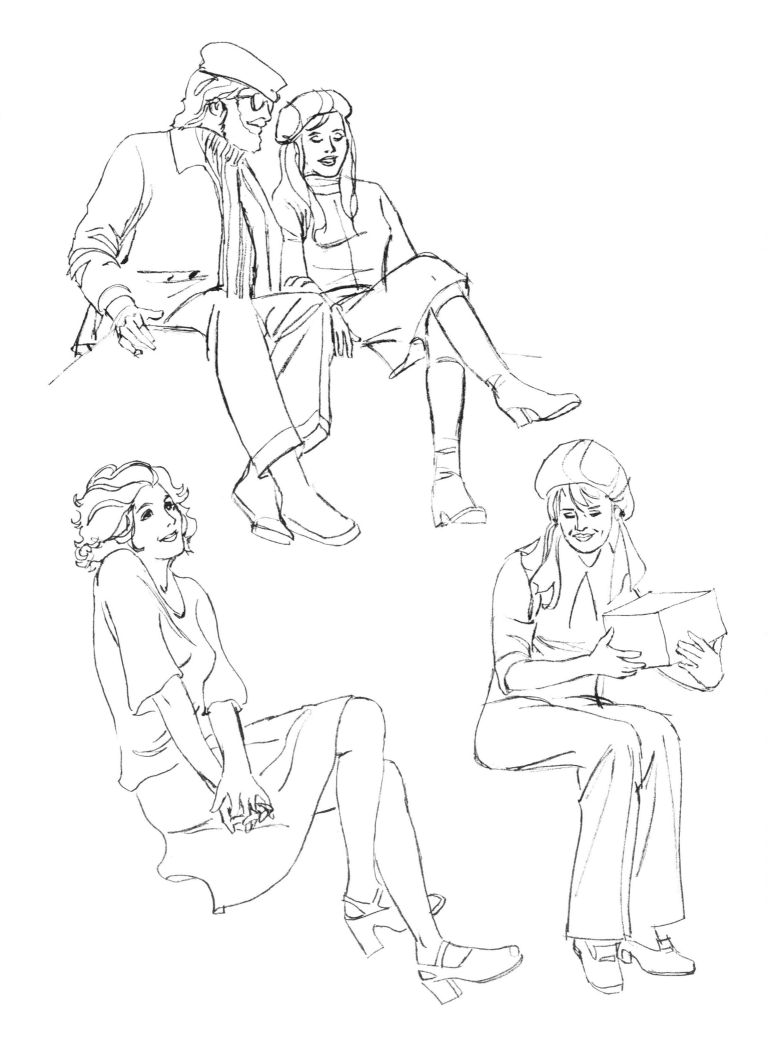

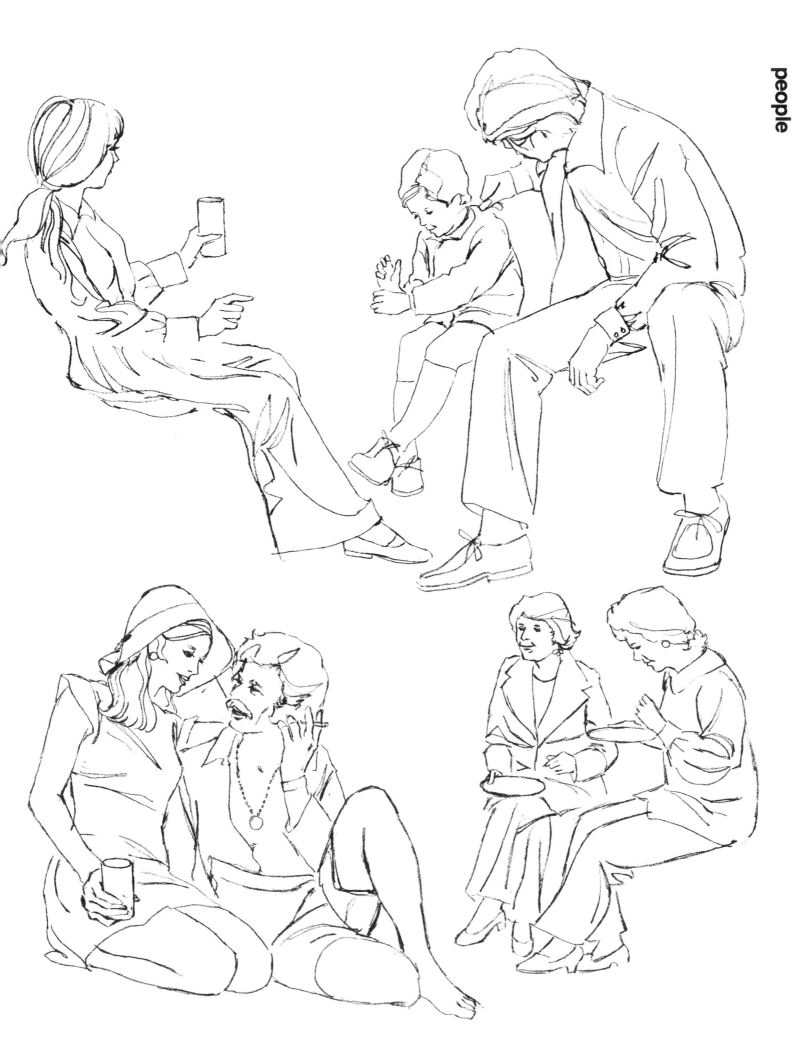

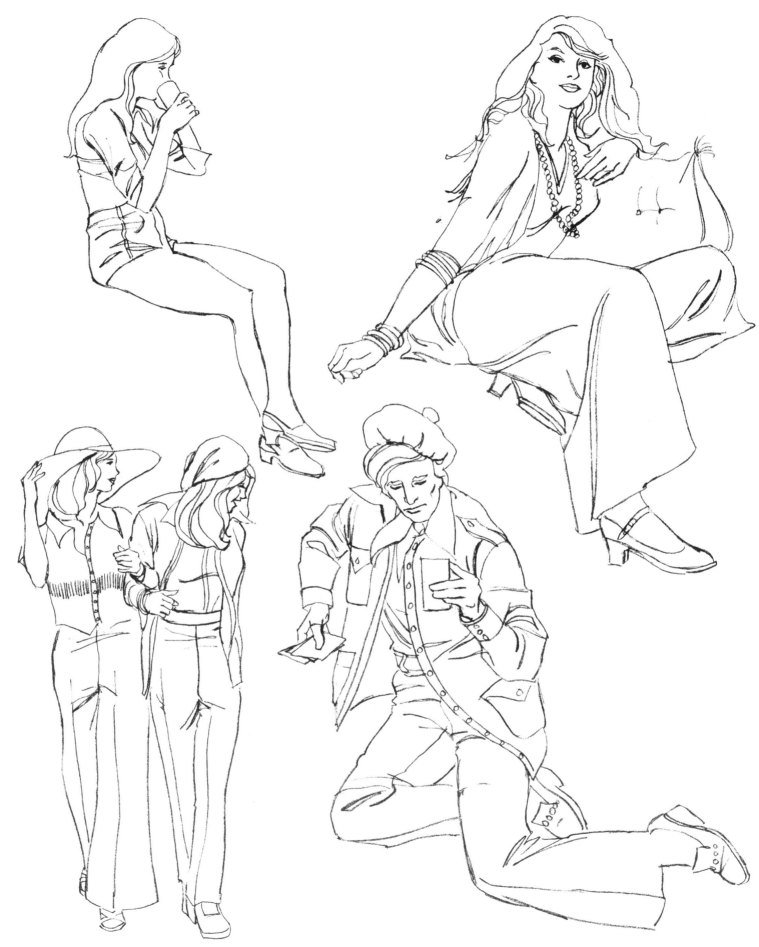

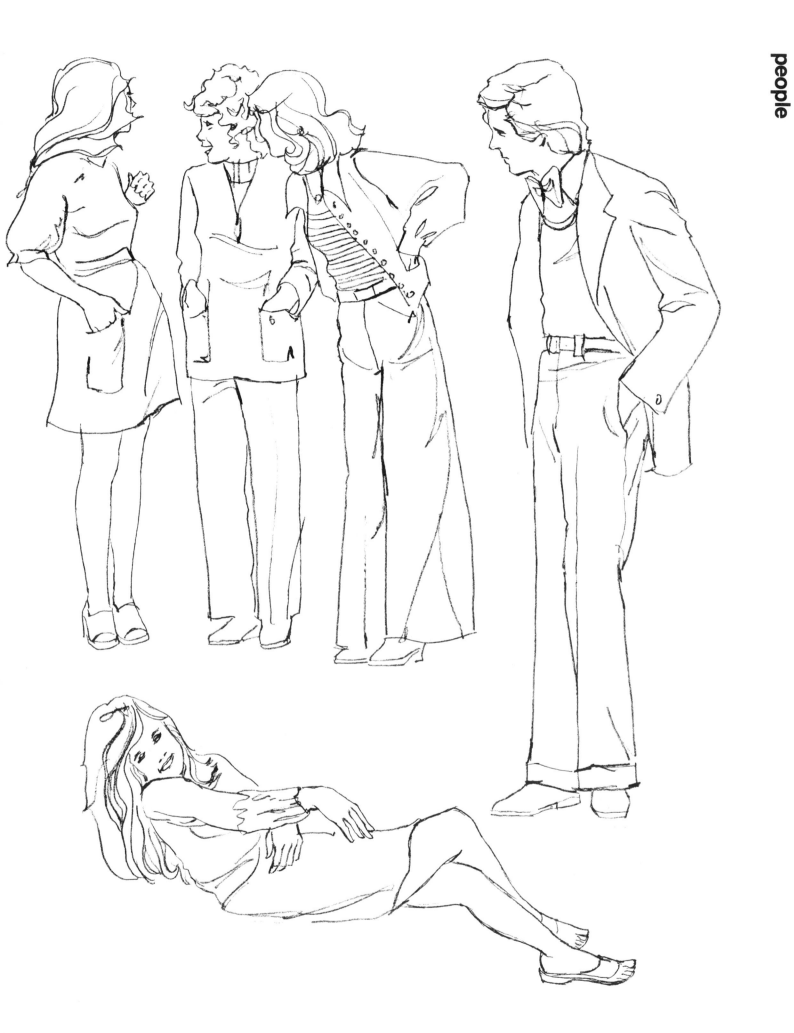

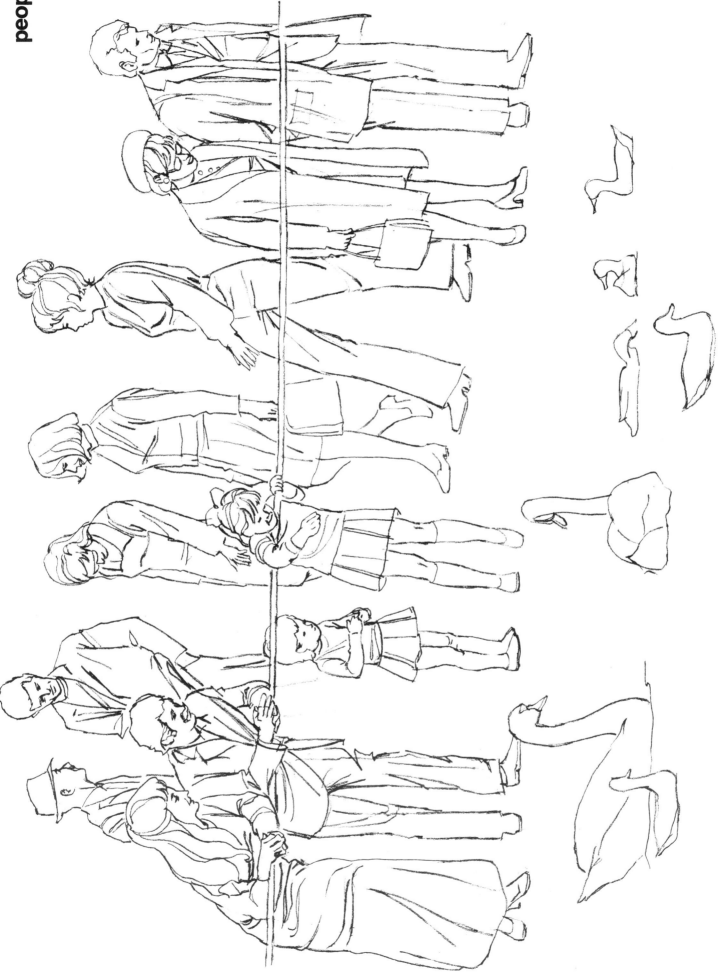

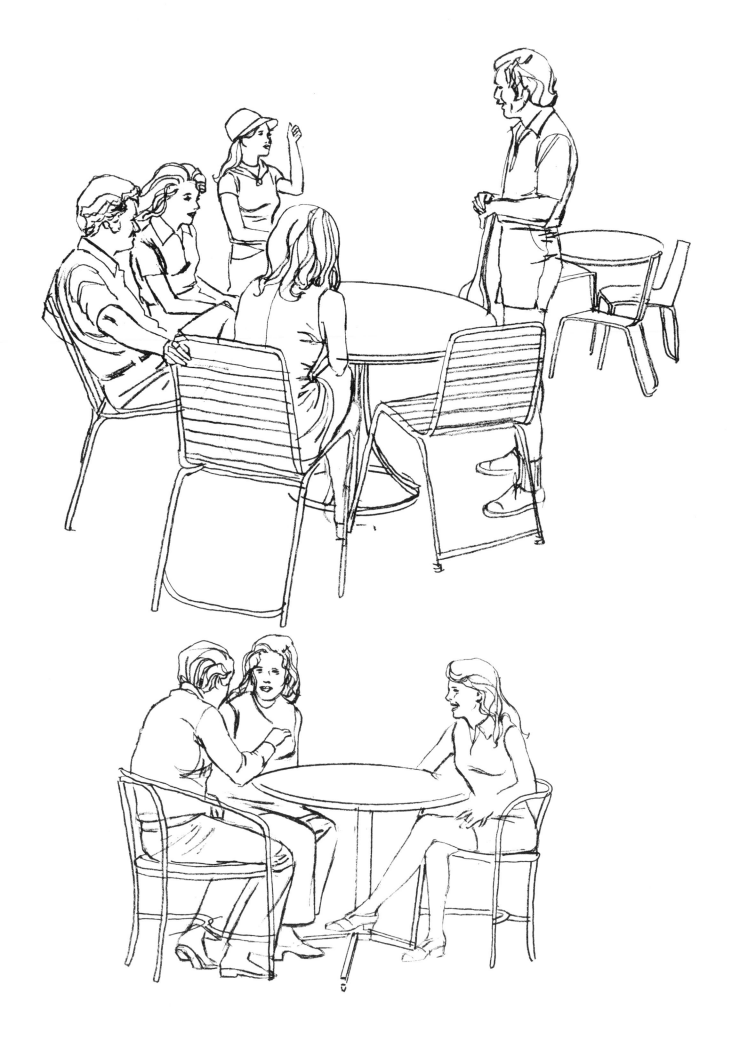

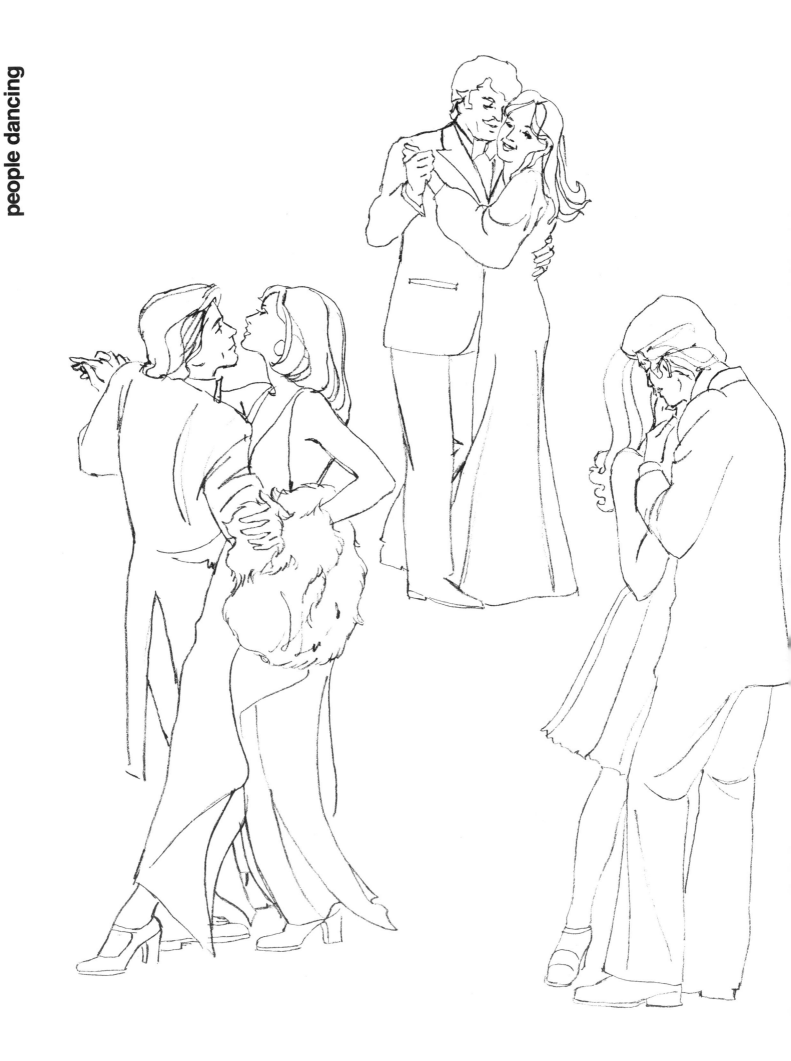

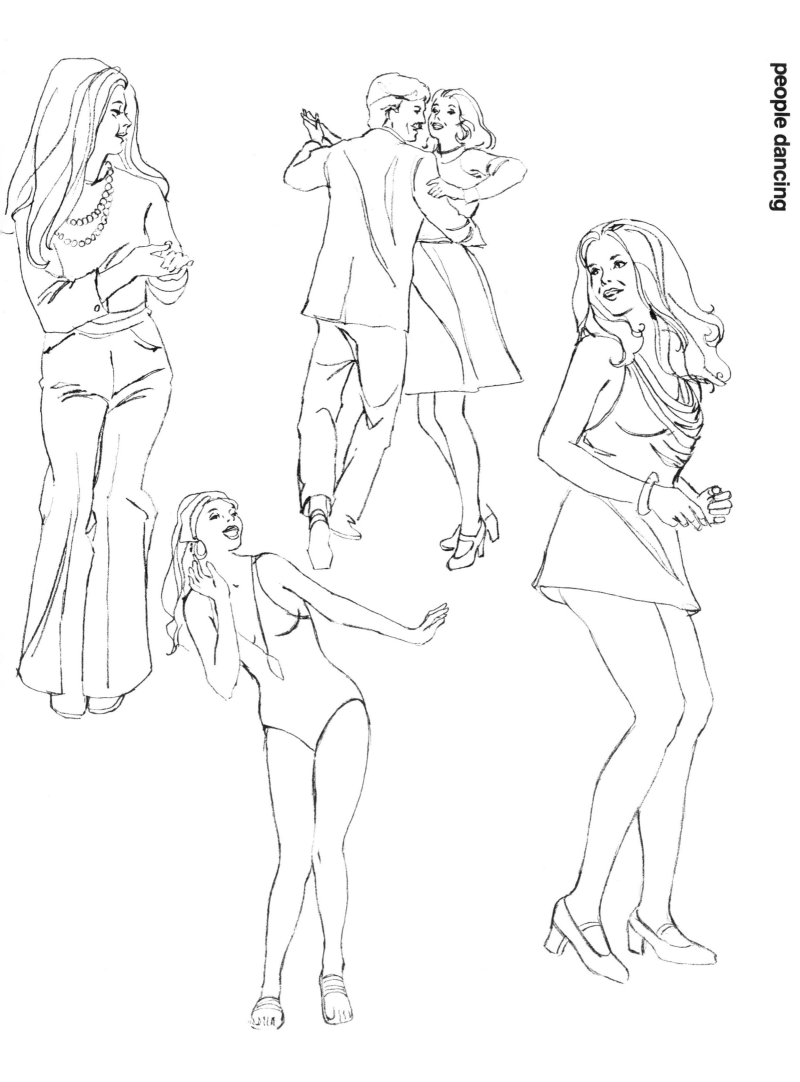

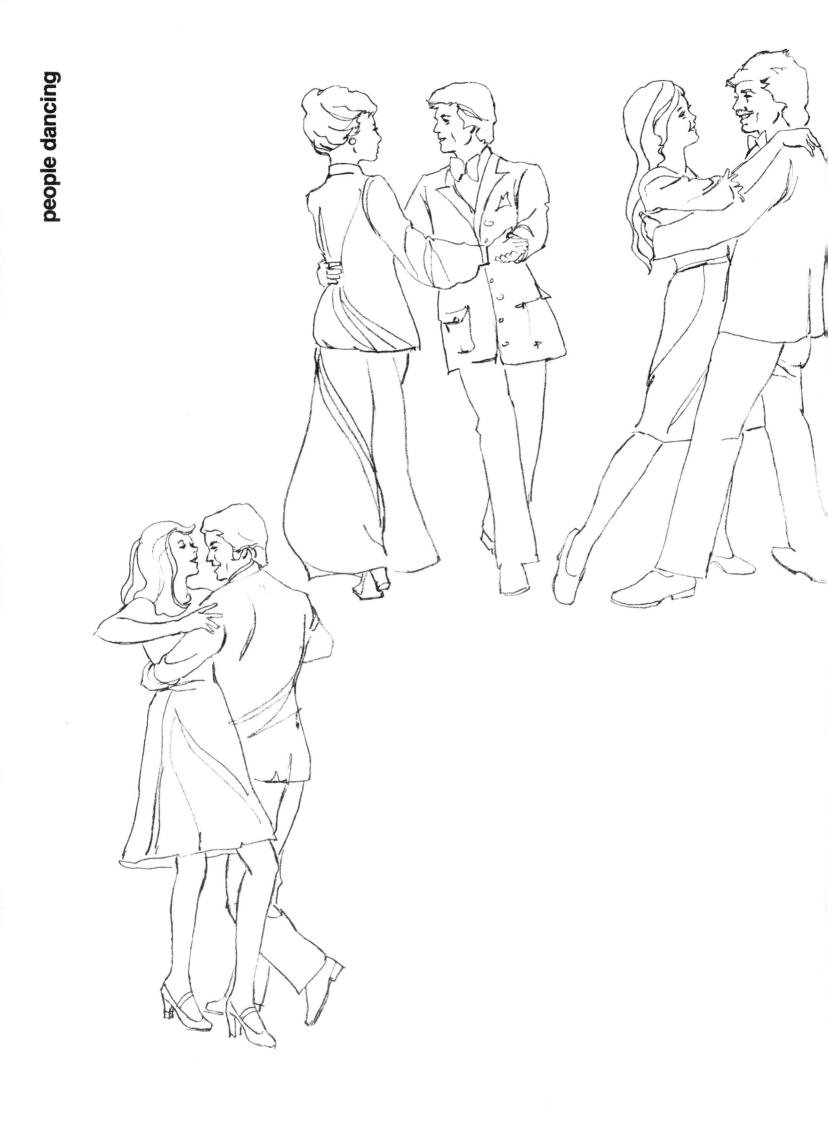

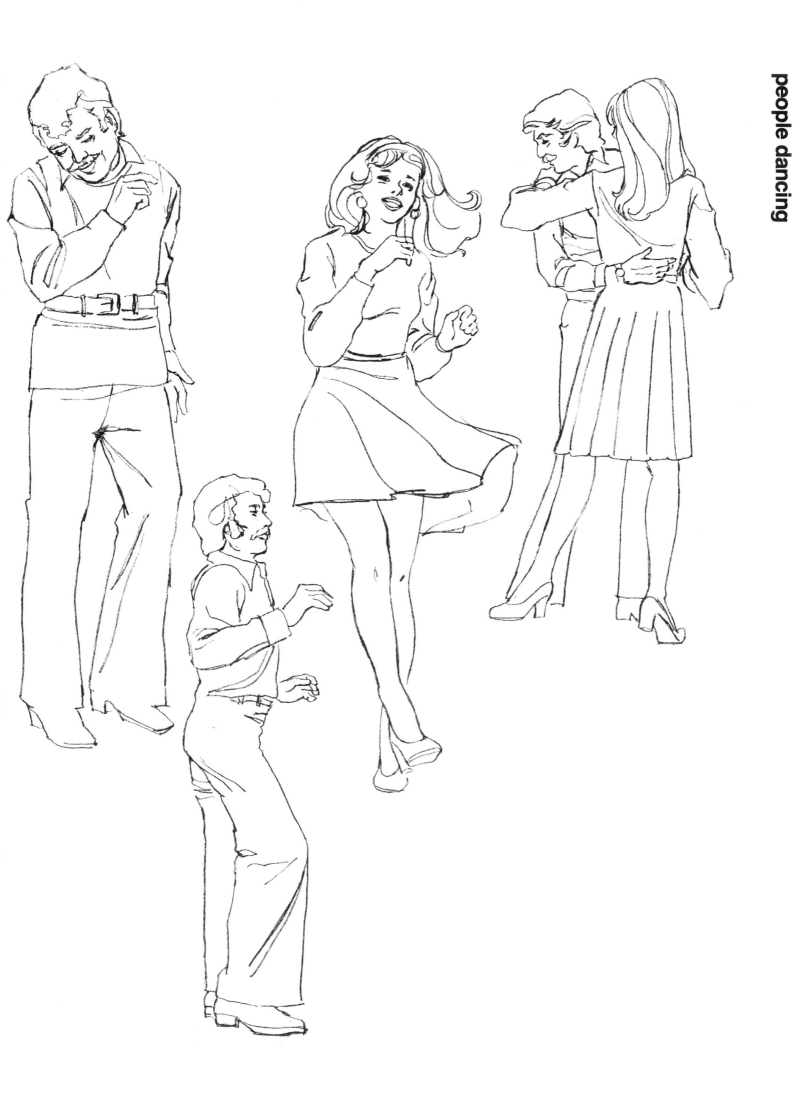

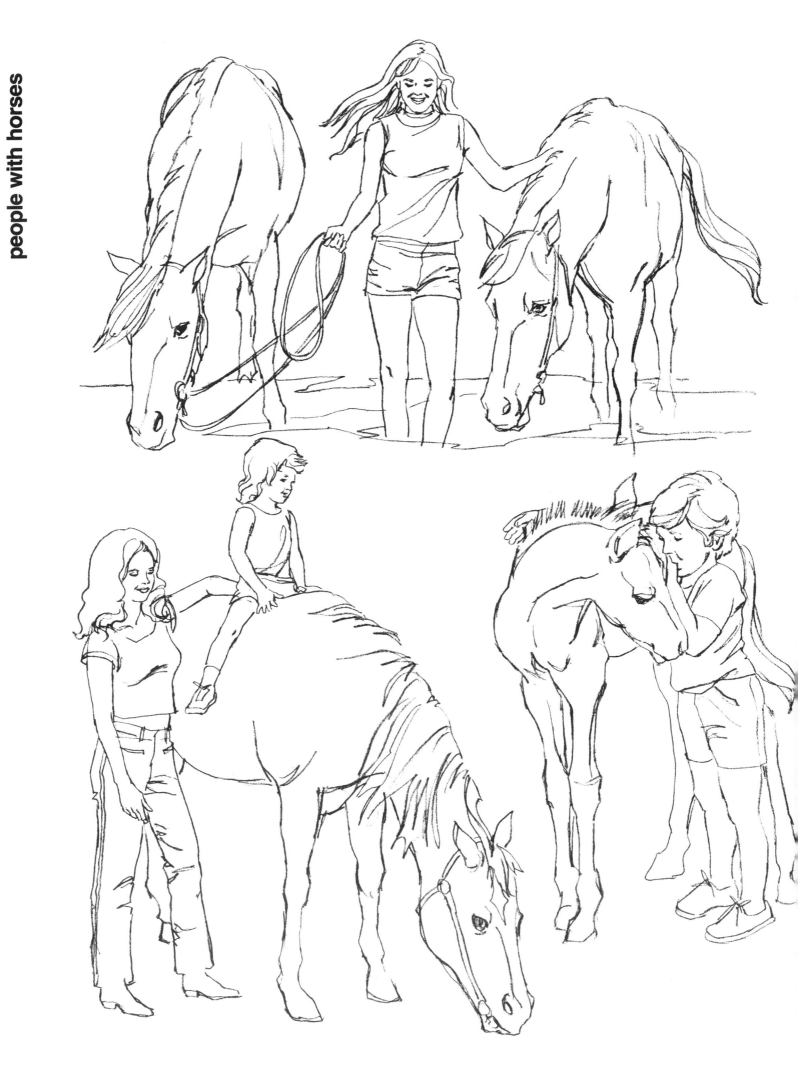

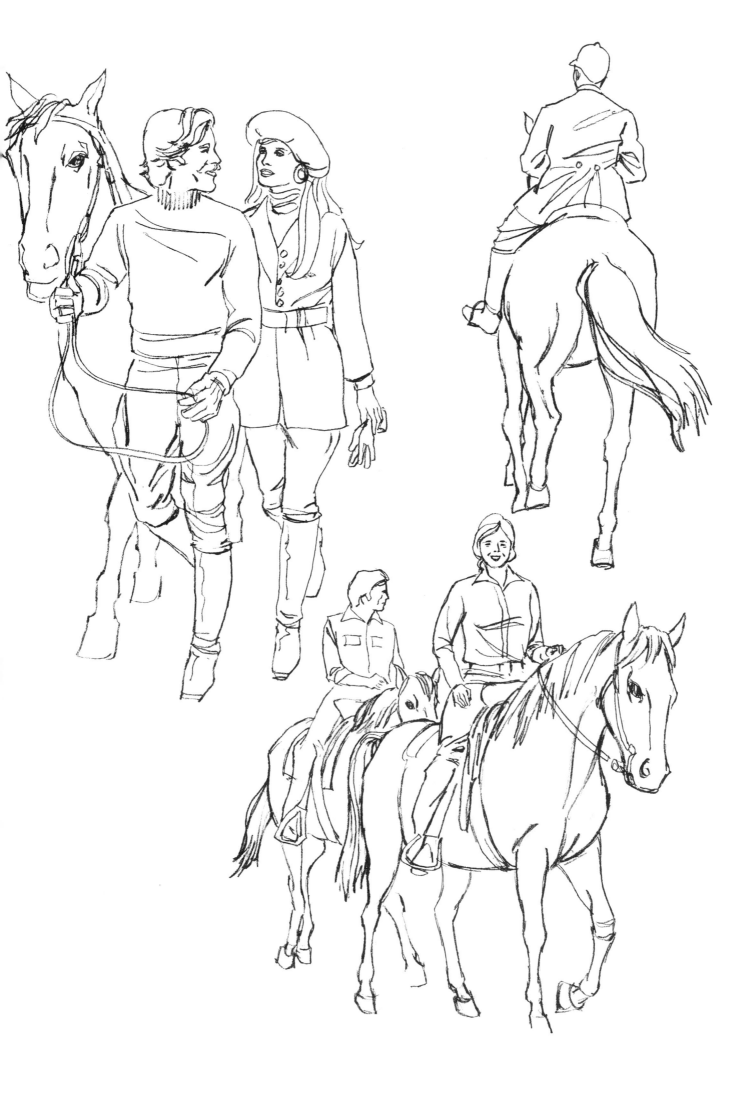

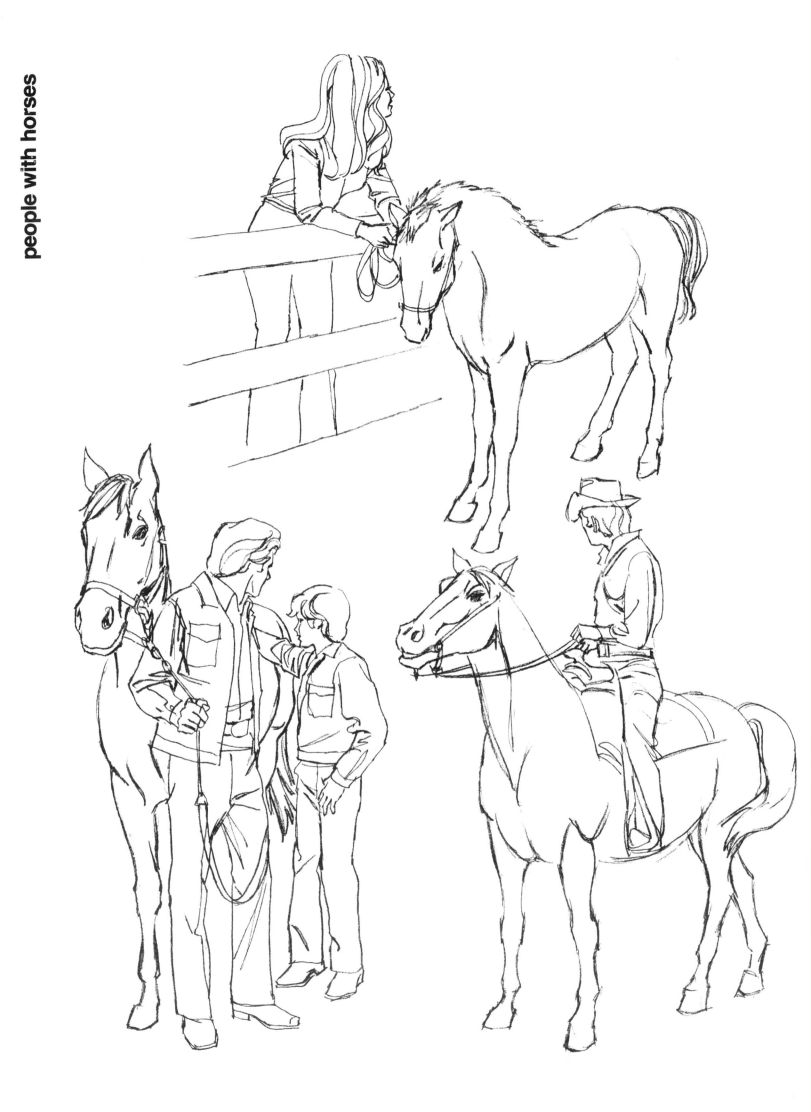

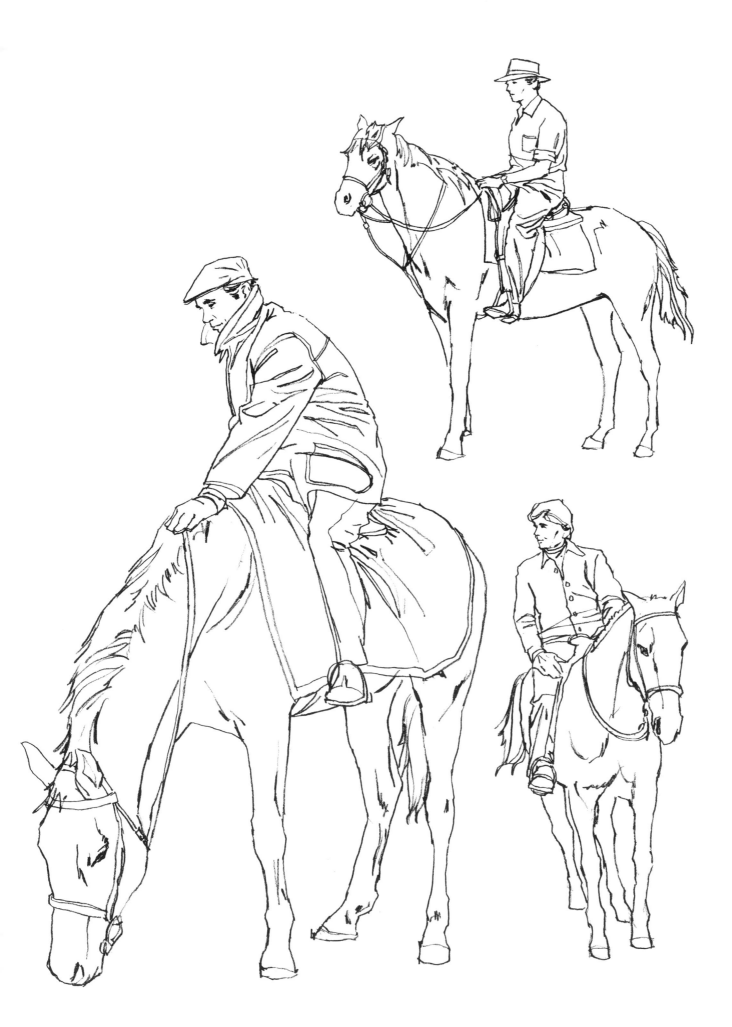

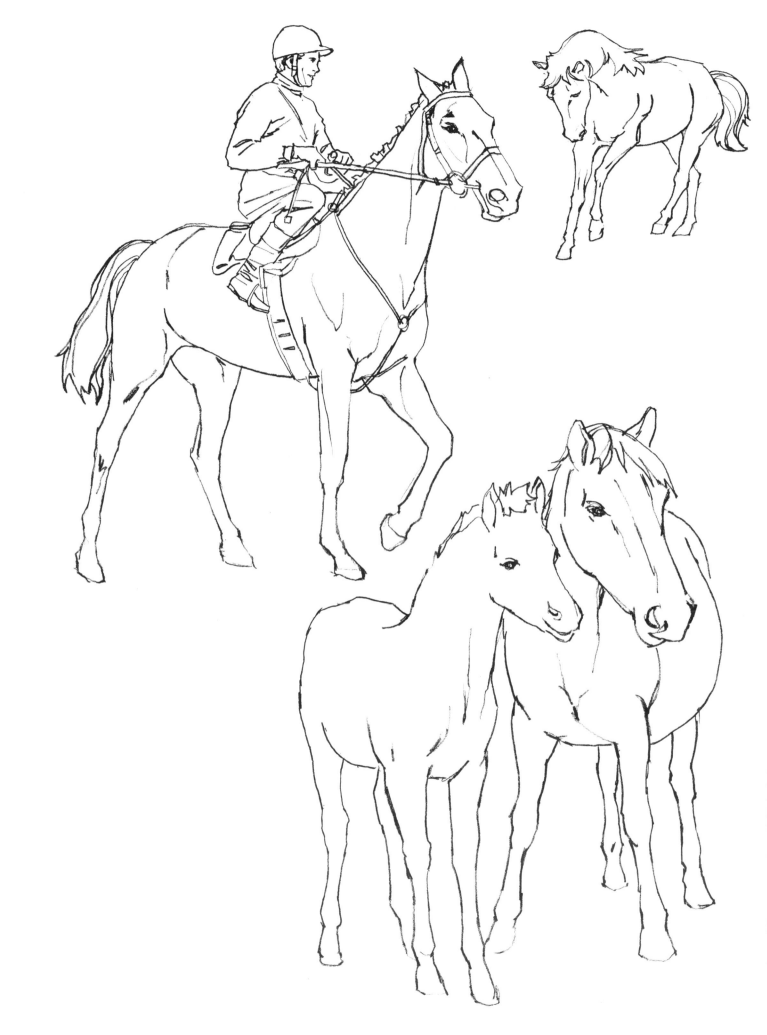

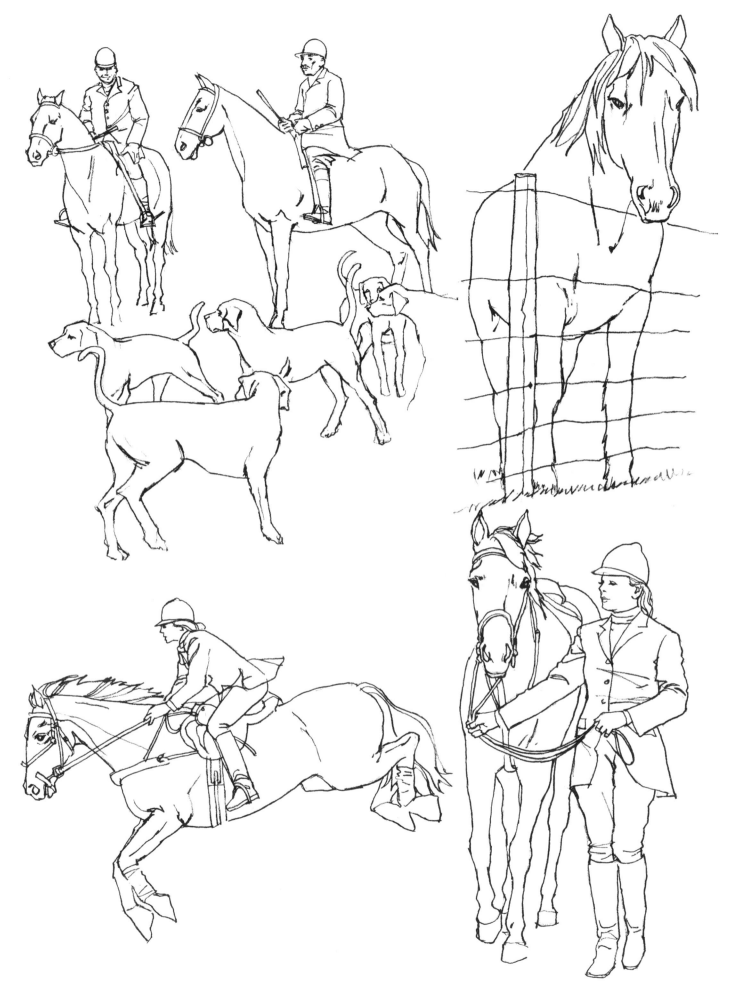

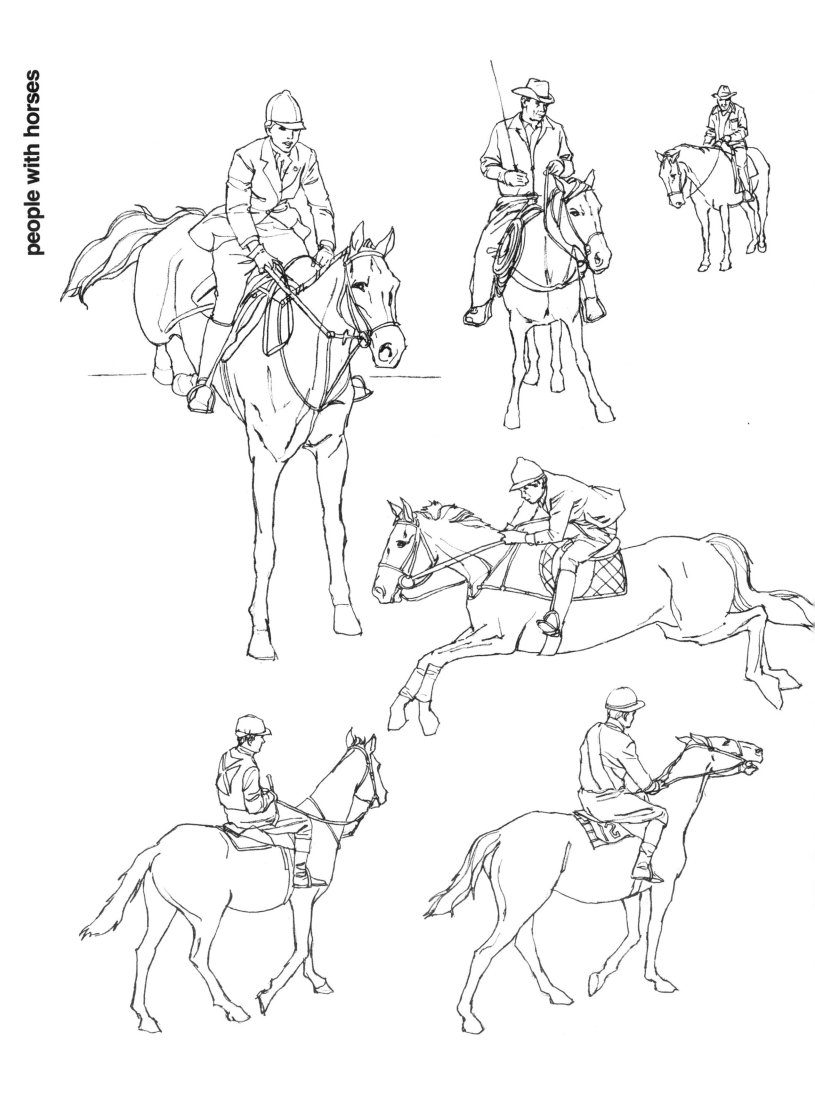

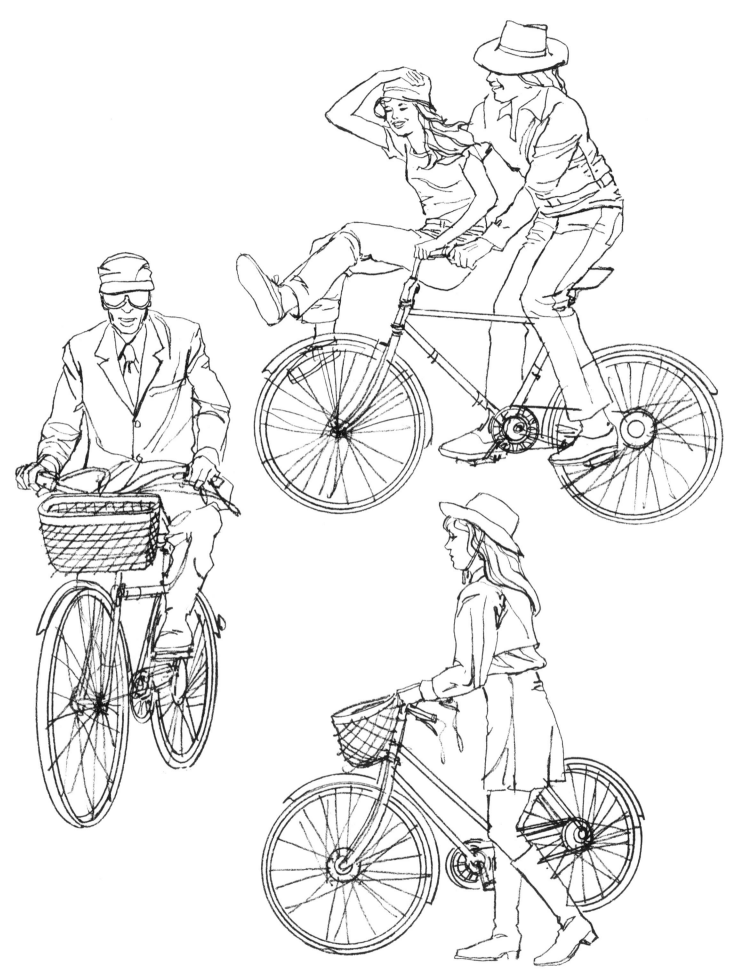

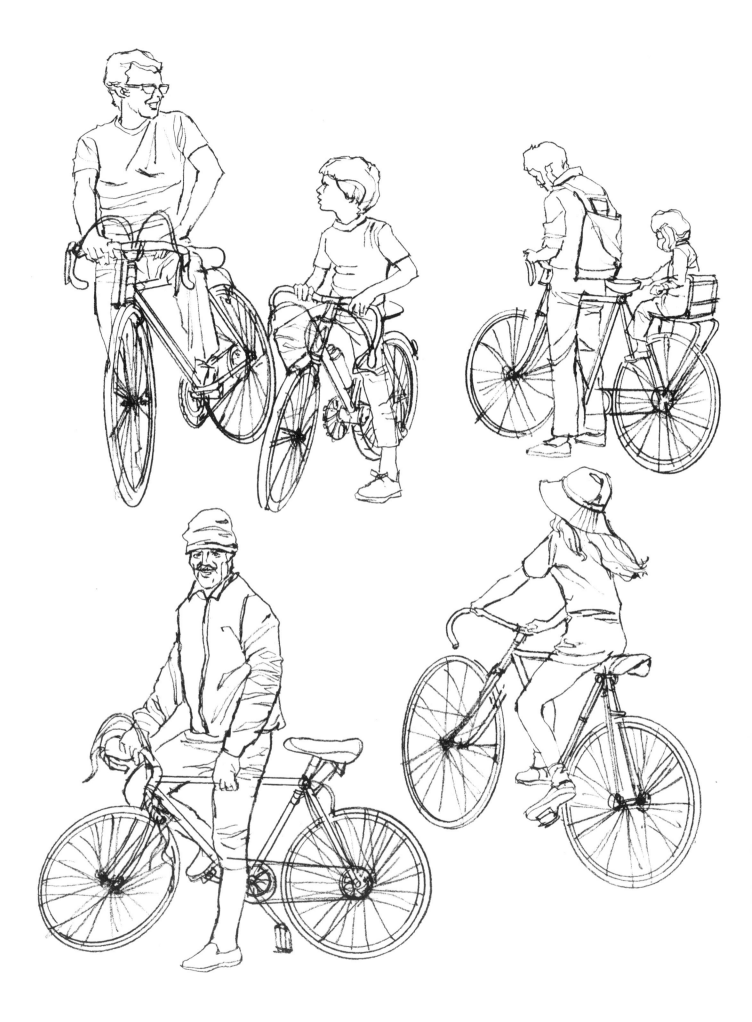

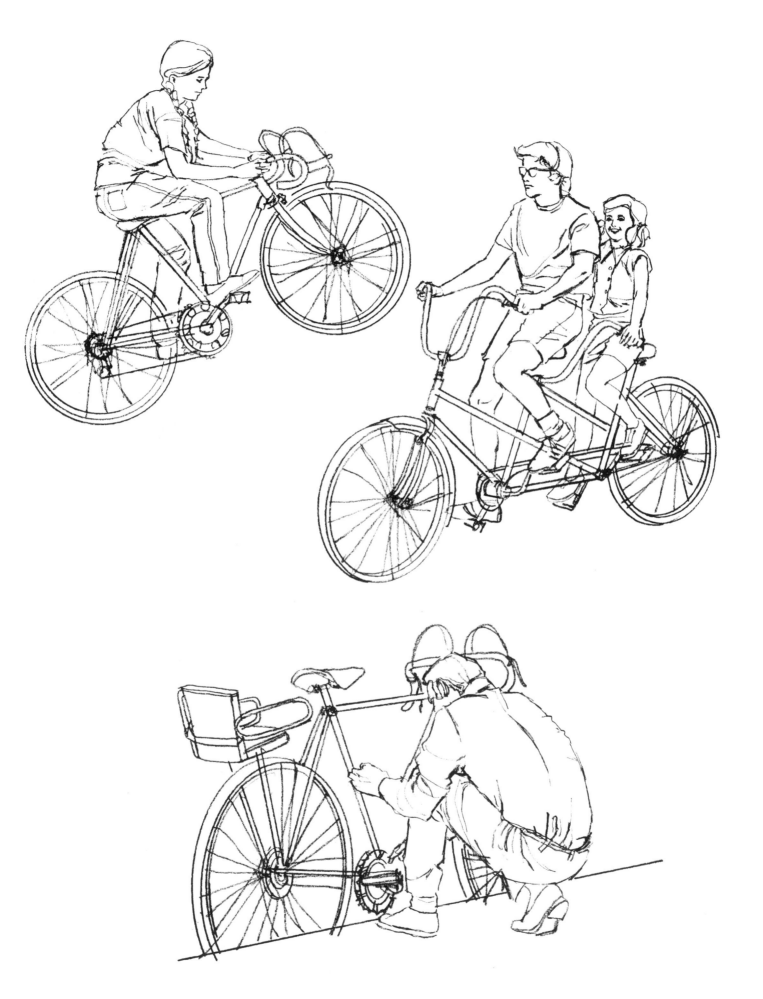

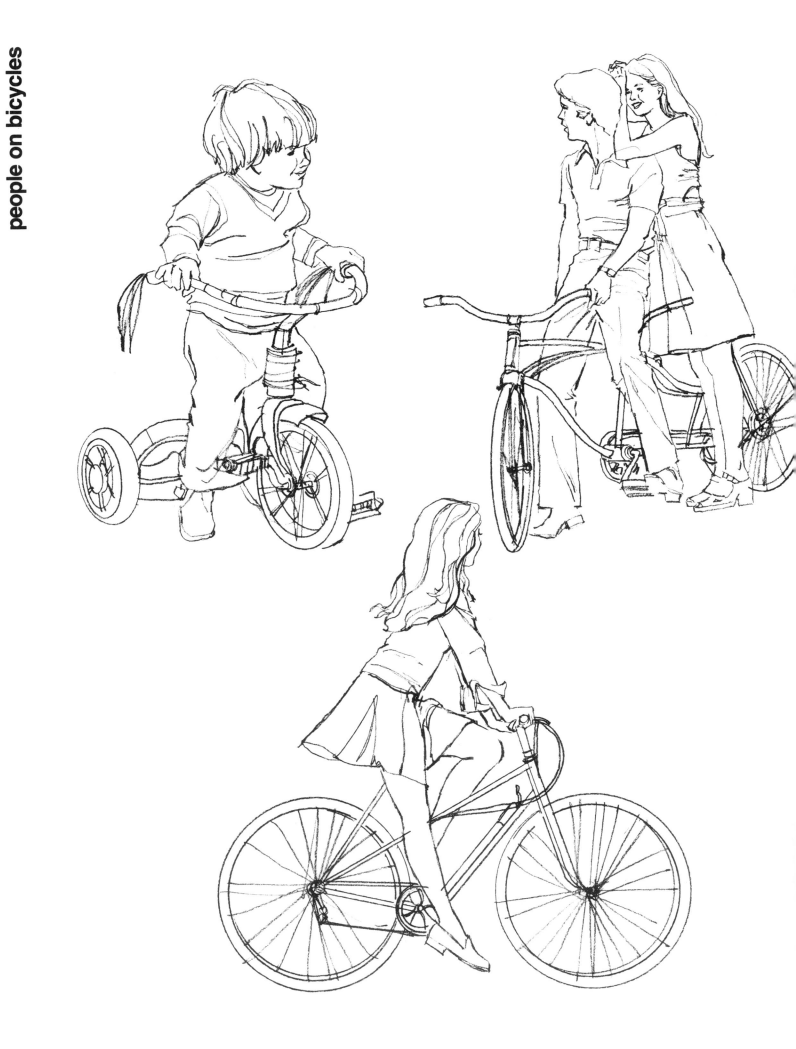

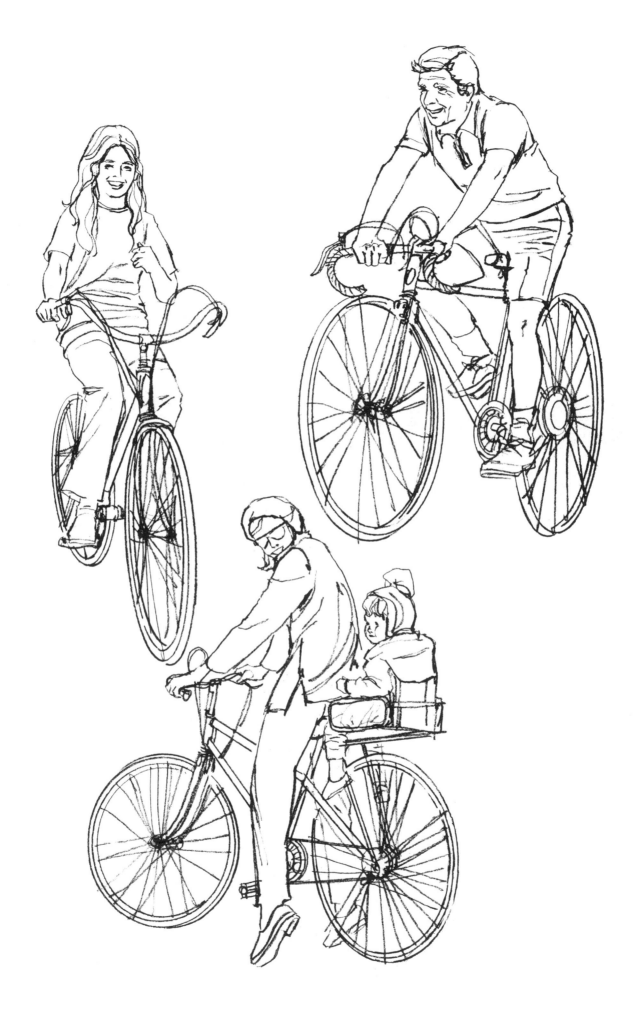

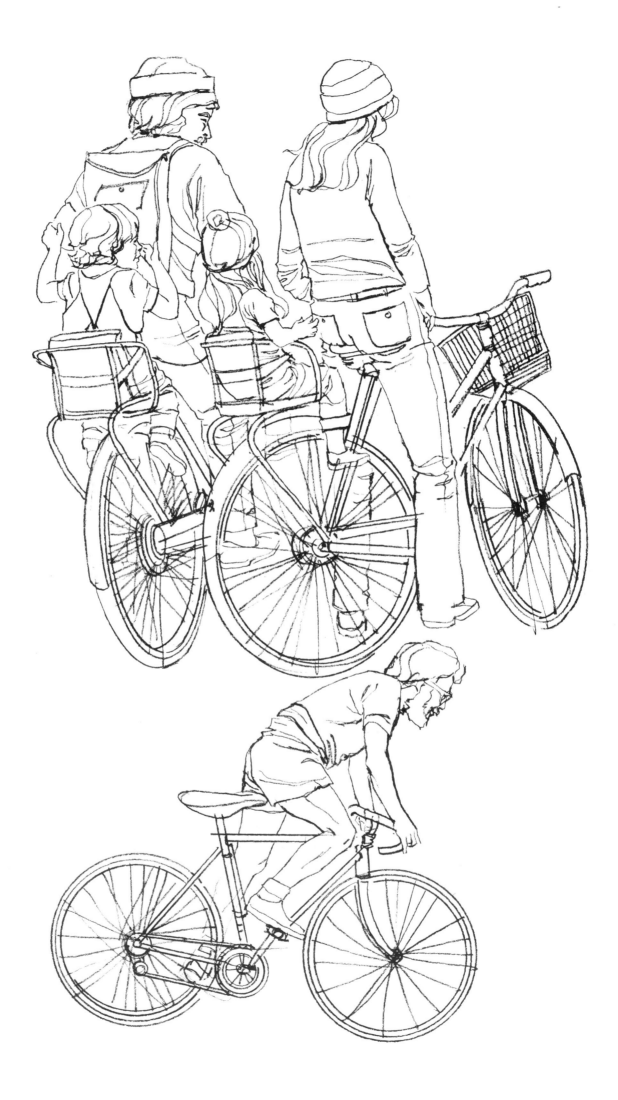

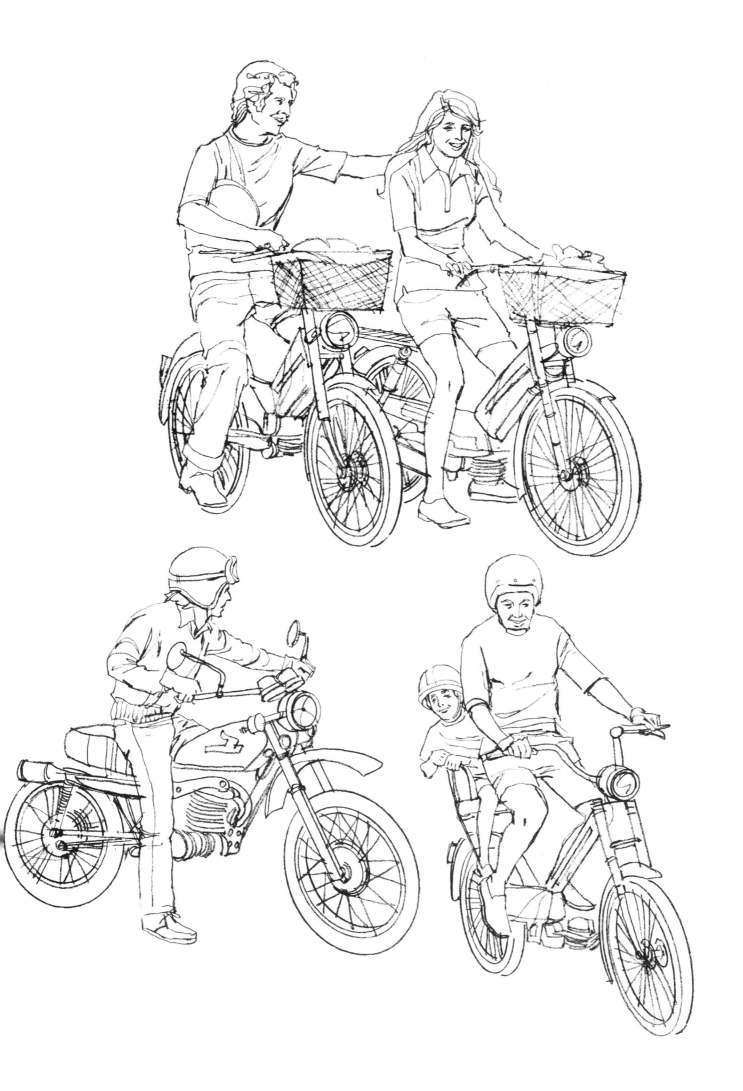

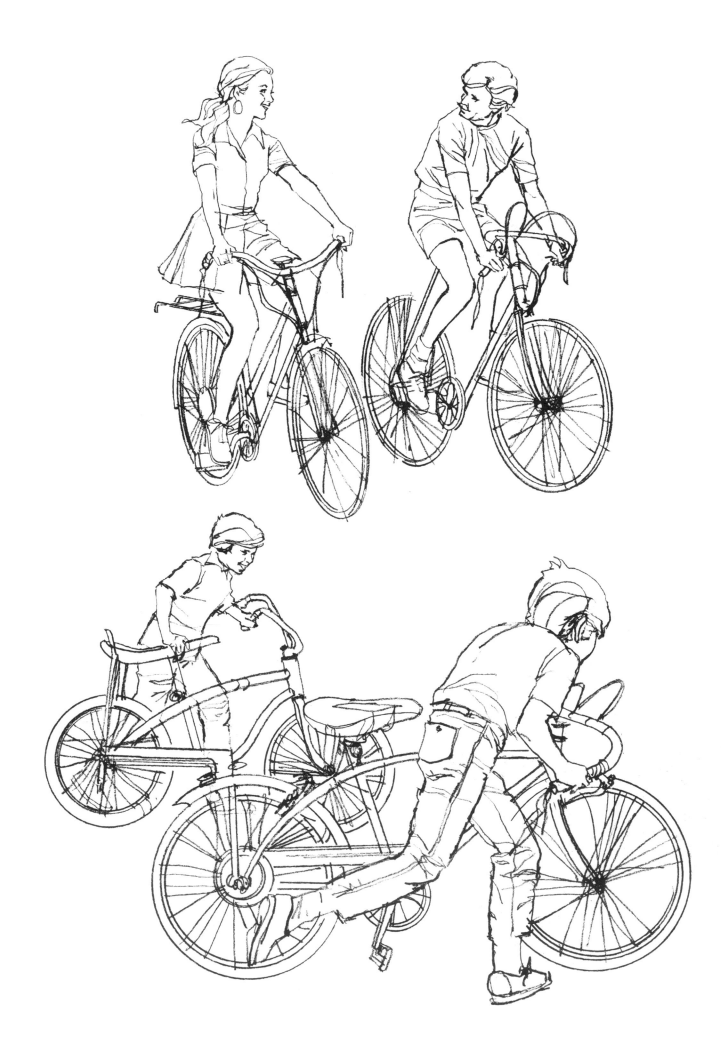

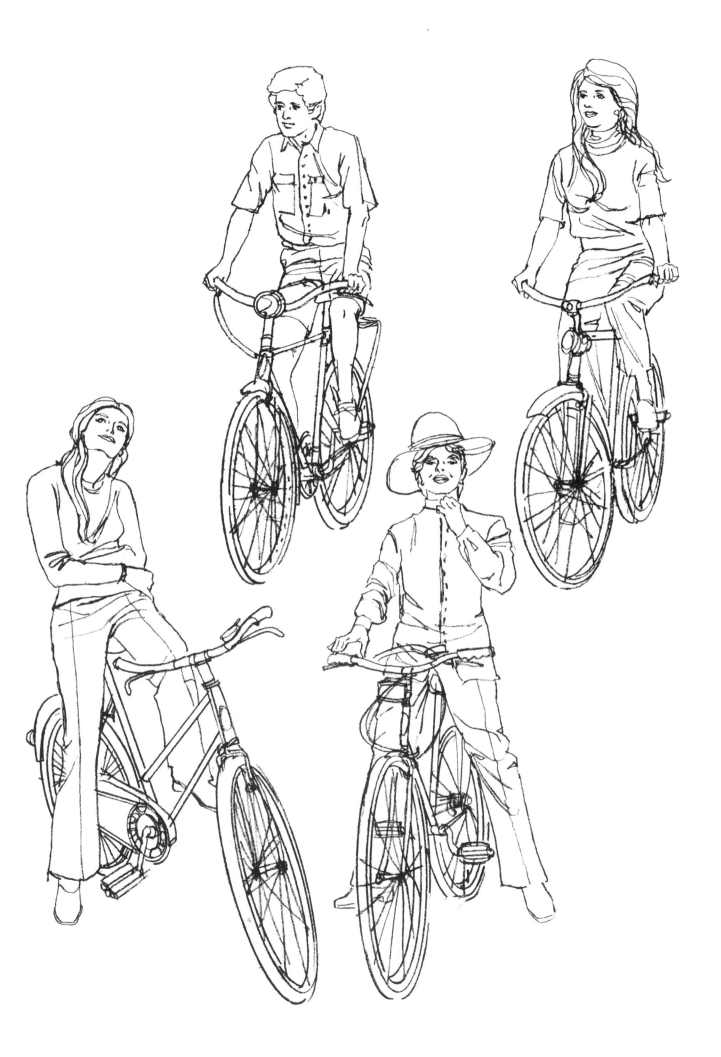

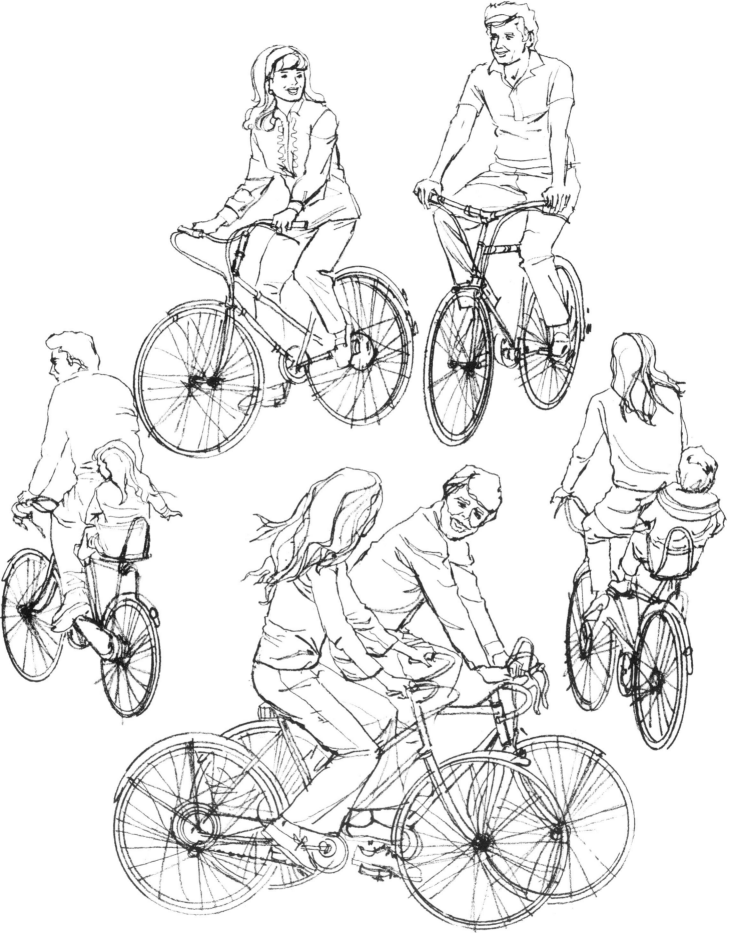

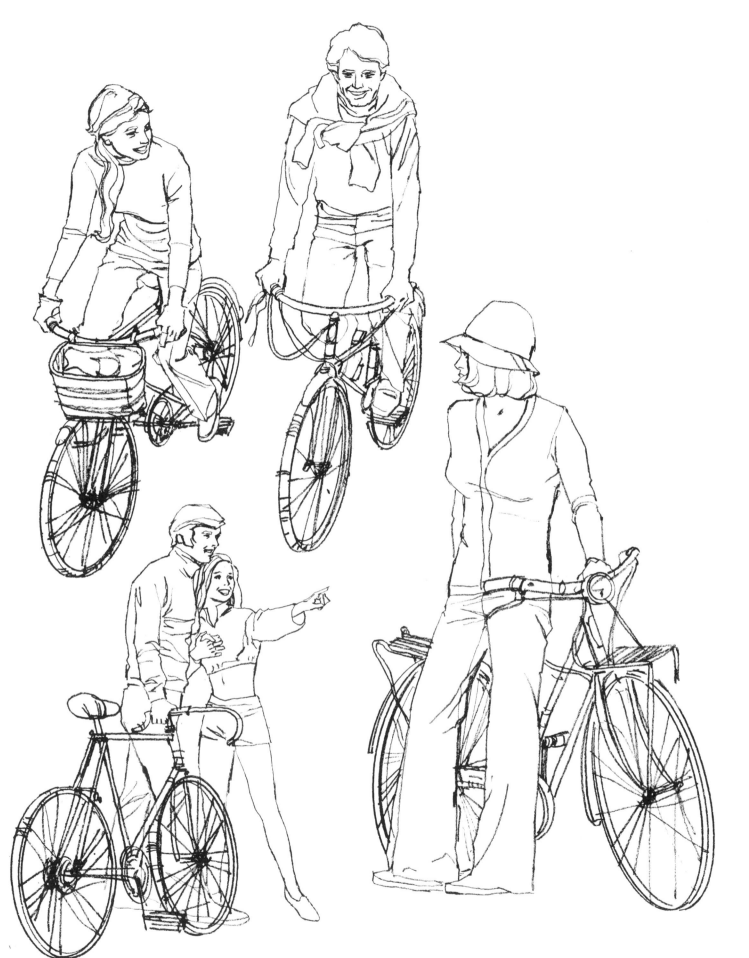

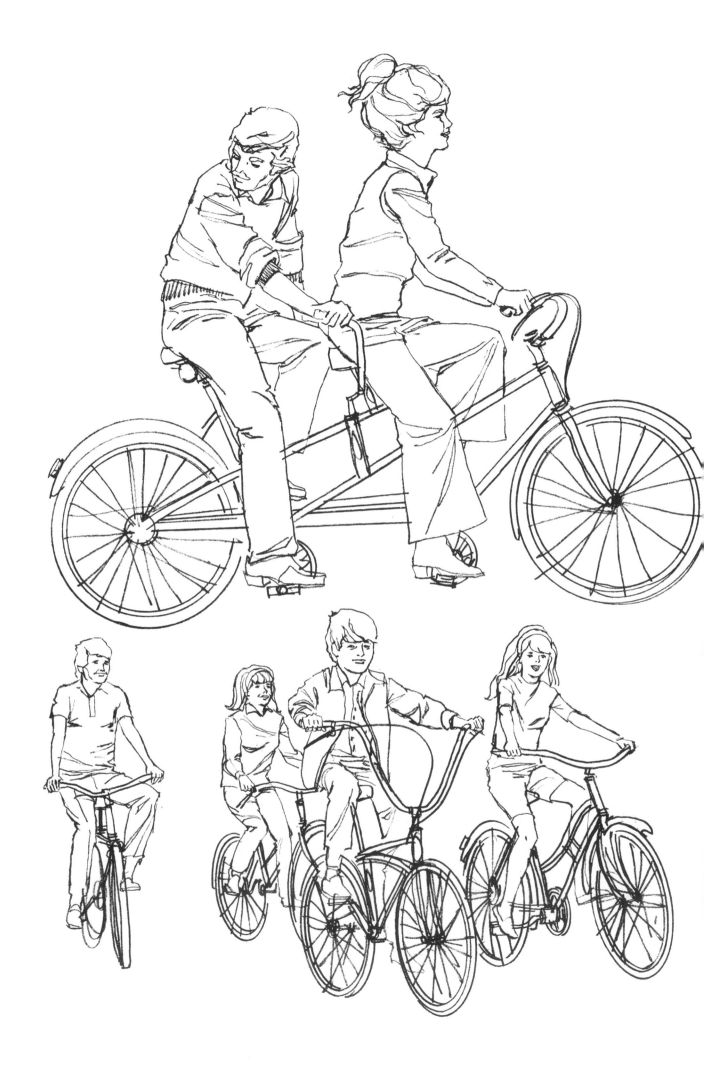

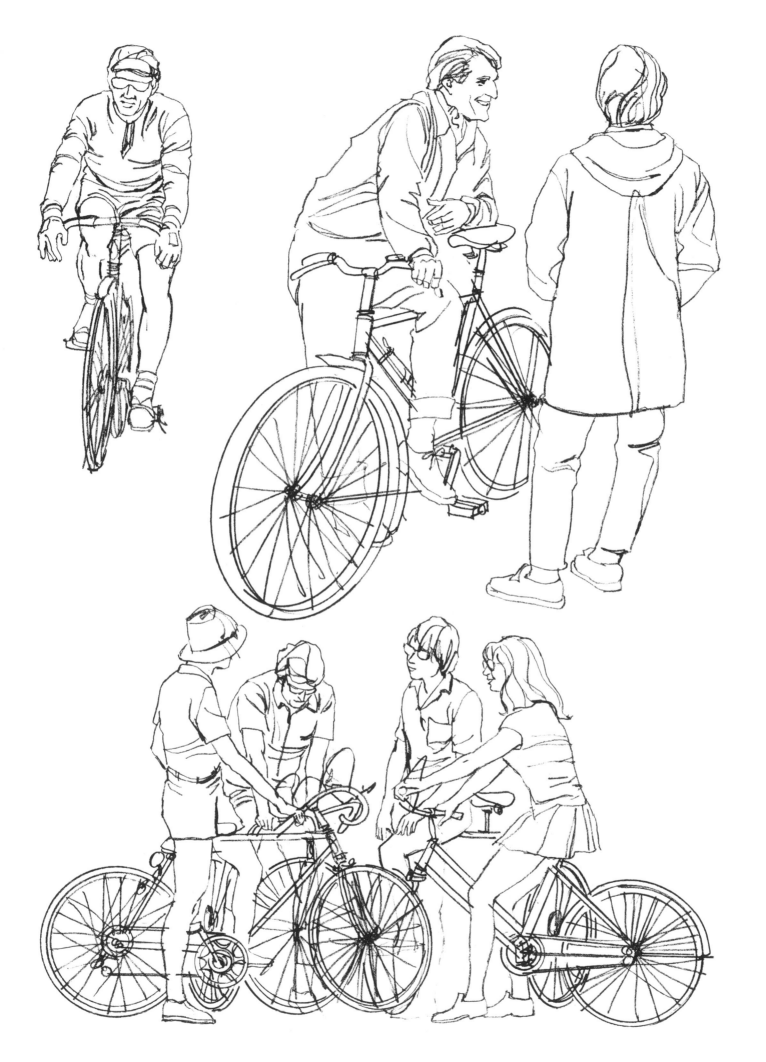

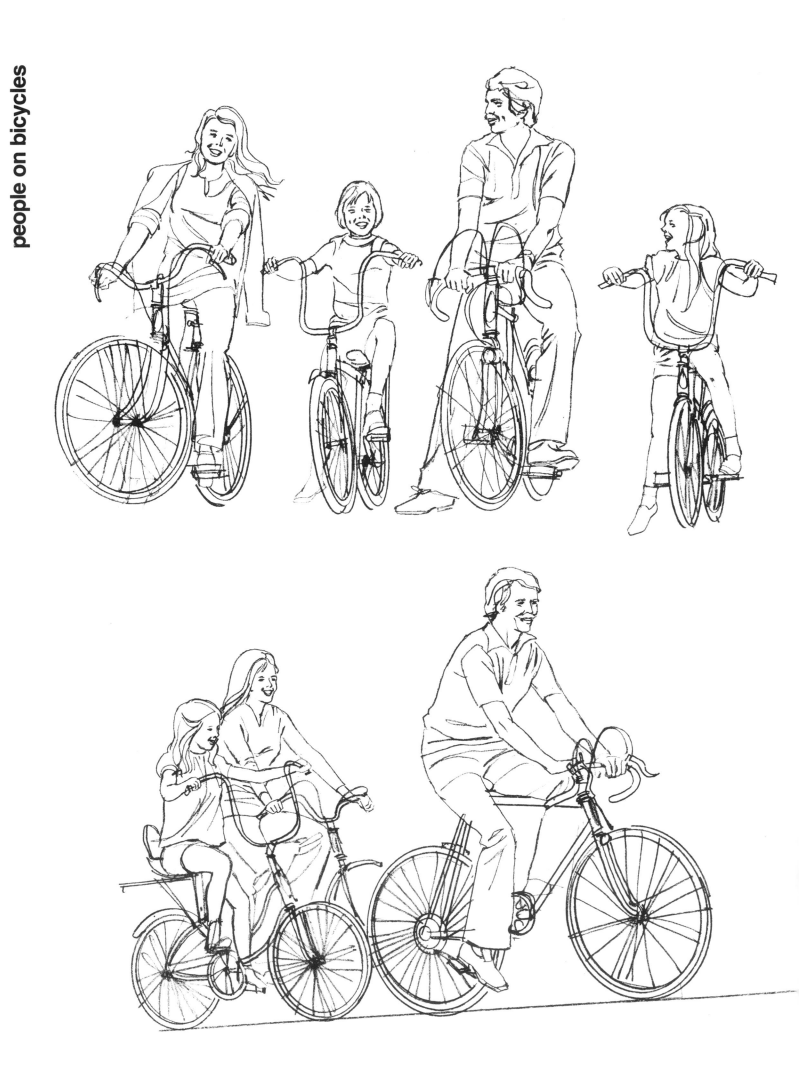

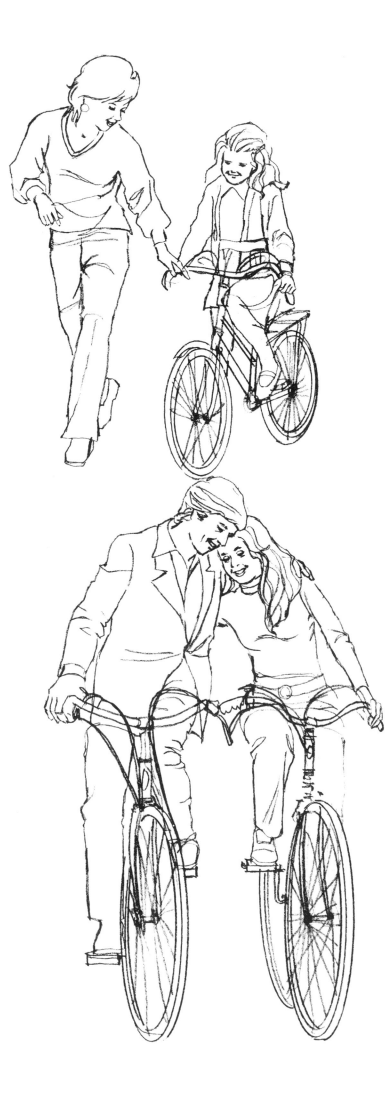
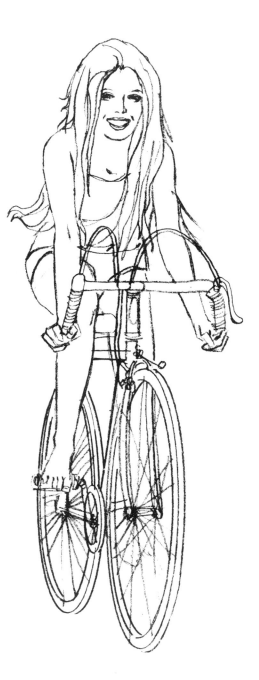

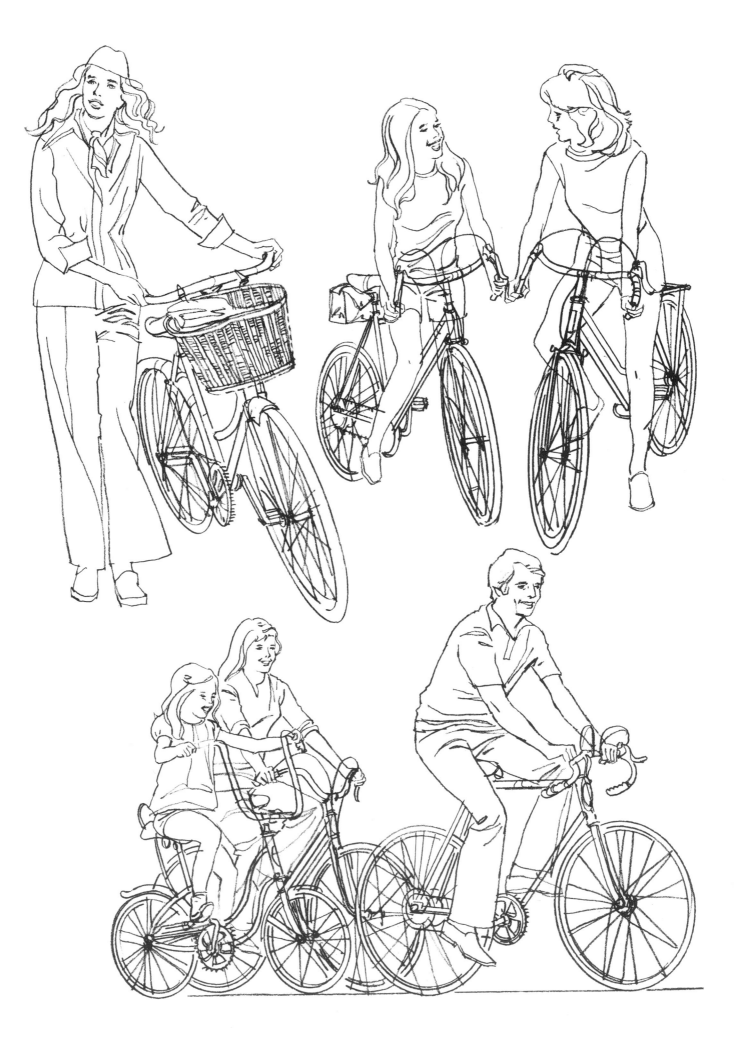

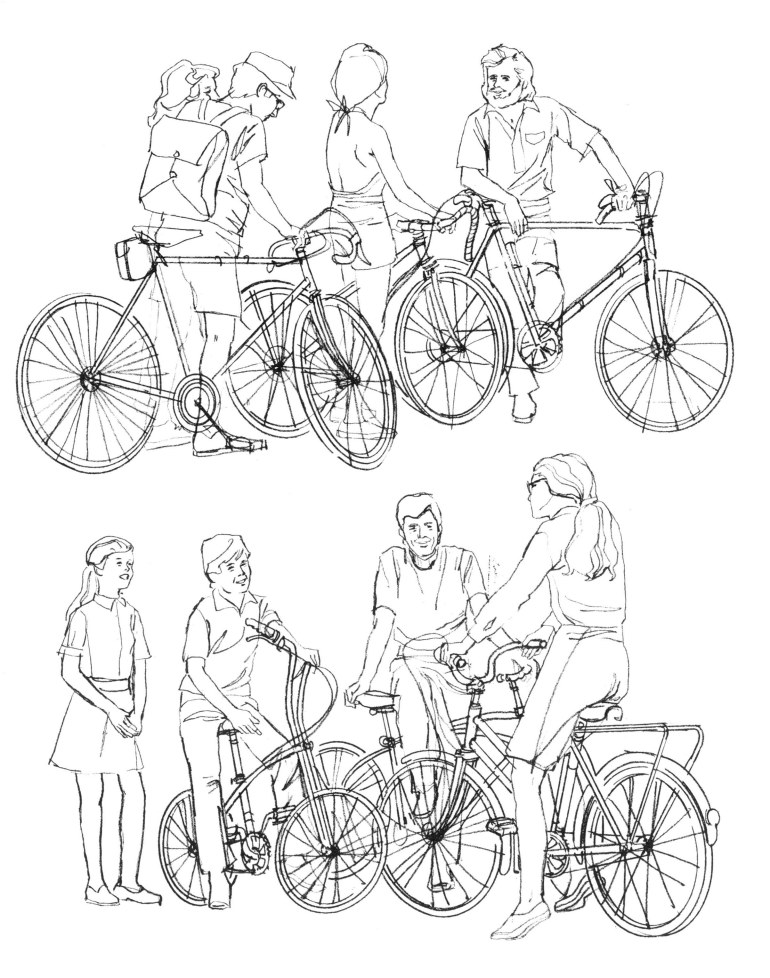

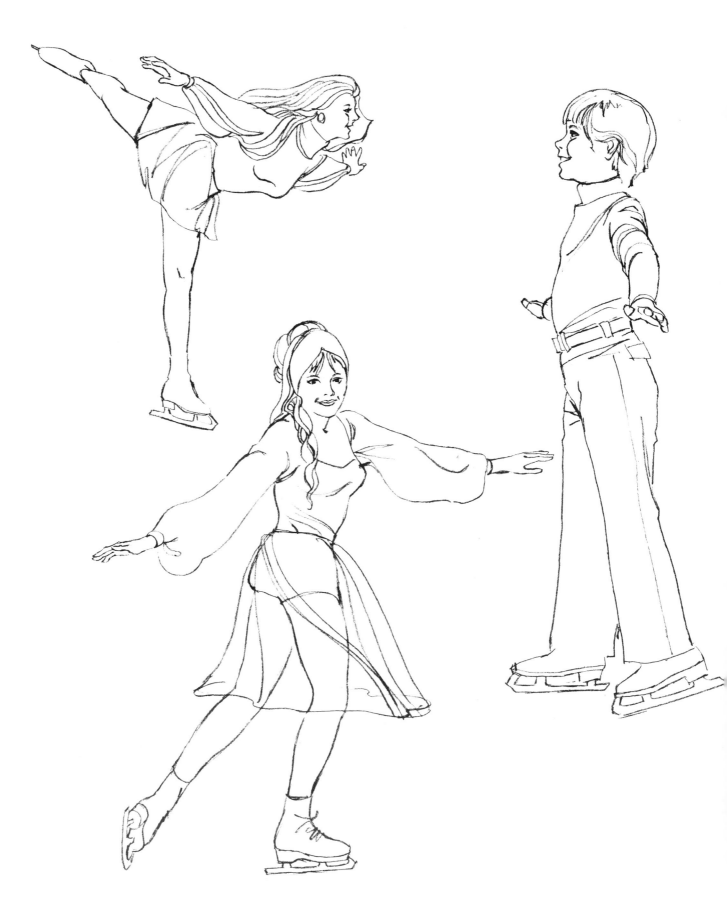

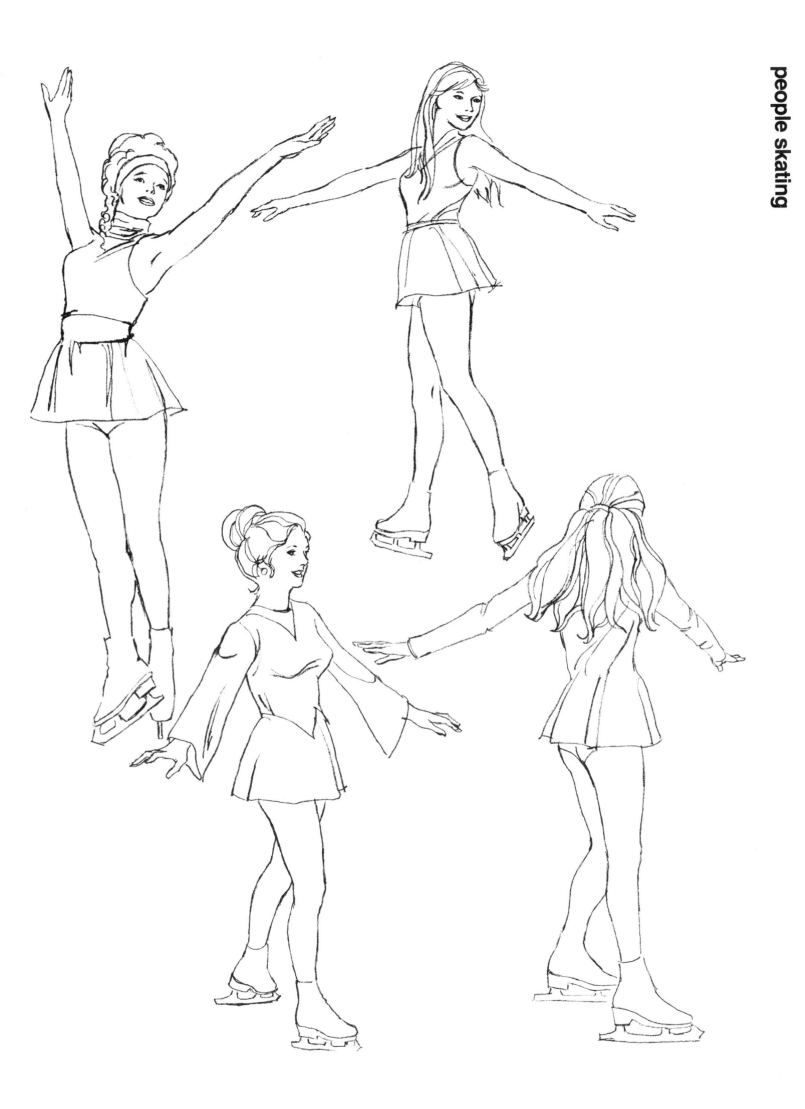

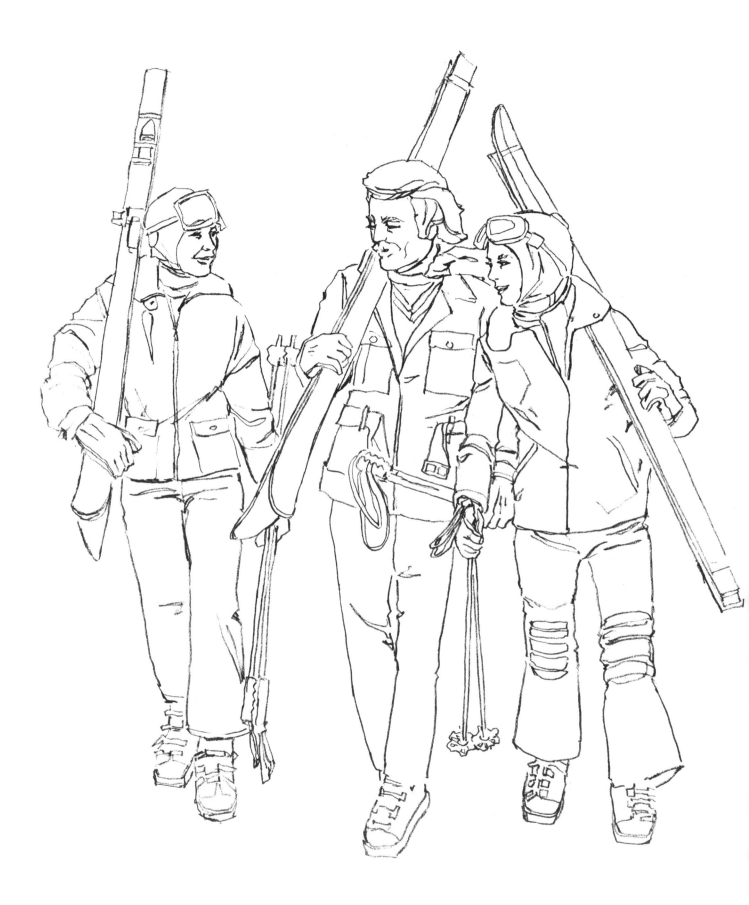

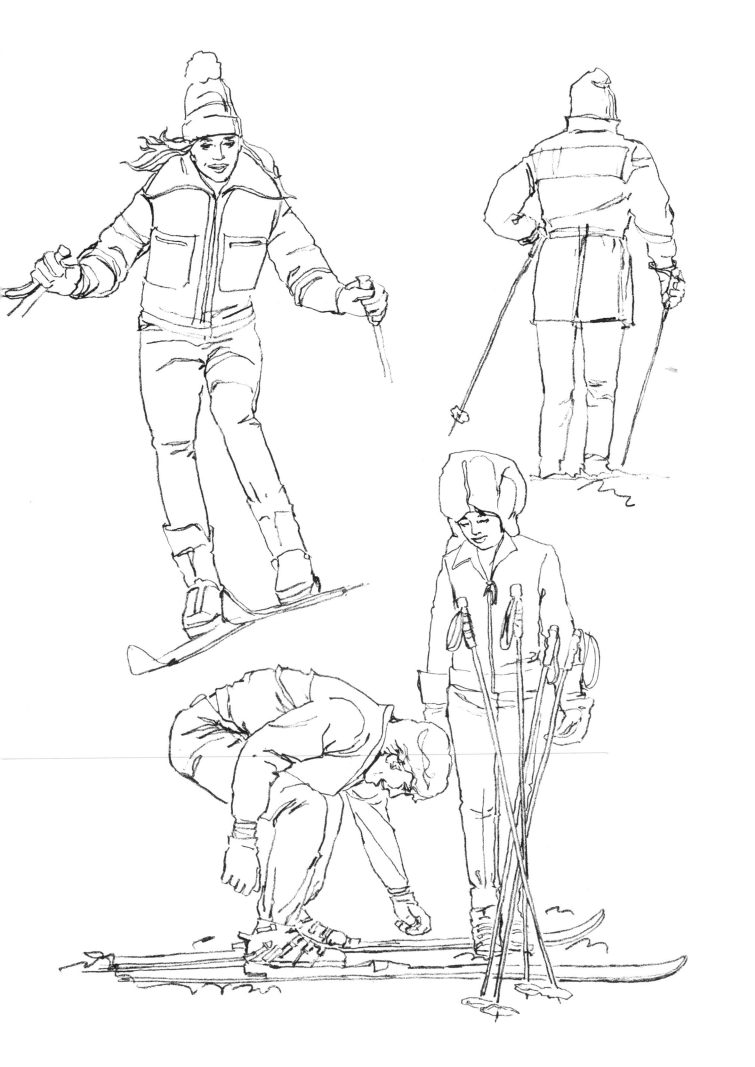

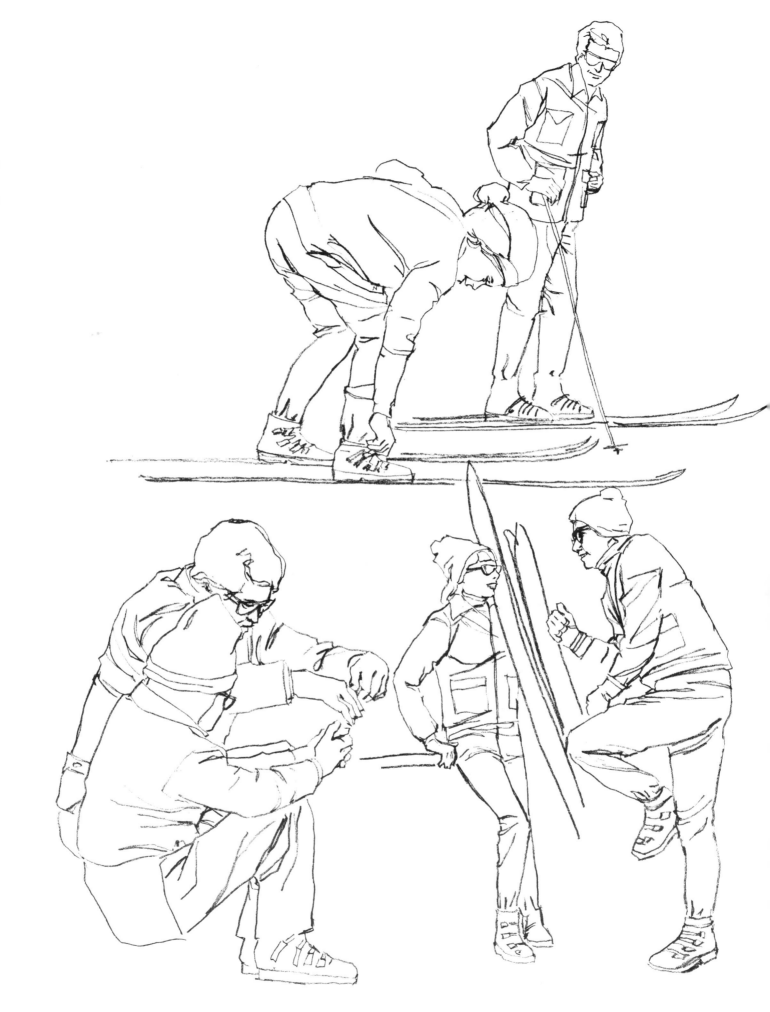

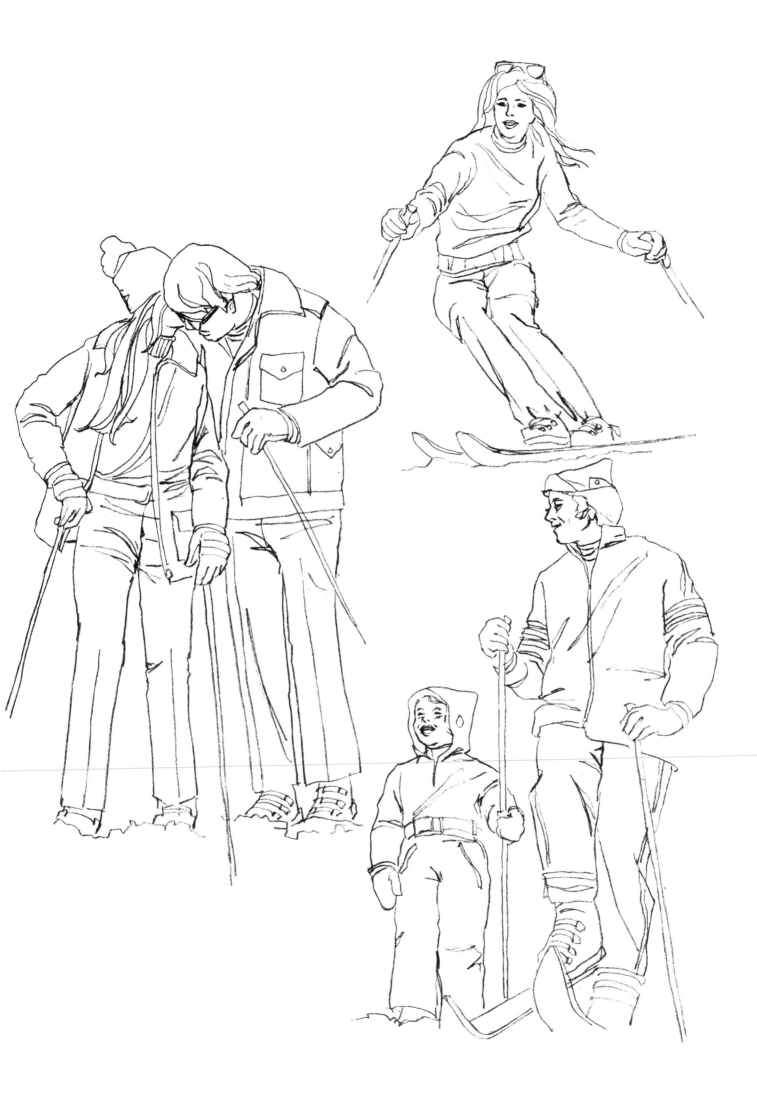

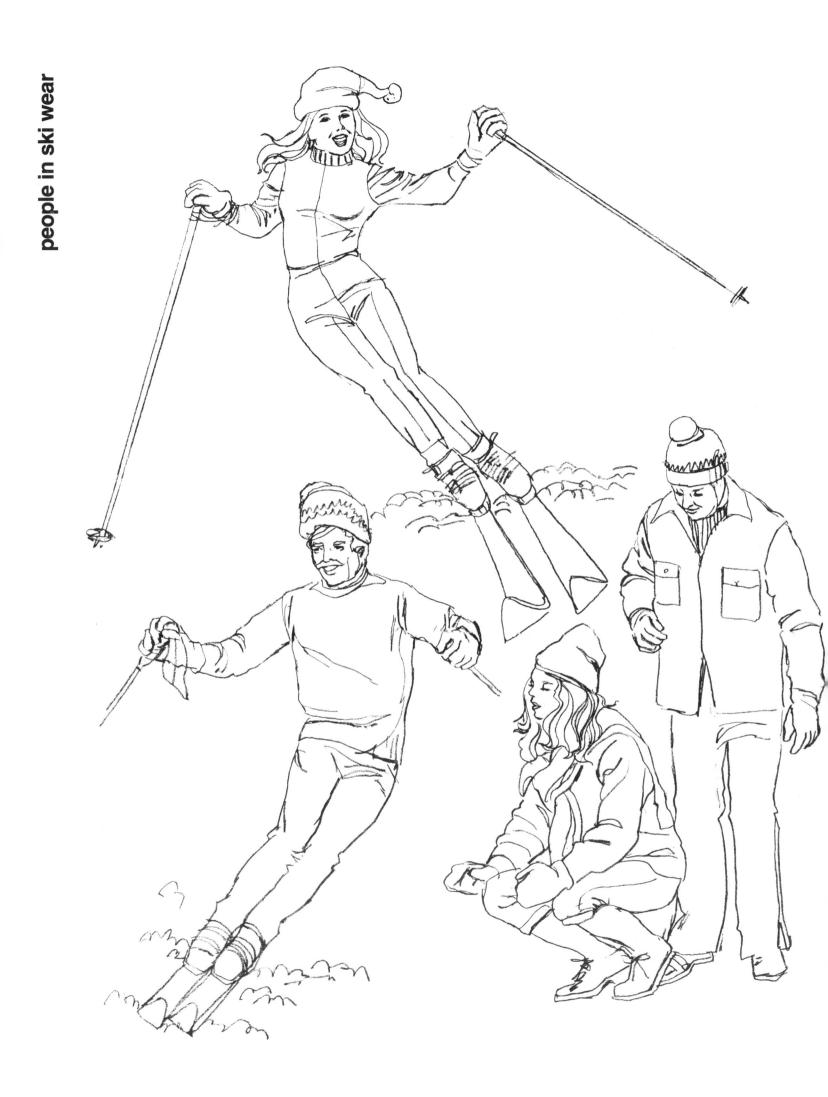

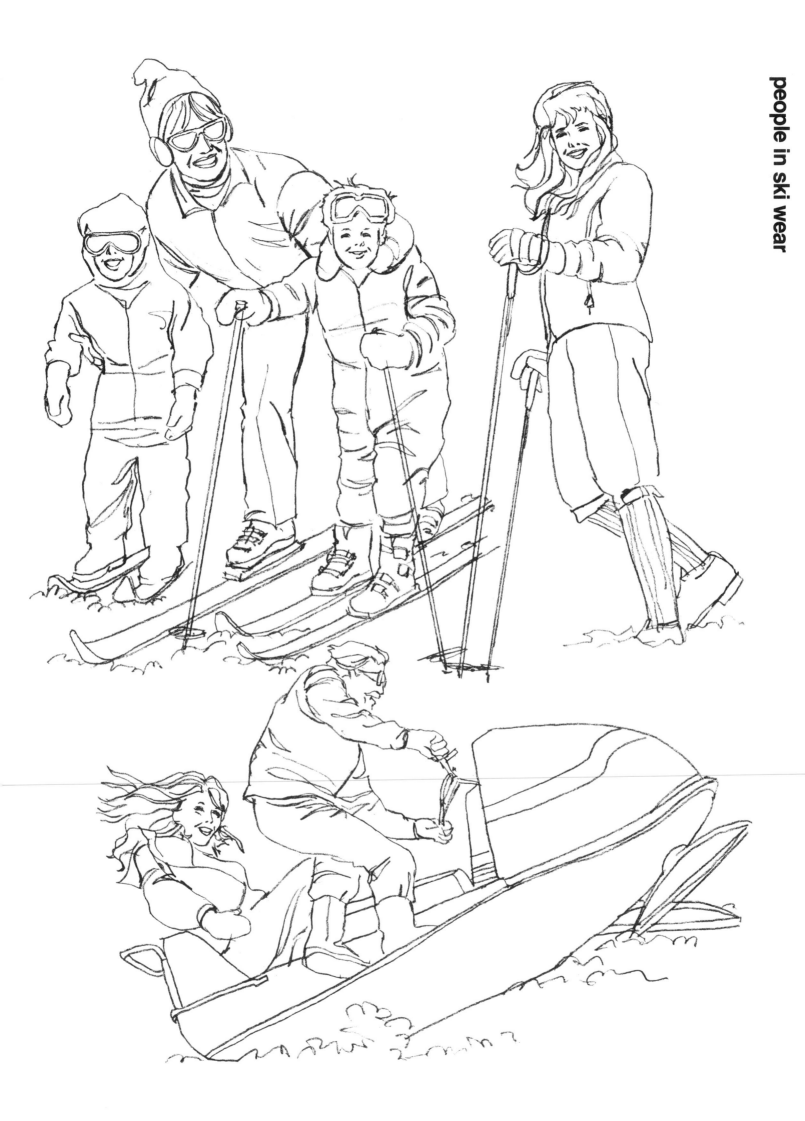

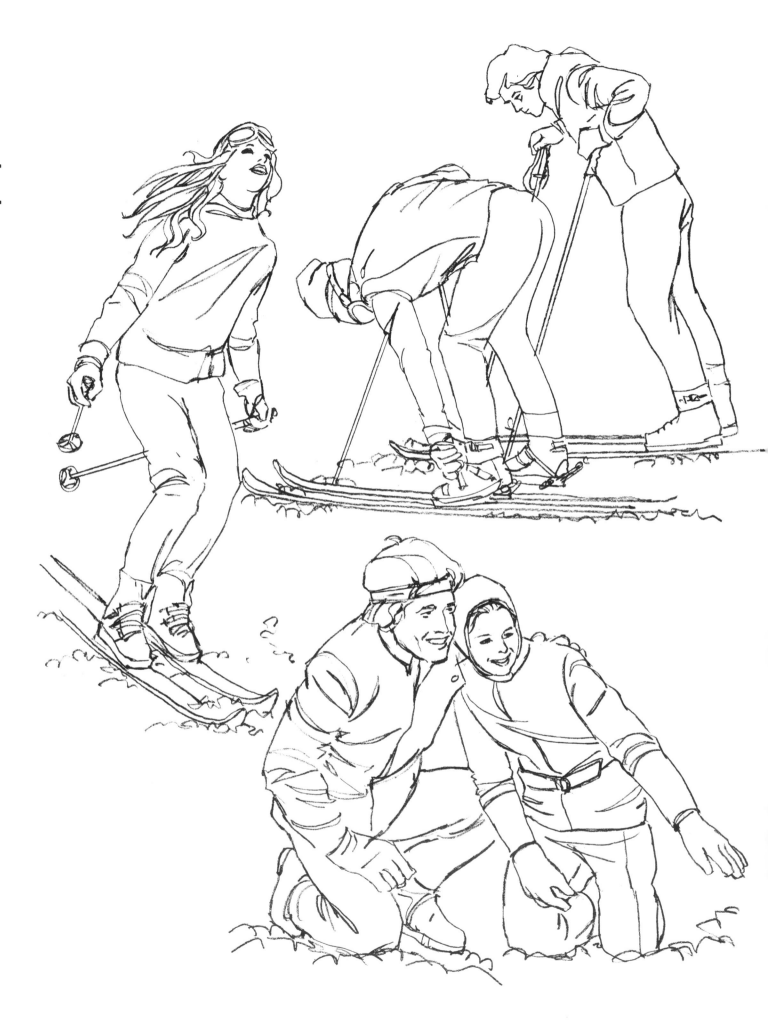

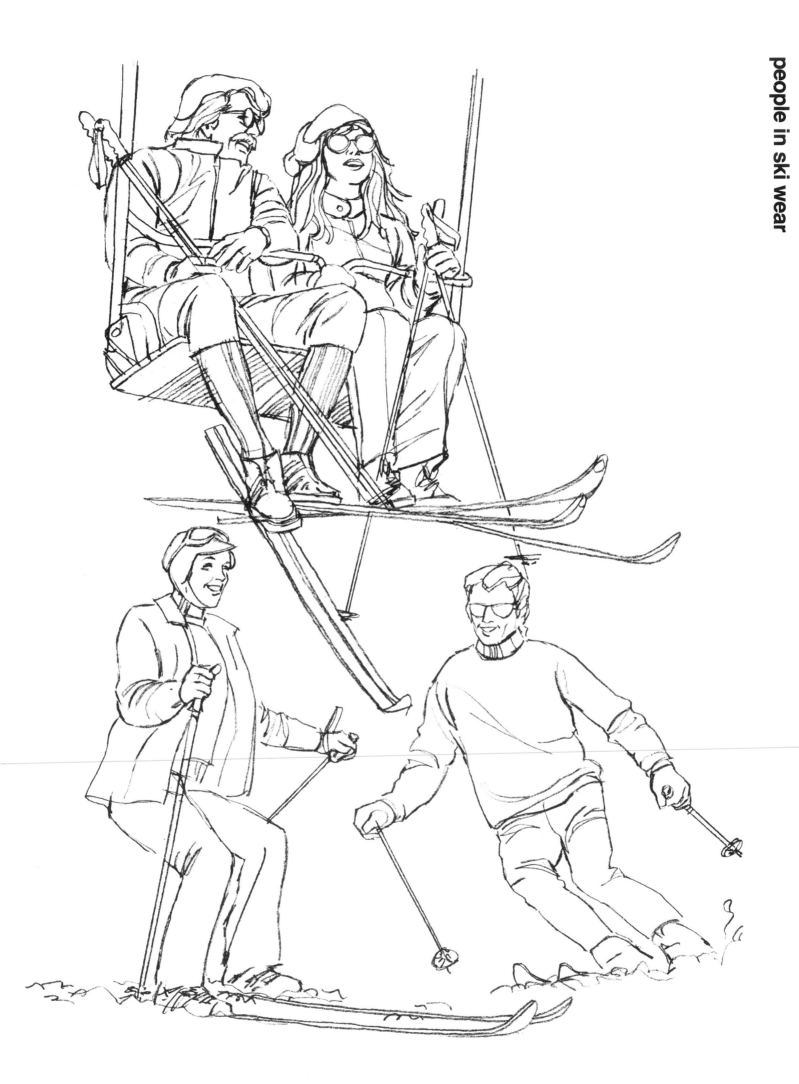

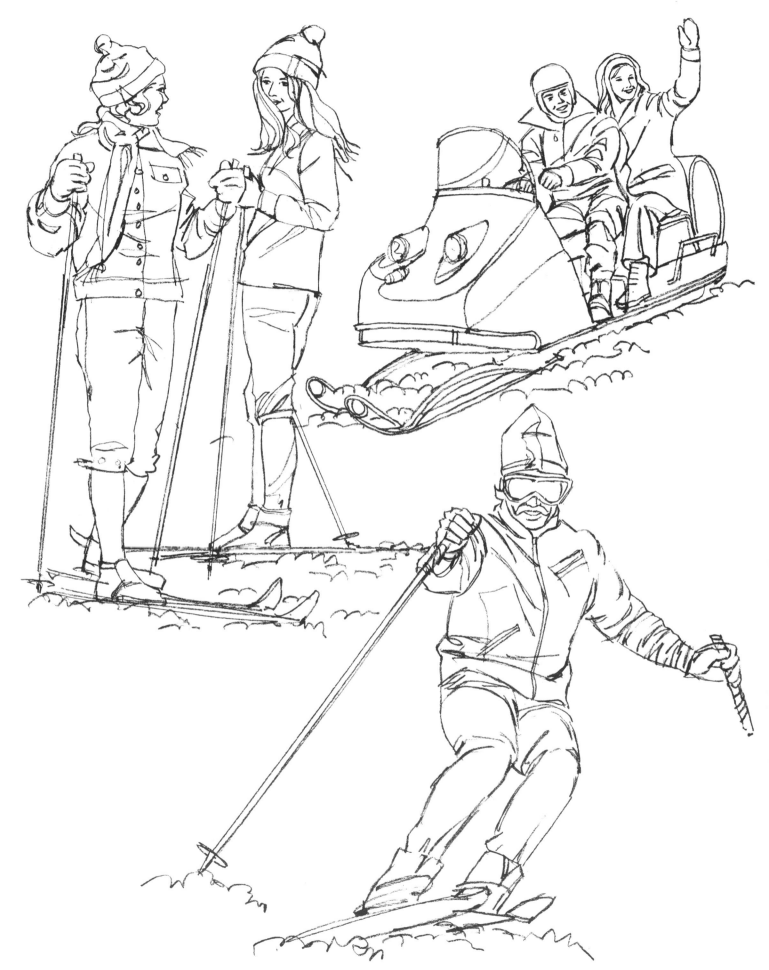

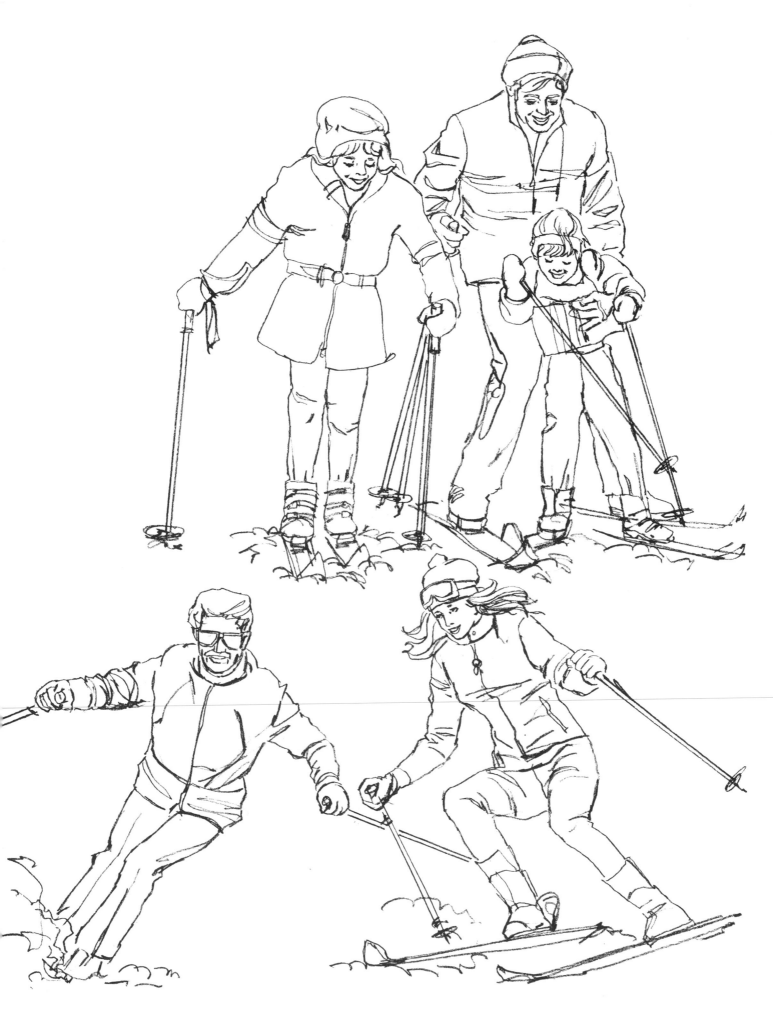

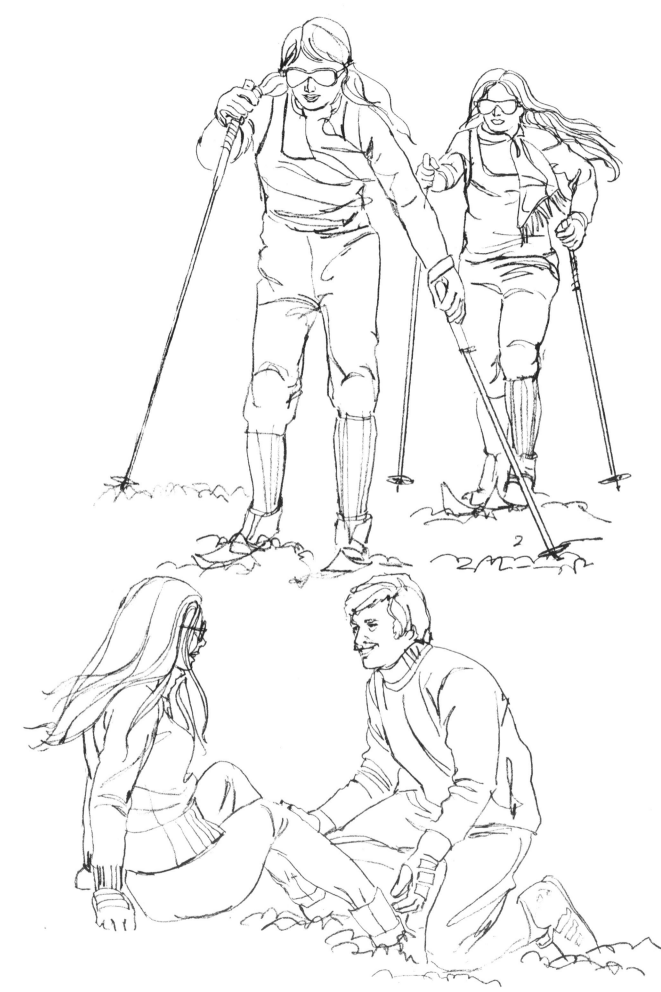

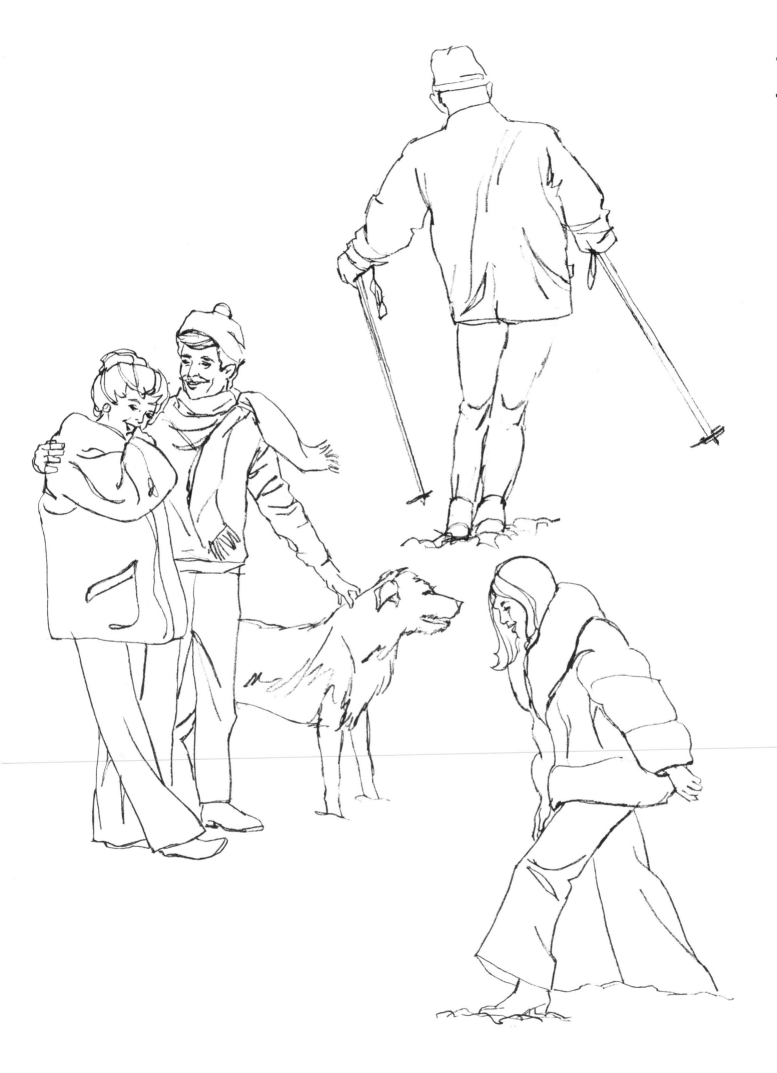

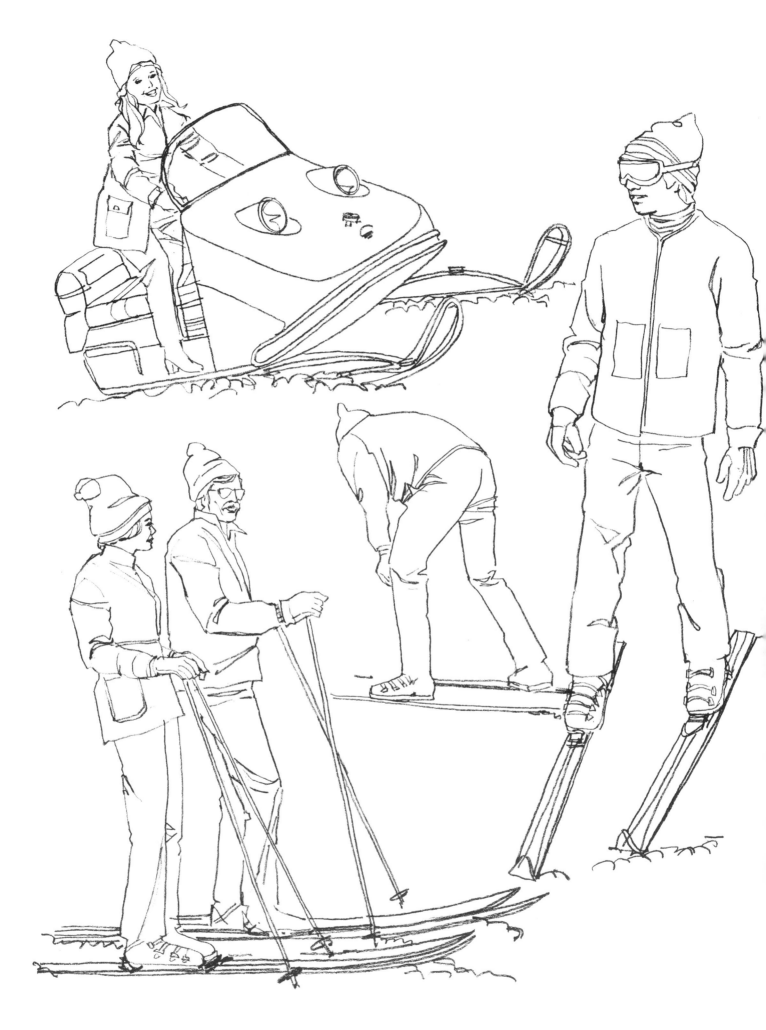

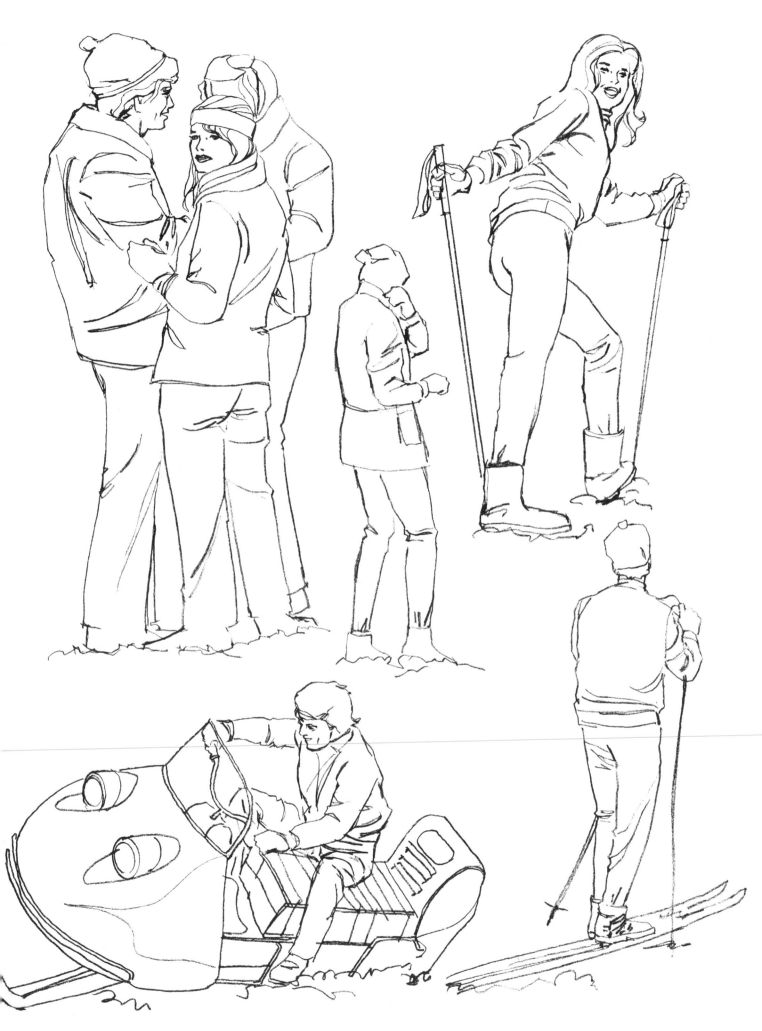

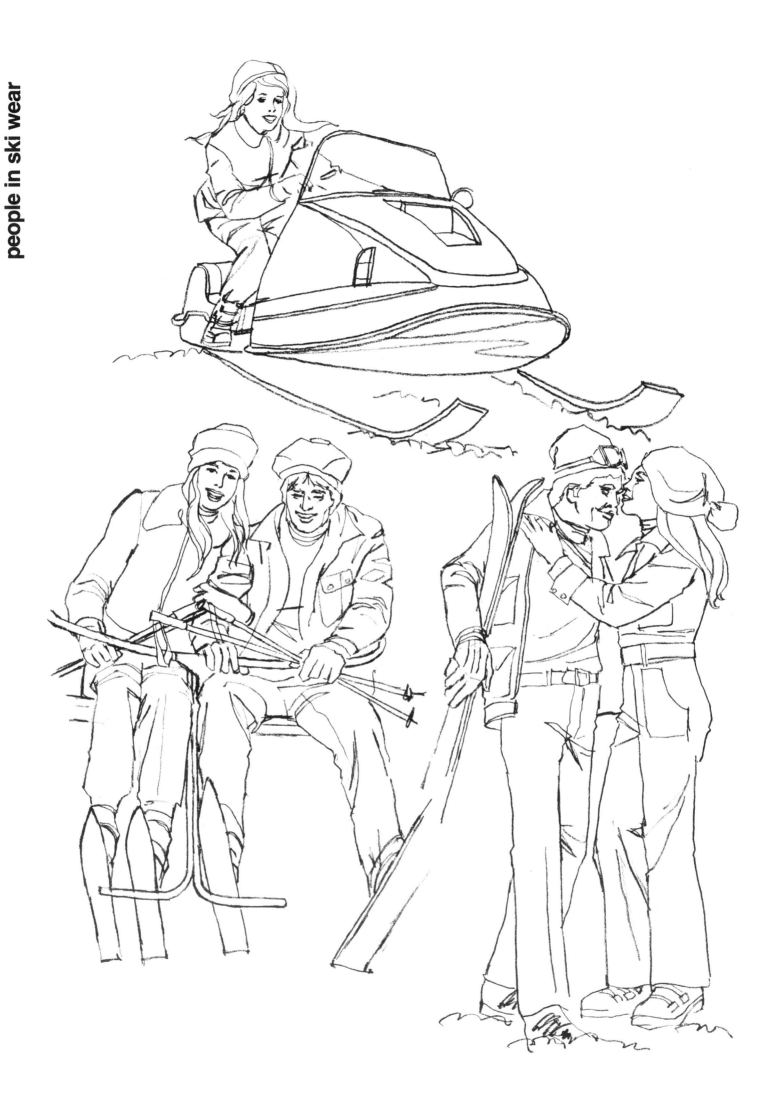

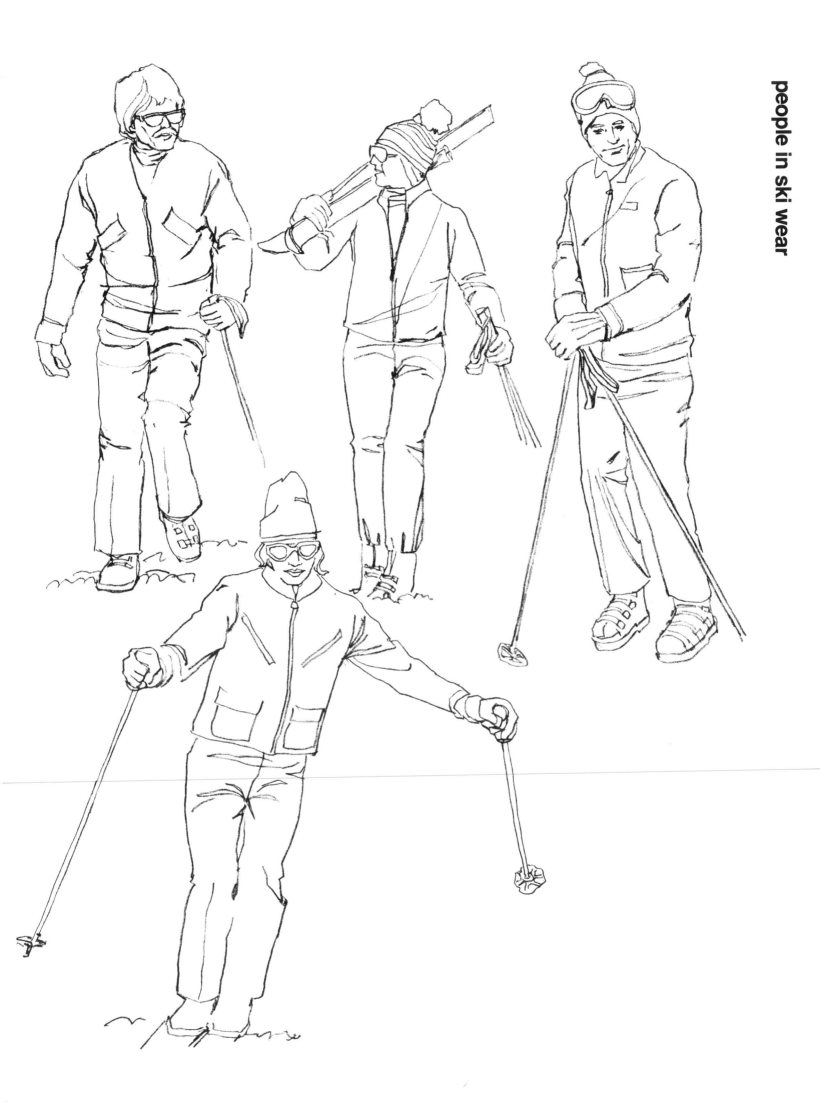

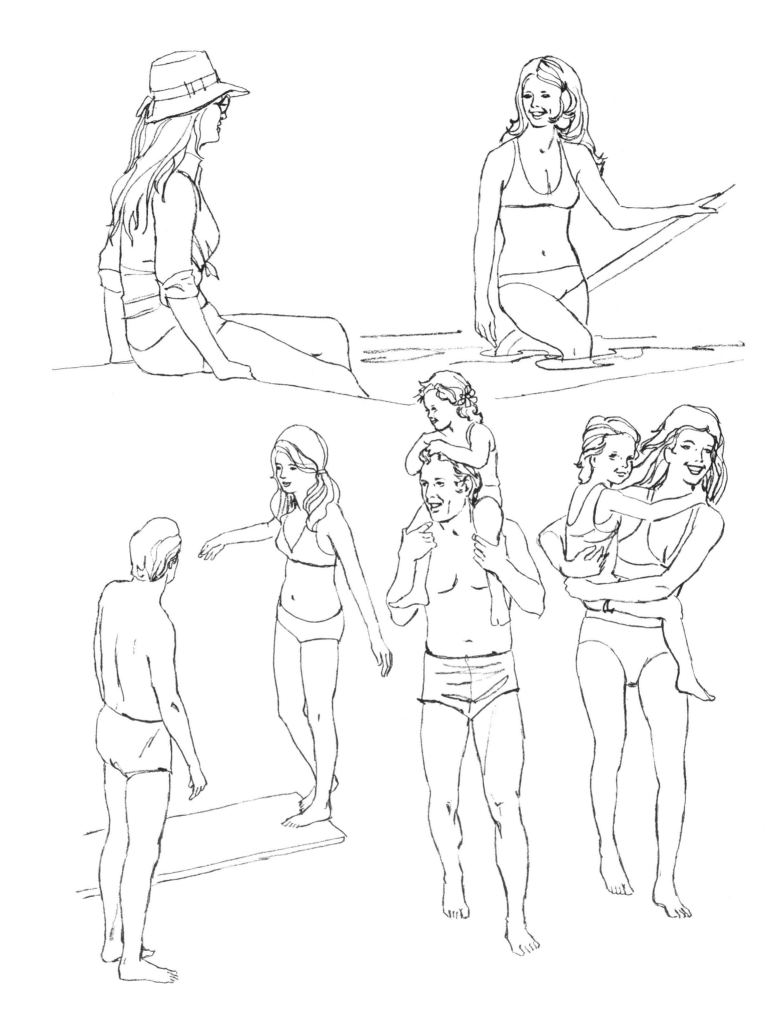

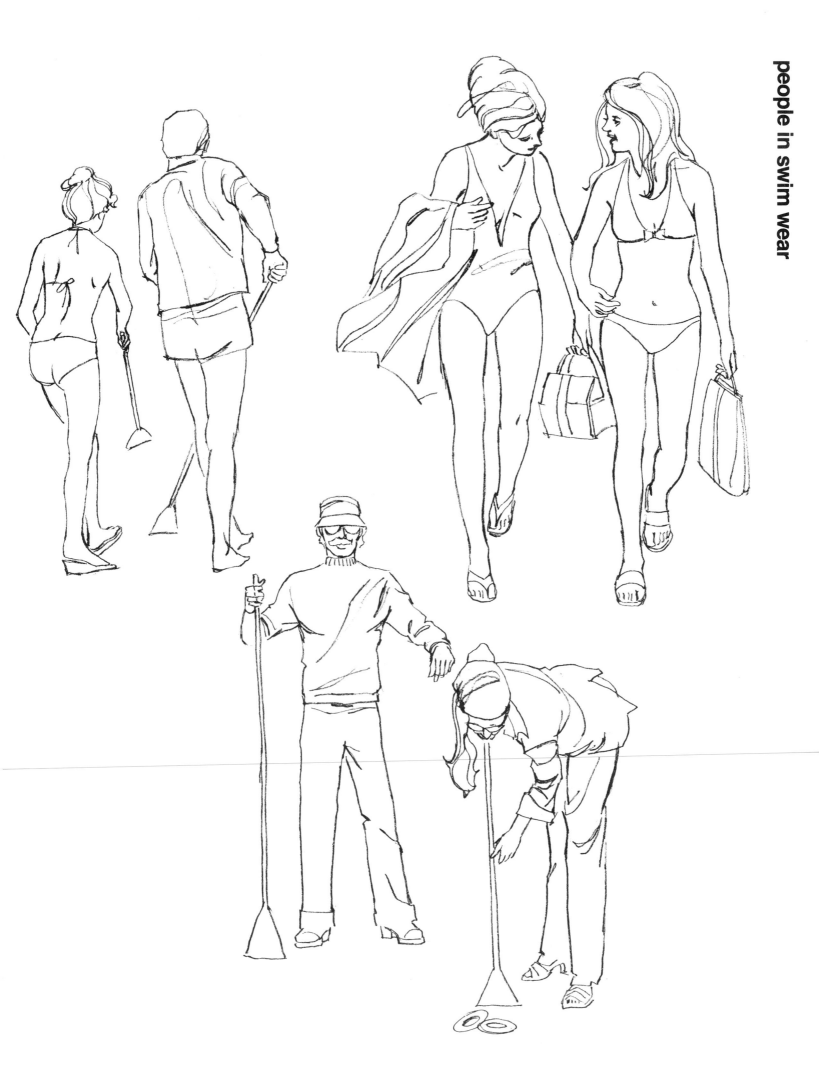

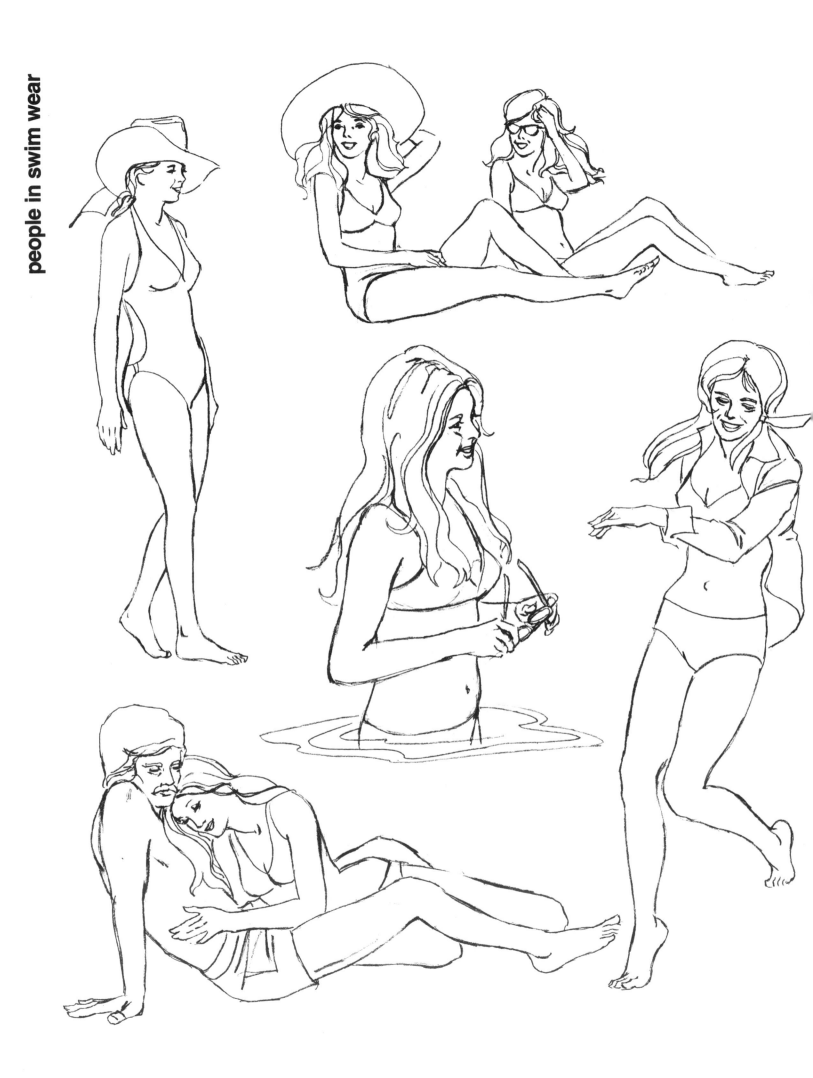

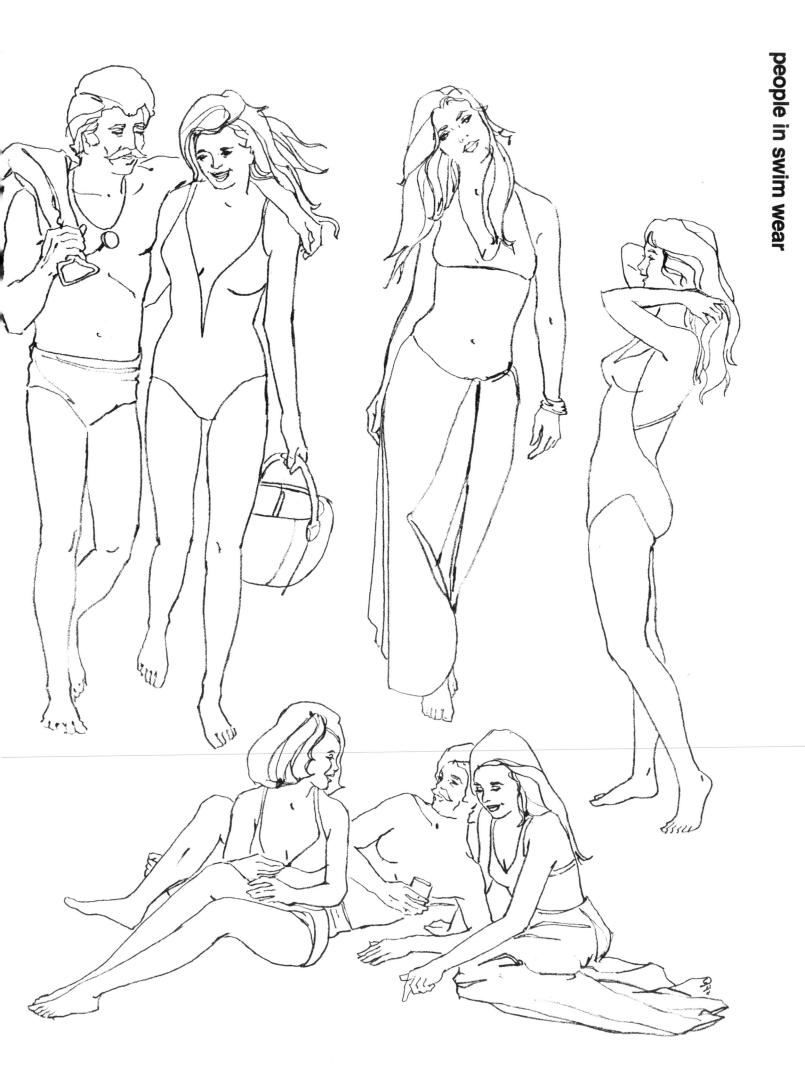

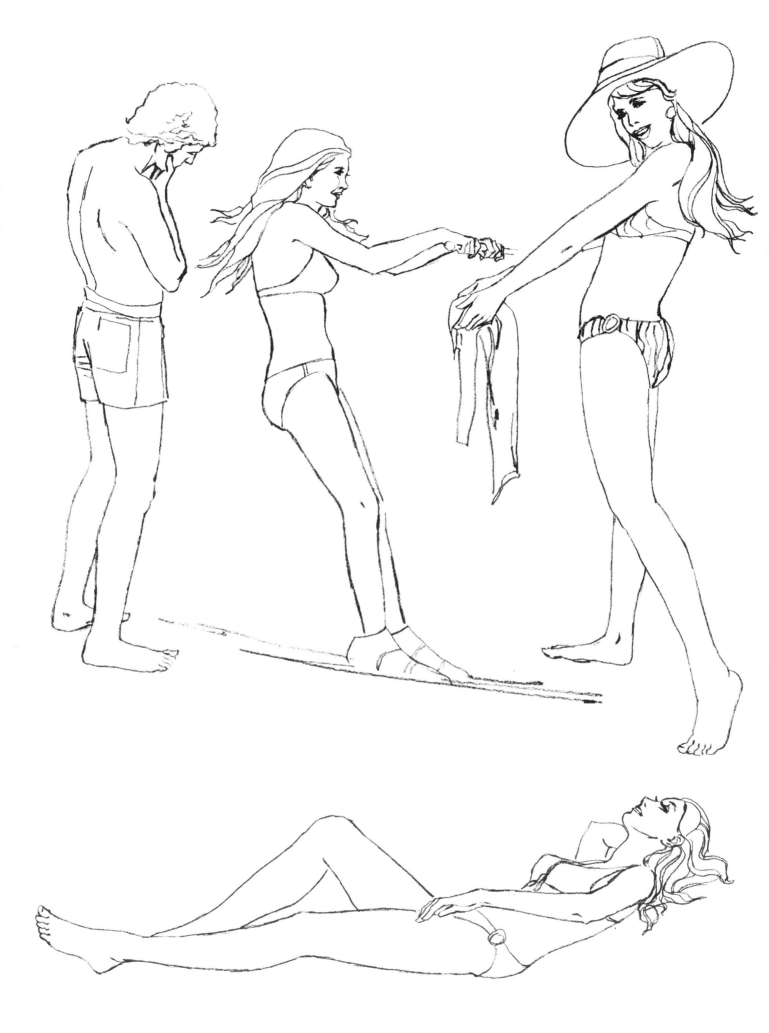

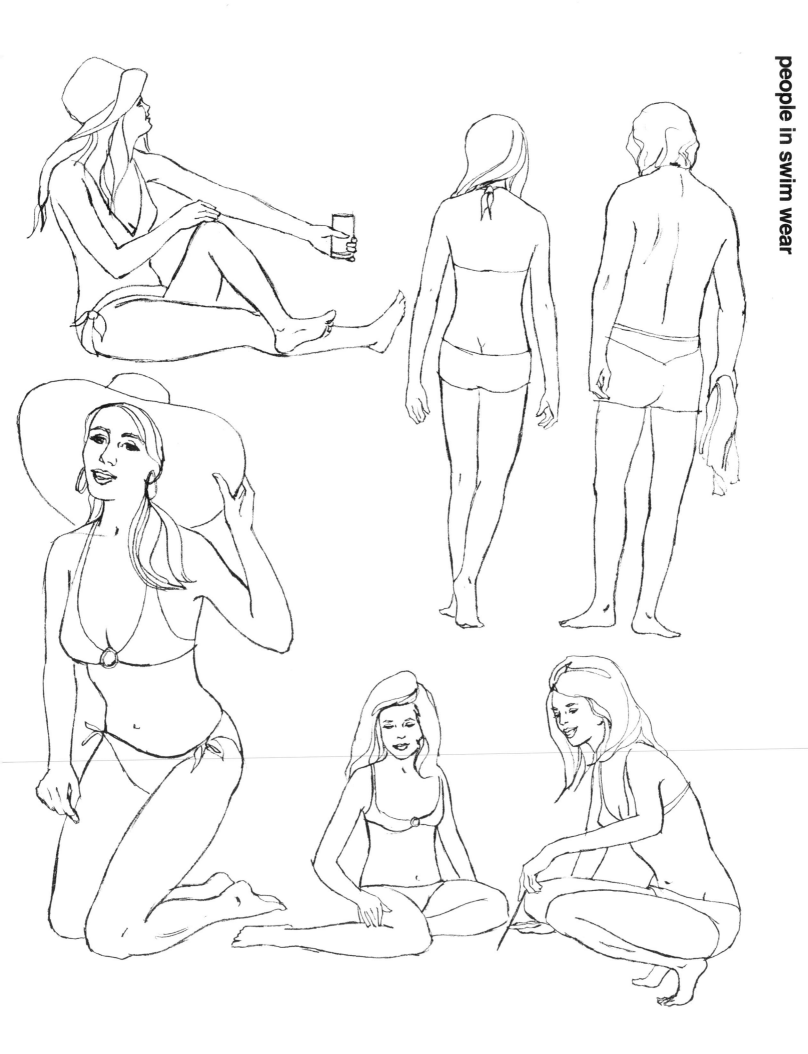

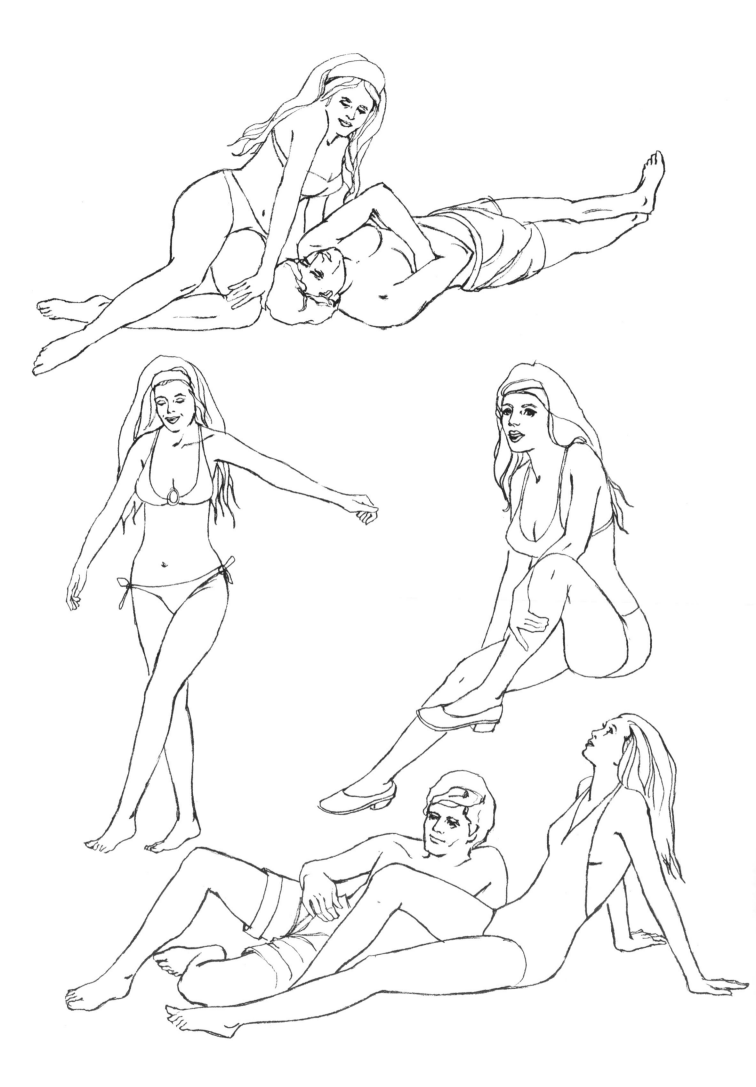

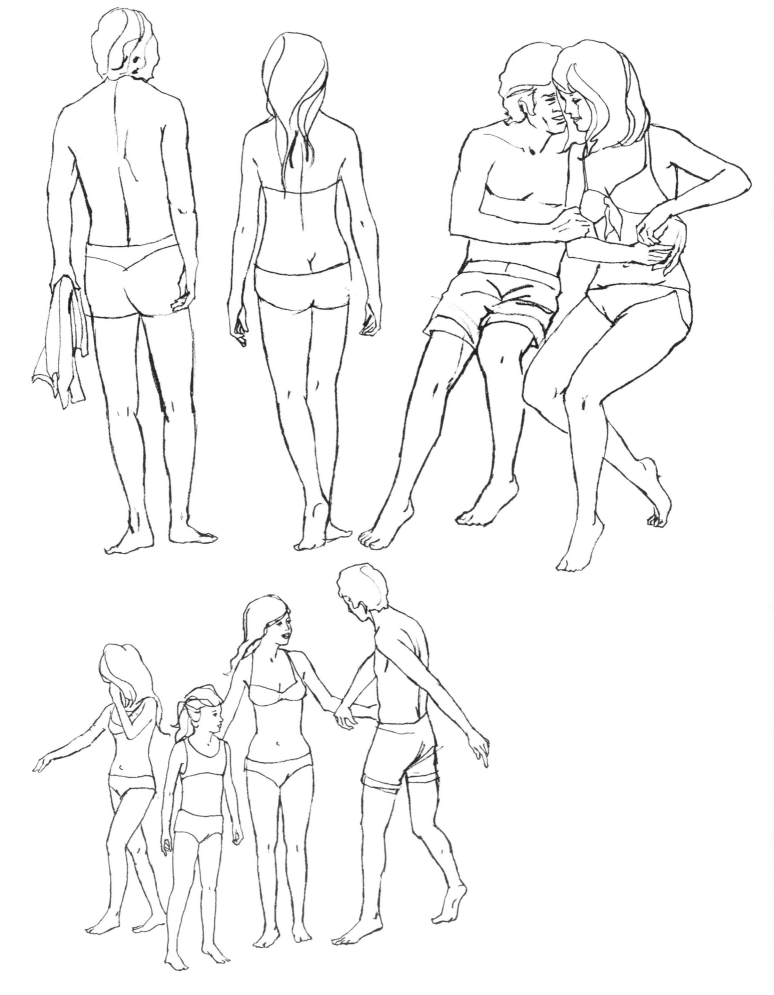

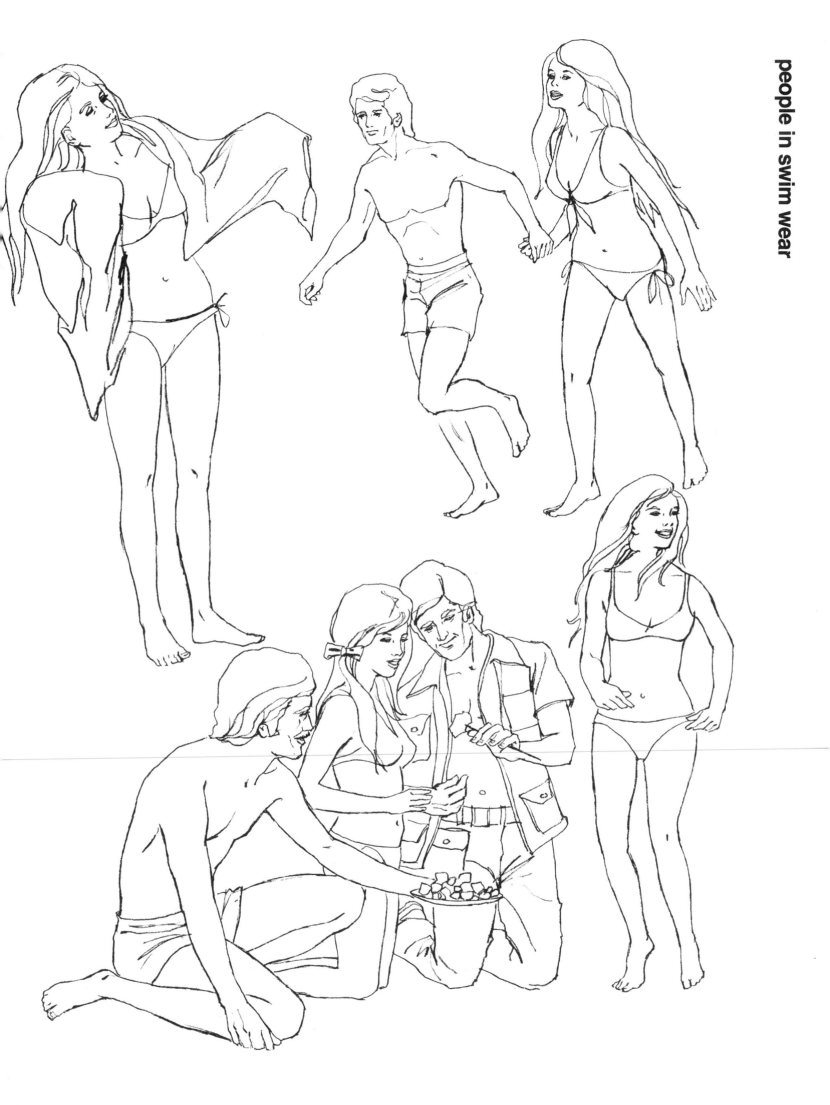

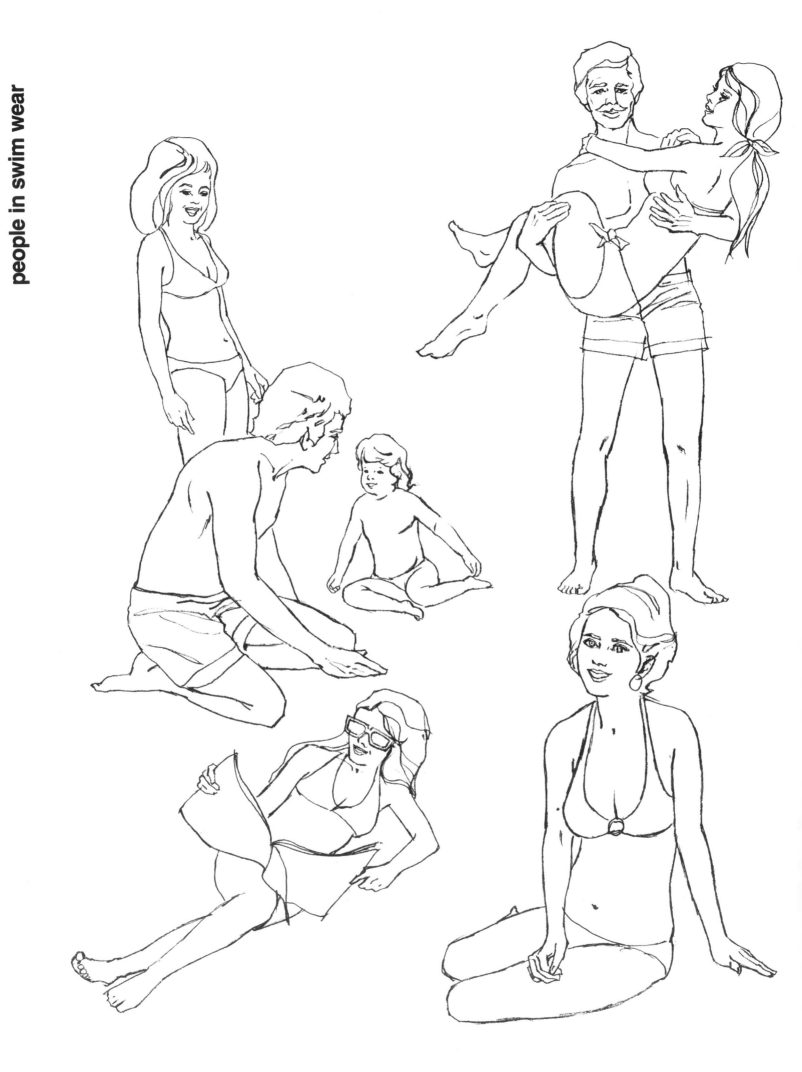

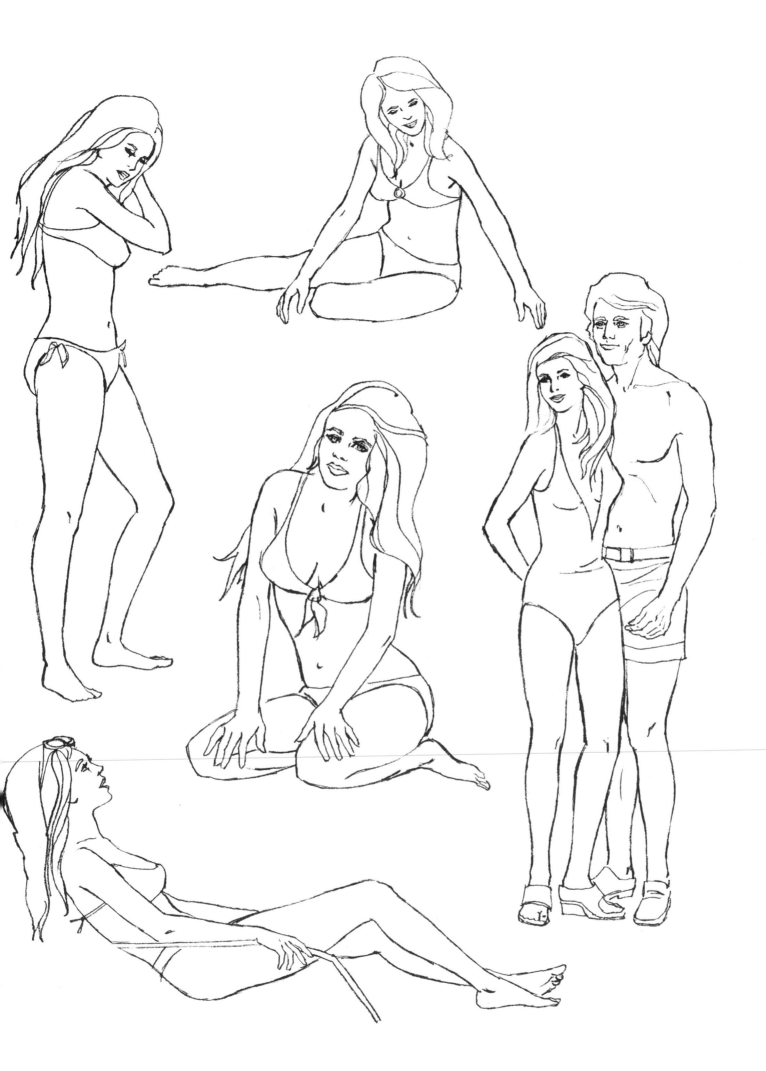

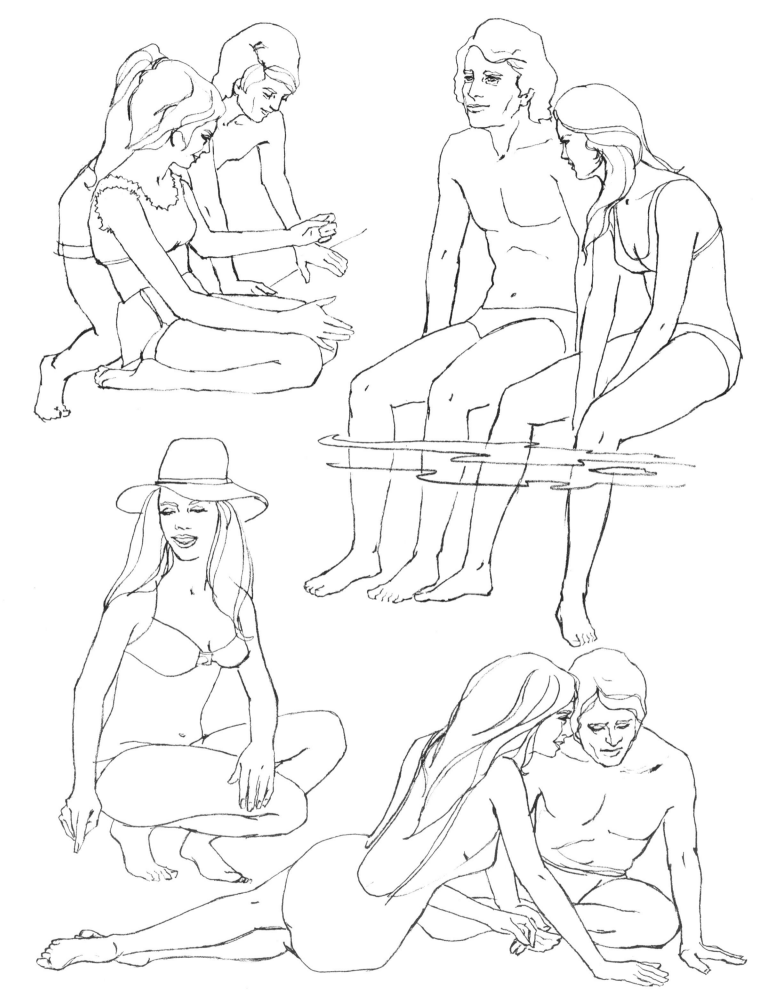

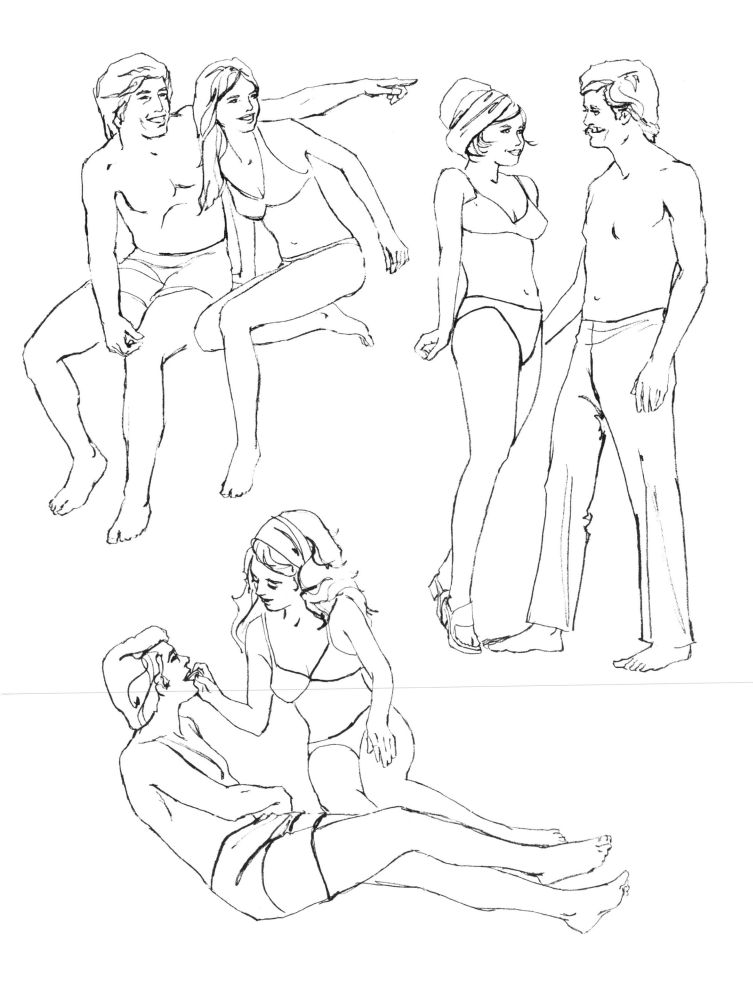

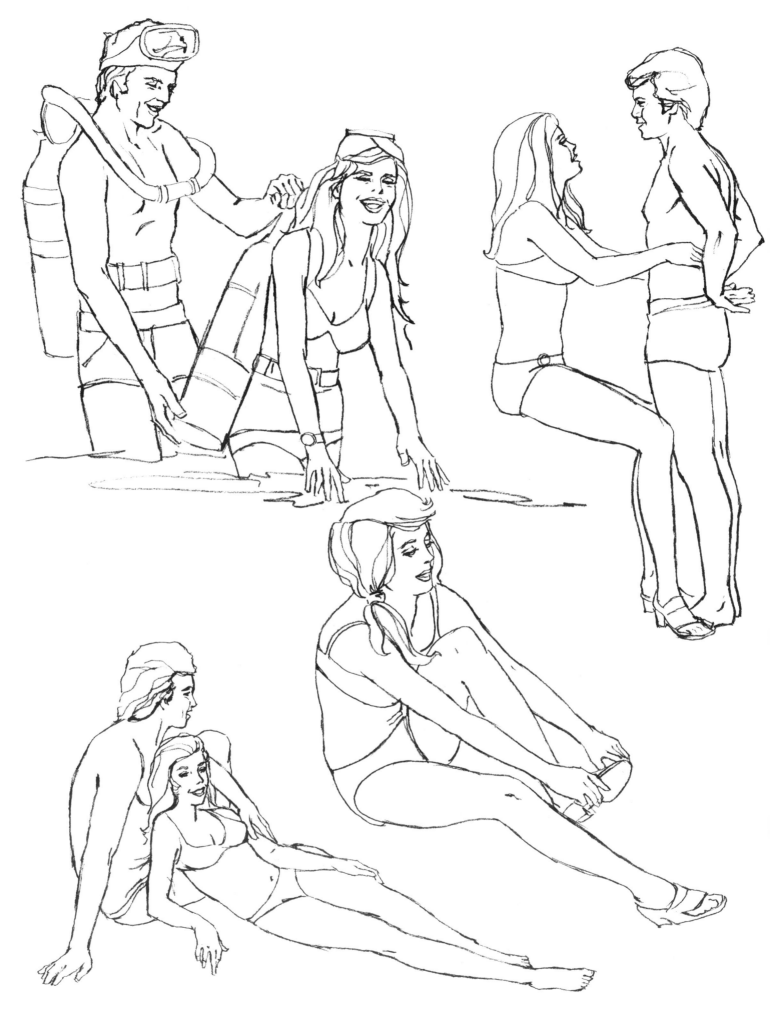

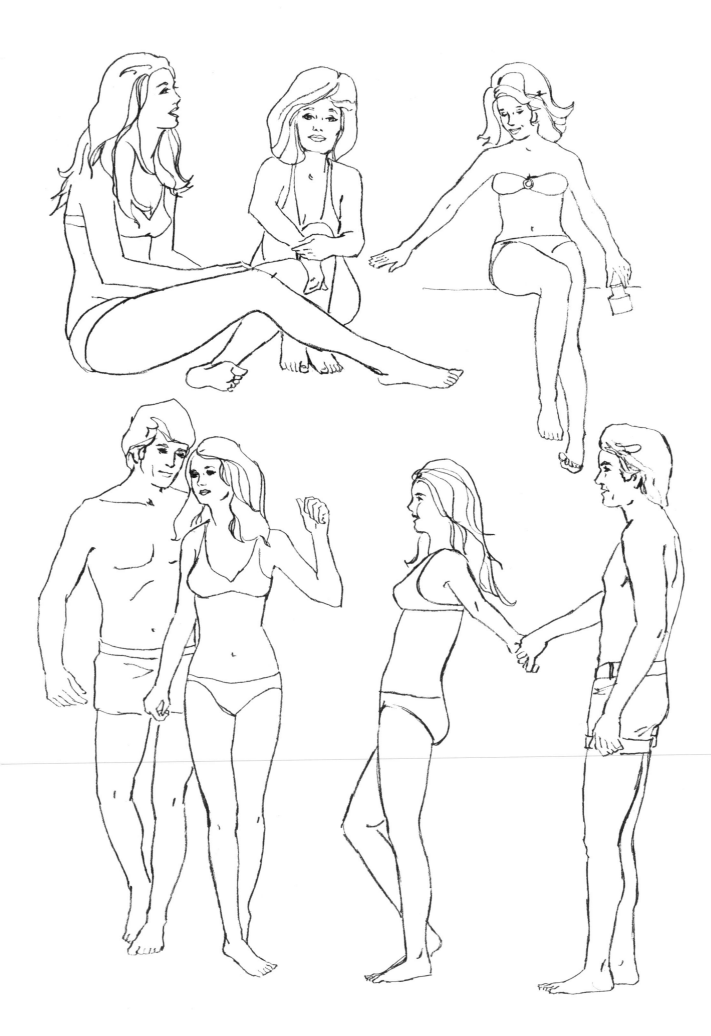

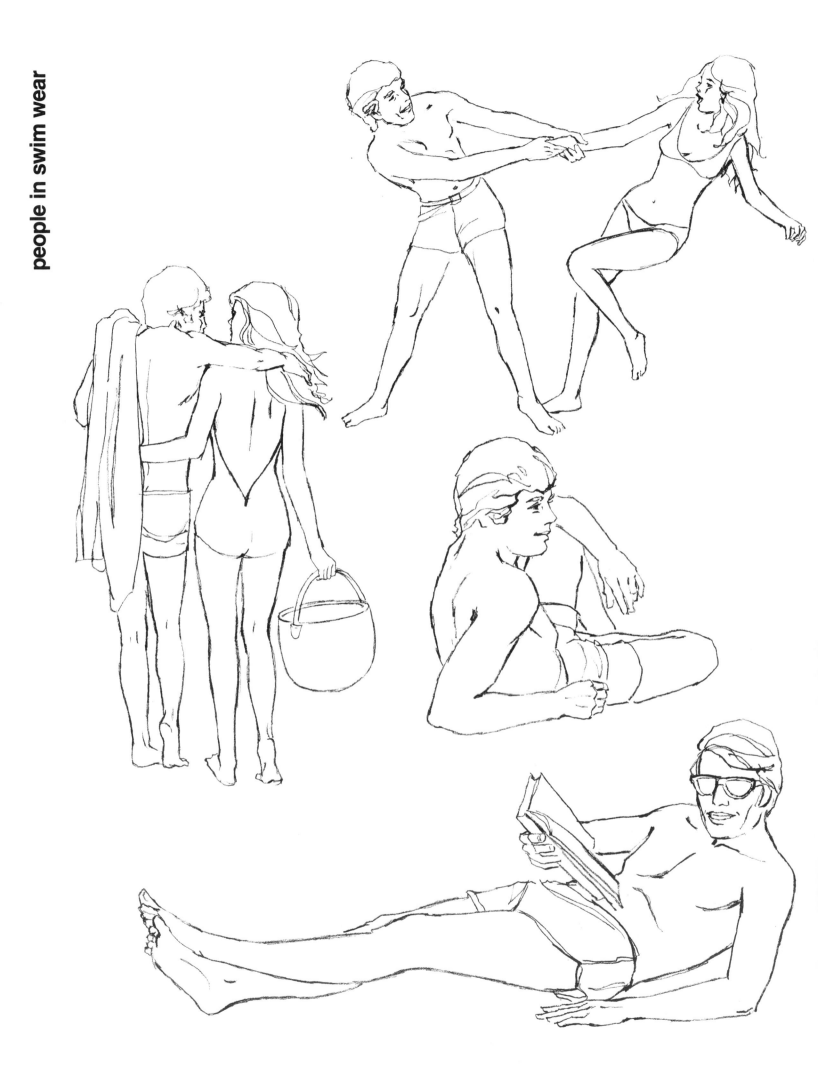

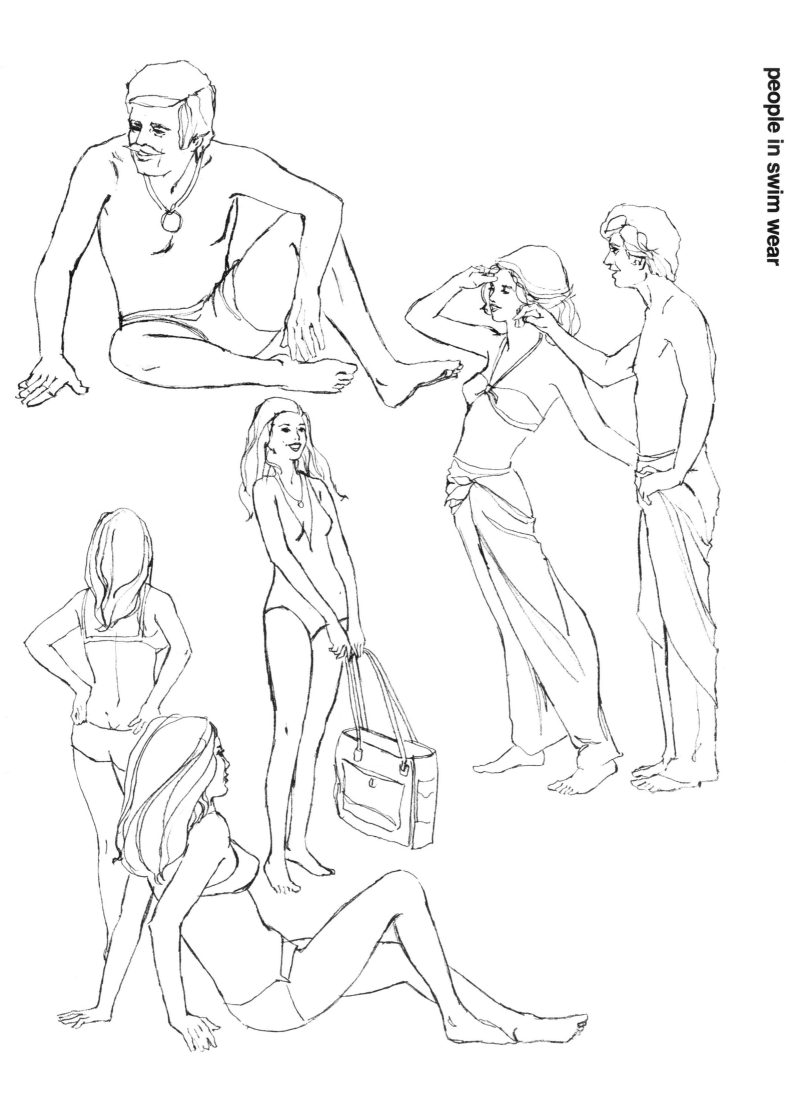

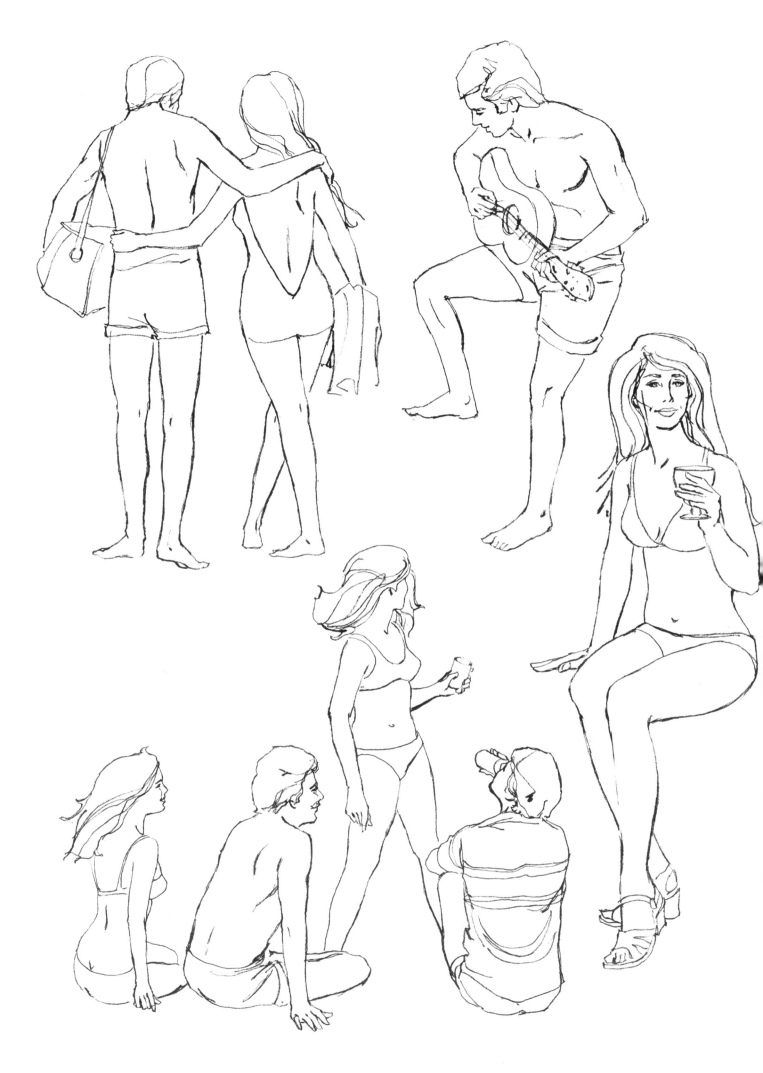

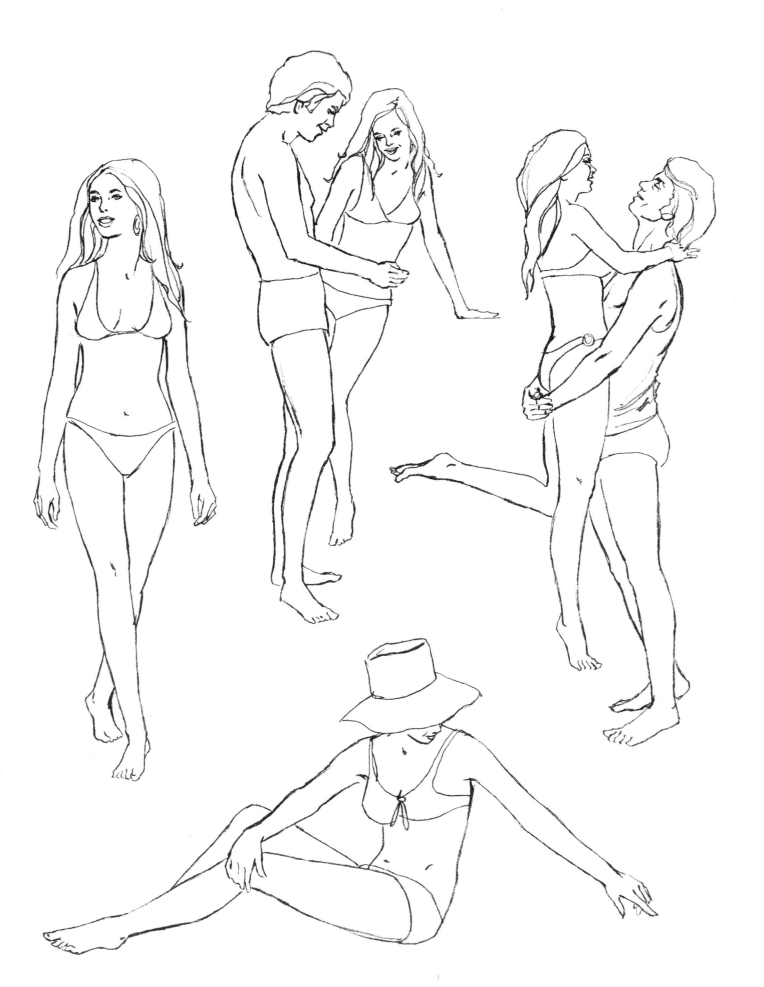

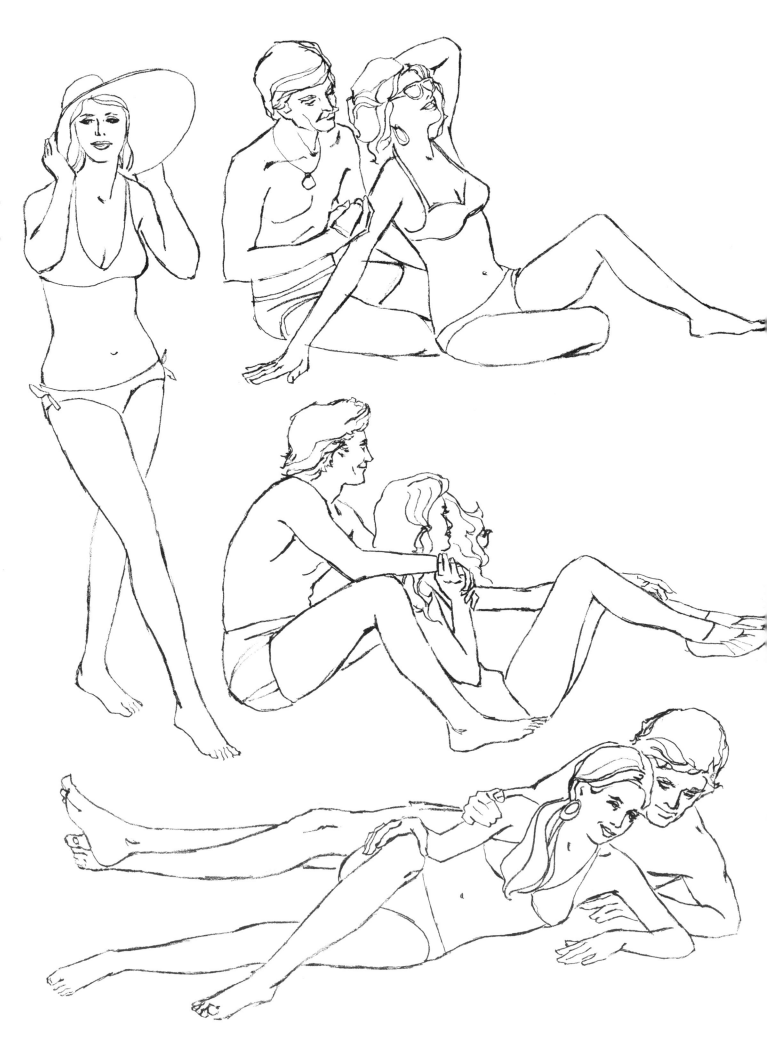

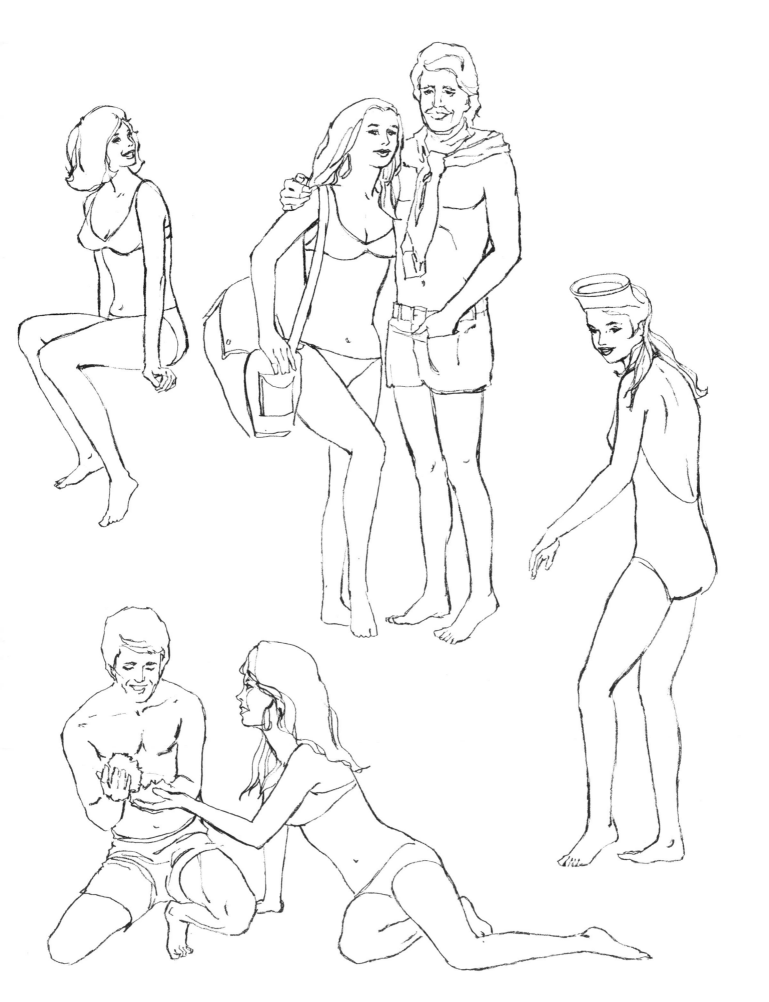

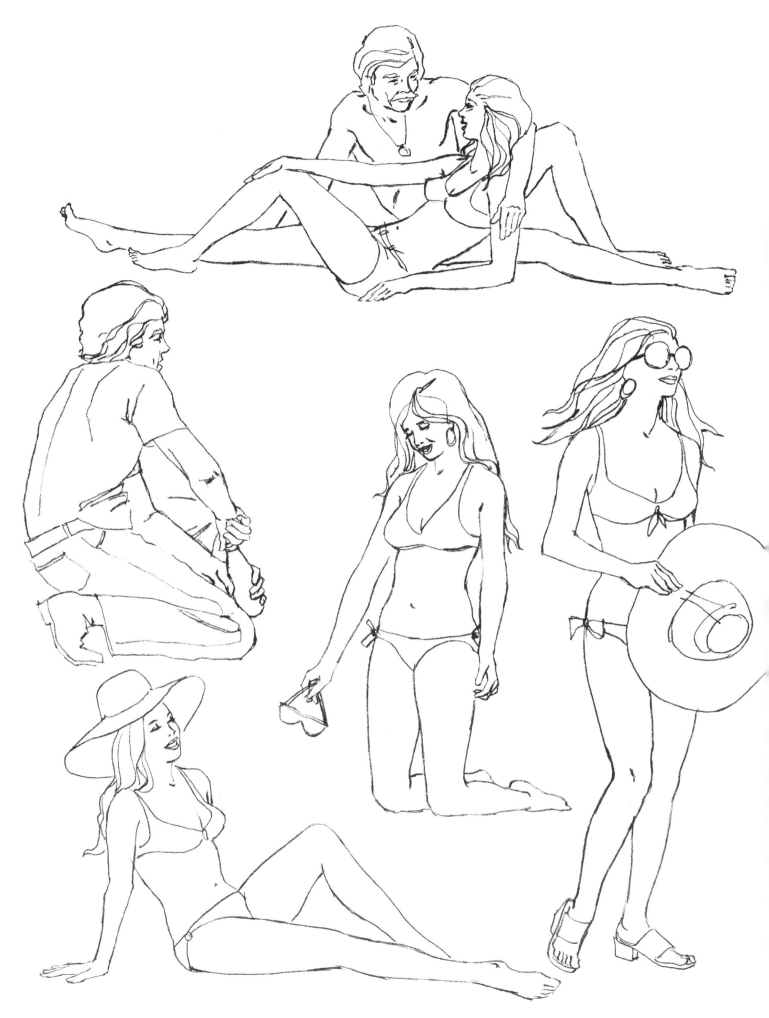

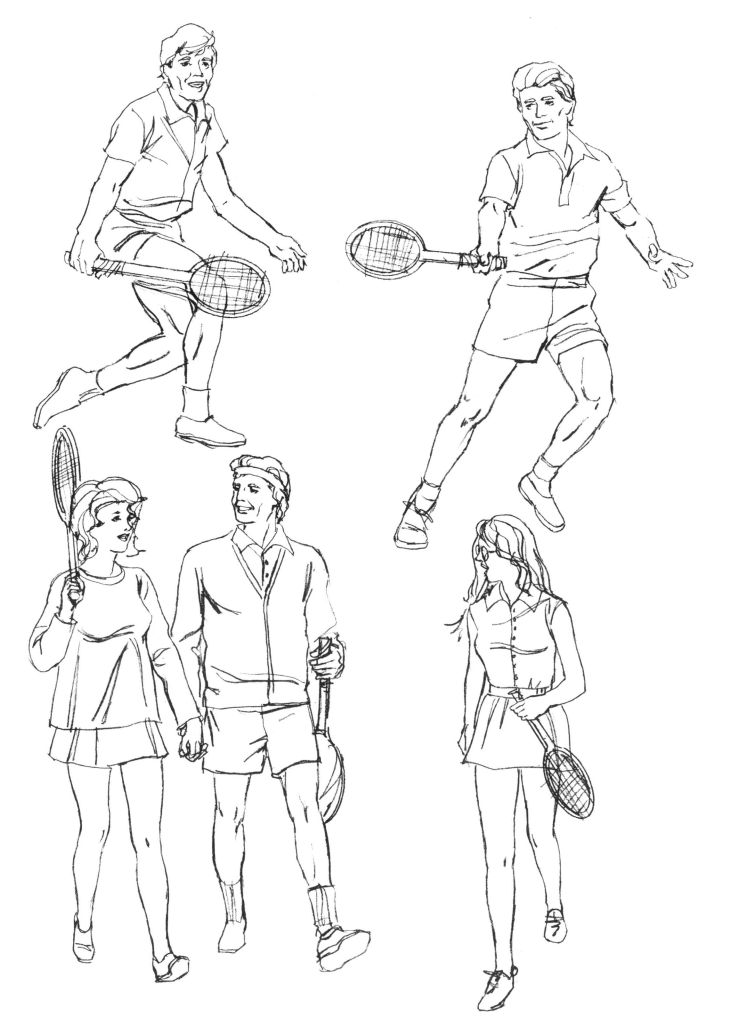

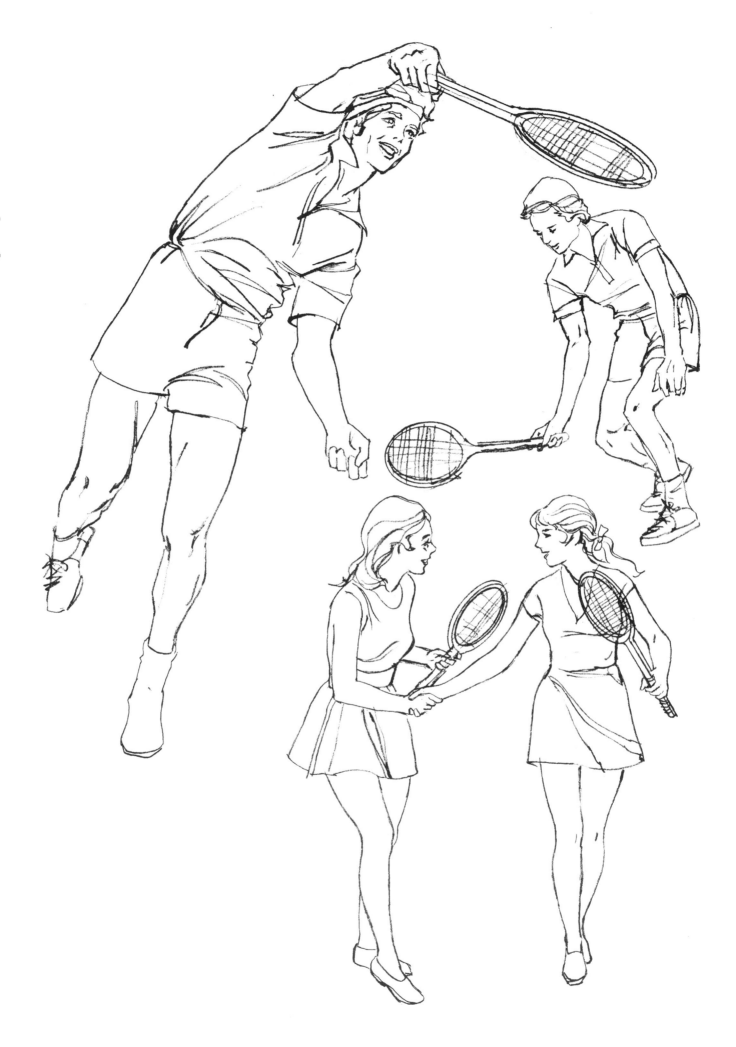

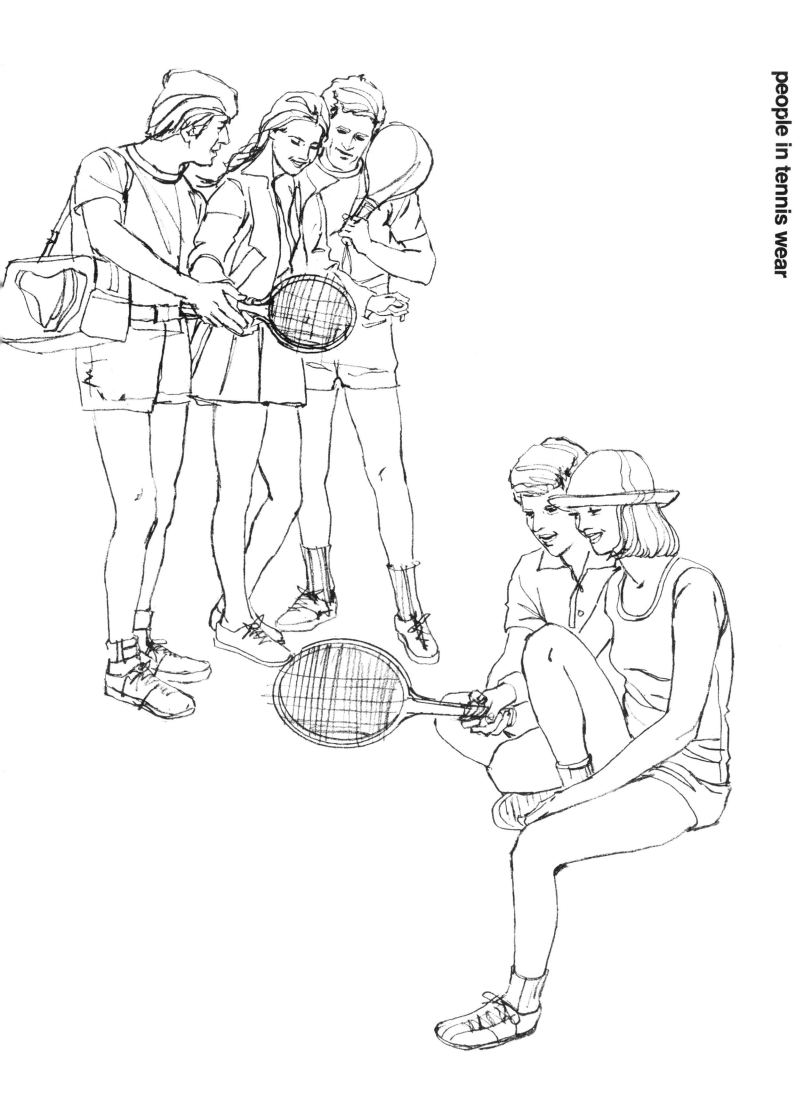

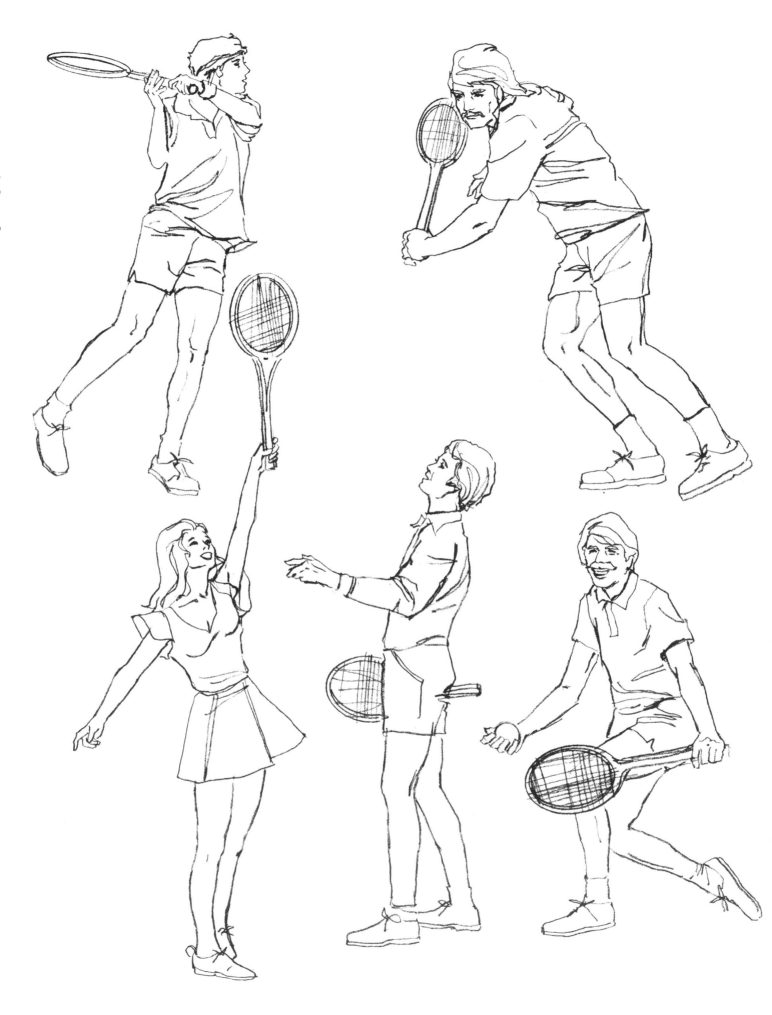

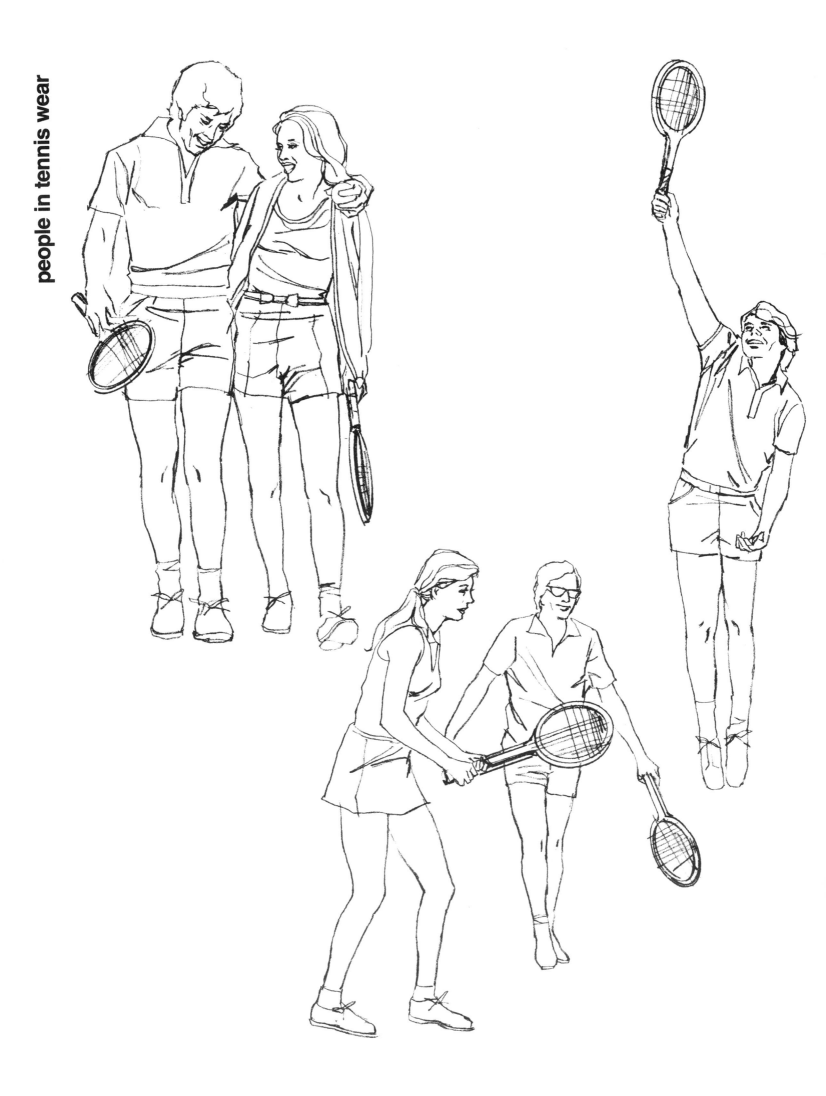

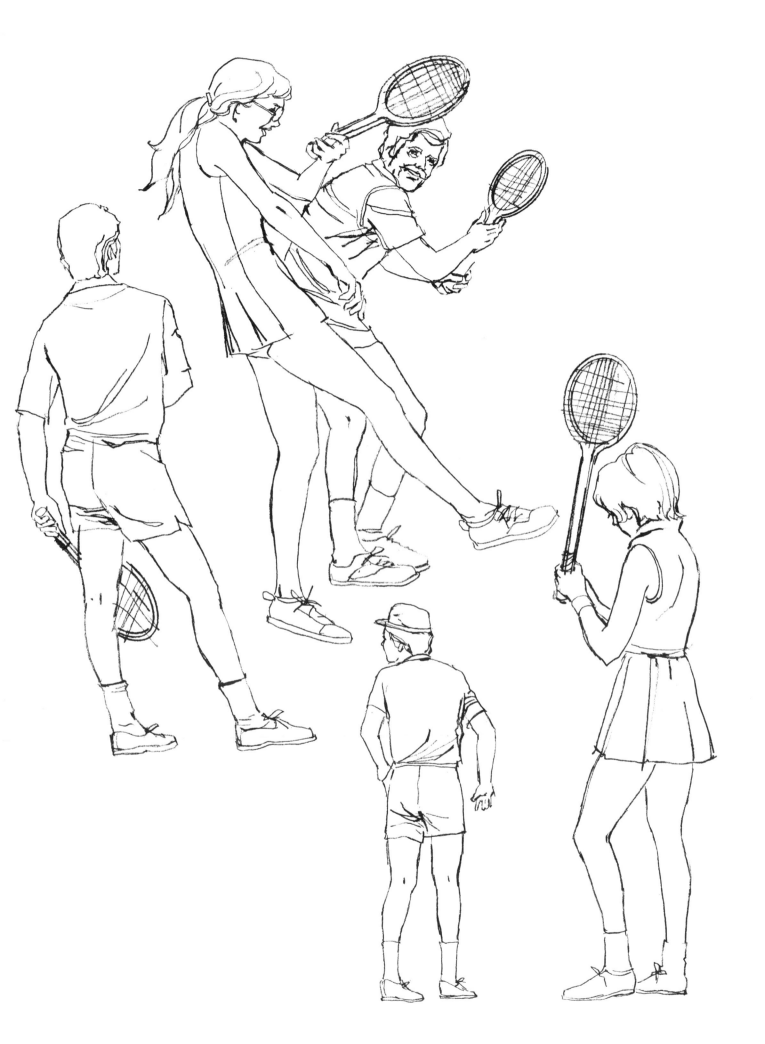

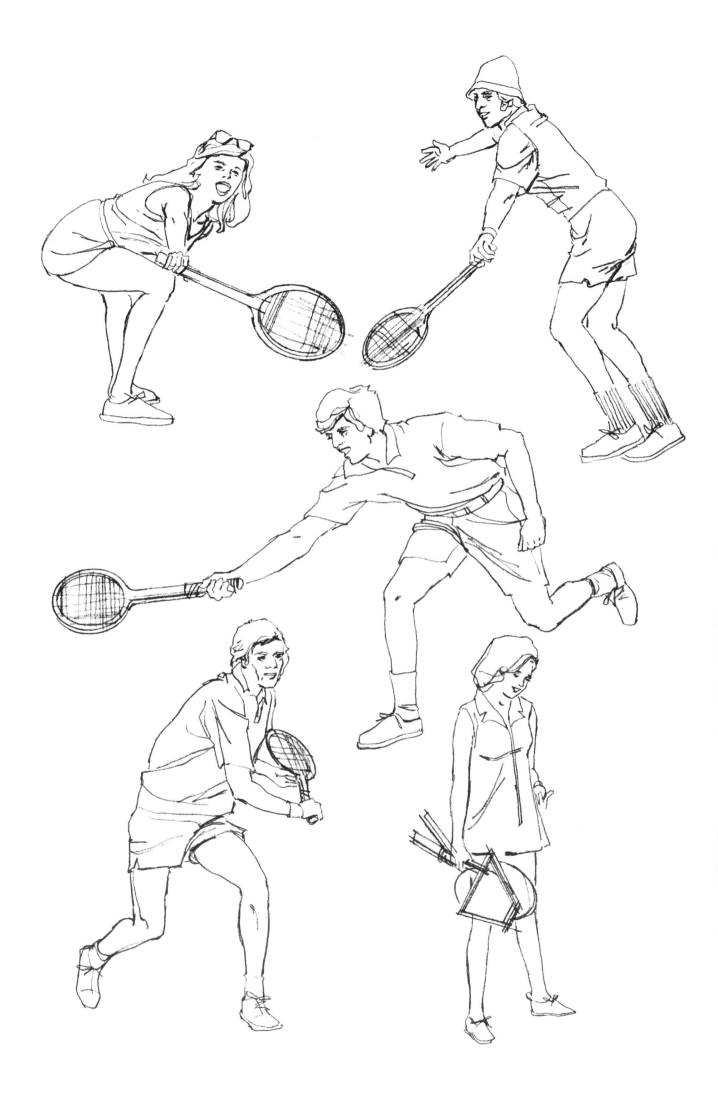

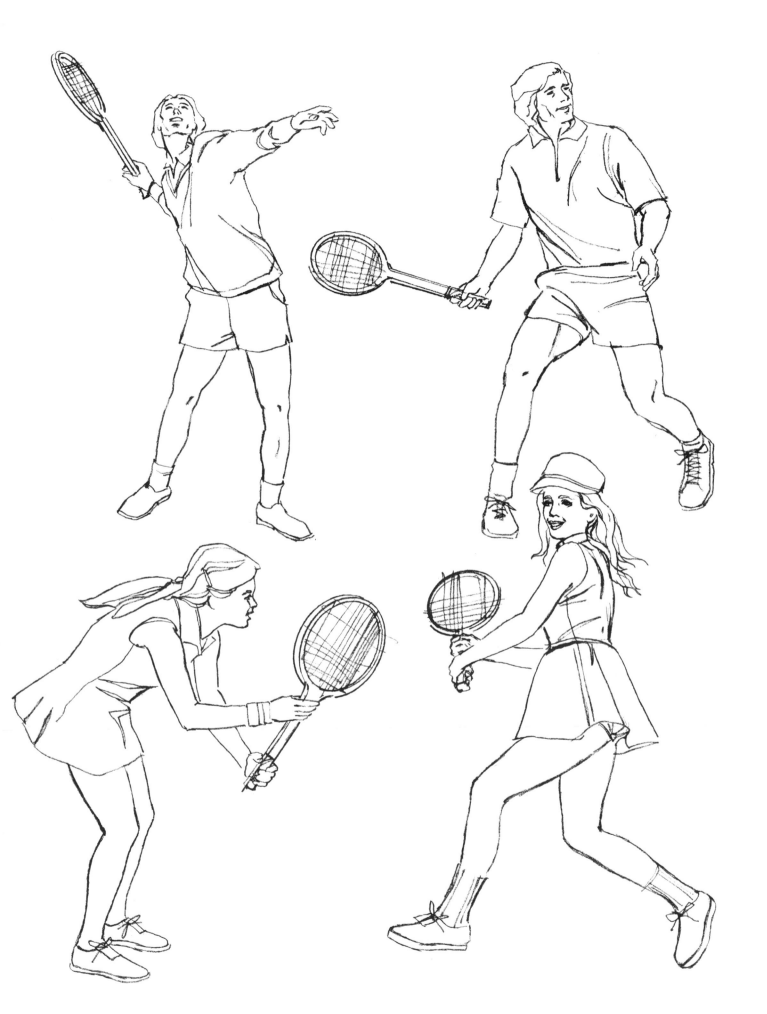

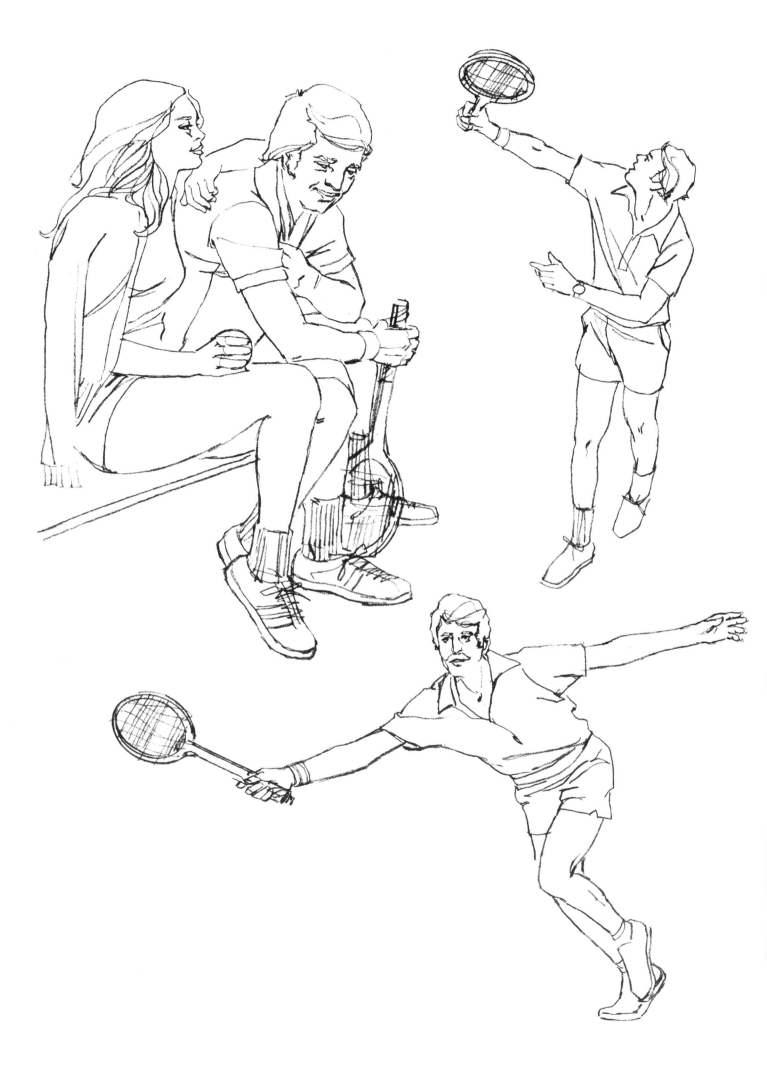

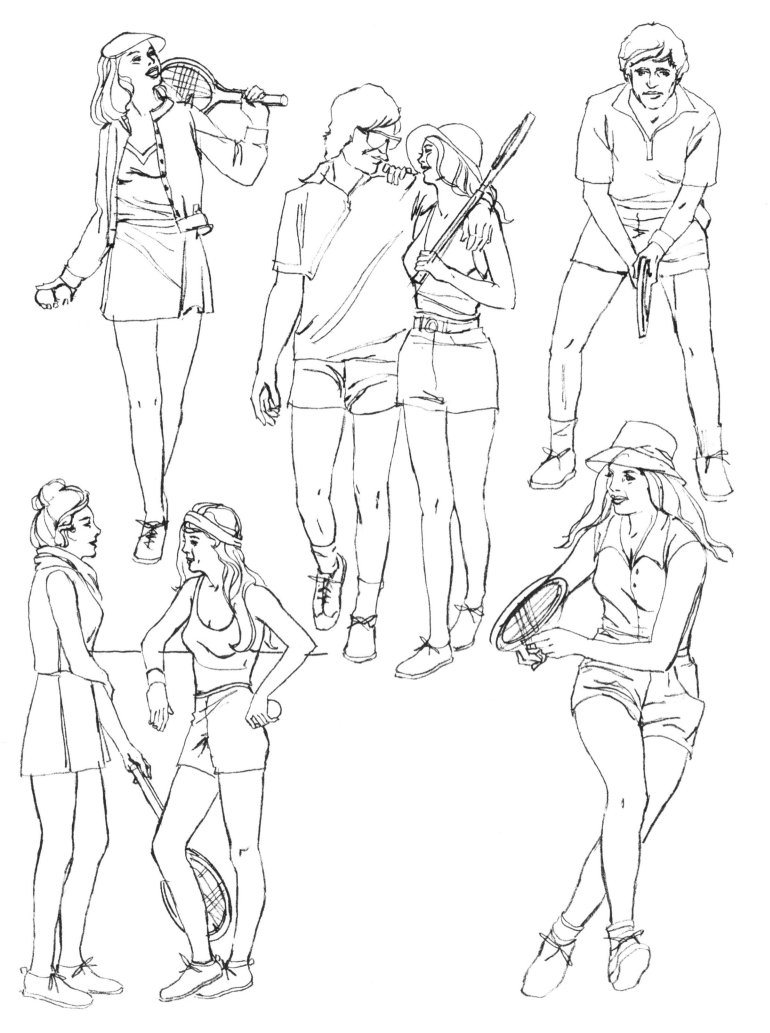

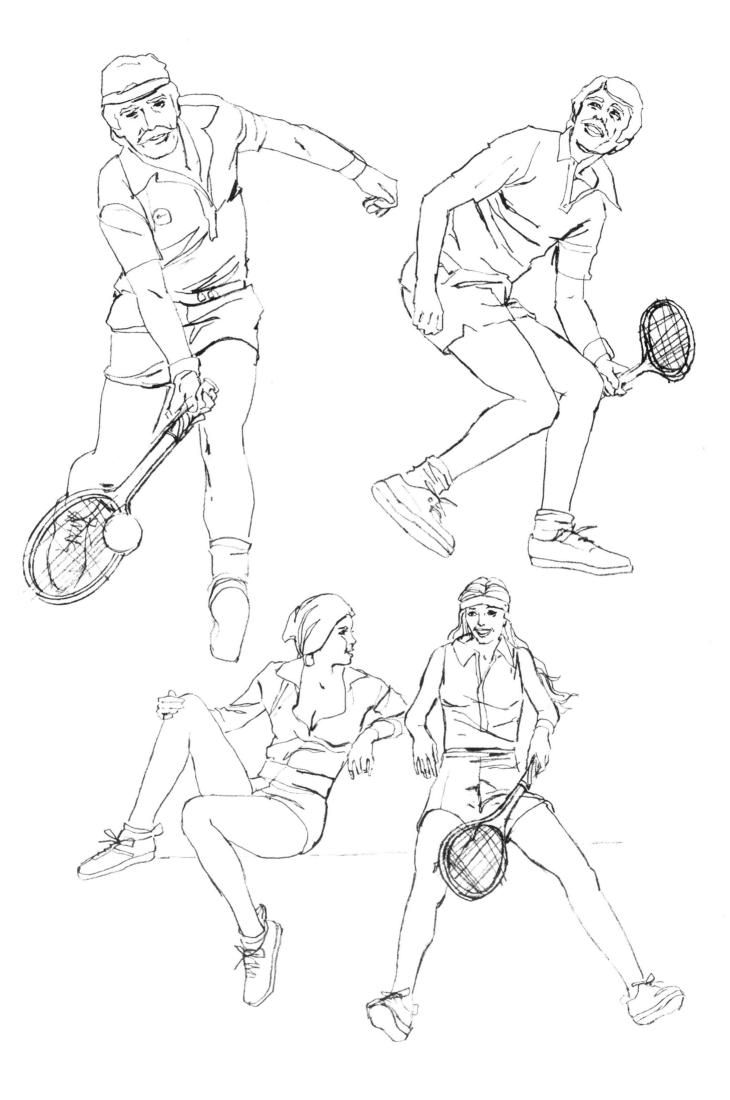

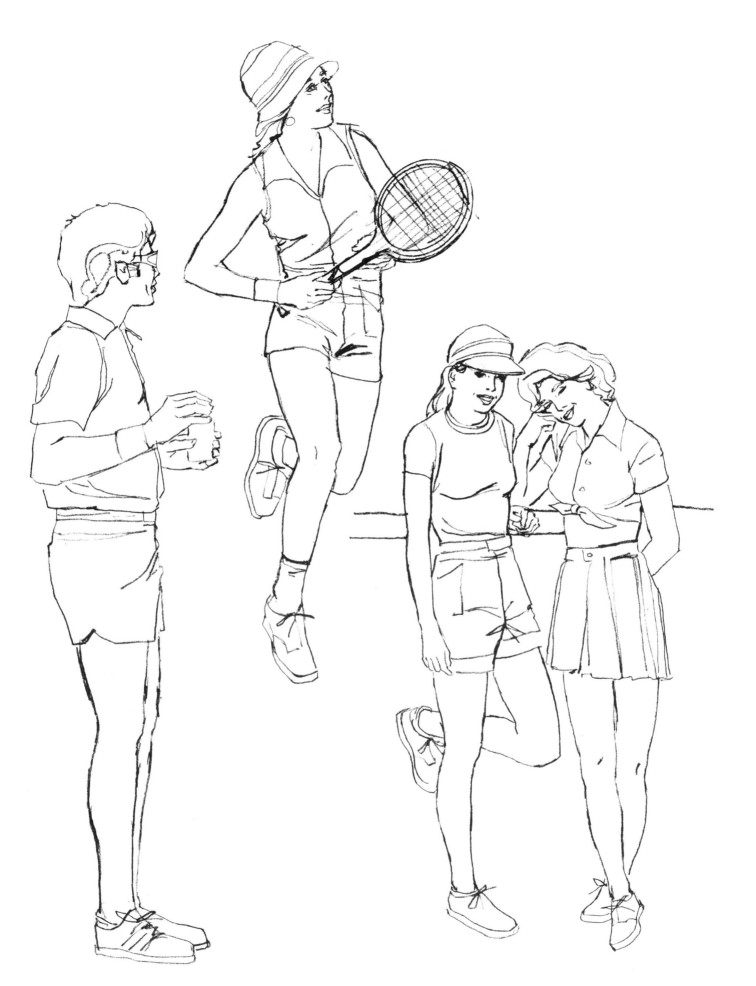

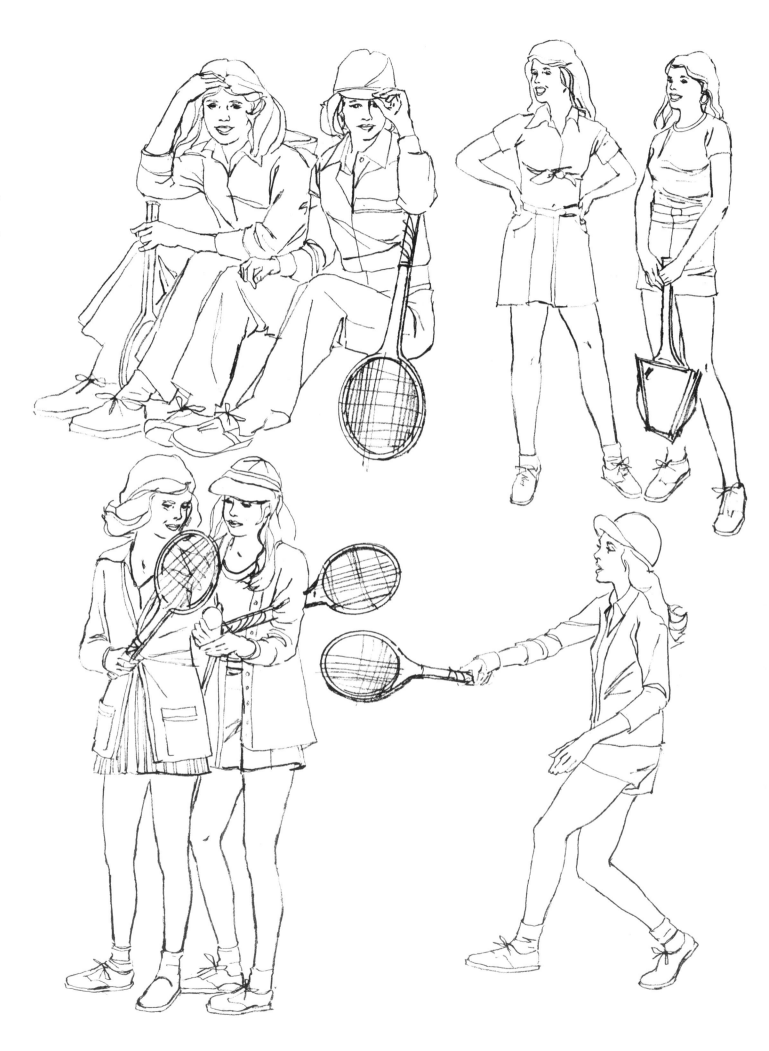

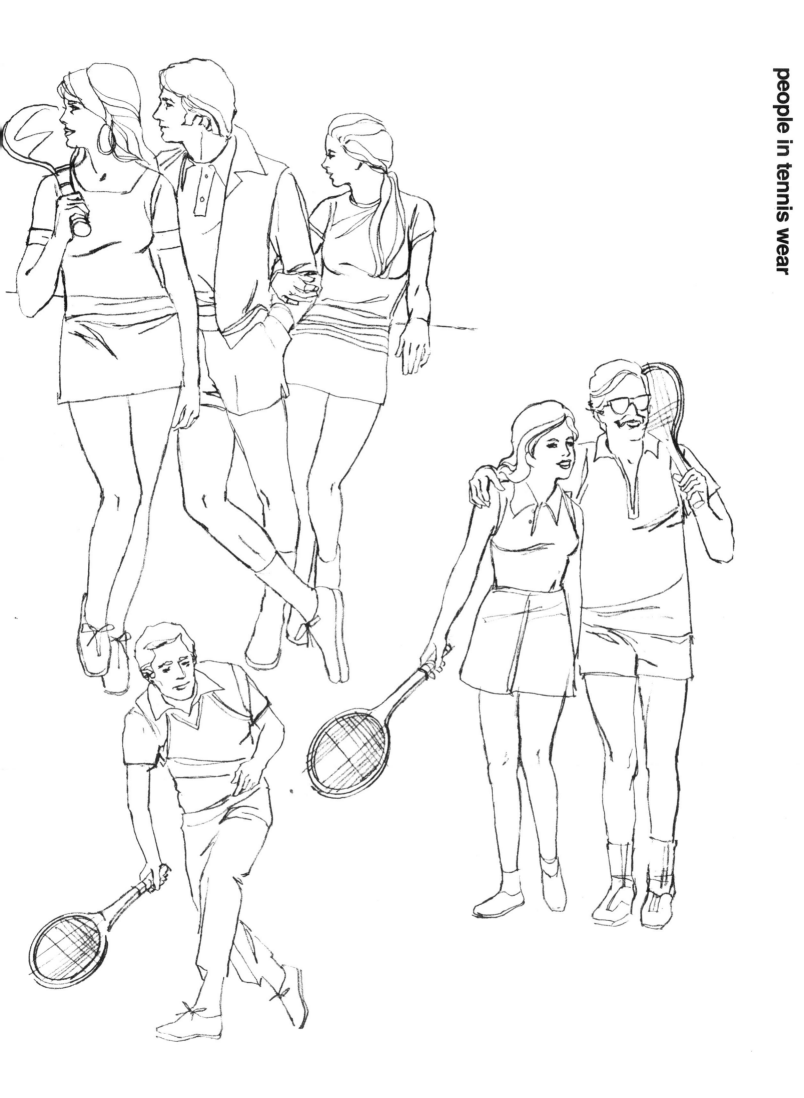

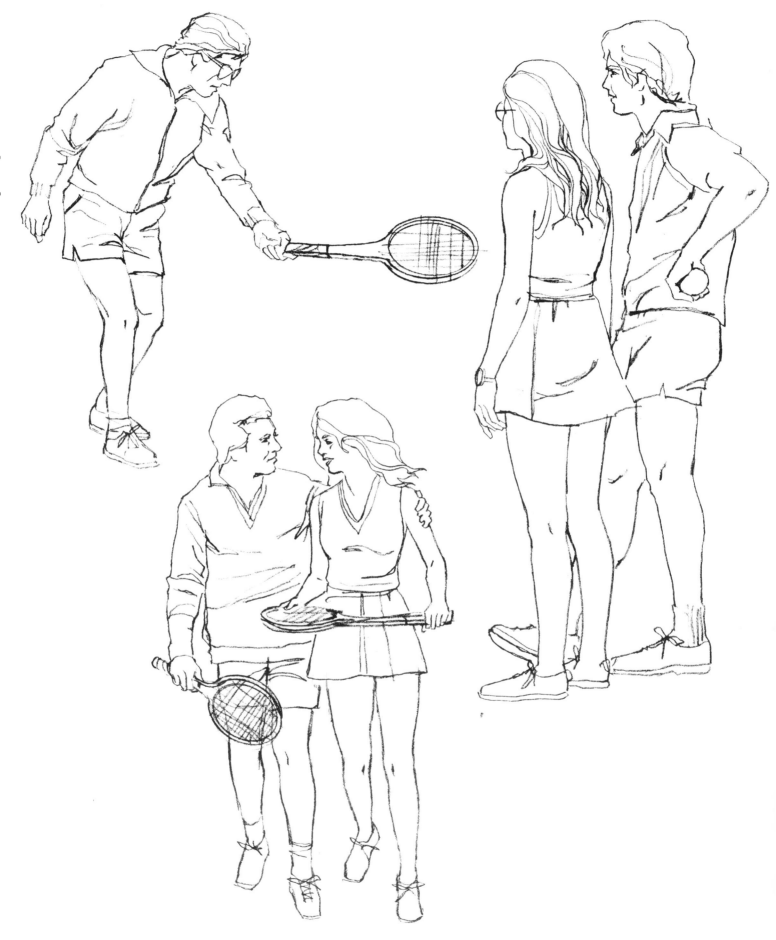

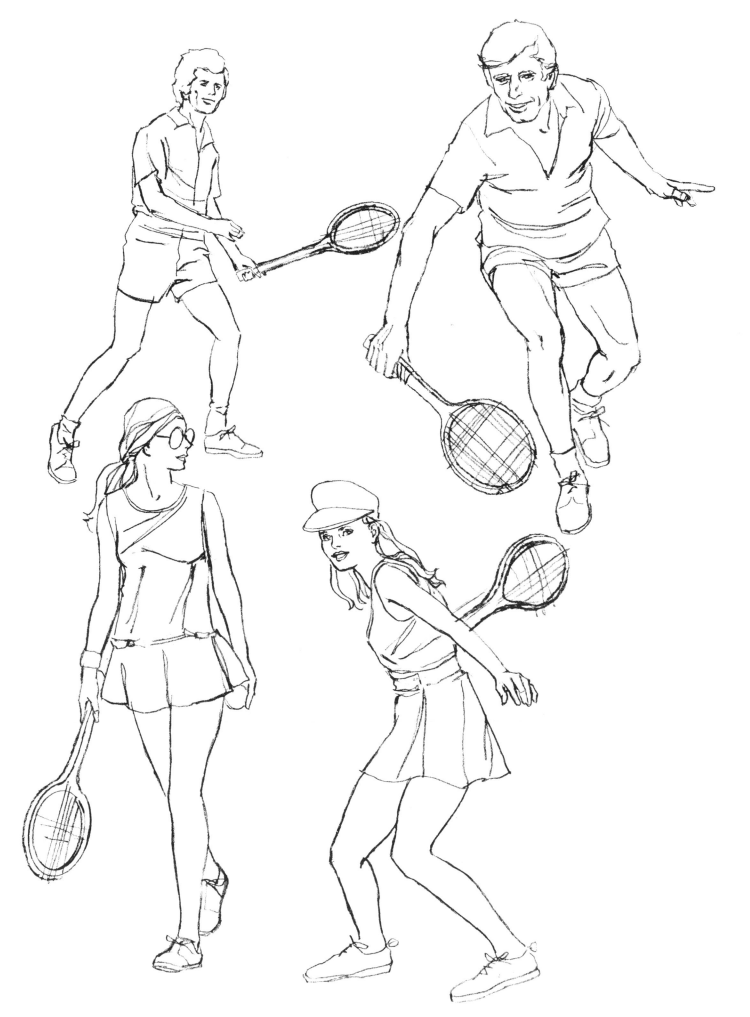

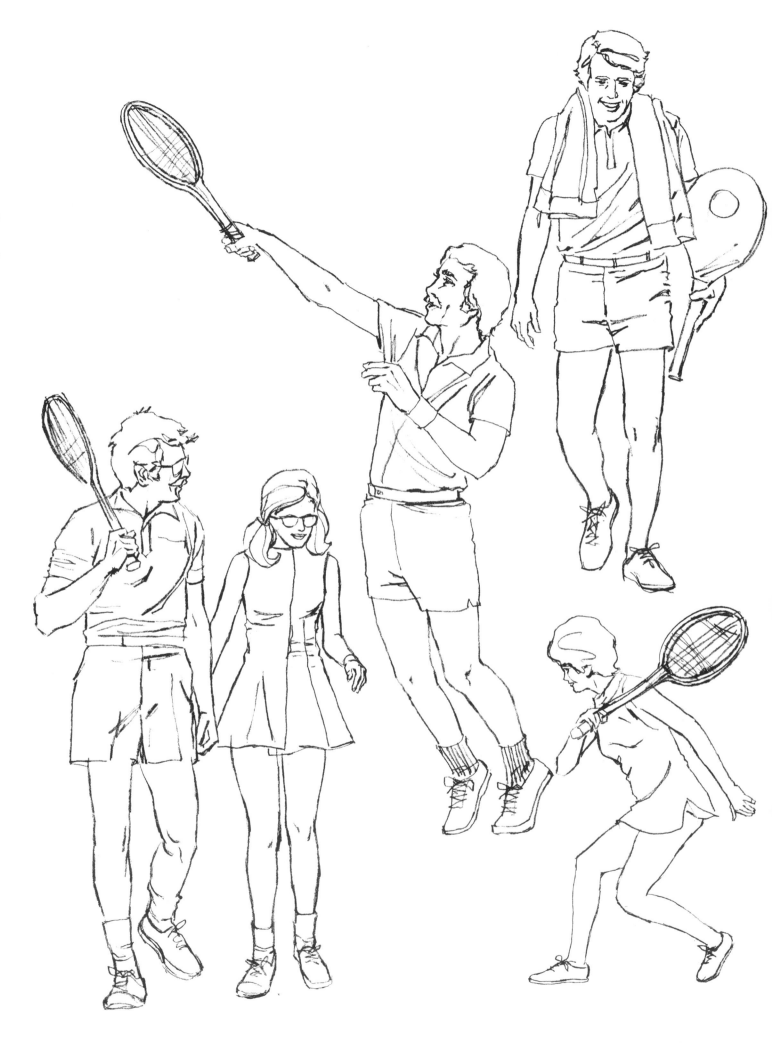

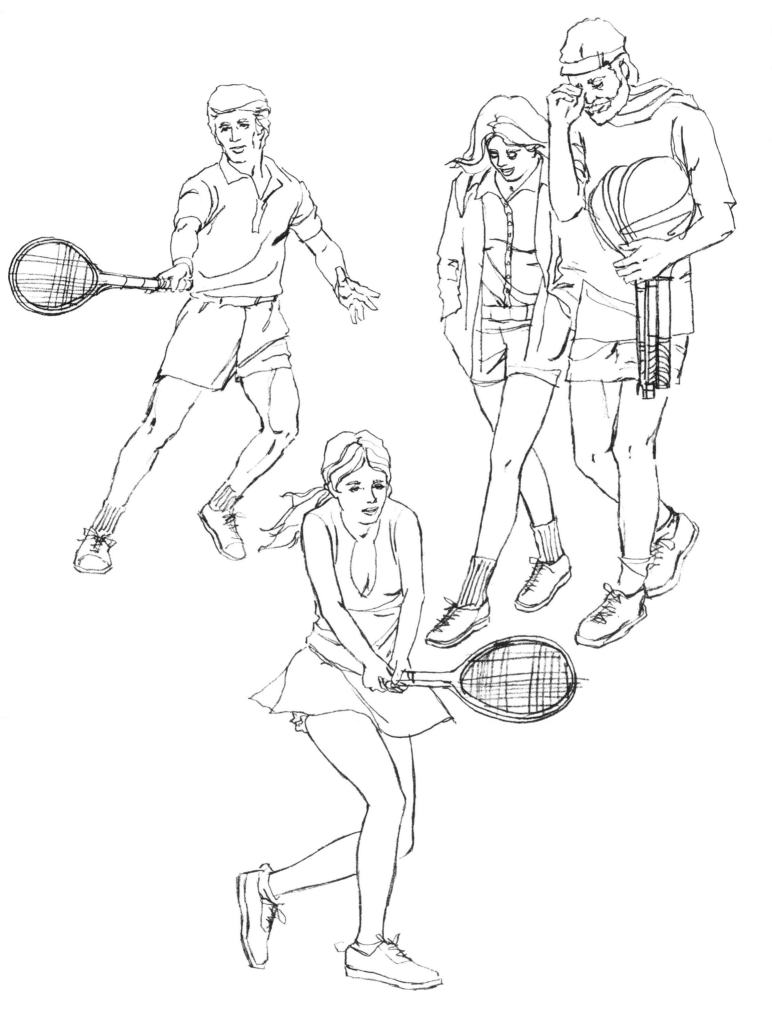

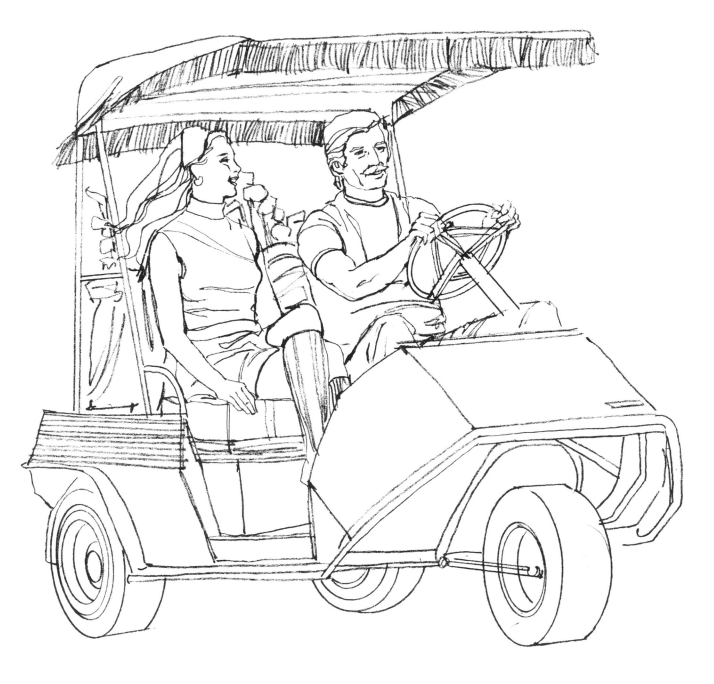

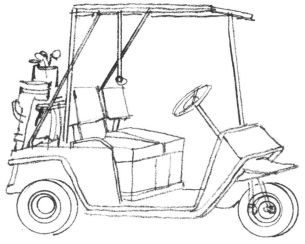

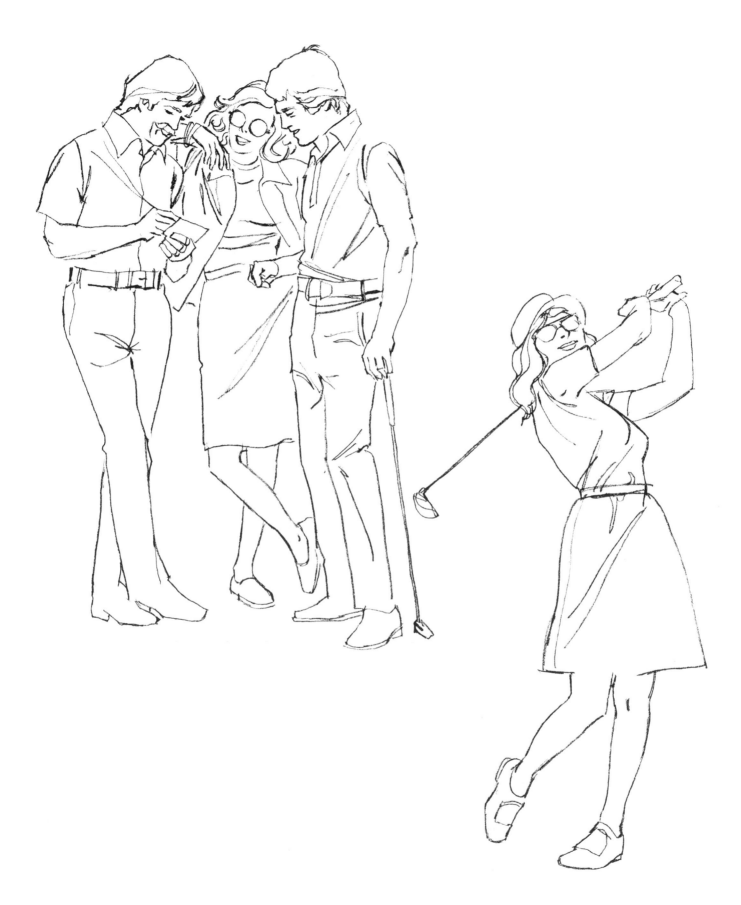

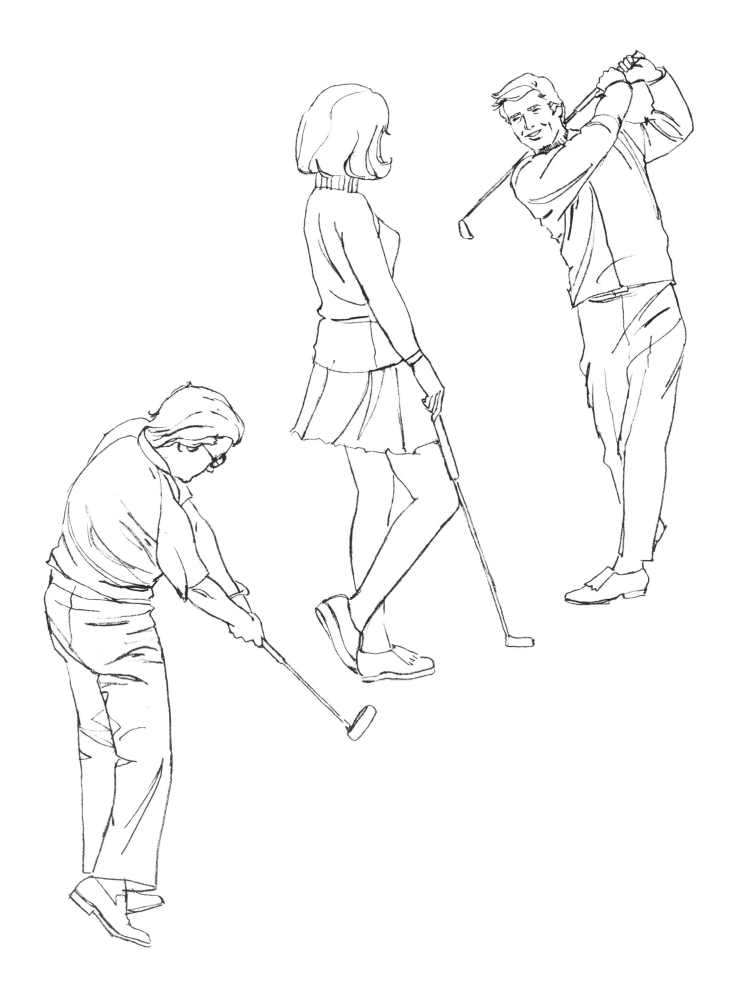

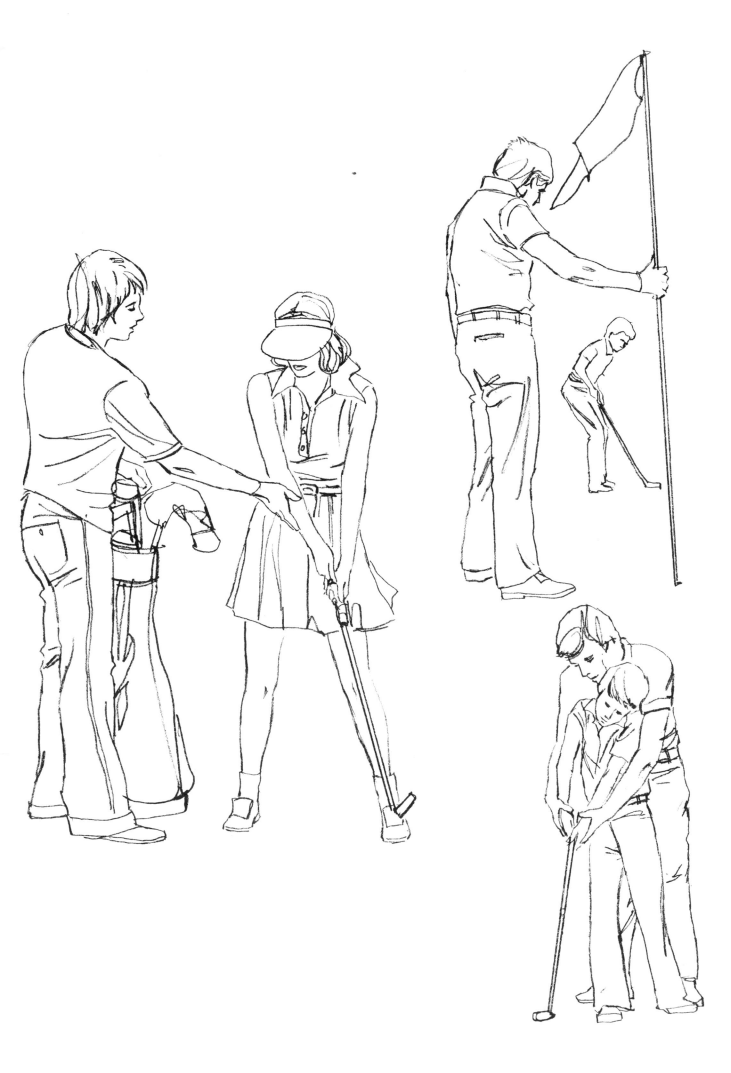

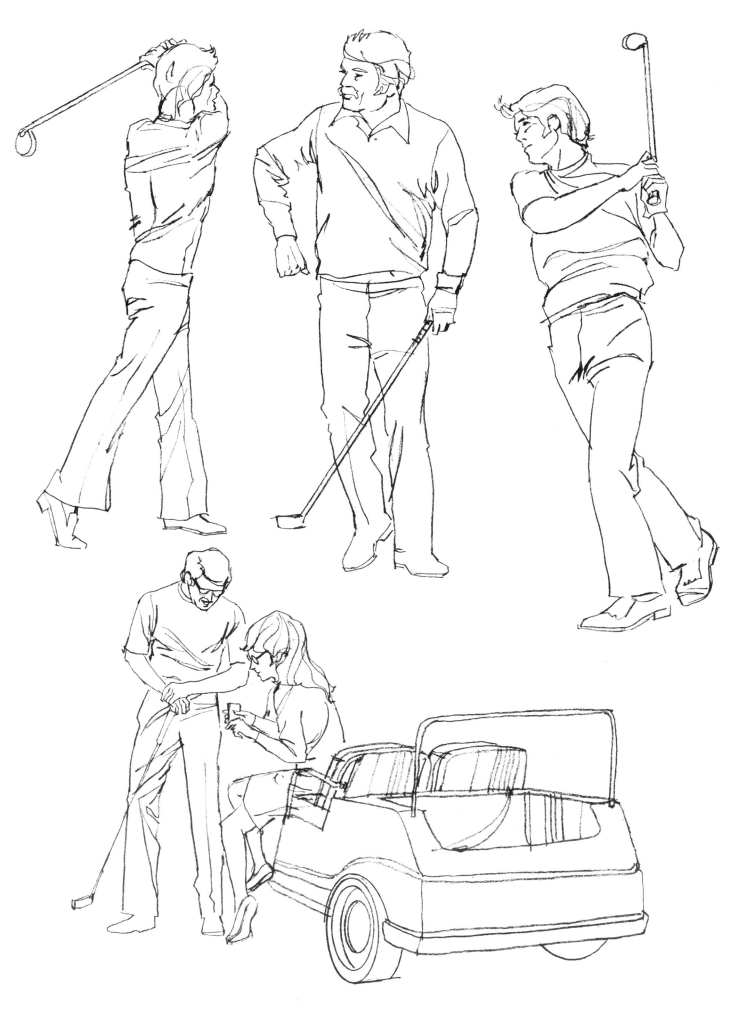

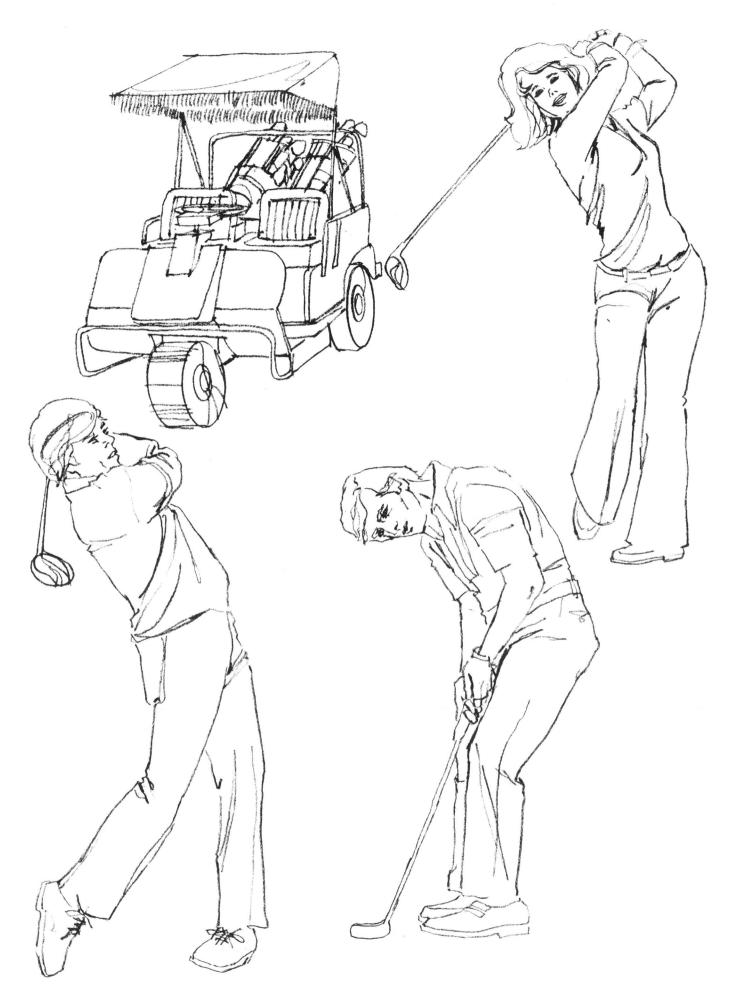

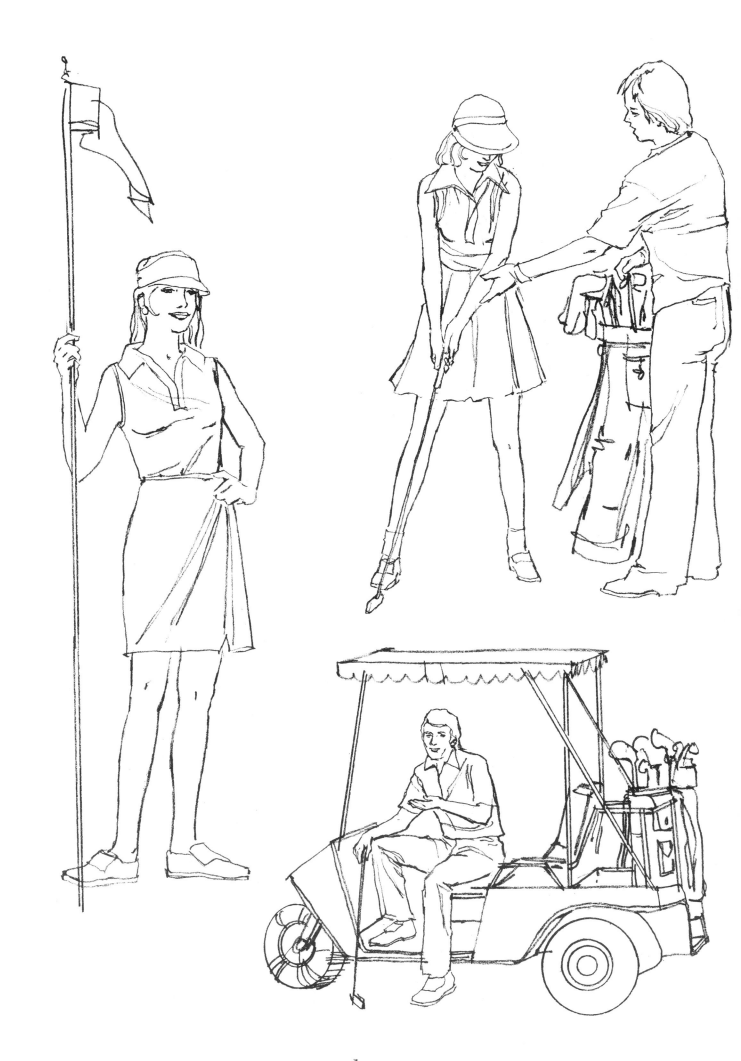

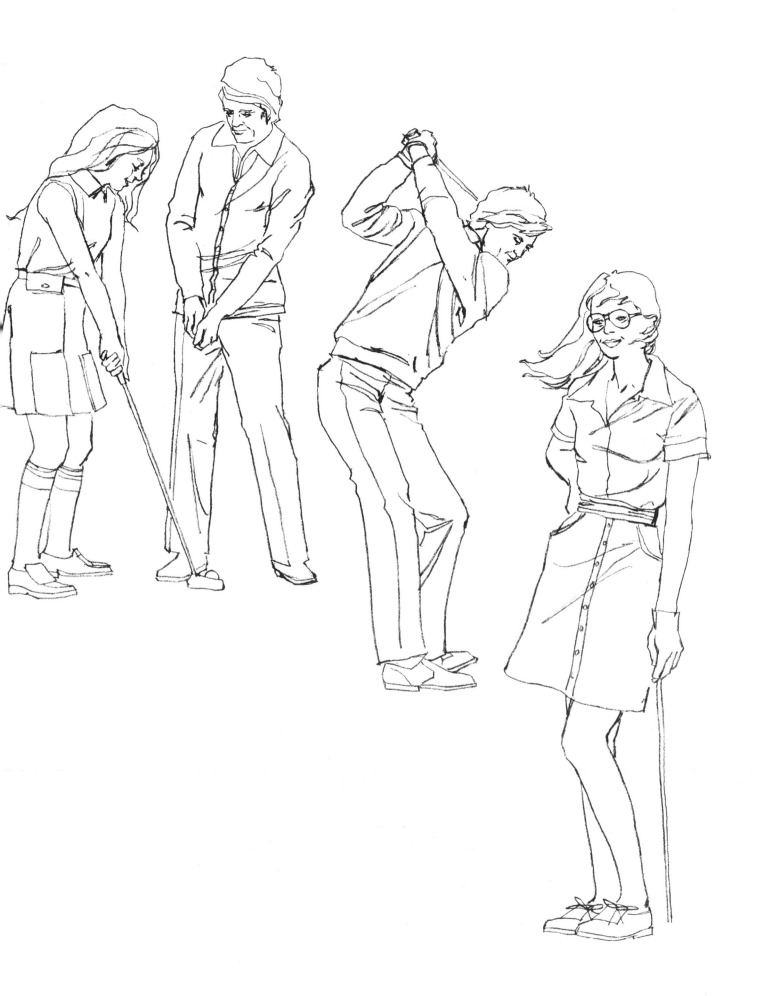

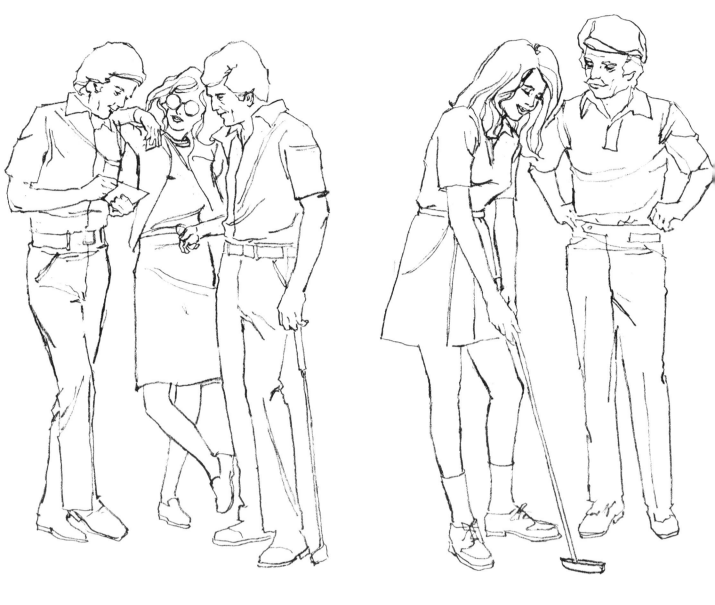

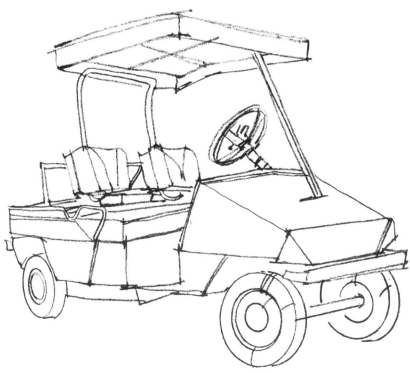

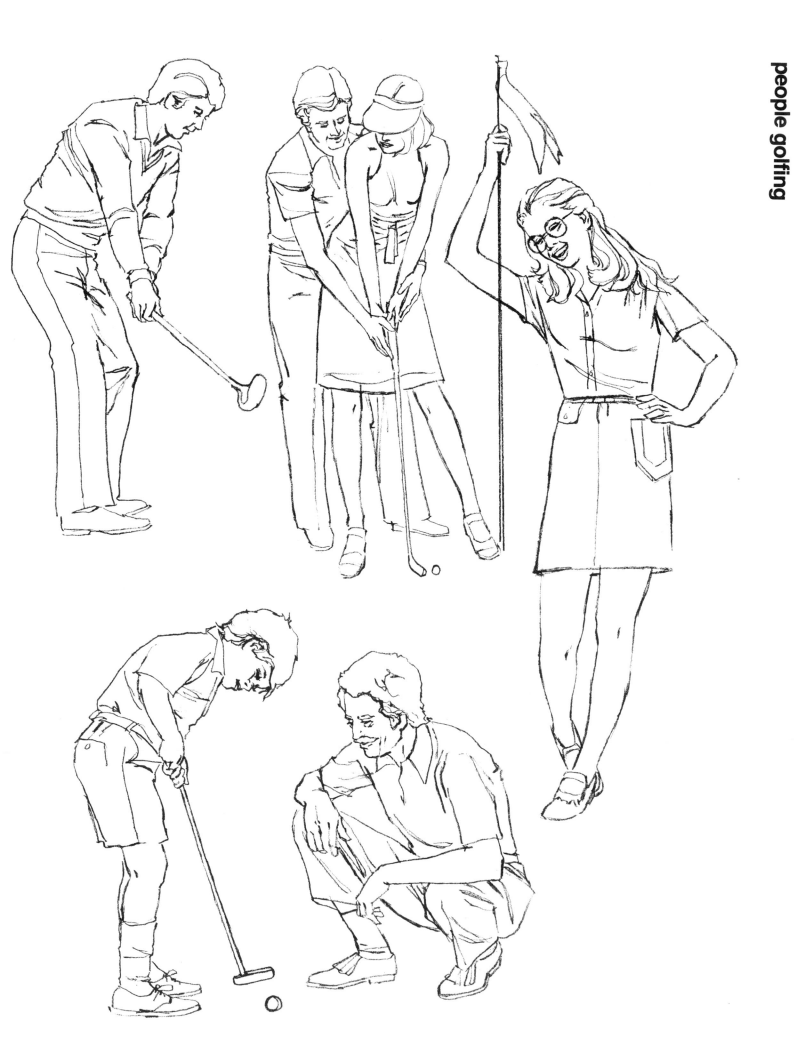

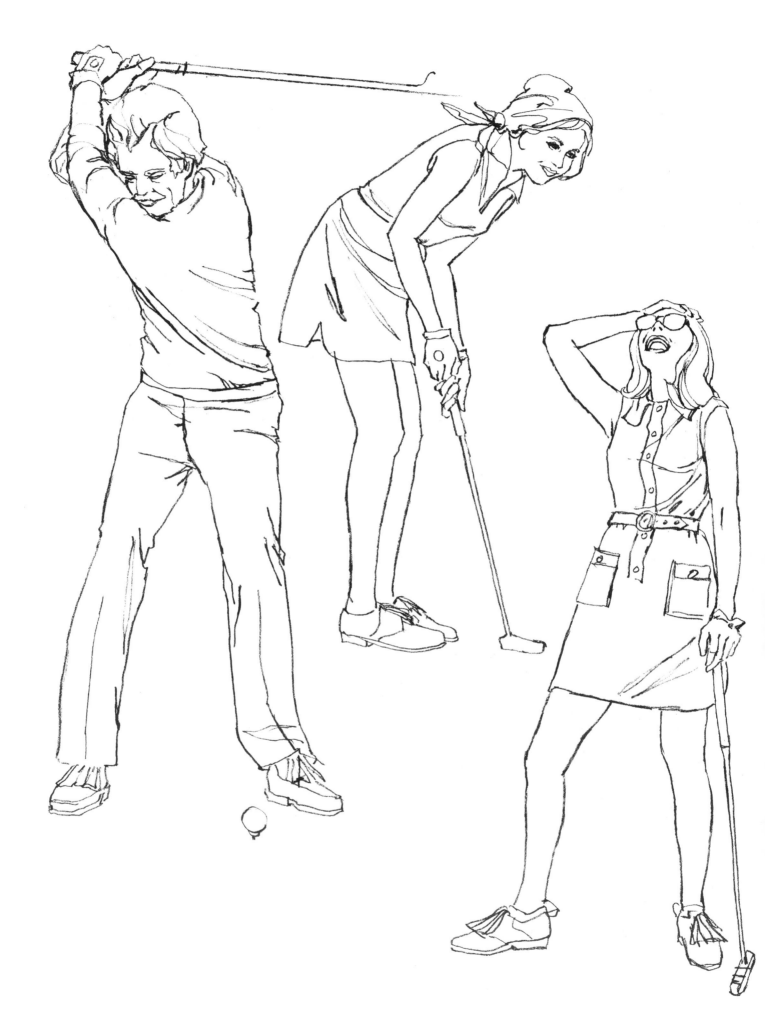

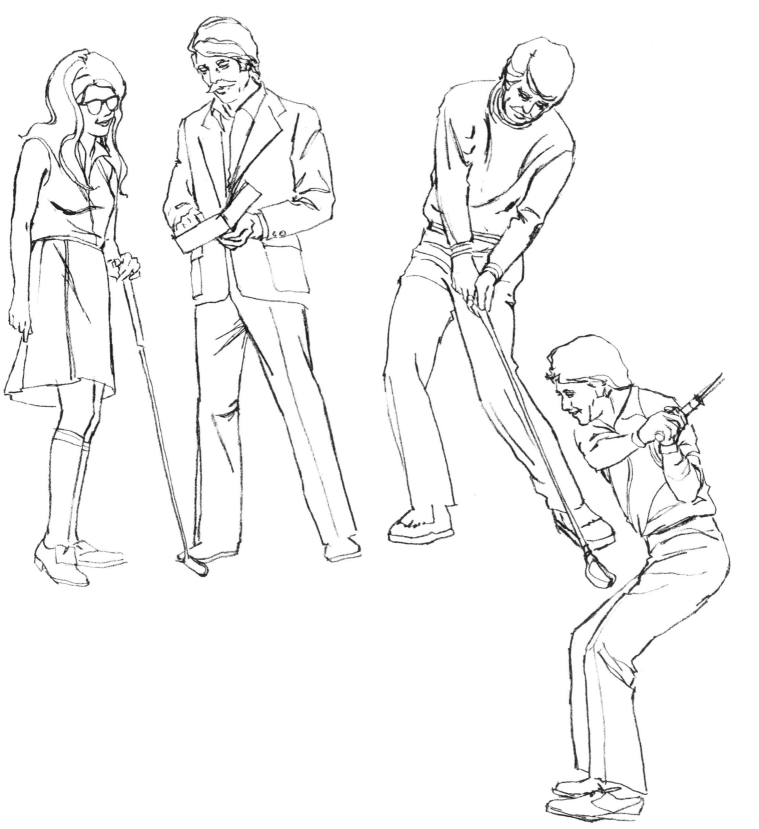

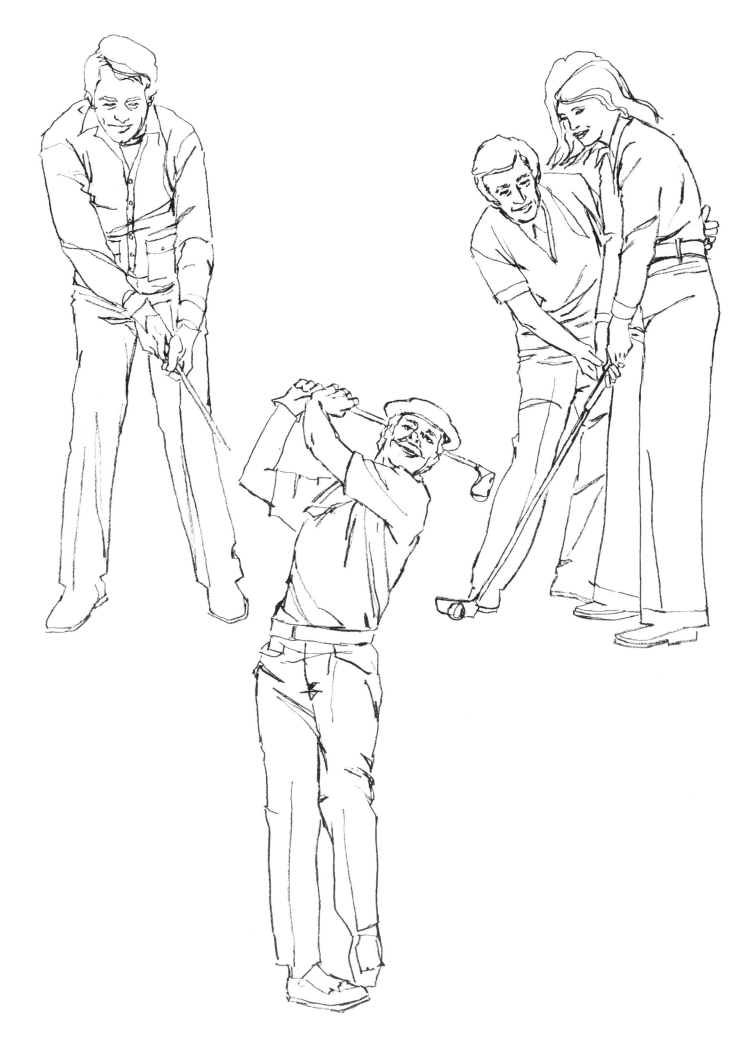

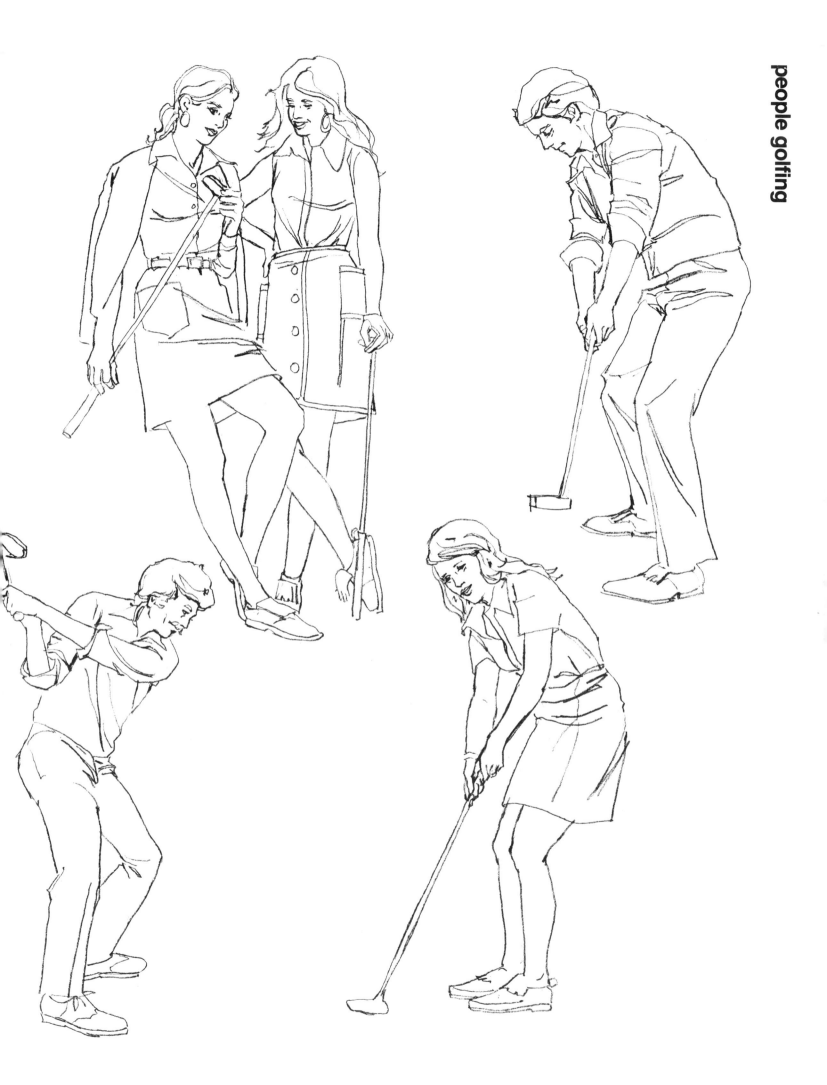

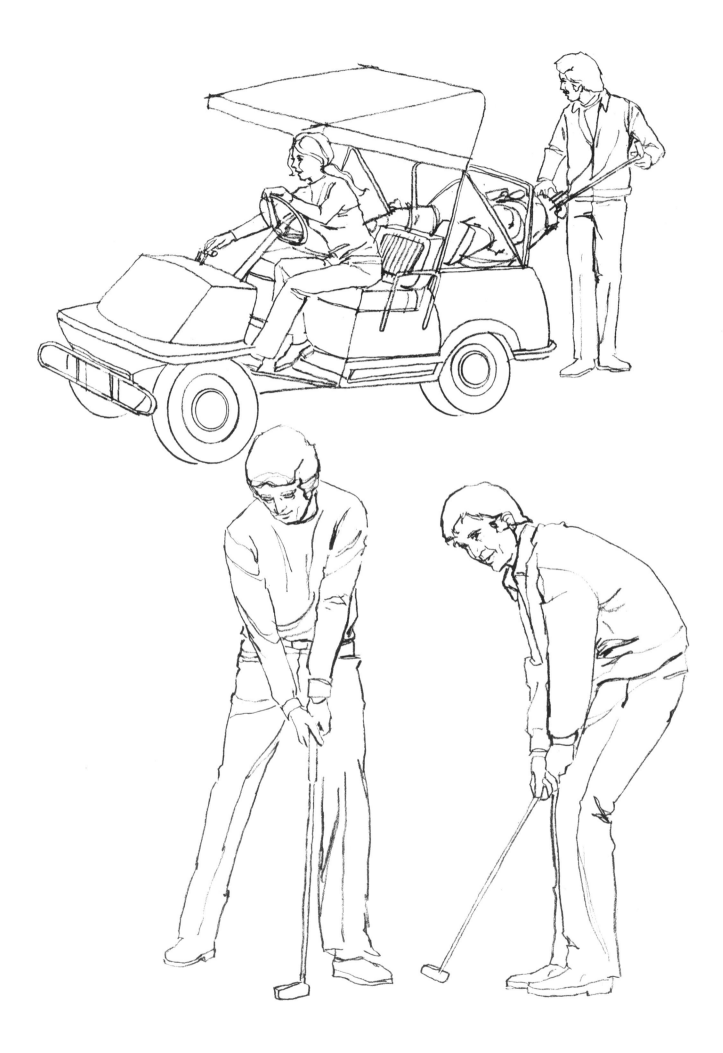

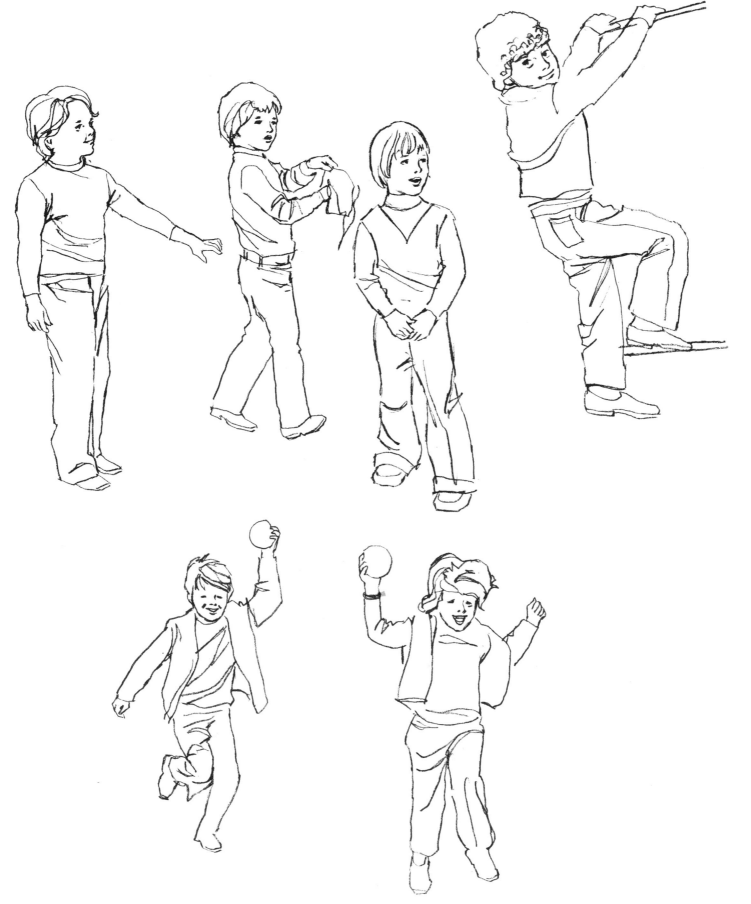

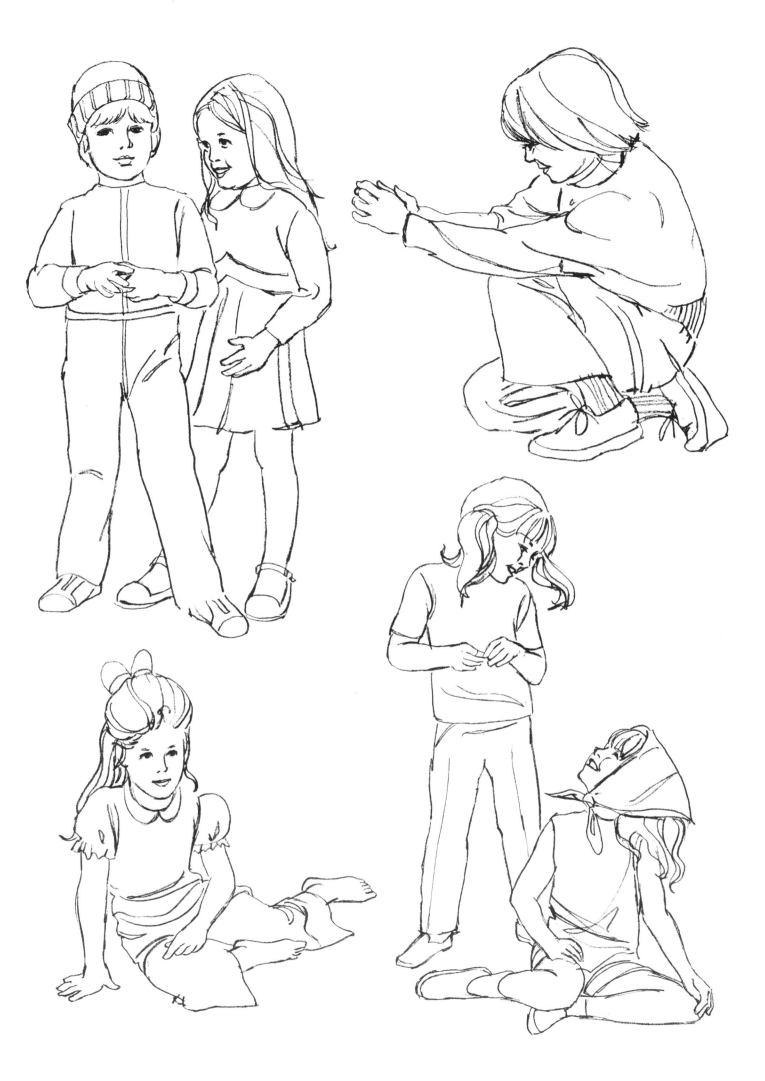

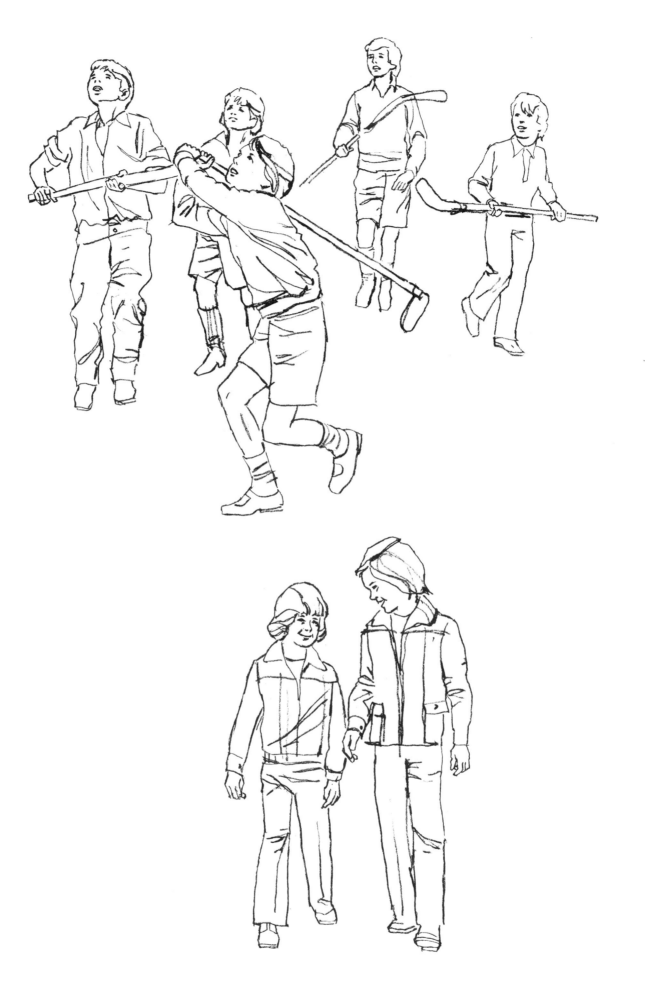

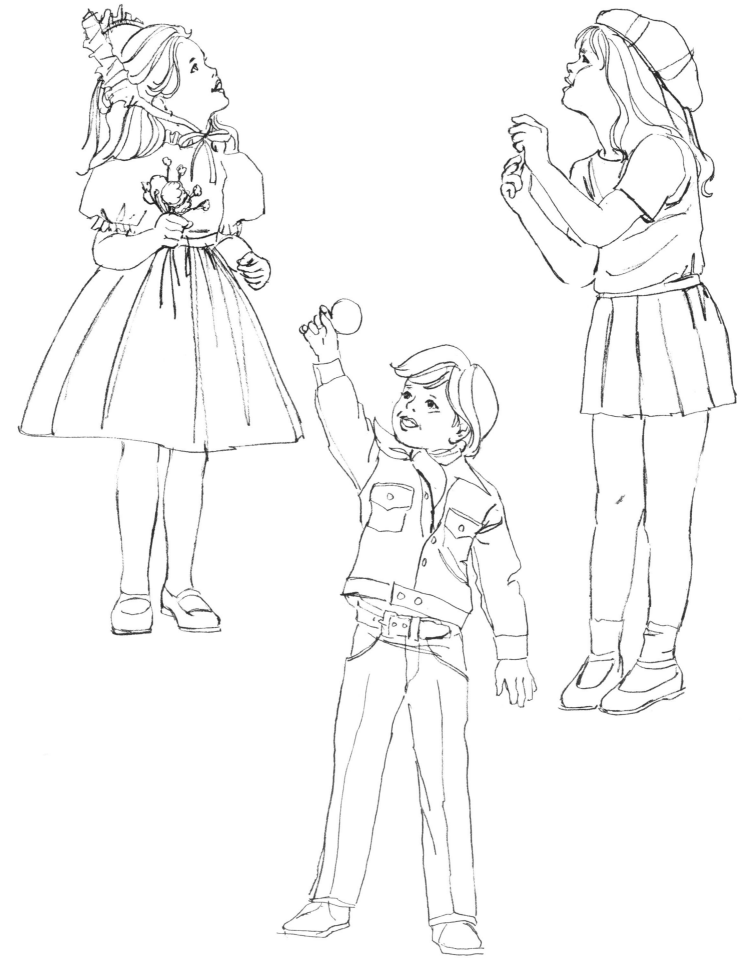

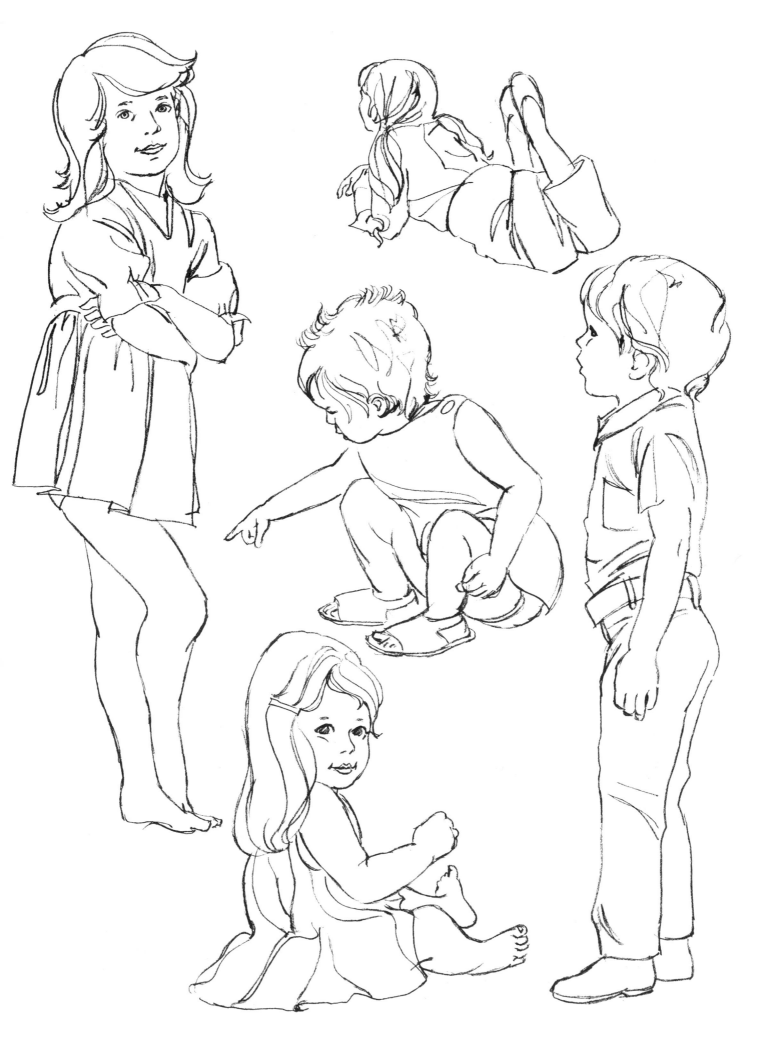

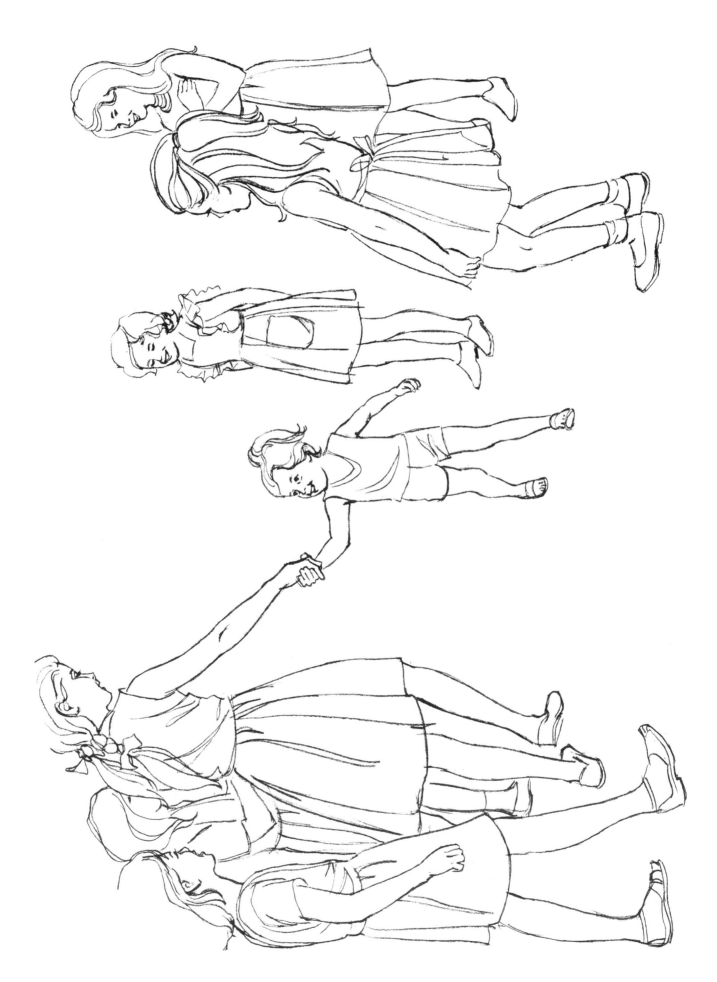

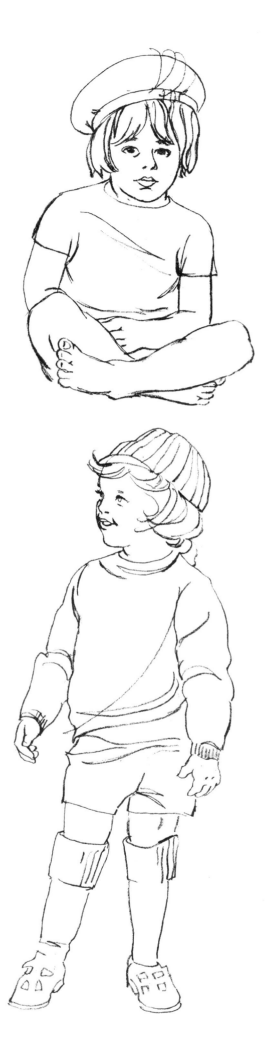

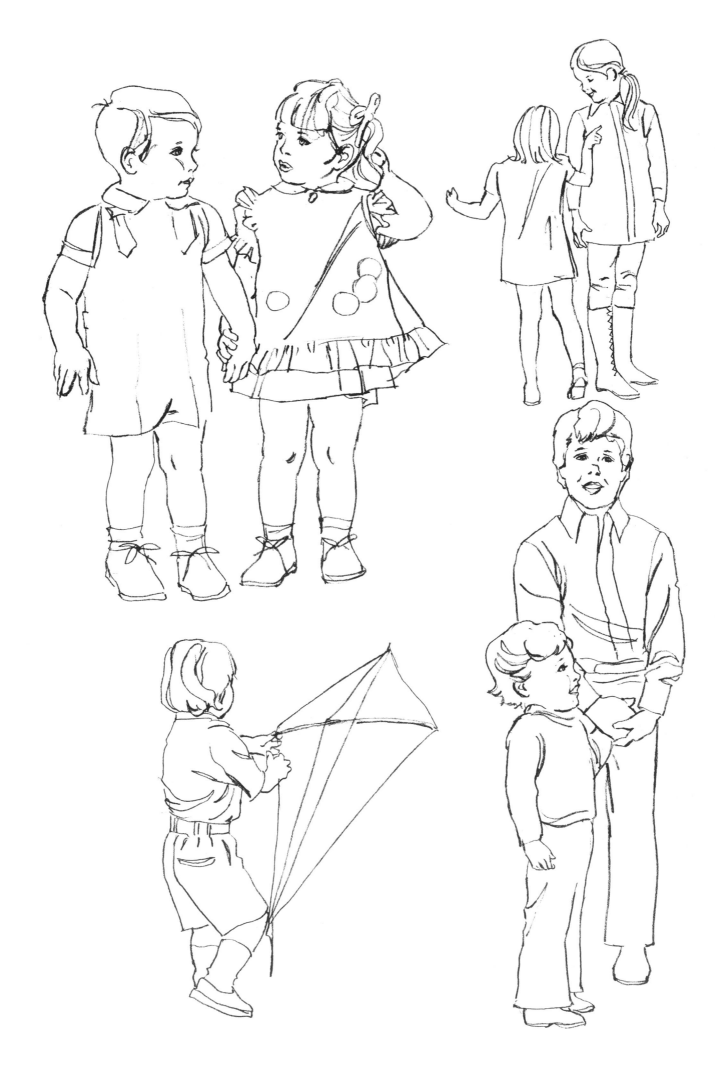

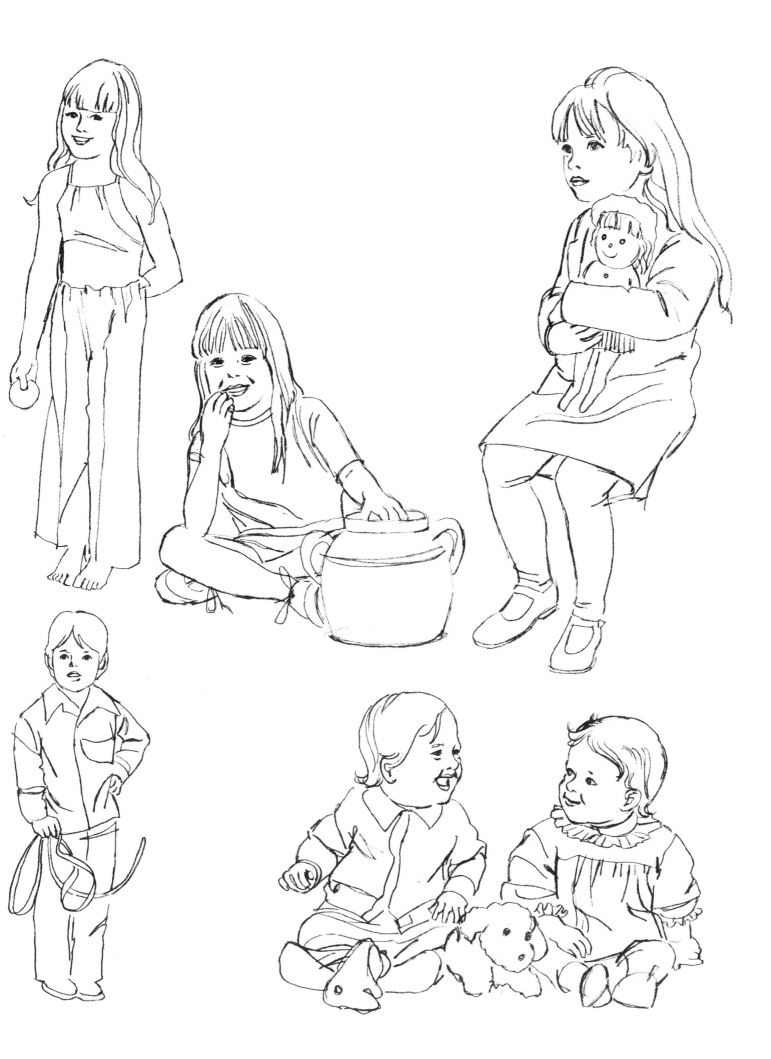

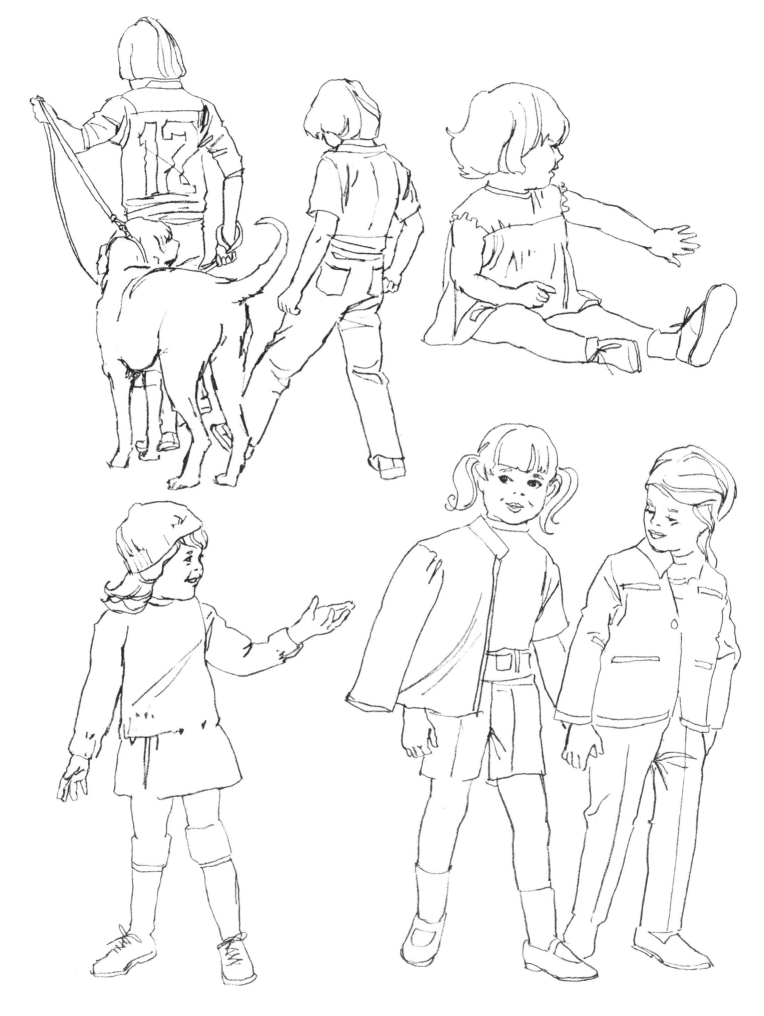

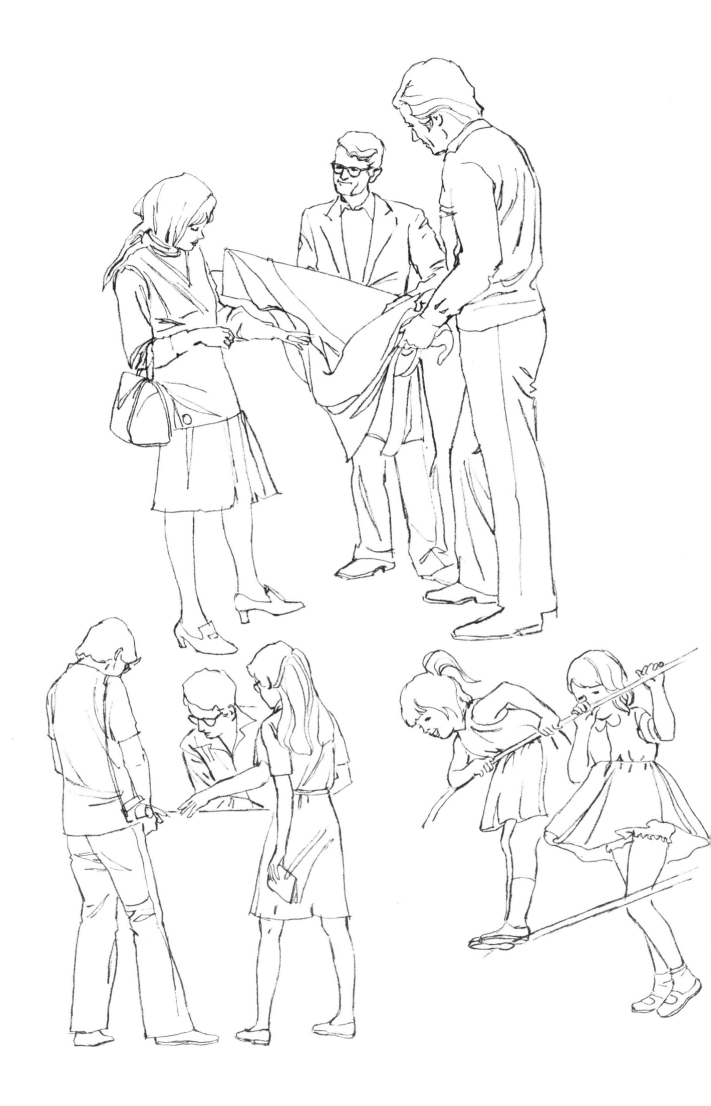

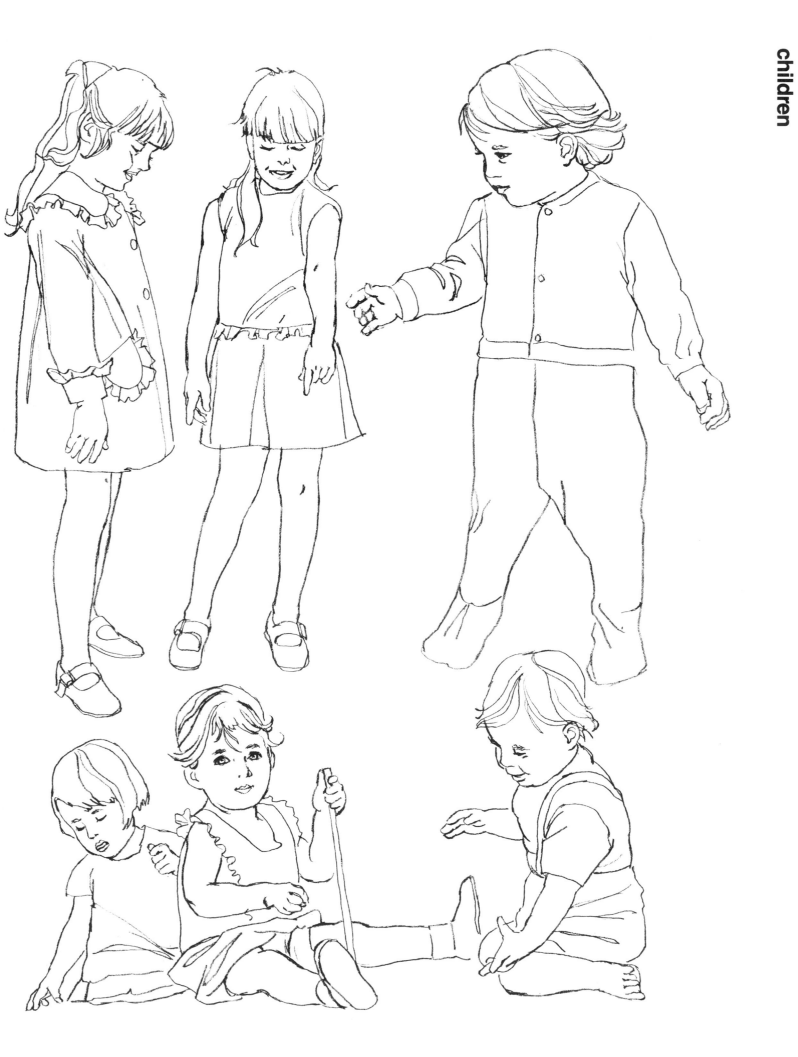

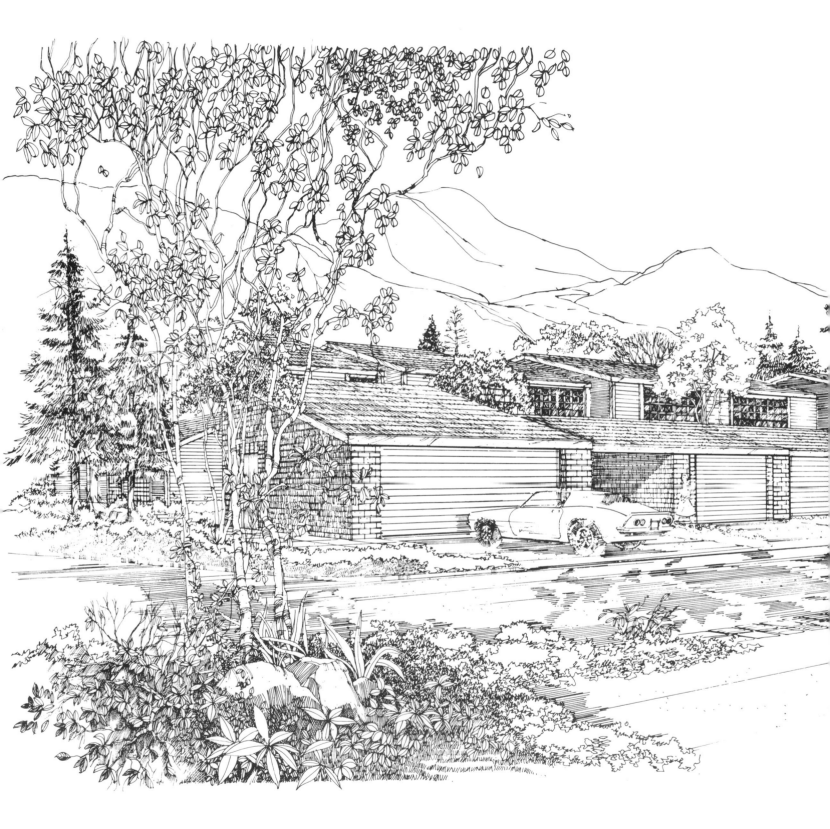

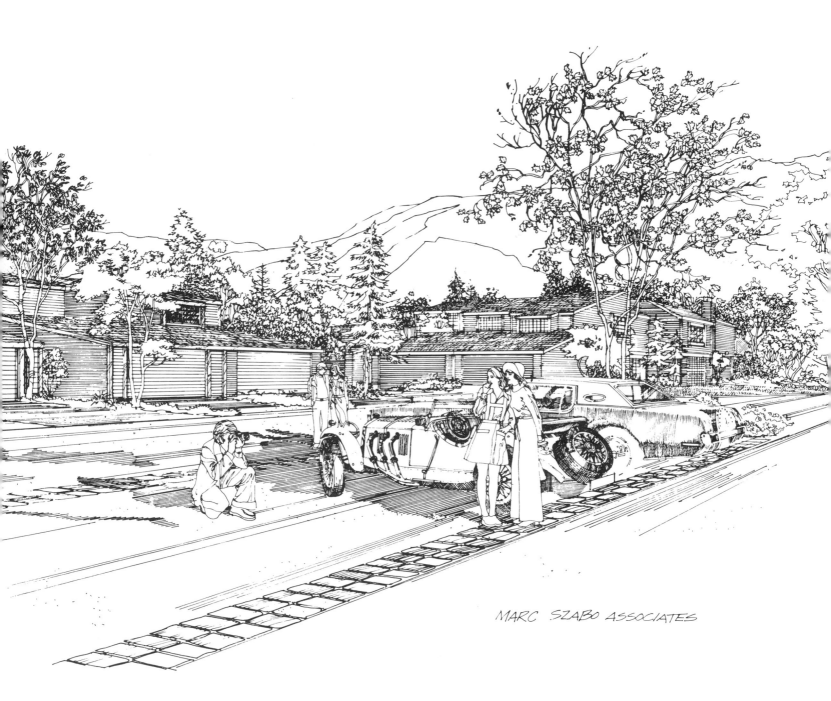

MARC SZABO ASSOCIATES

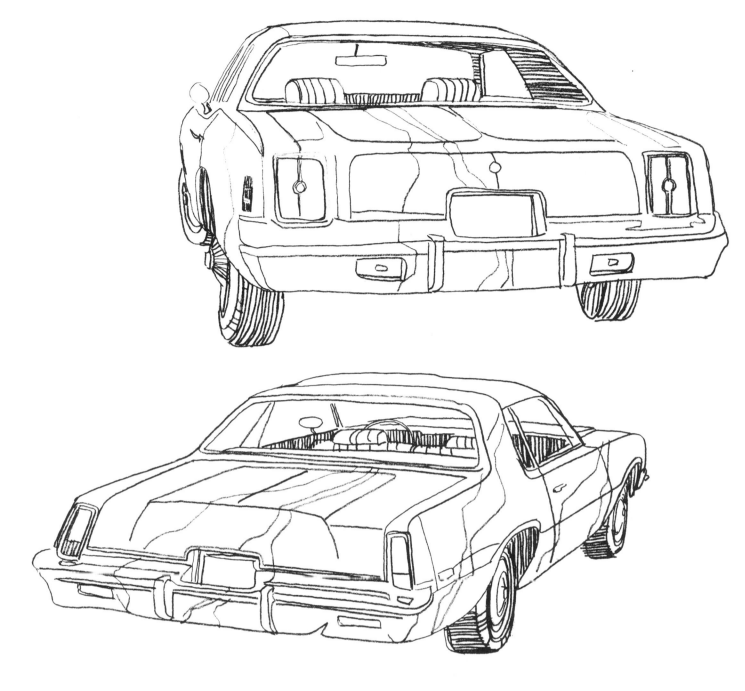

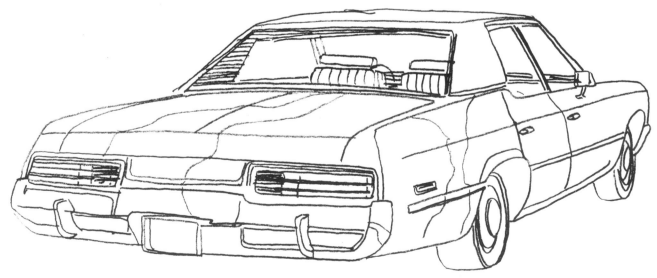

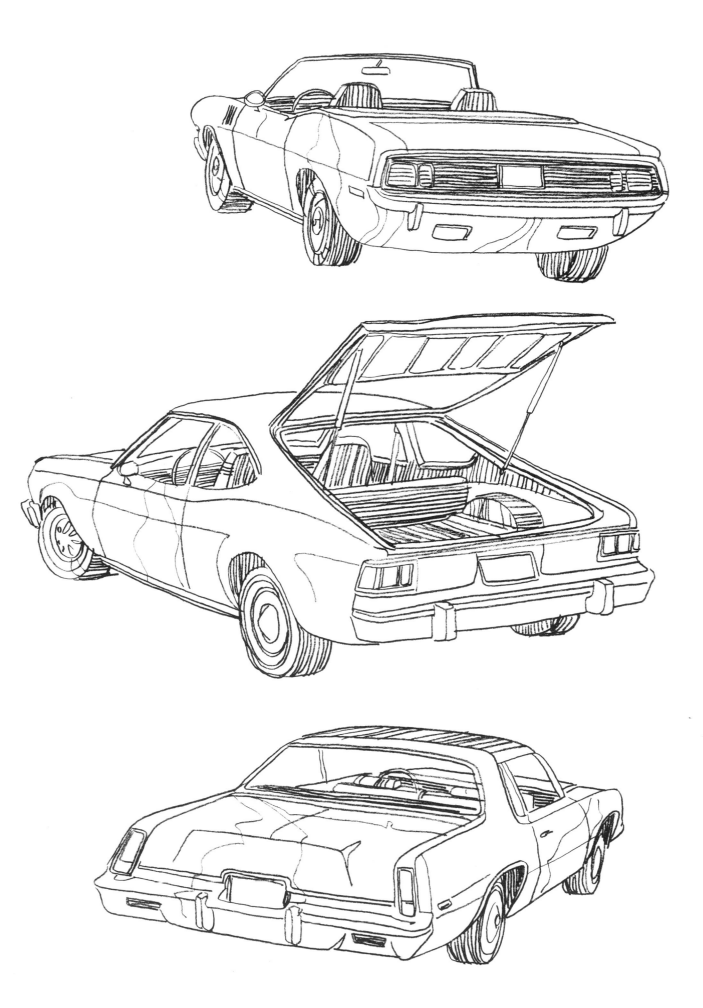

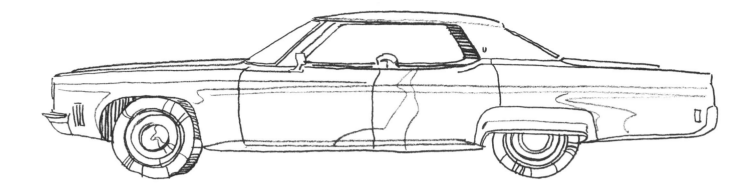

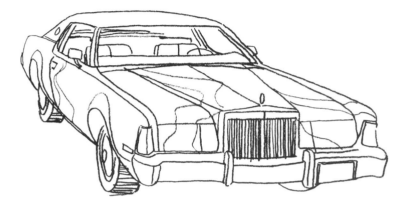

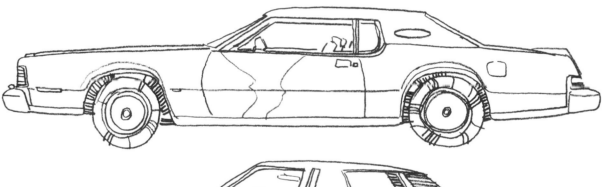

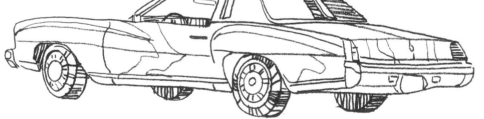

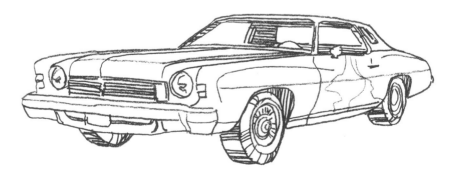

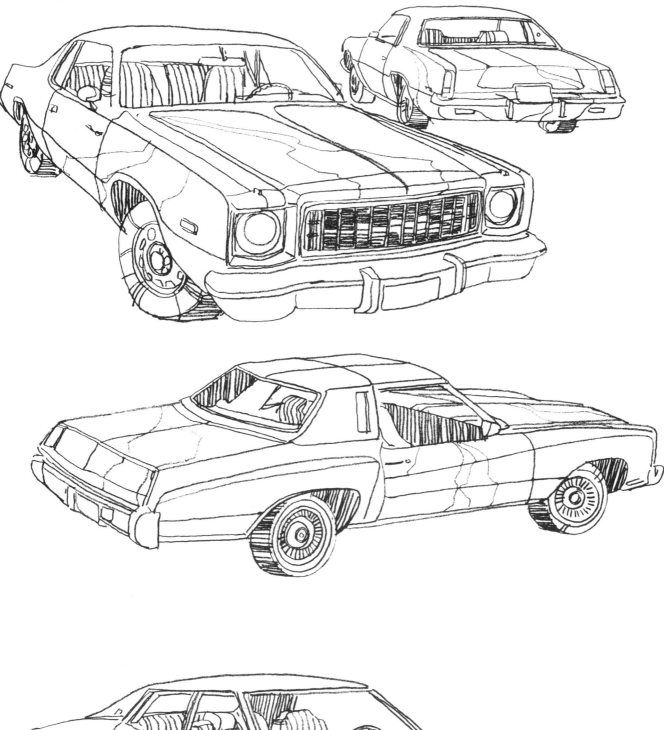

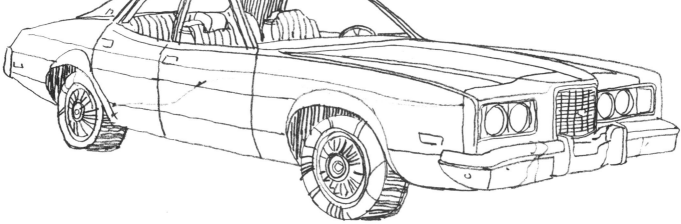

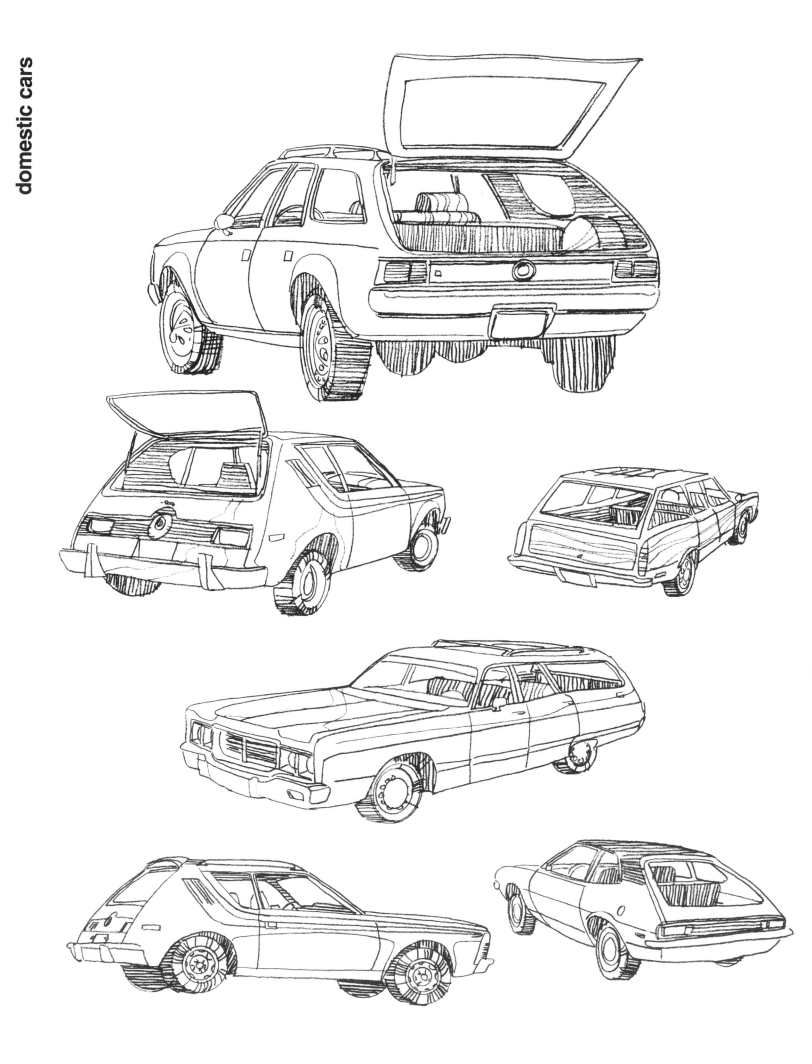

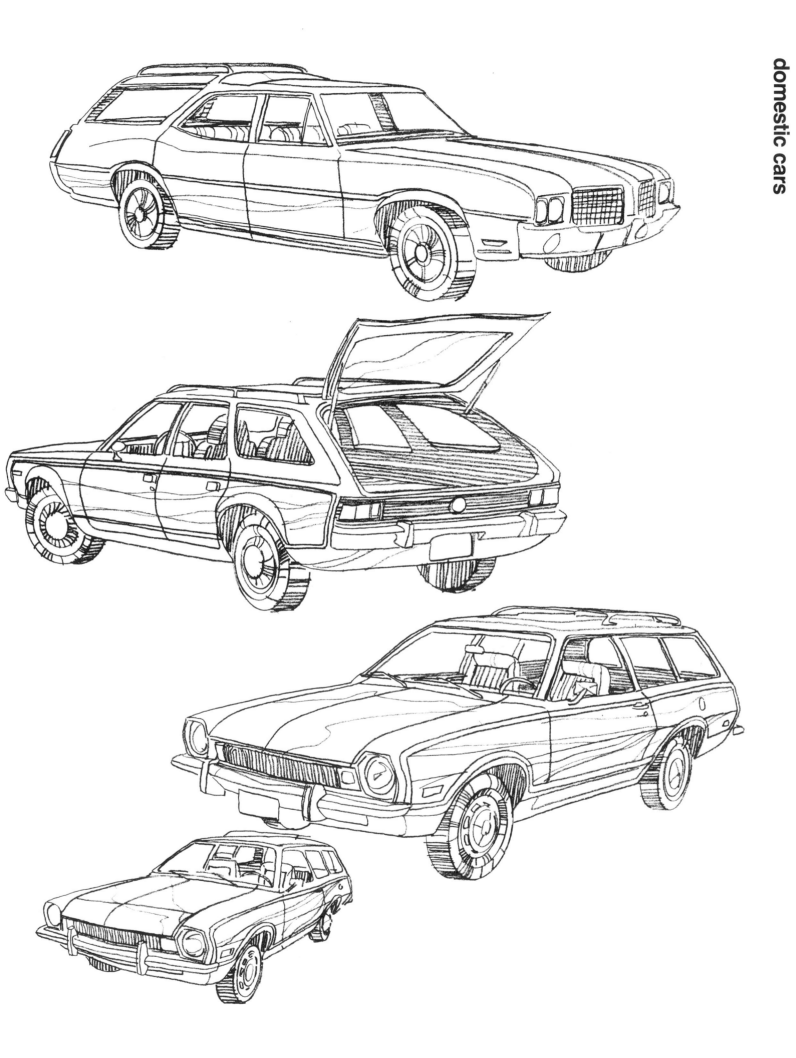

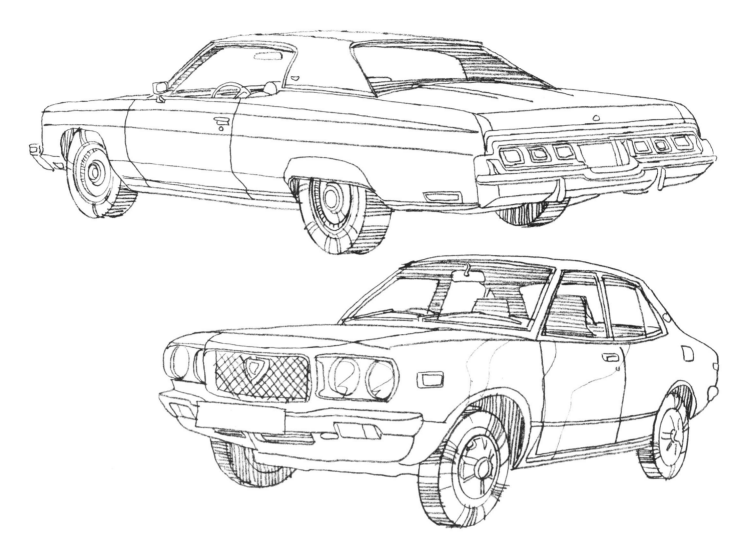

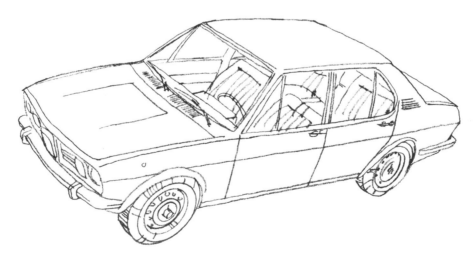

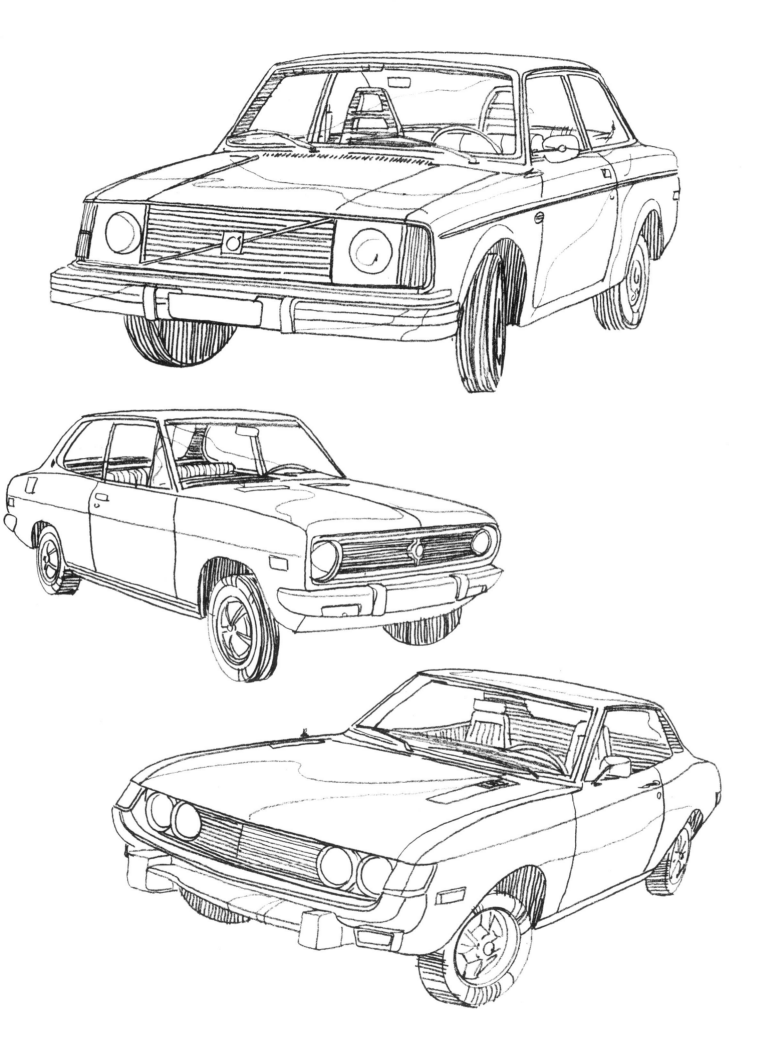

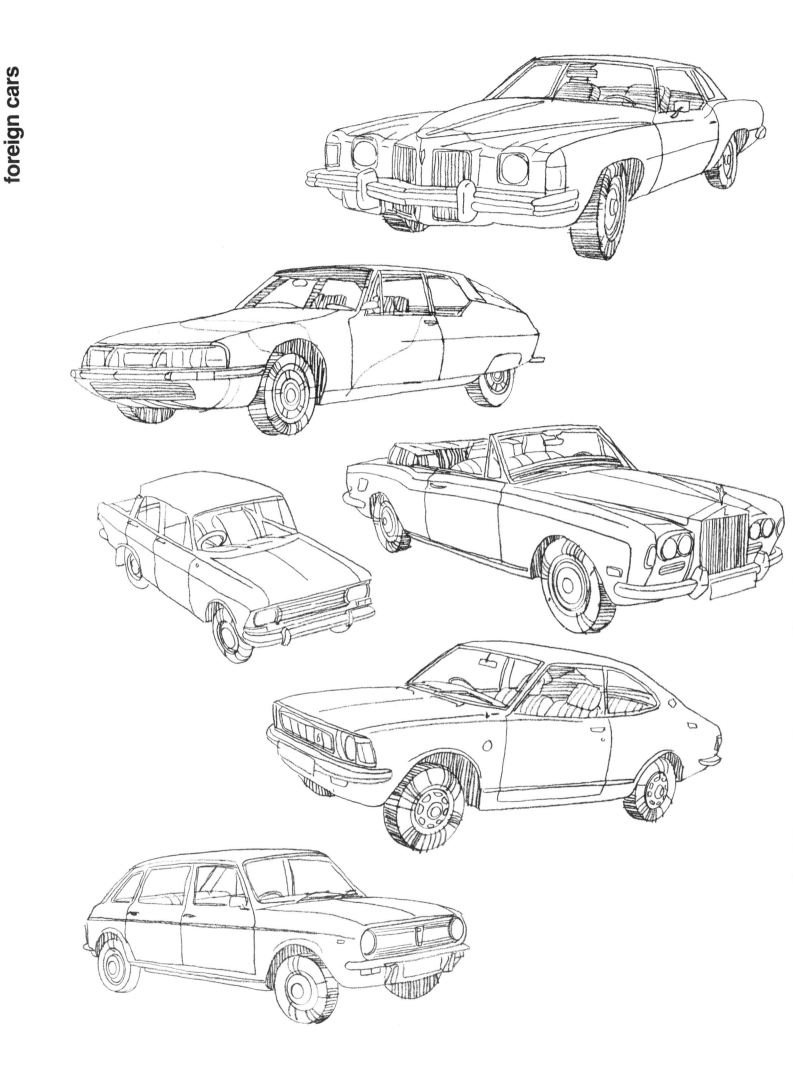

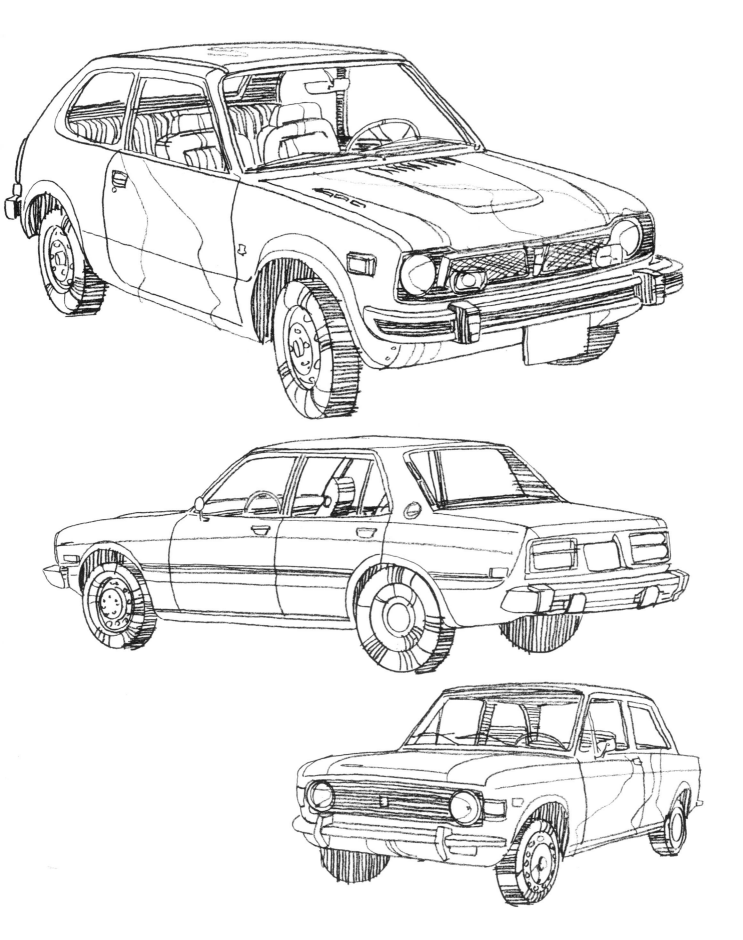

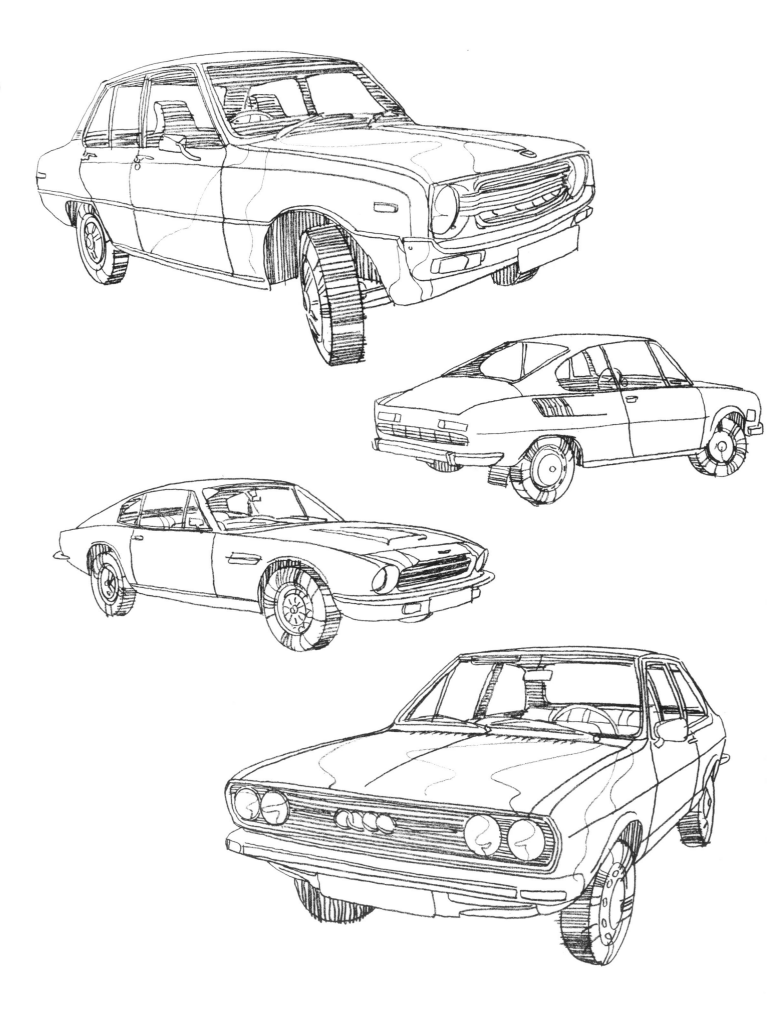

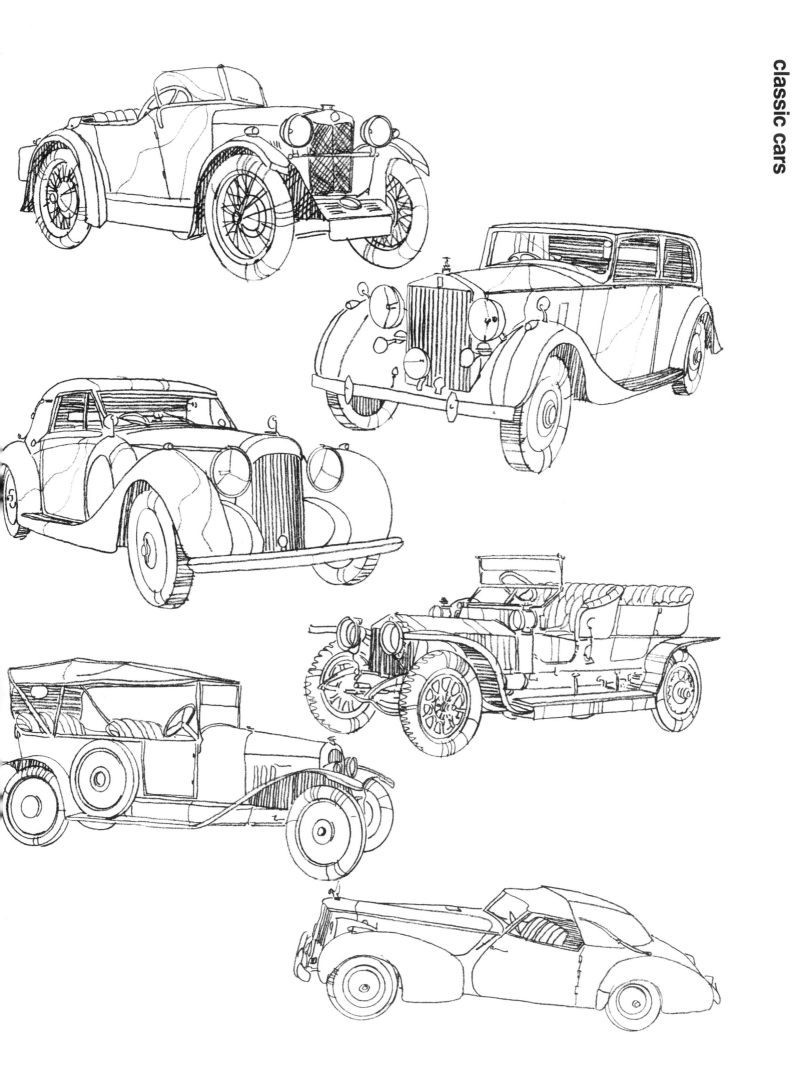

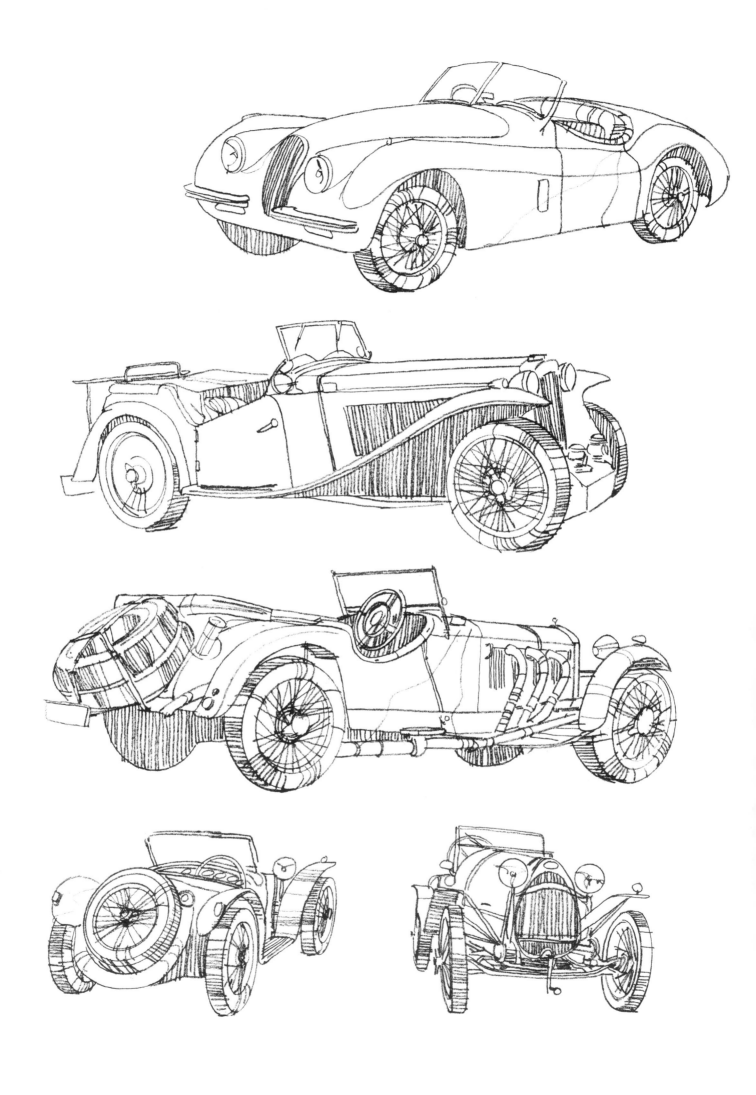

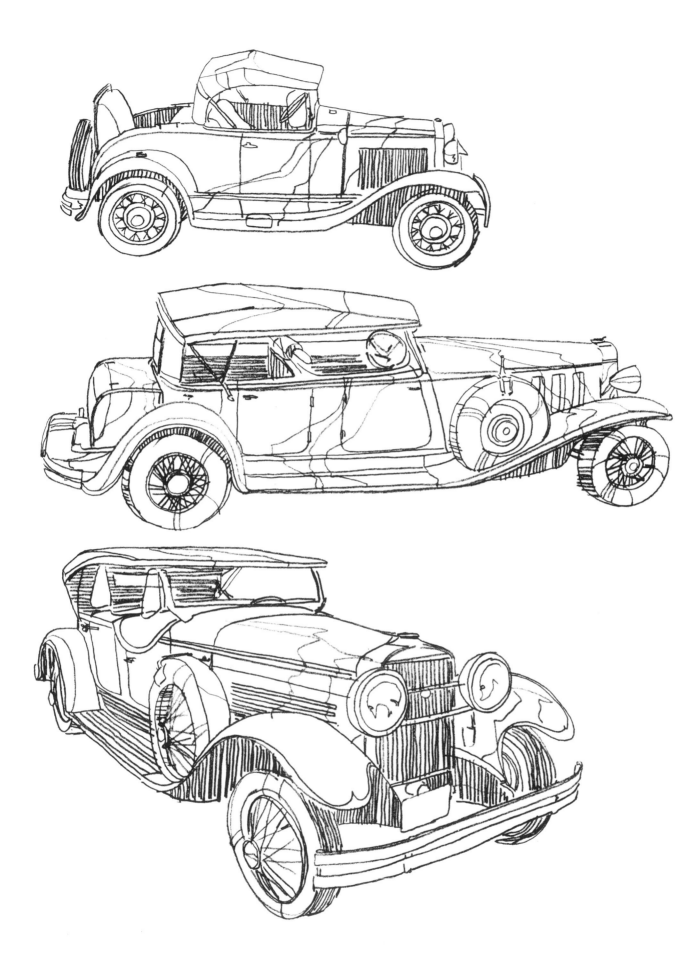

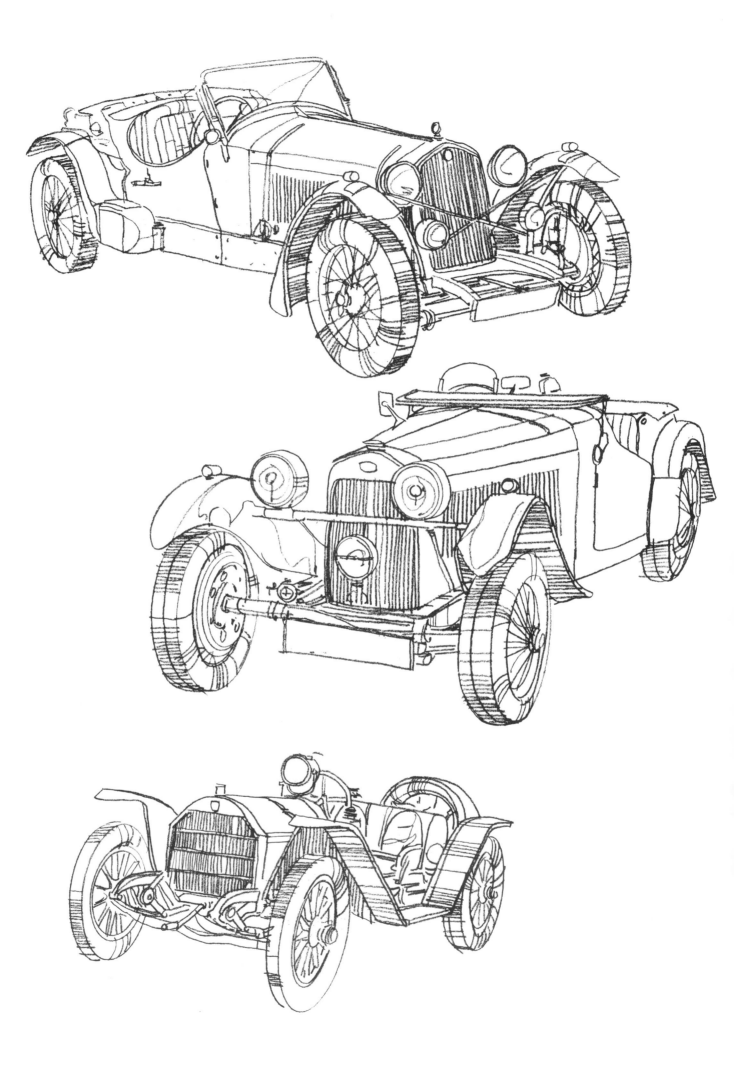

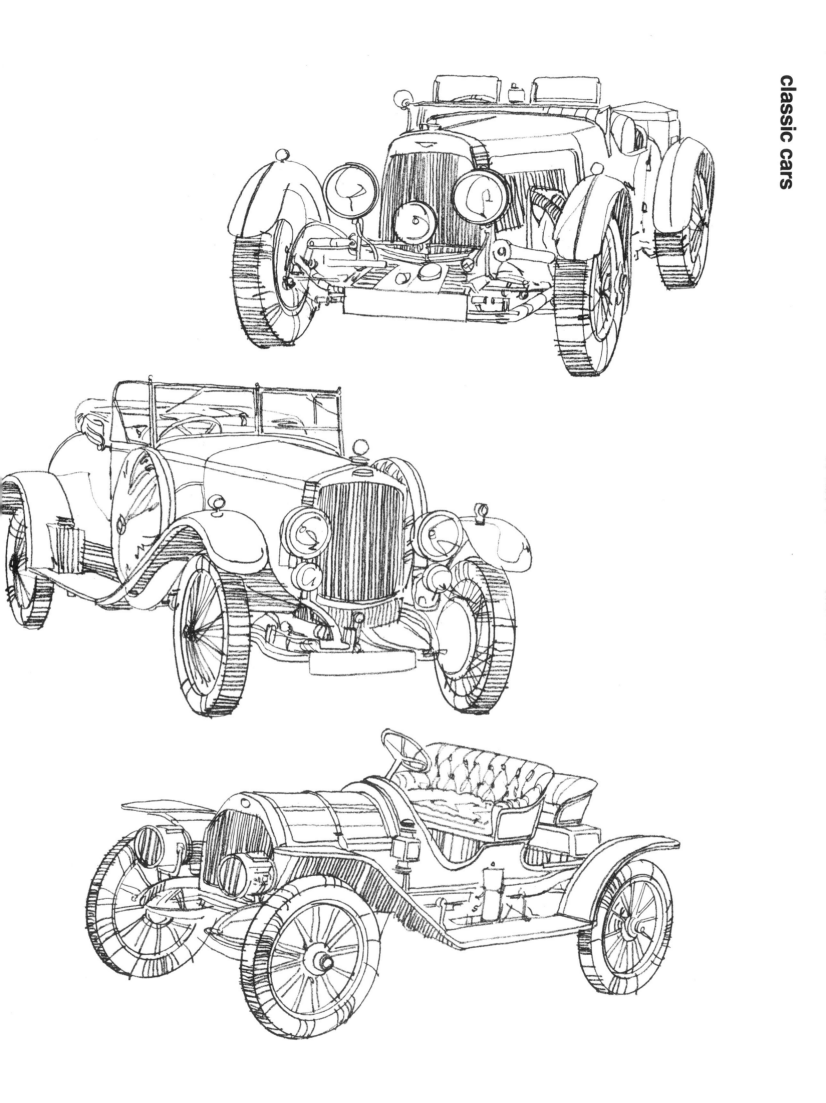

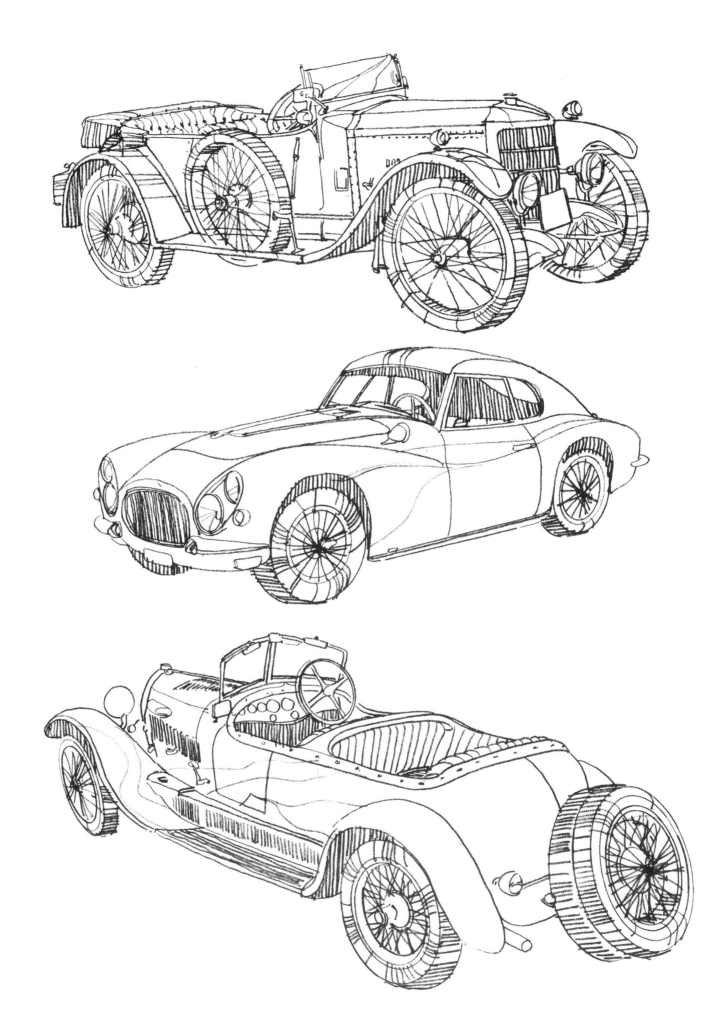

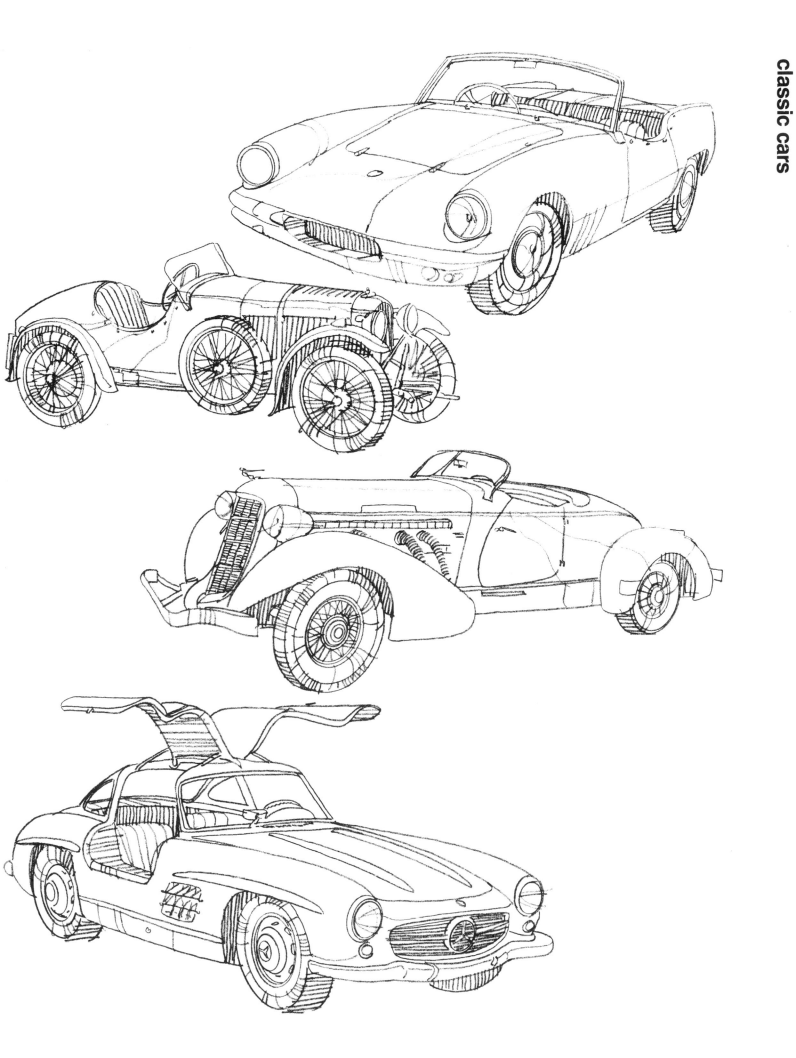

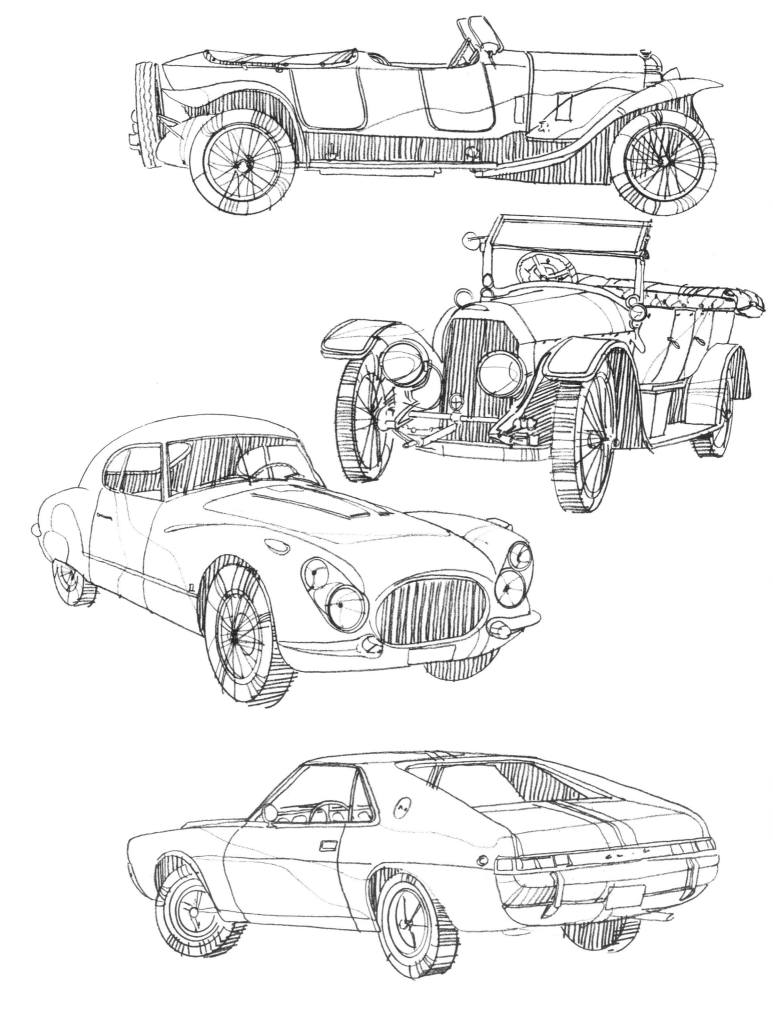

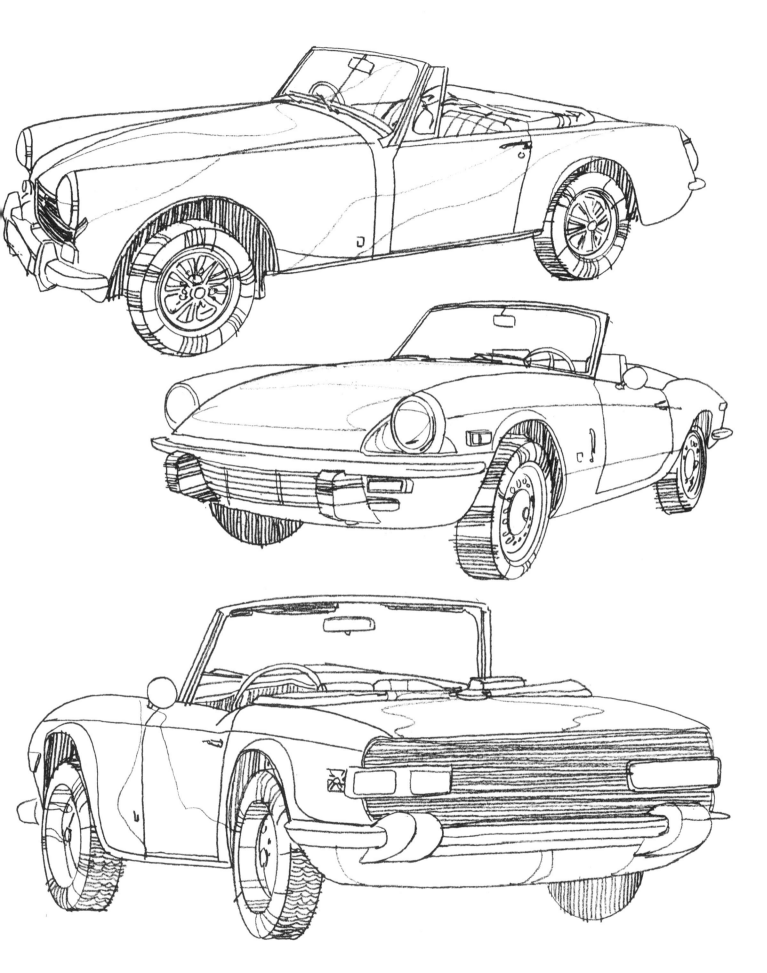

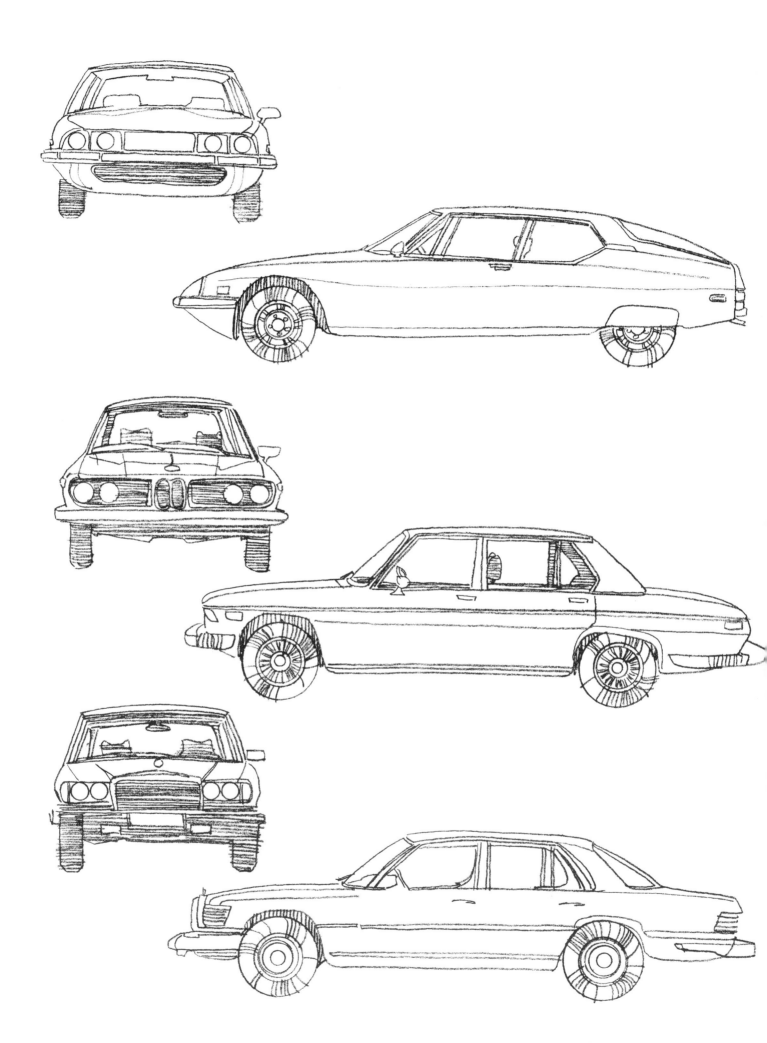

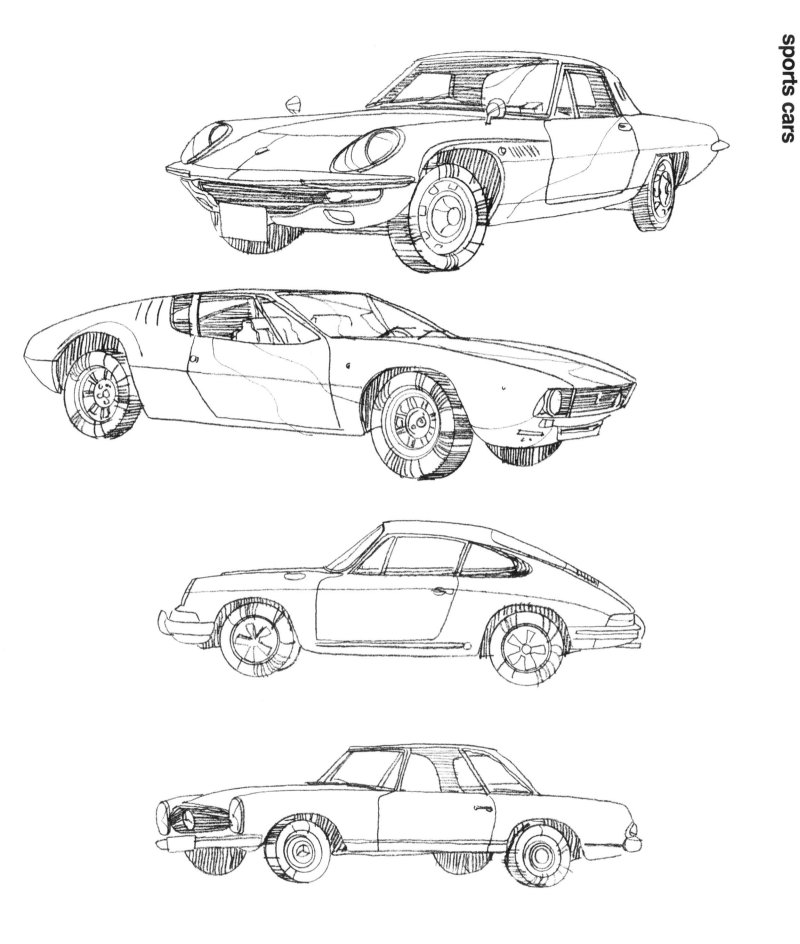

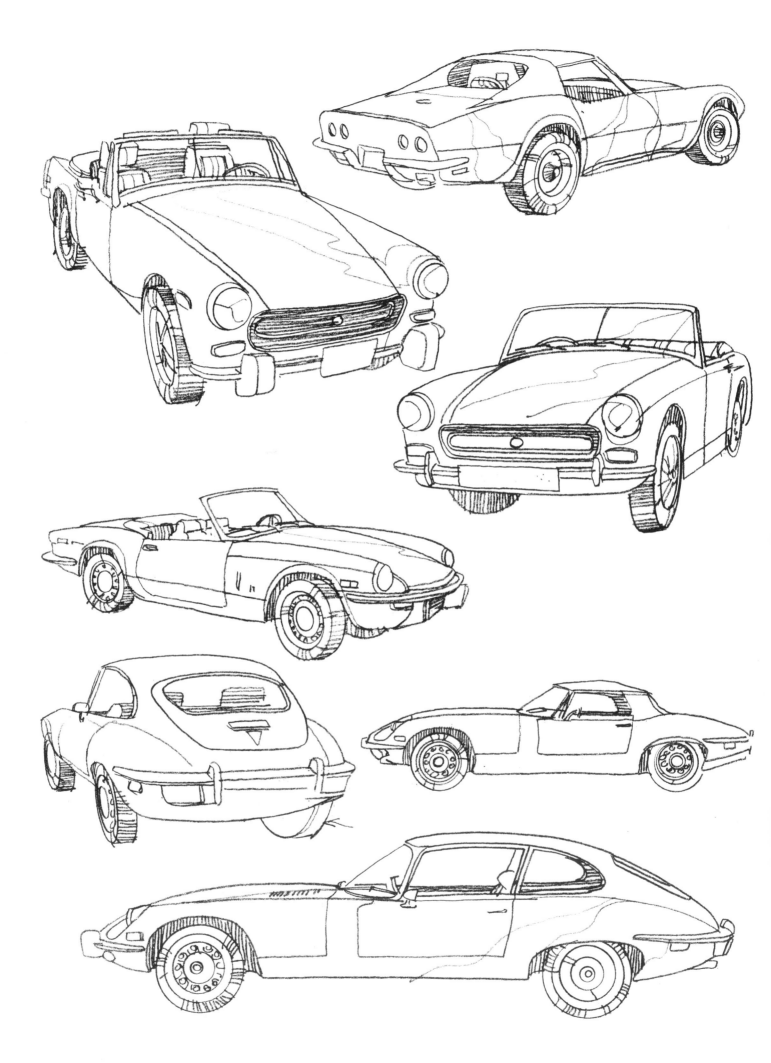

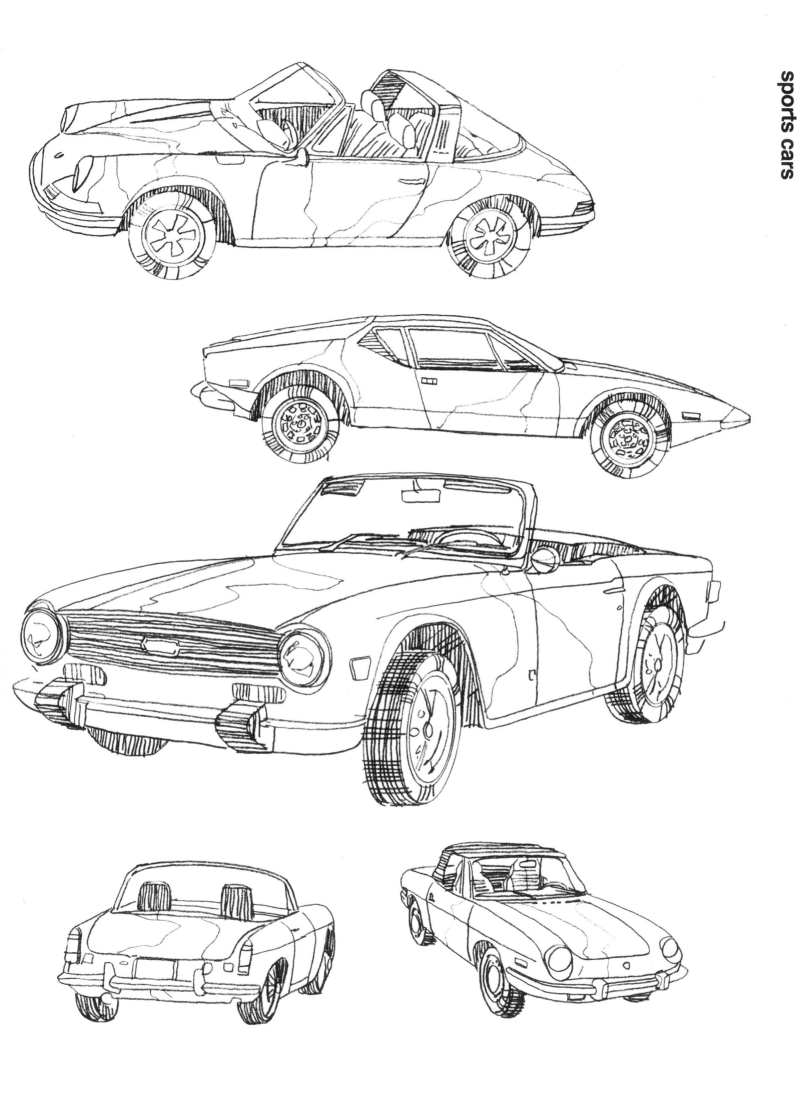

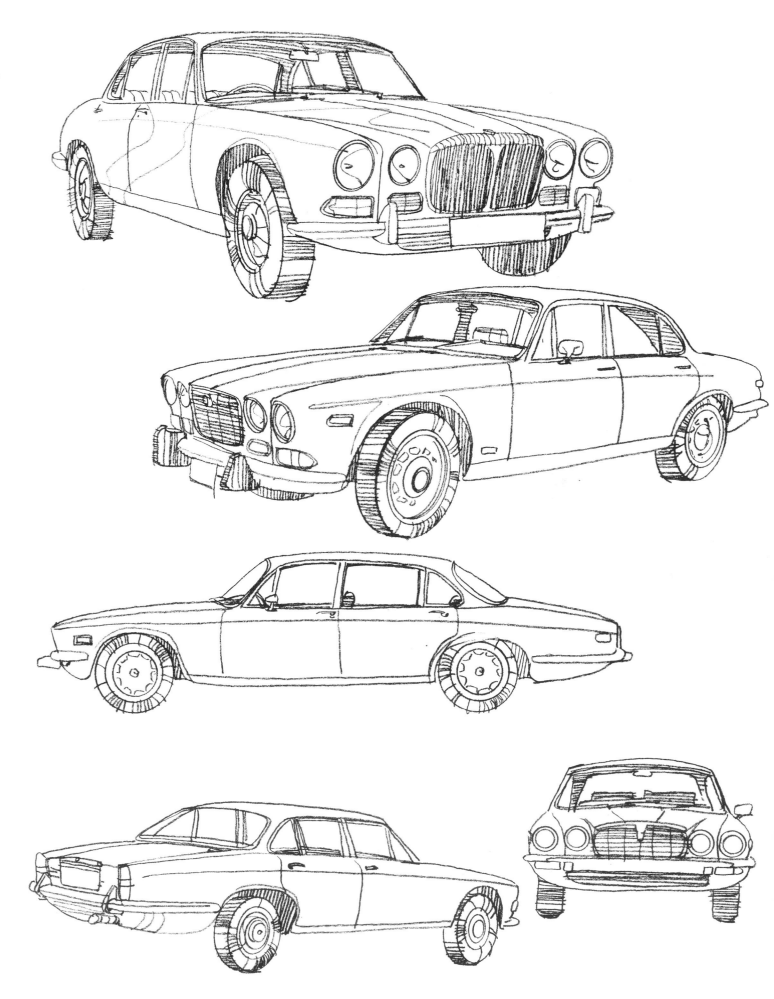

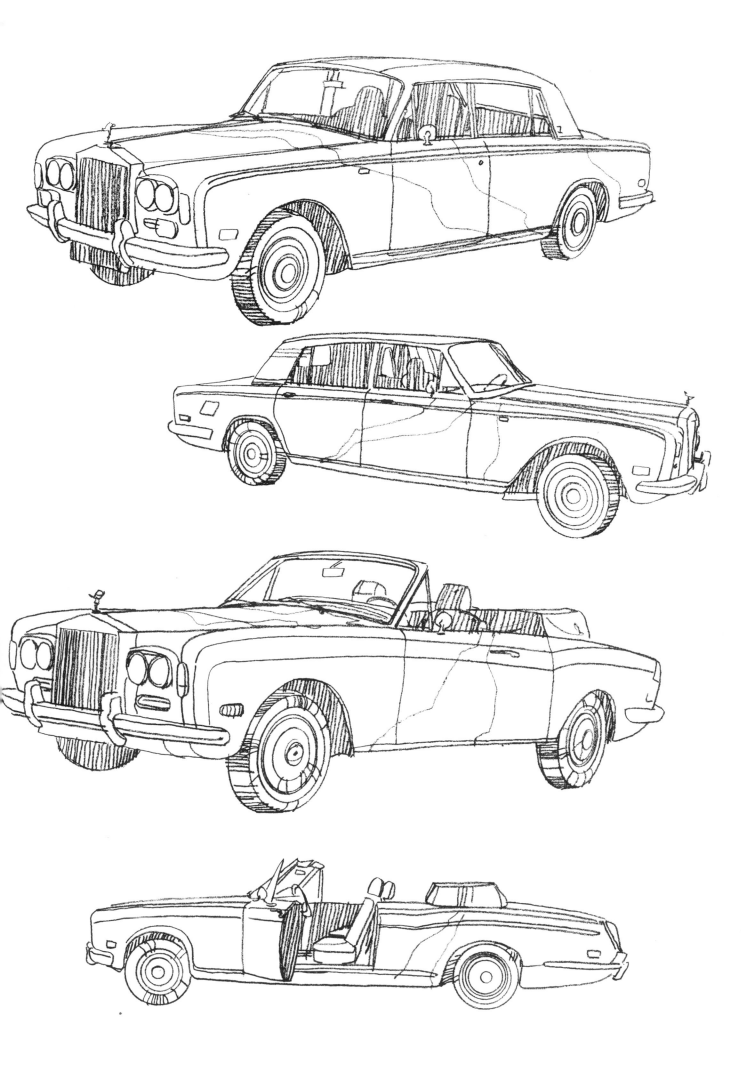

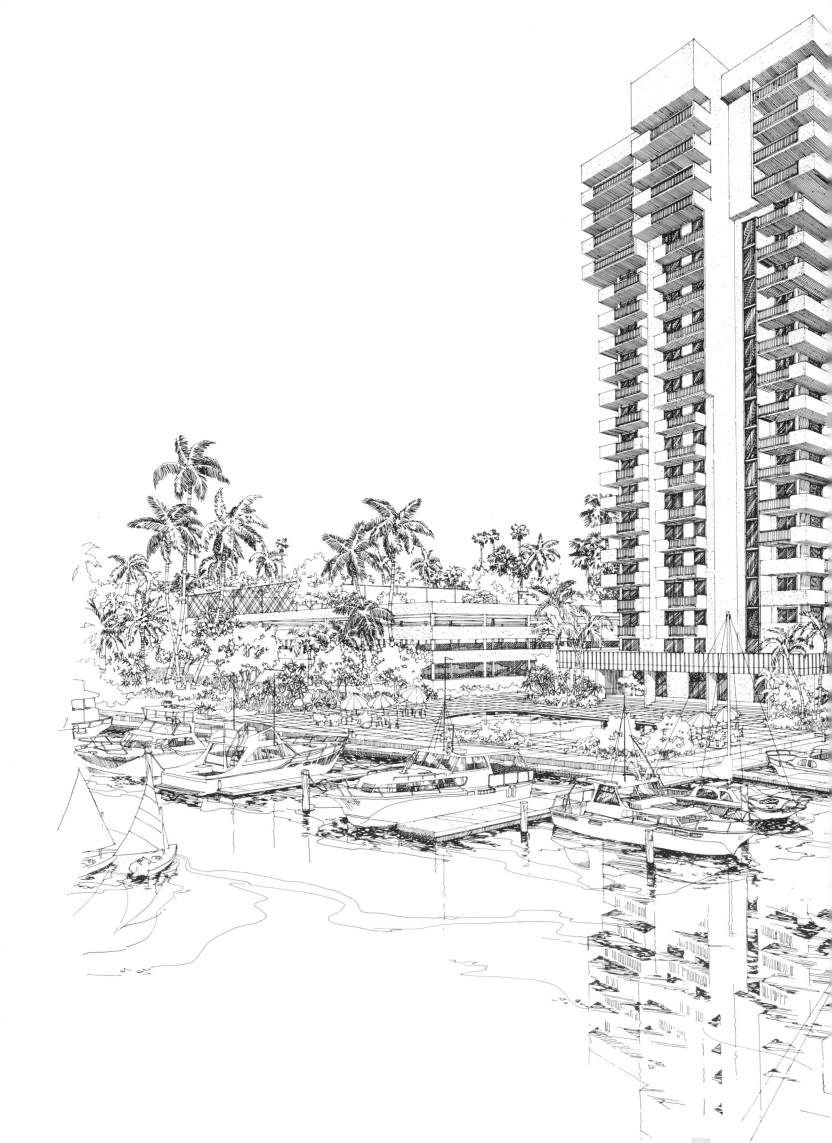

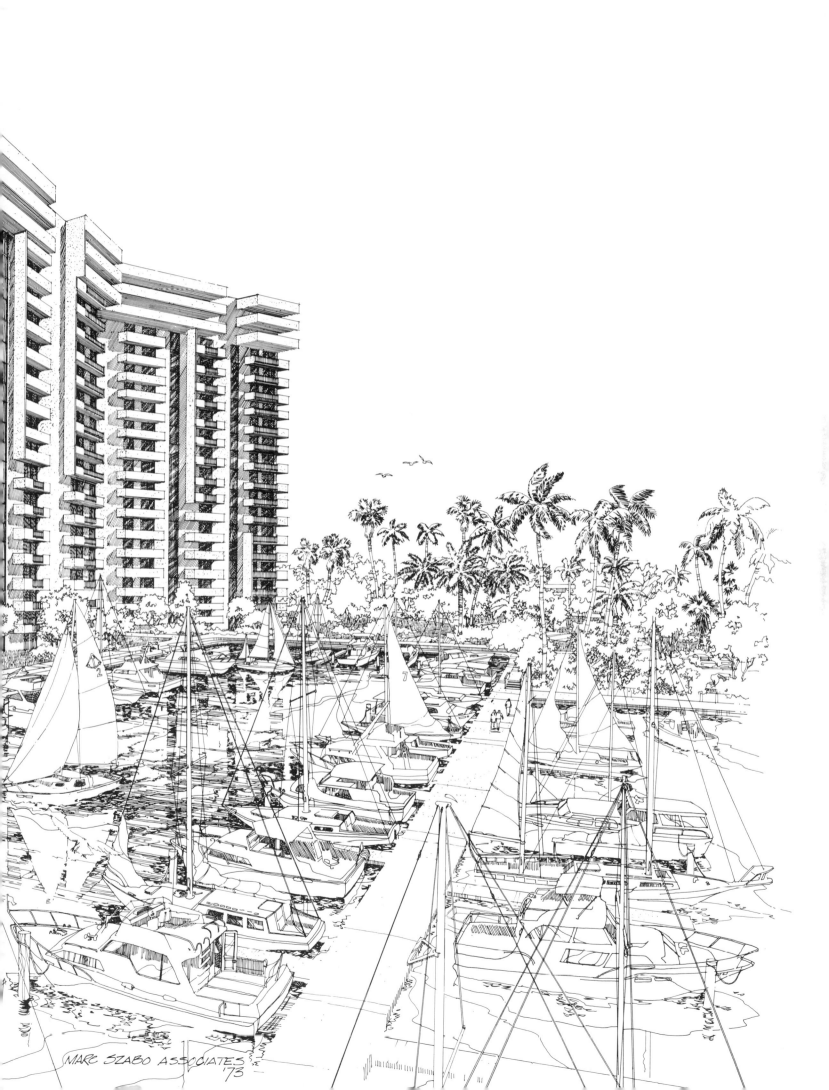

MARC SZABO ASSOCIATES
'73

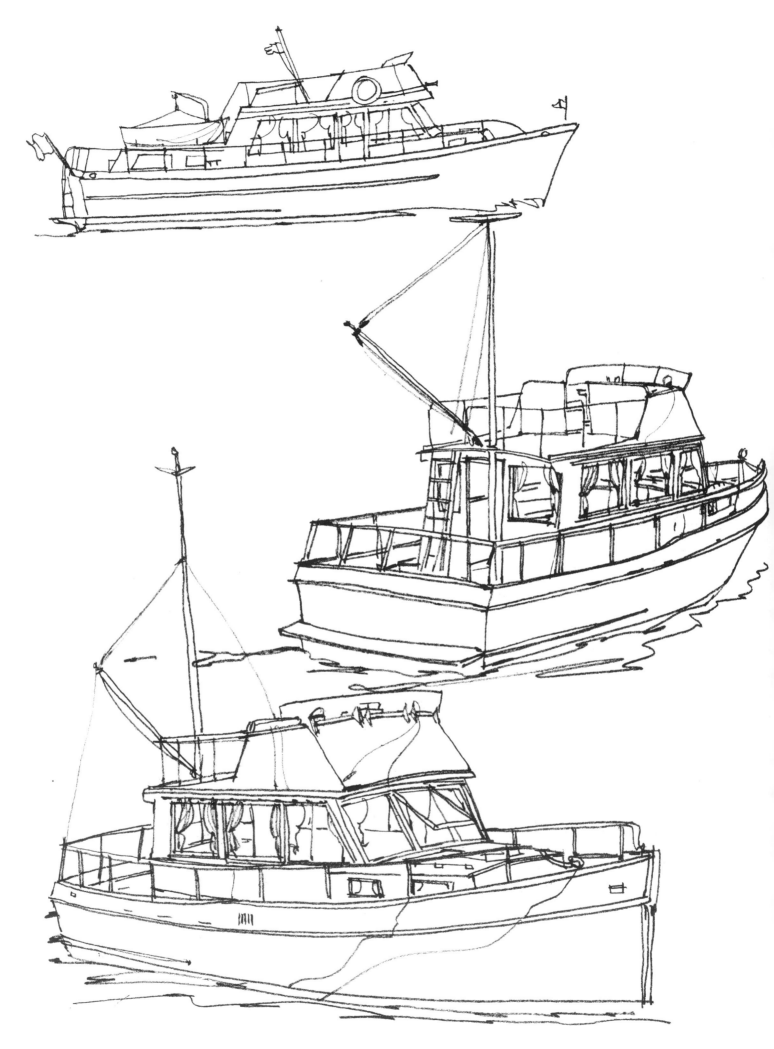

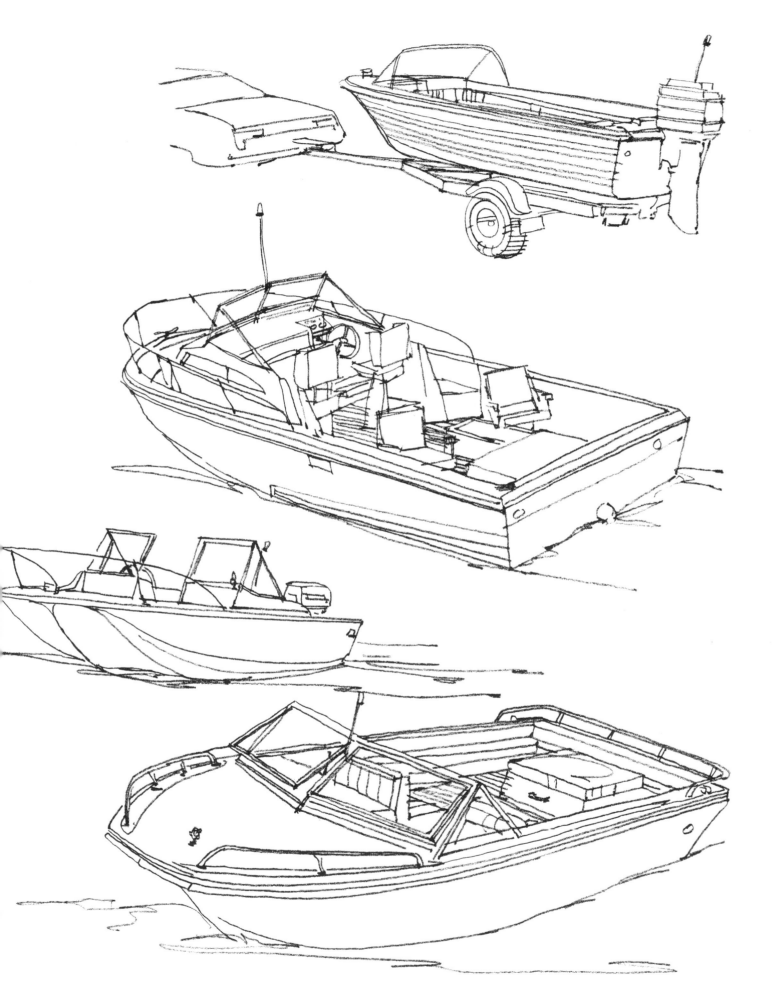

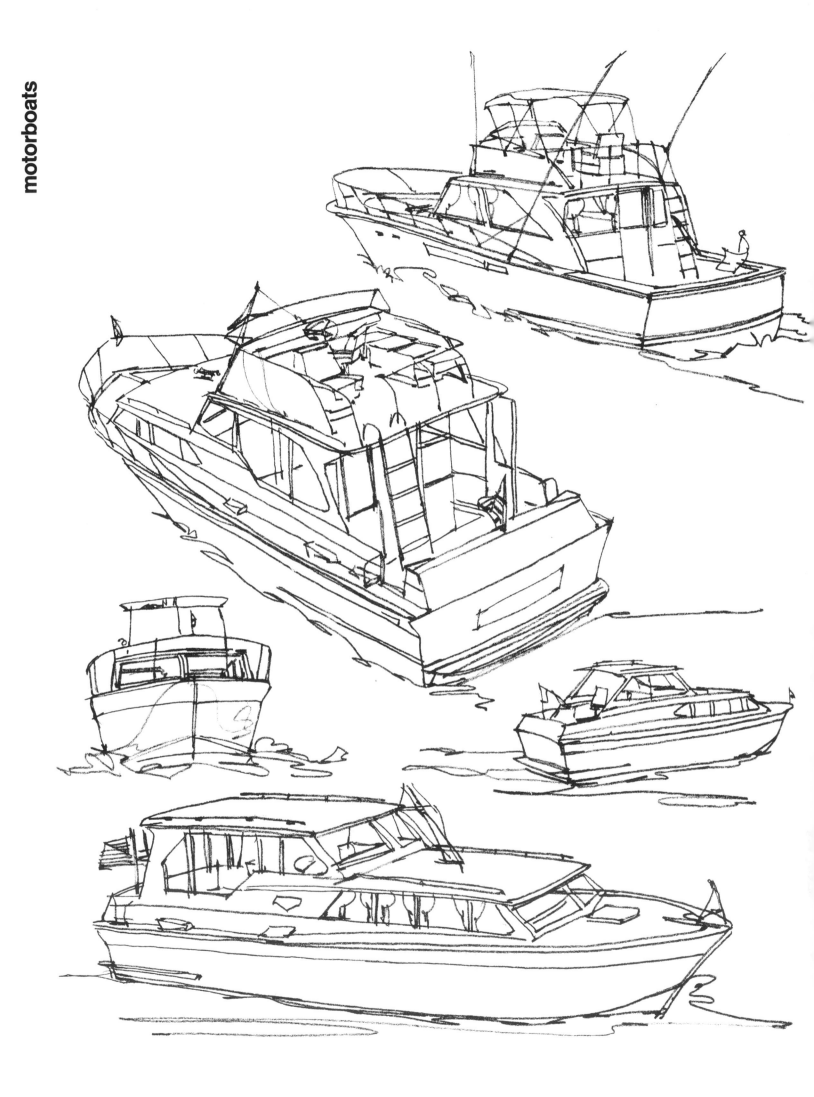

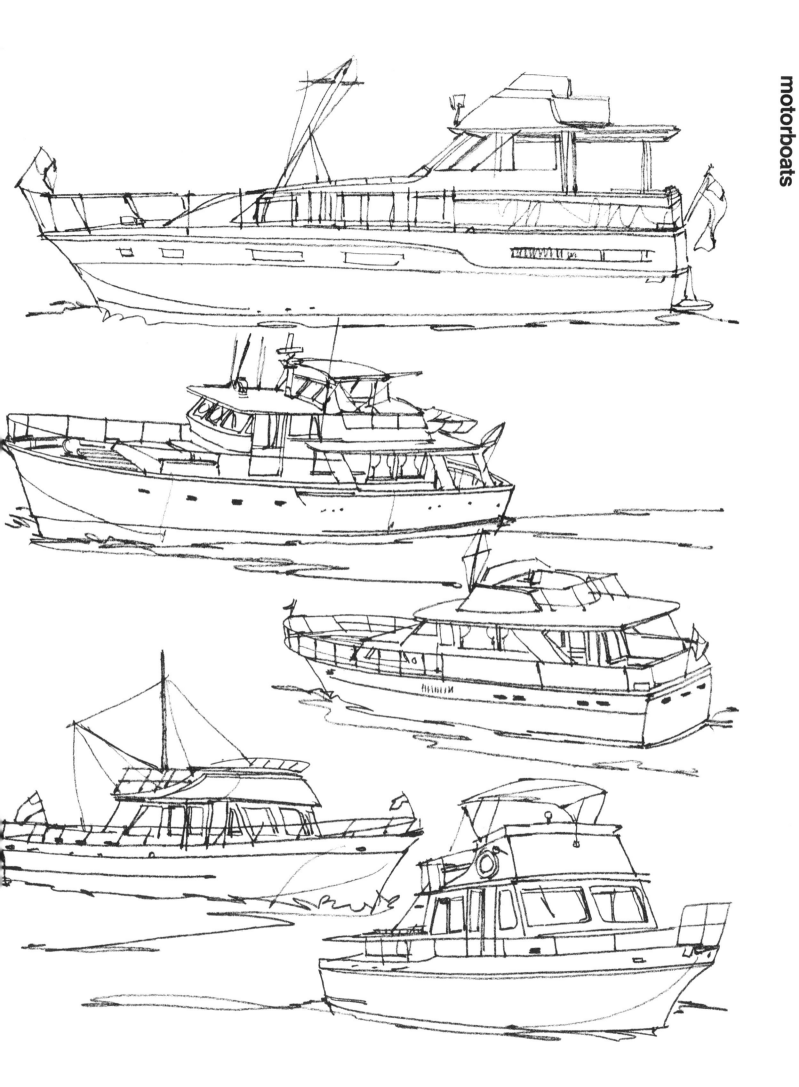

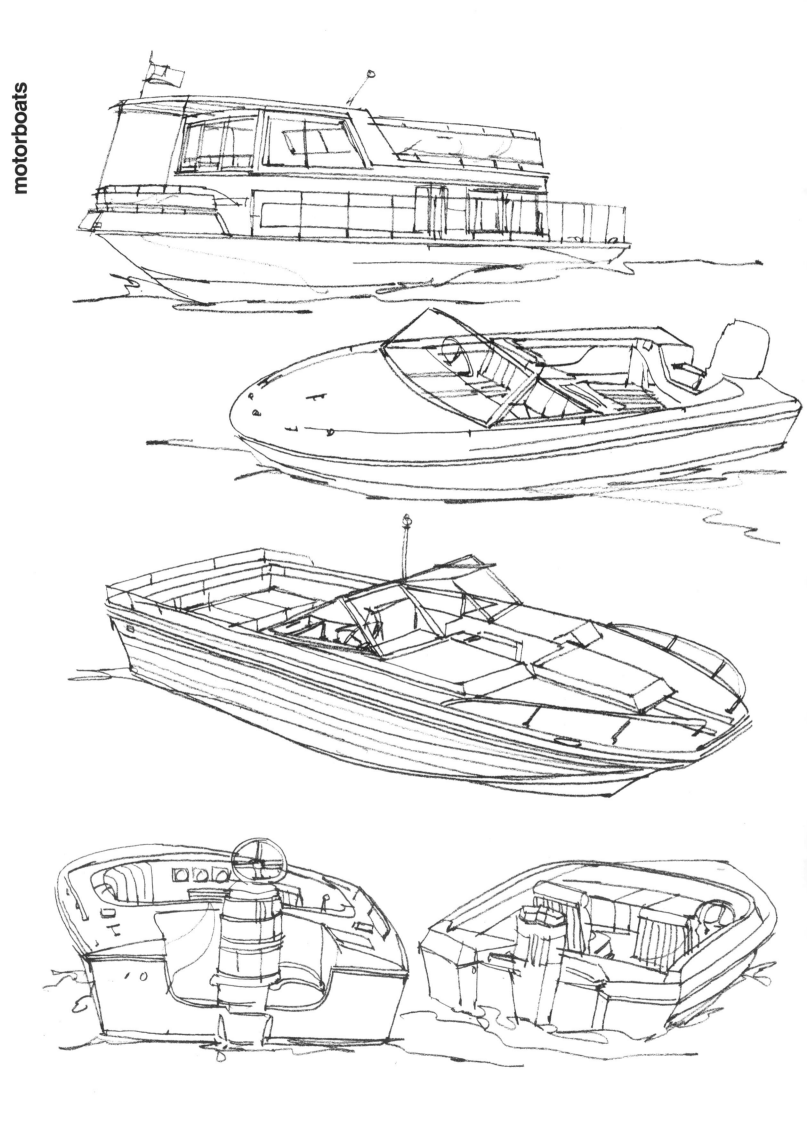

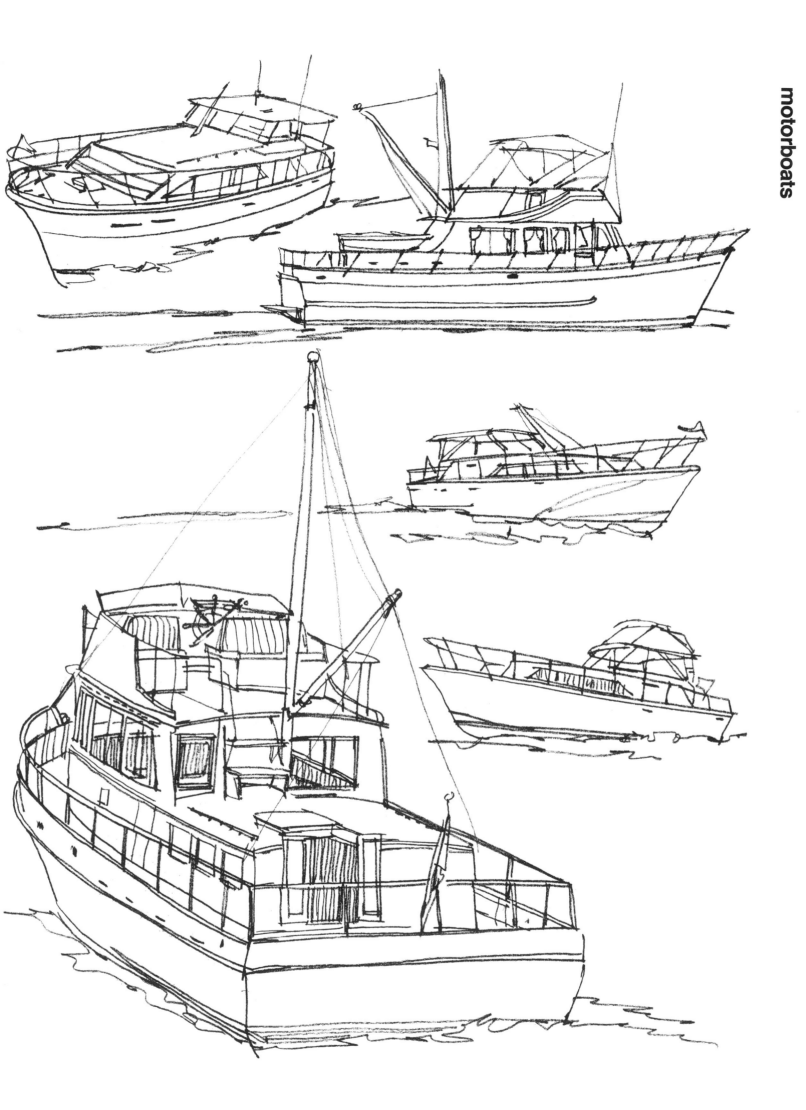

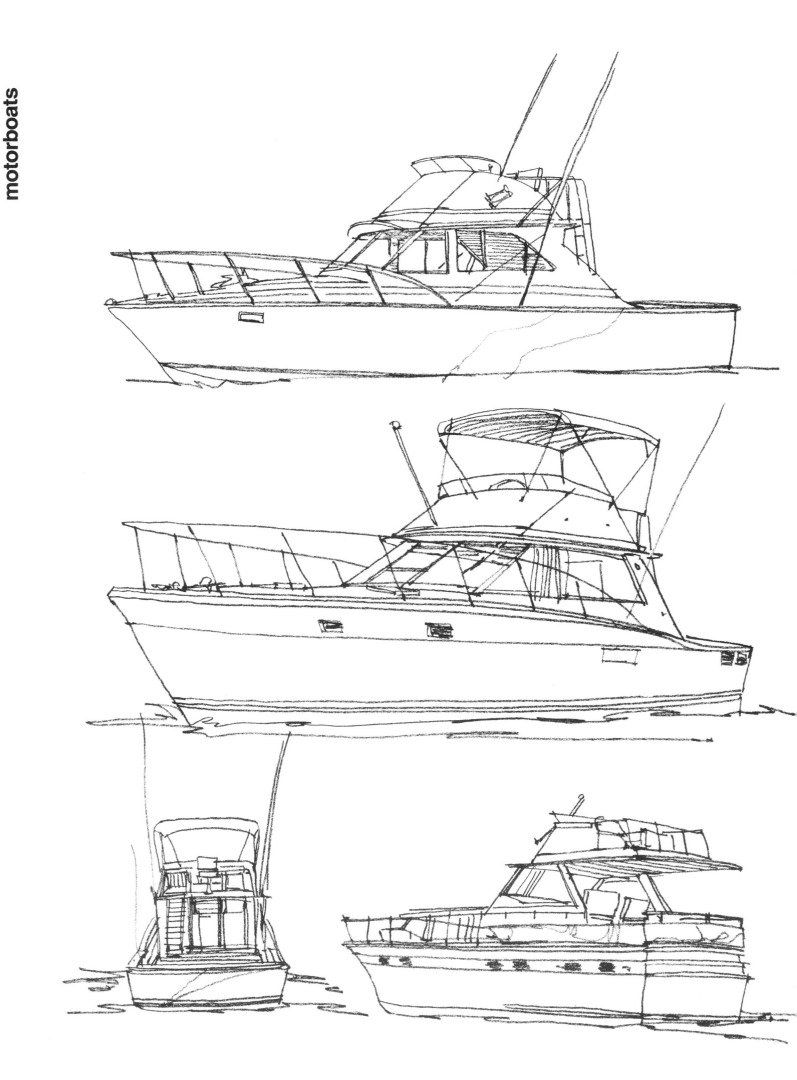

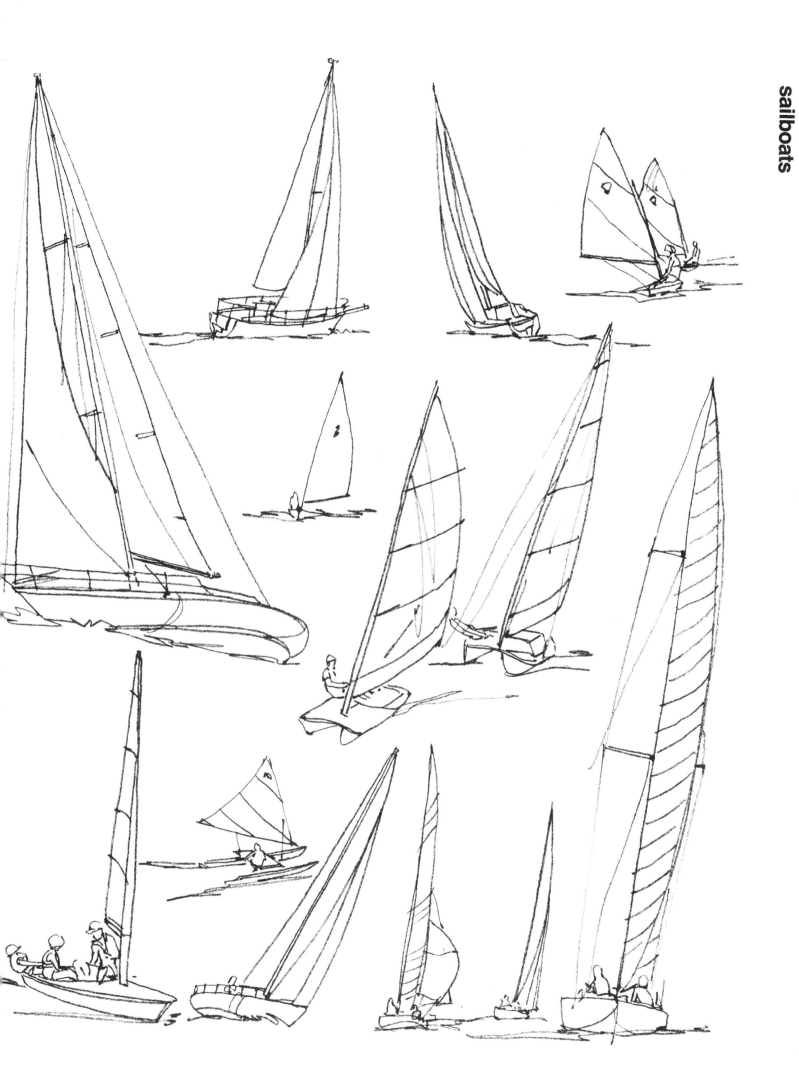

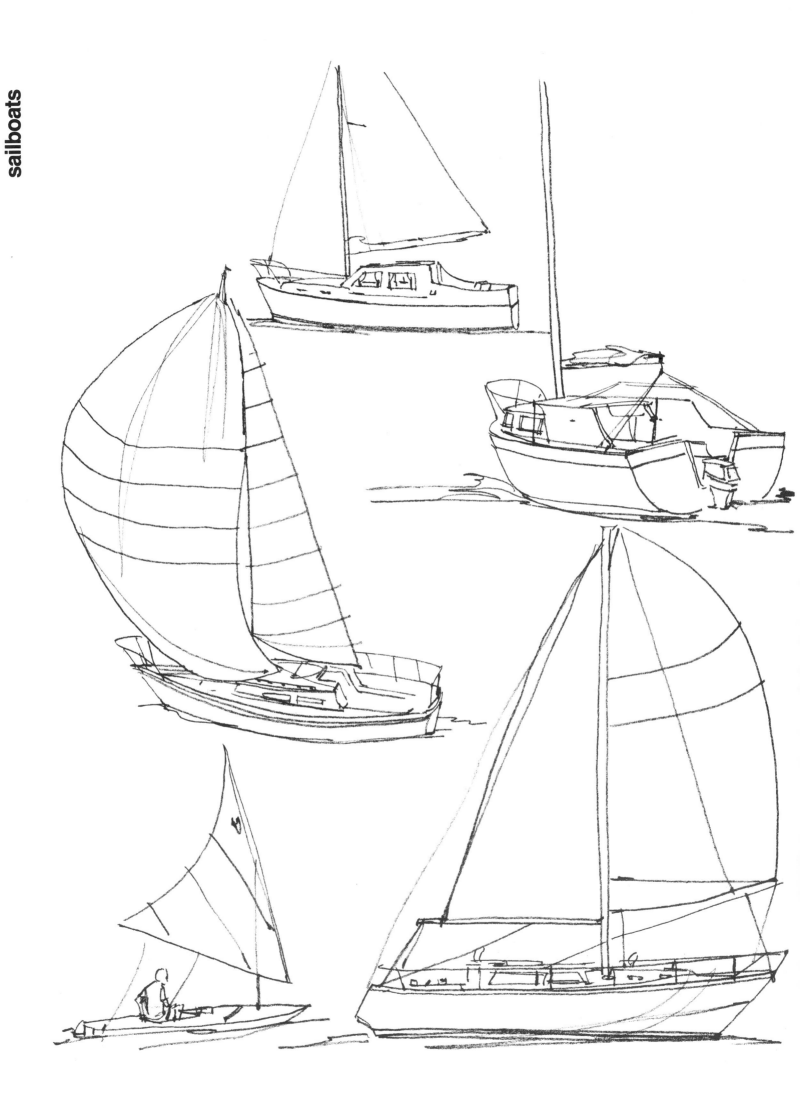

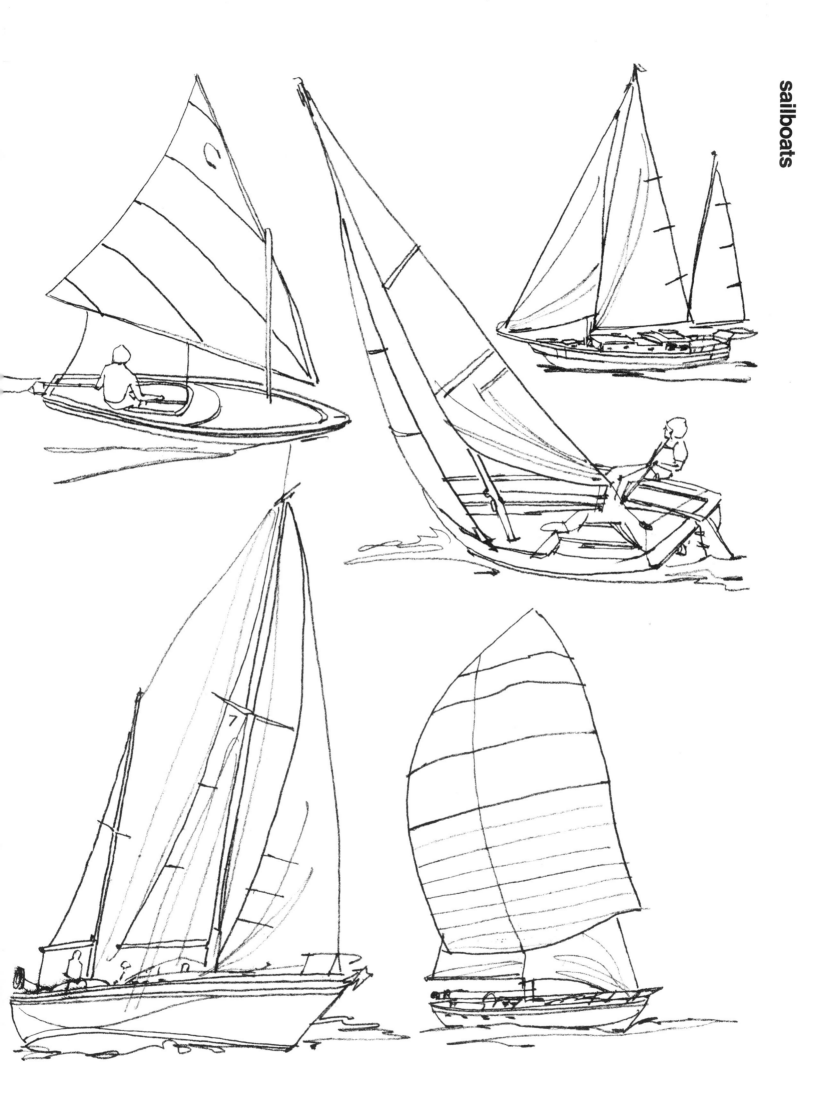

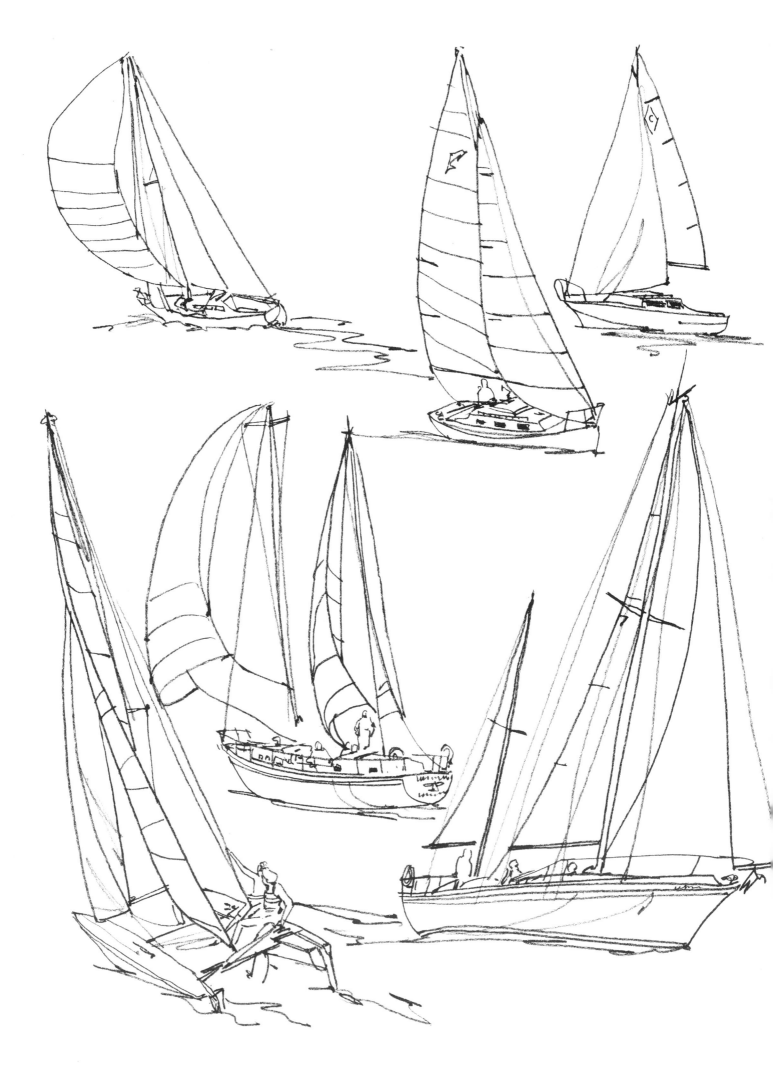

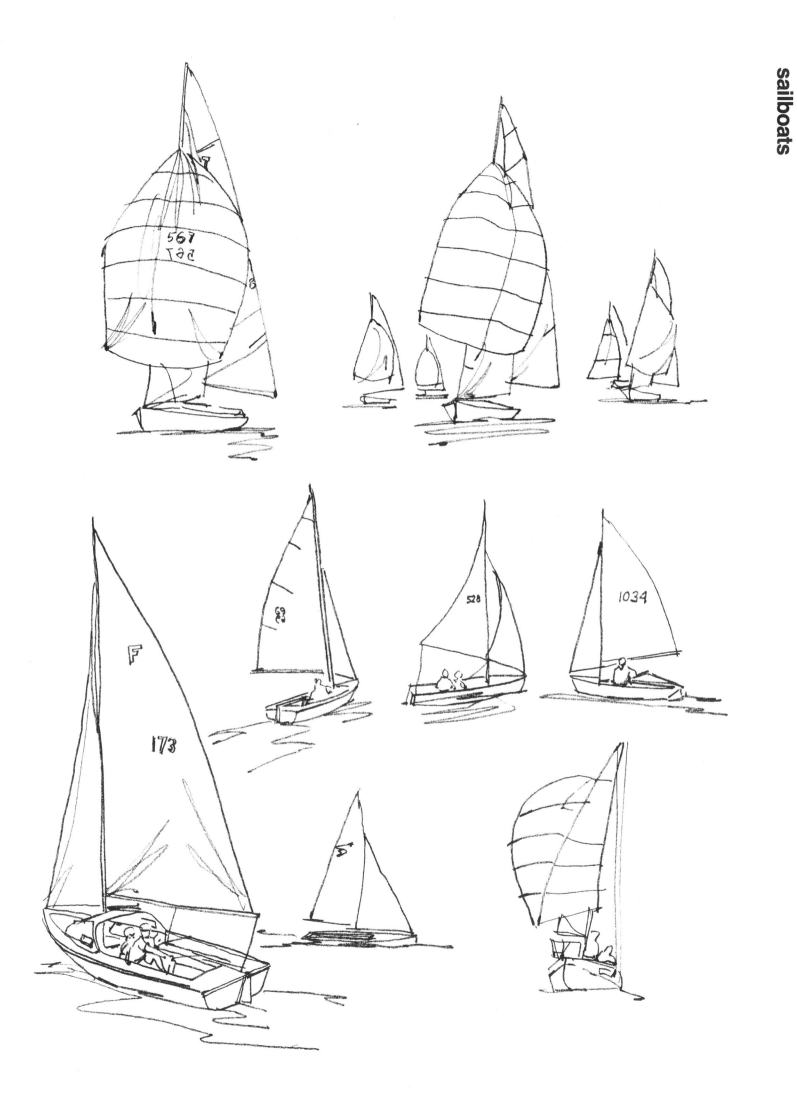

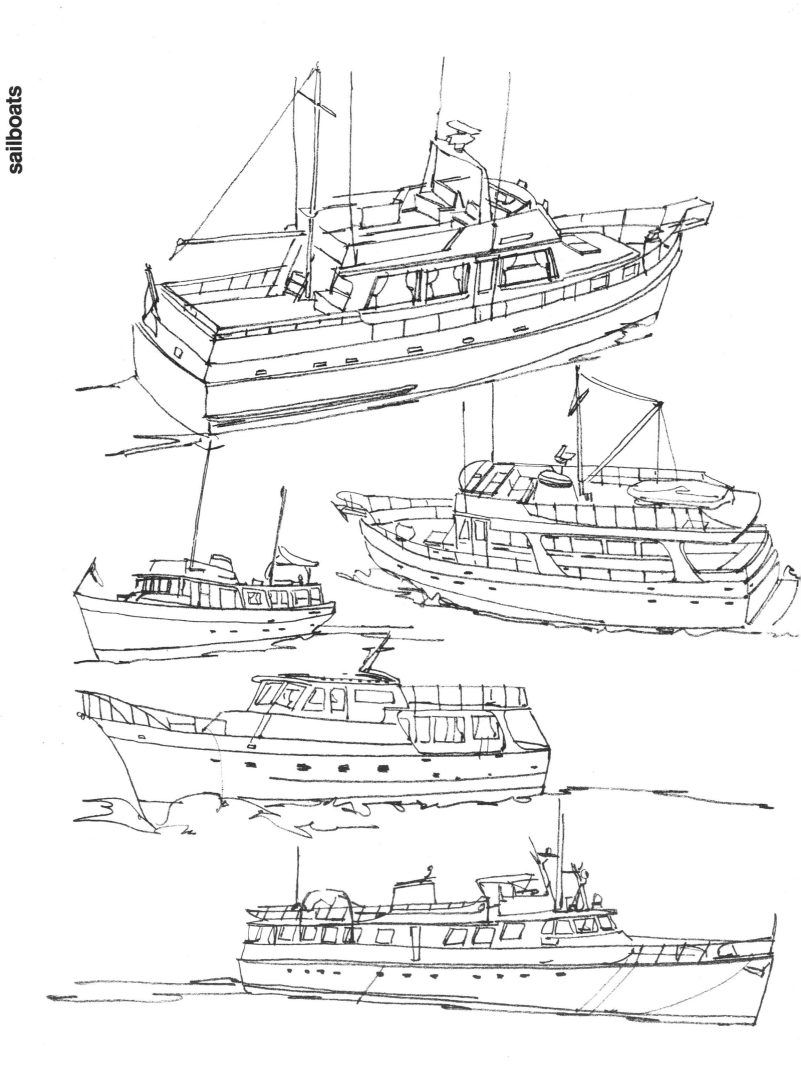